Marriage A-la-mode

Hogarth's MARRIAGE A-LA-MODE

ROBERT L. S. COWLEY

Cornell University Press
Ithaca, New York

First published 1983 by Cornell University Press

International Standard Book Number 0-8014-1525-X

Library of Congress Catalog Card Number 82-70749

Printed in Great Britain

Contents

Colour plates

Marriage A-la-mode, c. 1742–43 by William Hogarth
—the colour plates appear between pages 20 and 21

Monochrome illustrations

By William Hogarth unless otherwise stated. His titles are in brackets

Acknowledge-
ments

I would like to thank the following: the British Academy for a research grant towards the cost of publication and the City of Birmingham Polytechnic for its contribution to expenses; Dr Colin Bailey, Librarian of the Barber Institute, for his advice; Dr B. T. Davies, Forensic Pathologist of the Birmingham Medical School, for his knowledge of eighteenth century medical practice and lore; Liz Morris and John Banks of Manchester University Press for their editorial support and Max Nettleton for the design; the Director of the National Gallery for giving me access to the paintings, the Hogarth dossier, and the conservation rooms and, in particular, to David Bomford for allowing me to watch him at work, sharing his knowledge of restoration, and for making available the report of a colleague's and his technical examination; Her Majesty the Queen for gracious permission to reproduce works in the Royal Collection; Mrs S. M. Newton and Dr A. Ribeiro of the Courtauld Institute for their knowledge of eighteenth-century dress; Professor Ronald Paulson of Yale University for his encouragement and advice; the late Professor T. J. B. Spencer of the Shakespeare Institute for his prompting and guidance; Sir John Summerson, Curator of Sir John Soane's Museum, for his knowledge of eighteenth-century architecture; Professor Sir Ellis Waterhouse for his help with obscurer detail; the Whitworth Art Gallery, Manchester, for allowing me to reproduce prints from its Hogarth collection; all those other interested individuals, private collectors, and institutions who have given advice, information, or permission to reproduce their pictures; my wife and son for their support and tolerance.

Introduction

WILLIAM HOGARTH'S NARRATIVE MODE

William Hogarth's famous declaration in his *Autobiographical notes* suggests that he regarded his series uncritically as a mixture of prose, drama and mime. He wrote: 'subjects I consider'd as *writers do* my picture was *my stage and men and women my actors* who were by mean[s] of certain actions and express[ions] to exhibit a dumb shew' (italics added).[1] In making his claim to be an original artist, he did so in terms of the modernity and moral force of his subjects and not of his form.

The closest he came to a consideration of his narrative form was in explaining why Europeans used the term *historical* of his progresses: because of their being 'design'd in series and having something of that kind of connection which the pages of a book have'.[2] In defining his works in this way, he did not dissociate them from the literary mode and he regarded himself as an *author*, the contemporary term for any kind of first beginner. He also used the general term *to invent* at a time when an *inventor* could mean a *novelist* in the now accepted sense of the word as well as an artist or an innovator.

Hogarth's commentators have also been uncritical in their use of terms. He has been called a writer of comedy, a dramatic and an epic painter and a visual biographer. He has been said to use colours instead of language and his prints have been called graphic journalism. The series have been called novels and *romans muet. Marriage A-la-mode* has been identified as a poetic tragedy and as having the feeling of theatrical *tableaux vivants*. There is truth in all these claims because one form of narrative is bound to have affinities with the others, but the associations in common have obscured the fact that Hogarth's picture series belong to a narrative mode which is essentially independent of other forms.

Aristotle identified the fundamental continuity of narrative as a succession of well-connected events, a definition which allows a narrative to be a sequence of separate but related events as well as a continuous flow. The notion of one 'event' before others and one after others provides such a sequence of juxtapositions with the essential temporality. According to this fundamental definition, narratives can occur in a variety of modes: speech, writing, pictures, mime, music, or combinations of these.

The precise location of Hogarth's series among a range of pictorial types of narrative (and incidental confirmation of the authenticity of his narrative form) is to be found in twentieth-century studies of the cartoon strip. Pierre Couperie, in a special issue of *Graphis* given to the subject of definition (1972–73), typifies the cartoon strip as:

a story (though not necessarily a story) consisting of pictures drawn by one or more artists (we can thus eliminate the cinema and novel in photographs), the pictures being static (as opposed to the animated film), multiple (as opposed to the cartoon) and juxtaposed (as opposed to illustration or the engraved novel).[3]

The principles of multiplicity and juxtaposition distinguish the authentic pictorial narrative, which must consist of more than one picture or depicted event, from the single picture, which can only have potential for narrative. A narrative picture, as traditionally termed, cannot be regarded as truly narrative even if it makes reference to the events of an independent story outside the depicted moment. Such references have temporal significance only in relation to the extraneous event on which the picture is dependent.

Juxtaposition is the active principle in a static narrative because the temporal relationship of one *before* or *after* others can be redefined as one *beside* others. The juxtaposition of sentences, paragraphs, and chapters makes writing one kind of static, visual narrative. Hogarth showed that he partly understood this relationship in asserting that 'drawing and painting are only a much more complicated kind of writing'.[4] He had no need to imply, however, that either of these static, visual forms derives from or is dependent on the other; both images and words are capable of forming independent modes.

Written narratives are usually represented in monolinear sequences, whereas the images in a picture strip form looser, multilinear patterns. They allow a viewer more freedom to vary his approach than a reader (a special kind of viewer). As it happens, the figures in Hogarth's elaborate picture strips are usually well spaced out so that it is fairly easy to establish an order of discussion for what is called a *viewing sequence* in this monograph. An order is harder to establish for the diverse elements of the setting so an attempt has been made to consider first those details which have most bearing on the immediate situation. The ordering of priorities is much more a matter of a viewer's personal preference than it is for a reader whose response is controlled by the tyranny of the single line. In a life-like picture, circumstantial evidence of previous action can extend into a distant past, but predictions about a supposed future can only be hypothetical because alternative courses of action can always be postulated. The rhythm of life-like picture narratives, therefore, emphasises causes rather than effects. Hogarth's narrative mode itself encourages a viewer to adopt a retrospective, meditative approach: he is a *re*-viewer and a discussion such as this is a *re-view*.

The intervals between pictures mark the necessary advances in imagined chronology which make the juxtaposition of pictures a narrative mode. The intervals between the frames of a film are so minute that they deceive the eye, but Hogarth's intervals involve such leaps in time that the relationship between one step of the narrative and the next is often difficult to comprehend. The impression he gave that the pictures in a series correspond to the pages of a book is misleading. The intervals mark off the equivalents of the major, structural divisions of a narrative work, its acts, movements, or chapters. A narrative mode

in which juxtaposition is a prominent feature is also antithetical in its effect. Hogarth's narratives, in moving from stage to stage without the connection being made explicit, are essentially dramatic, ironic and difficult.

A narrative may have little intelligible form beyond succession itself, but, as in other forms of narrative, a complex picture strip can represent events in chronological order, in reverse order, or out of order provided that the whole remains intelligible. A sophisticated picture strip can present more than one plot in a single work and represent action apparently as happening in one area of a picture at a tempo different from that in another. In a longer series, recurrent elements can be omitted from some pictures without a loss of coherence and several recurring elements can weave in and out of the structure in the manner of motifs in contrapuntal passages of music or iterative imagery in literature.

A picture narrative has no authorial voice (unless provided in the form of a caption). Events have the immediacy of drama and the figures have an apparent freedom of action like that of characters in a play. The freedom is only apparent because the influence of the narrative form (with its stress on causality) is such that the figures appear oppressed by their antecedents. This effect is heightened by Hogarth's preference for enclosing his figures in box-like settings. Because the intervals carry so much information, psychological development is a matter of abrupt change. Hogarth's figures are inescapably represented as *in medias res*, jumping from one crisis to the next.

The invention of film encouraged the picture narrator to experiment with variations in standpoint; to use close and distant views; to analyse an action into many frames. The advent of the picture strip as an ever-running serial allows a narrator to design works of substance and complexity. Without such advantages, Hogarth proved himself to be a varied and resourceful narrator. His technique is particularly remarkable in that he only went beyond a limit of six pictures on two occasions and needed neither balloons nor captions to help out the narrative line.[5] It is unreasonable to expect an artist to define the exact nature of his own achievement, but it is ironic that the often defensive discussion of an under-valued narrative mode, the cartoon strip, should lead to a more exact identification of Hogarth's achievement than he himself achieved in his writings.

MARRIAGE A-LA-MODE IN THE CONTEXT OF HOGARTH'S NARRATIVE ART

Hogarth began his career in about 1713 as a silver engraver, but he did not complete his apprenticeship because, as he was to recall, he found the craft too 'tedious' and restrictive on his imagination.[6] The training, however, gave him the lasting knowledge of the language of emblems, the decorative engraver's stock in trade which was to give a deeper meaning to all his narrative art.

By 1720, Hogarth had set up in business as an independent engraver and print-seller, designing book-plates, shop-cards and benefit-tickets, and composing his own satires on sensational topics such as the bubble

scandals or the notorious public masquerades. His most important projects in the early years of his career (in terms of the development of his narrative art) are the two sets of illustrations (1725–6) for Samuel Butler's satire on puritanism, *Hudibras* (1663–78), a shrewd choice because of the poem's continuing popularity. Hogarth was drawn to the 'inimitable' Butler because of his own interest in the comic relationship between the heroic and the mundane, and the ridiculous consequences which occur when the two are confused. The motif of holding a mirror up to nature first appears in Hogarth's *Frontispiece* to *Hudibras* where nature is personified as Britannia. The 'genius' of Butler is lashing Hypocrisy and other evils.

The task gave Hogarth the experience of translating a written account into visual forms, of selecting a small number of essential incidents to illustrate, and of making the illustrations of particular incidents take account of previous or subsequent events in the poem. The laborious process of making preliminary drawings, inscribing the plates and issuing the prints inevitably encouraged him to regard a set of illustrations as having an inner consistency of their own and, therefore, a semi-independent existence. Significantly, one of the sets was published without an accompanying text.

Hogarth began to paint a number of versions of the climax scene of *The beggar's opera* in 1728. They show the actors and identifiable members of the audience in dramatic poses and in ironic relationship one to another. The fascination with Gay's ballad opera marks the beginning of Hogarth's alternative career as a painter of conversation pieces in which he was to depict his sitters in informal attitudes in their domestic surroundings, the real-life equivalent of his modern, moral subjects. The access which his commissions gave him to the houses of the well-to-do, storehouses of baroque art, meant that one career became to an artist with Hogarth's powers of observation and retention the education for another.

His first experiment with a wholly independent narrative was *A harlot's progress* (painted 1730, engraved 1730–2). This first progress made Hogarth famous, even notorious, as an original and modern artist. Its subject matter was both traditional and up-to-date in that it drew upon a variety of contemporary newspaper accounts. It was sensational because it showed well-known people in recognisable localities in London. Its effect was sobering because of its grim, moral truth. It was memorable because the commonplace, yet erotic subject was treated with the skill of a clever painter and a competent engraver. Its success, however, marked in Hogarth the beginning of the painful conflict between the pride he took in his reputation and his ambition to succeed his future father-in-law, Sir James Thornhill (1676–1734), as the second Englishman to be accepted as a serious history painter on the monumental scale who could compare favourably with the French and Italians.

A harlot's progress (six pictures) and its more elaborate successor, *A rake's progress* (painted 1733–4; engraved 1734–5 in eight pictures), are the visual equivalent of fictional 'histories'. Both are variations on the popular tales of wanderers about town; the Harlot's name, M.

Hackabout, identifies the type. According to George Vertue's notebook, there was an element of improvisation about the composition of the first progress typical of a picaresque narrative.[7] Hogarth began with what was to be the central grouping of the third picture: 'this thought pleased many. some advisd him to make another. to it as a pair. which he did. then other thoughts, encreas'd & multiplyd by his fruitfull invention. till he made six. different subjects which he painted so naturally'. Vertue pointed out the differences rather than the similarities between the paintings, an emphasis which suggests that he, like Hogarth, saw them as a sequence of expressive moments rather than as a unified narrative. Vertue's recollection also supports A. P. Oppé's claim, in *The drawings of William Hogarth* (1948), that Hogarth composed his narratives on canvas without making preliminary drawings.

During the months in which Hogarth composed his first series, he also painted a companion pair, *Before* and *After* (painted 1730–1, engraved 1736). It shows the immediate preliminaries to and the aftermath of a seduction. The interval carries the undisclosed climax of the event; hence, a perfect narrative incident is presented with its beginning, undisclosed middle and end. This pair, more clearly than the progresses, demonstrates that a principle of juxtaposition guarantees a temporal and therefore a narrative relationship between two or more pictures.

A rake's progress was followed by an episodic series, *Four times of the natural day* (painted 1736–8, engraved 1737–8), which depicts four separate localities in or around London on a Sunday. This series, ostensibly a classical allegory according to its title, is also a variation on the many poetic accounts of City journeys, except that it dispenses with recurrent figures so that an abstraction, duration itself, is the unifying factor.

Hogarth turned to *Marriage A-la-mode* (painted 1742?–3, engraved 1743?–5) having already composed three different types of narrative. He returned to the length of his first progress, six pictures, and combined some of the structural features of the progresses with that of *Four times of the natural day*: the histories of recurrent figures, none of which appears in every picture, are subordinate to the subject, not of duration, but of the arrangement of a marriage and its consequences. The comparable model is that of a situation-play like John Dryden's comedy *Marriage à la mode* (1663), on which Hogarth drew. His innovations made it difficult for his admirers to adjust to each new structure. Reports of their inability to identify *Marriage A-la-mode* have survived (page 85).

Both the earlier narratives and a variety of single pictures provided source material for *Marriage A-la-mode*. *The marriage contract* oil-sketch (*c.*1733) is concerned with the subject of an already disloyal sportsman of rank agreeing to marry a wealthy woman with a mania for collecting. The sketch supplies some of the furnishings for a number of pictures in the series. Two oil-sketches, *A night encounter* (*c.*1740) and *Ill-effects of masquerades* (date unknown), offer models for the wife's imploring gesture in the fifth picture of *Marriage A-la-mode* and her dying attitude in the sixth. Their subjects, a duel and the consequence

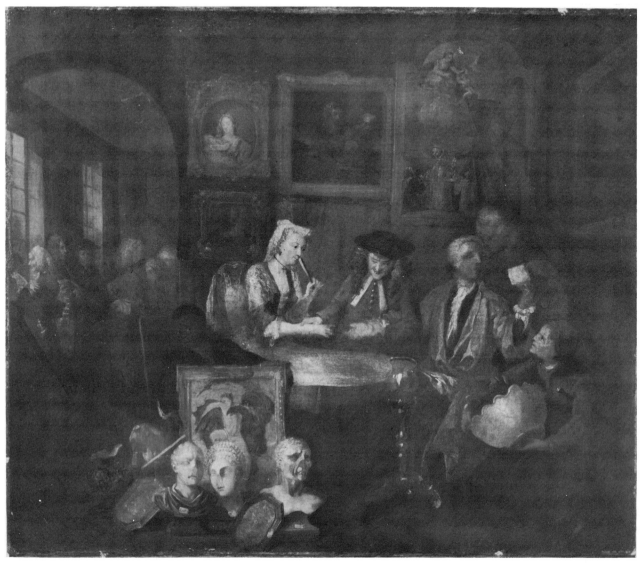

of attendance at a masquerade, form the links in the causal chain which leads to her suicide in the last picture. *Taste à la mode* was painted in 1742: Hogarth's patron, Mary Edwards, had asked him to paint a satirical reply to her friends' amusement at her old-fashioned taste in clothes. Her request, along with a lack of commissions, may also have encouraged him to relinquish portrait painting for a while, and to return to modern, moral subjects, the result of which was *Taste à la mode*. Hogarth's enthusiasm for *Marriage A-la-mode*, however, and the existence of other influences would suggest that Mary Edwards' encouragement was only one reason why Hogarth began a new series. Nevertheless, *Taste à la mode* is important in providing models for various poses and in developing an important strategy first introduced in *A rake's progress III*, whereby the figures and the contents of the pictures hanging on the walls are juxtaposed to ironic effect.

An advertisement in the *London daily post and advertiser*, 2 April 1743, contains the first reference to *Marriage A-la-mode*. The advertise-

[1] *The marriage contract* oil-sketch *c.* 1733 (Ashmolean Museum, Oxford). *Note:* the picture of a Madonna and Child, above one of a giant foot, together provide ideas for first thoughts and the revision to the curtained picture in *Marriage A-la-mode II* (p. 76); the *Ganymede and the eagle* used in the fourth picture (p. 115 and Illus. 30); the busts of Roman emperors – a variant was used in the second picture (p. 73); Hogarth's irreverent humour can be judged by the present of a picture of a 'transubstantiation' machine (top right, p.136).

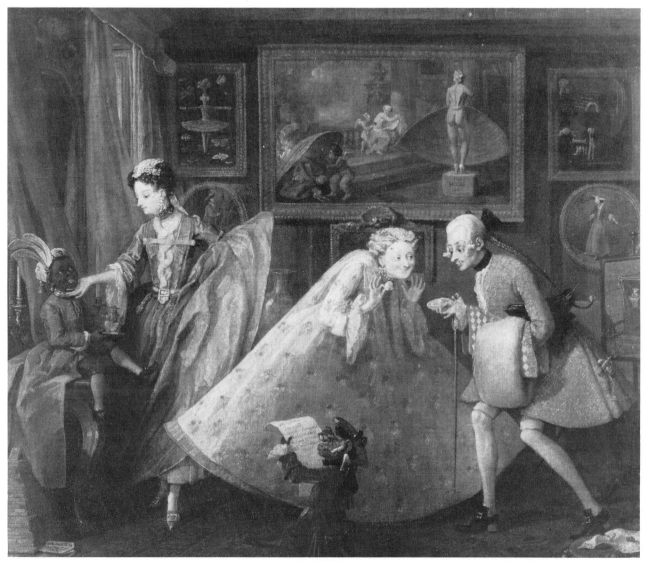

[2] *Taste in high life* or *Taste à la mode* 1742 (private collection). *Note:* the angular beau (with red-heeled shoes) is a prototype for the Viscount in the first picture of *Marriage A-la-mode* and a variant on the Prussian envoy in the fourth (p. 39 and p. 110); the black boy is a variant on the one in *A harlot's progress II* – both anticipate the boy in the fourth picture; the dressed-up monkey anticipates the Alderman's pose in the first picture; the ironic parallels and relationships between the pictures on the walls and the figures below anticipate the technique used extensively throughout *Marriage A-la-mode*; the superimposition of the shorter woman's head on the mirror like a halo recalls similar effects, especially in *A rake's progress V*, and anticipates the husband's head set against a mirror in the fifth picture (p. 125).

ment was repeated with an addition (indicated in square brackets):

MR HOGARTH intends to publish by Subscription, SIX PRINTS from Copper-Plates, engrav'd by the best Masters in Paris, after his own paintings [the heads for the better Preservation of the Characters and Expressions to be done by the Author]; representing a Variety of *Modern Occurrences* in *High-Life* and call'd MARRIAGE A-LA-MODE.

Particular care will be taken, that there may not be the least Objection to the Decency or Elegancy of the whole Work, and that none of the Characters represented shall be personal.

The Subscription will be One Guinea, Half to be paid on Subscribing, and the other half on the Delivery of the Prints, which will be with all possible Speed, the Author being determin'd to engage in no other Work till this is completed.

N.B. The Price will be One Guinea and an Half, after the Subscription is over and no *Copies* will be made of them.

The reference to 'decency' and 'elegancy' suggest that by early 1743 Hogarth had decided how he would depict an adultery; the composition

of the series must have been reasonably well-advanced. The after-thought implies that his views on *character*, as proposed in the subscription ticket to the series (below), were maturing. The promise to treat 'High-Life' carefully and the denial of personal applications show a determination neither to weaken the moral force of the series by distractions nor to offend those who could afford to buy the prints. (A set of prints cost the same as two seats on the stage at Drury Lane in 1744). Hogarth punctuated '*A-la-mode*' as one word, turning it into the catchphrase, which Johnson called 'low'. The phrase was used contemptuously of a cheap and short-lived fashionableness.

During the latter part of 1742 and early 1743, Hogarth worked out his ideas in oil on canvas as had become his custom (a practice inferred from Vertue's account of the genesis of *A harlot's progress* and the lack of preliminary sketches for the series up to *Marriage A-la-mode*). Hogarth used a standard (linen) canvas for the series, known as a 'Kit Cat', a frame usually intended for small portraits. He probably bought them in from a commercial framemaker already stretched and with the ground prepared. The first picture is different from the others in having a finer canvas and a thinner ground. It is interesting to speculate that when the idea for the series first occurred to Hogarth, he had one suitable canvas in his studio and he had to buy in the other five. Logic would have it that he set up the six together and worked from one to another according to the dictates of his imagination.

The technical analysis of the drying cracks in the paint implies that he painted on grounds which had been poorly prepared or insufficiently aged and that he painted over paint layers which were not dry. Hogarth was unlikely to have accepted canvases with poor grounds, but it would have been in character to work on canvases which were not properly aged out of eagerness and enthusiasm. Although he did not let his paints dry, the technical examination shows that he only made relatively minor alterations to the complex compositions of a com-plicated series. The examination also shows his technique to be careful, precise, and emphatic. The variations revealed by X-ray prove con-clusively that the National Gallery paintings were the originals. Circumstantial evidence suggests that Hogarth, exceptionally, pre-pared a set of oil-sketches from the paintings. A report in *The gentleman's magazine* (January 1842) refers to the sale of a version of *Marriage A-la-mode*, painted in a 'free and sketchy manner'.[8] The set had been bought in from the country by Smiths of Lisle Street and was sold to H. R. Willett, an extensive collector and a usually reliable judge. They were sold again in 1902 to Martin Colnaghi whose bills of sale have not survived and so their whereabouts are unknown and recent enquiries have failed to find them. It would not be inconsistent with the care Hogarth took over his most ambitious series that he prepared a second set of paintings as a precaution against loss[9].

Hogarth saw himself as a great painter, but regarded himself as an unwilling engraver of only modest ability who 'never accustomd himself to copy'.[10] He claimed in later life to have engraved his first progress himself only because he could not find someone else to do it for him. He was to employ French engravers for *Marriage A-la-mode*

because of the need to finish the plates in the light, soft style which did not come readily to his heavy hand conditioned by a training on the harder metal, silver. There was an element of false modesty in this self-estimate because he was to assume public responsibility for engraving at least the heads in the series. He preferred to represent himself as a painter who participated in a lesser craft only when he thought there was need.

A professional engraver was expected to produce a print which showed the image the same way round as the original from which it was taken. As a matter of common practice, therefore, he worked from a reflection in order to produce an image in reverse on the copperplate. The imprint would thus come off the copper on to the paper the same way round as the original. Hogarth disliked using a mirror probably because, as a silver engraver, he had become used to inscribing his designs directly on to the metal with no need to reverse them. He developed the unusual habit, therefore, of blocking out his designs on canvas the wrong way round in order to anticipate the requirements of the prints.[11] The groupings and alignments, if not the buttons or hands, would then be the right way round for the prints.

His attitude towards the function of the paintings of the series is also surprising. In the first advertisement for *Marriage A-la-mode*, he described them as representing a 'Variety' of occurrences and was later to advertise that he was prepared to sell the individual paintings of the earlier series separately, 'each Picture being an entire Subject of itself'.[12] In the same advertisement he referred to the 'six pictures call'd THE HARLOTS PROGRESS' and 'the six pictures call'd *Marriage A-la-mode*'. The narrative is difficult to follow in the paintings partly because, unlike the prints, they were not intended to convey the impression of unity and left to right momentum. They represent the relatively disjointed states of feeling associated with an idea. The results of Ashok Roy's paint examination show that Hogarth paid considerable attention to his choice of pigments to heighten the dramatic impact of the compositions and reinforce the ironic message of the narrative. Three separate pigments (Prussian blue, ultra-marine, and the rare smalt) for blue alone, for example, were used to produce different colour effects. He concludes that the six pictures were painted with such care that they must be regarded as independent easel paintings in their own right.

The examination also shows that Hogarth avoided using pigments with a reputation for impermanence such as lake pigments based on organic dyestuffs or surface glazes. This practice was consistent with his later declared view that time does not improve a picture. A similar concern may have lain behind his insistence that the eventual purchaser of the paintings, John Lane, should only ever allow him to clean them. His responsible attitude may explain why the paintings are still in so basically sound a state of preservation that Ashok Roy could not take as many paint samples as he would have wished.

In May 1743, Hogarth visited Paris to commission engravers to work on *Marriage A-la-mode*. In view of his prejudices against the French, some of which are evident in the series, the visit represented an unexpectedly open-minded action and is perhaps indicative of the

esteem in which he felt himself to be held on the continent. An advertisement, dated 8 November 1744, declares that he had intended to commission six engravers, arguably the best and most up-to-date in Europe.[13] They were to engrave a plate each, a sign that he was prepared to spend liberally in order to guarantee the quality and to hasten the issue of prints. He also announced that he had intended to send the paintings to Paris for engraving, a gesture of almost remarkable trust in uncertain times. The intention supports the claim that he prepared a second set of sketches; it is unlikely that he would have even thought of sending an only set to Paris.

Because of the outbreak of war between England and France (March 1744), the plan had to be changed. The engravers were asked to work under his 'inspection' in London instead. Three of them – Le Bas, Dupré, and Suberan – could not come 'on account of their families', but the others agreed to share the work. The first and last pictures were engraved by Louis Gérard Scotin, the younger (1690–?). Bernard Baron (1700?–66) engraved the second and third and Simon François

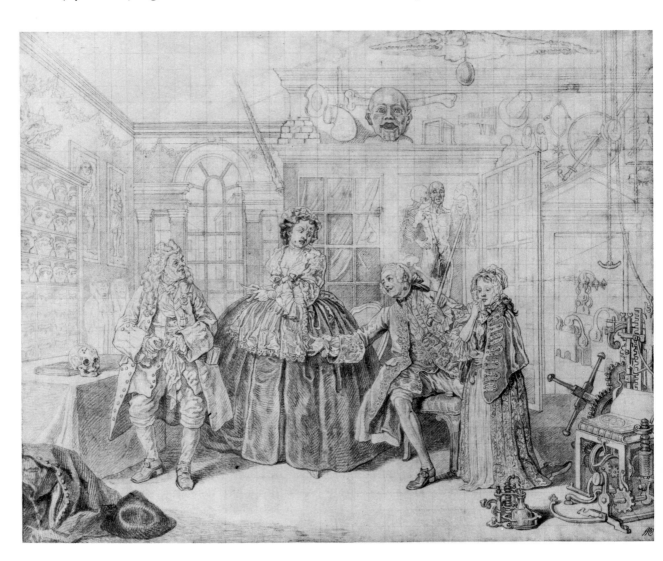

Ravenet (1706?–74) the fourth and fifth. Both Scotin and Baron already had semi-permanent bases in London and had worked for Hogarth before. Scotin had engraved the second plate of *A rake's progress* and contributed to the seventh and eighth. Baron had engraved *Evening* from the *Four times of the natural day* and had recently engraved Hogarth's portrait of Bishop Hoadly (July, 1743).[14] Ravenet came to London for the first time to work on *Marriage A-la-mode* and he, too, was to remain, eventually to help found the French school of line drawing. Perhaps because he had not worked previously for Hogarth, Ravenet was involved in disputes over his fee and over the difficulty of toning down the background in the fifth picture. The three were experienced engravers of history paintings in the French style and, as it happens, had all contributed to the engraving of Watteau's *Recueil julienne*. Their potential unity of approach demonstrates the shrewdness of Hogarth's choice of copy-engravers.

Elaborate intermediary drawings, probably by Baron, for the second and third pictures of *Marriage A-la-mode* have survived (Royal Collection, Windsor).[15] The images are the same way round as the paintings but the paintings have been reduced by about half to the size of the copper plates (from $27\frac{3}{4}'' \times 35\frac{3}{4}''$ to approximately $14'' \times 18''$). The drawings are in red chalk, a medium chosen because its colour approximates to that of the copper before the plate is inked. Traces remain of the squaring required for accurate copying onto the paper. Once the initial difficulty for the artist (of painting in reverse) had been overcome, several advantages of Hogarth's unusual method of copy-engraving become apparent: first, the implications of the loss of colour could be worked out on paper in advance of the engraving process; secondly, alterations could easily be made and mistakes corrected on the intermediary sheet of paper; thirdly, the image could be traced accurately from the drawing on to the copper. Lastly, the reversal guaranteed that buyers of the prints received a version of the series which was similar to and yet significantly different from the paintings.

The drawings repeat the contents of the paintings and prints so closely that they add little to a study of Hogarth's narrative art, although they do, of course, provide a valuable insight into his publishing method. The inscriptions, for example, are missing because they would have had to be inscribed on the copperplate in mirror-writing at a later stage. For the first time, Hogarth was to acknowledge fully the work of his commissioned engravers by publishing their names under each plate. The references to well-known craftsmen would in turn have enhanced his own position as a painter, inventor and publisher.

A further set of drawings of all the pictures of *Marriage A-la-mode* has also survived (photographs in the Hogarth dossier at the National Gallery, originals in private collection).[16] These free-hand, pencil and chalk drawings were also made to the same approximate size as the prints and generally show the elements of the pictures the same way round as in the paintings. The disposition of figures is different from that in both the paintings and the prints. The contents of the fourth drawing are intriguing because the figures are the same way round as in the

[3] *The inspection*, engraver's drawing *c.* 1744, B. Baron (Royal Collection, Windsor). *Note:* the drawing is half scale; it remains the same way round as the painting; red chalk and pencil may have been used to give an impression of the picture as it would appear on the copperplate; the squaring of the paper shows the care needed to maintain accuracy (in contrast to the freehand copy, Illus. 4); a similar drawing for the second picture of *Marriage A-la-mode* has survived also in the Royal Collection; the attention paid to the heads (among other details) may be a sign of Hogarth's own handiwork.

painting, but the setting is reversed. The lack of any correlation between the drawings and Hogarth's first thoughts in the paintings as revealed by X ray proves that the drawings are not Hogarth's preliminary works. Also they bear no resemblance to the painstakingly accurate engravers' copies. The drawings would appear to be the work of the 'ingenious' copyist who, according to J. T. Smith in *Nollekens and his times* (1766–1833), made a living in the 1820s by making 'spirited drawings' with variations from the prints in order to pass them off as Hogarth's 'first thoughts'.

The subscription closed on 1 May 1744, well before the prints were ready, a sign of popular interest in the project, and subscribers were not to receive their purchases until June 1745, so long was the delicate and slow process of copying to take. After the issue of prints, the finished paintings were hung in Christopher Cock's auction rooms in Covent Garden. Hogarth had intended to sell them as soon as the engraving was finished and while interest was high, but his dissatisfaction with the proceeds from the bidders' auction of the paintings of the earlier narratives (February 1745) made him postpone the sale until 1751. The paintings of *Marriage A-la-mode* were then bought by one of only three bidders, Hogarth's friend John Lane, for the modest sum of £126.[17] The paintings remained in Lane's family until 1797 when they were sold to J. J. Angerstein, and they eventually passed with his collection to the National Gallery in 1824.

Two contemporary accounts of *Marriage A-la-mode* provide auth-oritative sources of nomenclature, attitudes and social background. Hogarth asked his friend, Jean-André Rouquet (1701–59) to turn his private notes into a series of letters explaining the meaning of Hogarth's prints for foreign buyers: the *Explication des éstampes qui on [t] pour titre le Marriage à la Mode. Lettre troisième* was issued in April 1746.[18] It is impossible to decide whether Rouquet's 'letter' owes anything to Hogarth's own observations on the series since he made little mention of their contents in his writings. Rouquet's views seem to have been sufficiently close to Hogarth's own for him to pay Rouquet well and to refer approvingly to him in his autobiographical notes. The account is of limited value to a re-viewer, however, because of its brevity and Rouquet's concern only with what a foreigner would need to know in order to follow the narrative line of the series.

The other account is in an anonymous pamphlet issued by Weaver Bickerton: *Marriage A-la-mode: an Humorous Tale in Six Cantos in Hudibrastic Verse; being an Explanation of the Six Prints lately Published by the Ingenious Mr Hogarth.*[19] The poem is a detailed account in over a thousand lines. Because the poet had satirical purposes of his own, his account is valuable testimony as to how an admiring and articulate contemporary saw the series. That such a poem should be thought worth publishing some time after the first issue of prints is a sign of their continuing popularity and of the difficulty of the series.

Hogarth's own writings present his views on art and life and provide information on his preferred nomenclature. His *Analysis of beauty* was published in 1753 and its earlier drafts have also survived.[20] The unfinished works, the *Apology for painters* (begun 1759) and the

[4] *The toilette* date and artist unknown, copy after Hogarth (private collection). The figures are the same way round as in the print, whereas the background is the same way round as the painting. Similar problems, particularly of proportion, are apparent in the other five drawings. The copyist appears to have made up the contents of the pictures on the walls where he could not identify Hogarth's subjects. Here, he replaced *Jupiter and Io* (p. 116) with a *Leda and the swan* which Hogarth used only on the tray in the black boy's basket (p. 111). Hogarth would not have repeated himself.

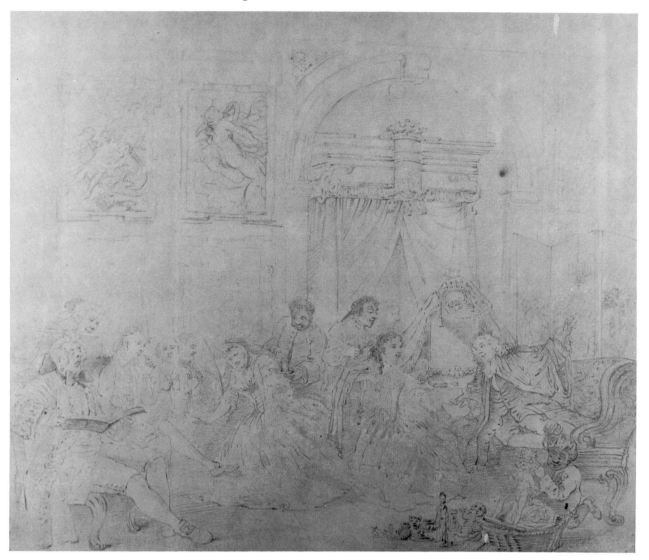

Autobiographical notes (begun 1763) offer further insights. Hogarth's theories formulated early in his life and changed only slowly. The writings are useful background for *Marriage A-la-mode*, provided that allowance is made for the bitterness apparent in the unfinished works.

This monograph is a re-view of Hogarth's narrative art as found mainly in the engraved version of *Marriage A-la-mode*. It should not be forgotten that the paintings meant more to Hogarth than the prints. They offer a closeness of contact with the artist himself and their colour, depth and brilliance provide a unique dimension to the study of his narrative art. The recent cleaning has deepened the contrast between the lighter and darker tones making the paintings more dramatic, exact and 'crystalline'.[21] The variations between the prints, the paintings and the X-ray and infra-red photographs are noted and assessed.

The verbal analysis of pictures draws attention away from the nature of their visual effects. Fortunately for the re-viewer, Hogarth believed

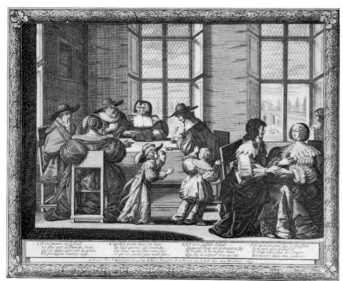

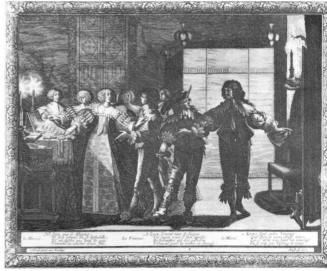

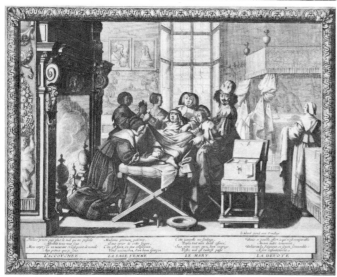

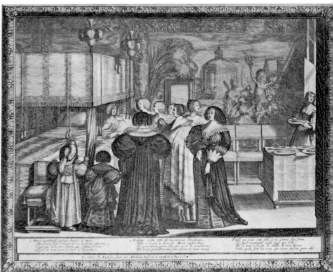

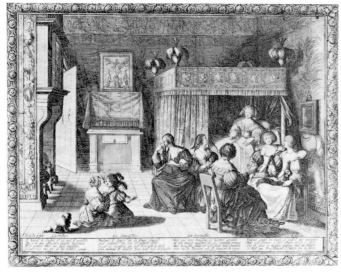

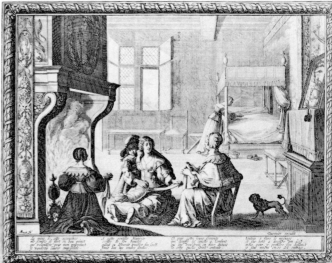

[5] *Le mariage à la ville* 1633, Abraham Bosse (British Museum, London).

[a] *Le contract* – a source for both *The marriage contract* oil-sketch (1733) and *The marriage contract (Marriage A-la-mode I)*. The main tableau of the parents and the notary together at the table is set in advance of the minor tableau, the reverse of Hogarth's picture. The parents are at one with each other, although the intentness of their expressions suggests that the bargaining is as hard as in Hogarth's series. The bridal couple display the traditional signs of lovers in accord: they gaze at one another; hold hands; touch their hearts. An attendant, anticipating Hogarth's lawyer with the plan, gazes out of a window at industrious gardeners instead of indolent servants. The presence of only two pictures on the walls draws attention to the Earl's over-enthusiastic passion for collecting. The playful children with a lapdog watching them offer a touch of exuberance in Bosse's otherwise restrained picture.

[b] *La rentrée des mariés* – Bosse's second picture is anticipatory, sociable and ceremonious, whereas Hogarth's is full of disillusion and loneliness. The husband superintends the departure of his friends: the trailing leg on the far right could have given Hogarth a hint for his departing steward. The oval picture with a candlestick before it to the right may have given him a hint for the Medusa in *Marriage A-la-mode I*.

[c] *L'accouchement* – the inevitability of events in Bosse's series draw attention to the way that Hogarth's withholding of information about the child of the marriage until his fourth picture was a challenge to viewers' expectations. It may account for those commentators who have attempted to read pregnancy into the wife's stretch (p. 60). *Note:* the pictures of saints on the far wall compare with those on the walls of Hogarth's second picture, and the knotted bed curtains are reminiscent of those in the third picture of *A harlot's progress*.

[d] *Le retour du baptême* – the attention given to the child contrasts with the neglect of the heir implied in Hogarth's fourth picture. *Note:* the tapestry of *Daphne's transformation* offers a contrast to the painted wall hanging in Hogarth's fifth picture (p. 133).

[e] *La visite à l'accouchée.*

[f] *La visite à la nourrice* – Bosse's series ends with no sense of resolution, whereas Hogarth transforms a wet nurse into the elderly servant in his last picture. The boy resting his hand on the nurse's shoulder draws the viewer's attention to an important detail as does Hogarth's black boy in the fourth picture.

that the relationship between writing and pictures is close. A discussion of his narrative art should do his paintings little disservice if it is remembered always that Hogarth was an intensely physical painter as well as a sophisticated narrator in pictures.

Marriage A-la-mode, a study of a city marriage, was to have been followed by a companion series about a country marriage. A precedent existed in the naturalistic and more restrained companion series by the French engraver, Abraham Bosse (1602–76): *Le mariage à la ville* and *Le mariage à la campagne* (both 1633). Bosse was known in the eighteenth century as the foremost authority on etching and engraving through his *Traité des manières de graver en taille-douce* (1645). Hogarth may have been drawn to him as a kindred spirit who spent much of his career wrangling with the Académie Royal because of its condescending attitude towards engraving. The influence of Bosse's sequences, both domestic and classical, is apparent throughout *Marriage A-la-mode*.

Hogarth's country marriage series, *The happy marriage* (c. 1745), exists only as unfinished oil-sketches.[22] There may have been several reasons for his loss of interest: the contents suggest that the series would have been little more than the straightforward representation of the stages of a marriage which in being 'happy' provided fewer opportunities for an ironic treatment of events (Bosse found little scope for amusement in *Le mariage à la campagne*). Hogarth may have begun the sequence in an over-buoyant mood and his elation may have faded when the results of the bidders' auction for the paintings of the earlier series warned him that the paintings of yet another series would be unlikely to sell. In his proposals for the auction of the paintings of *Marriage A-la-mode*, he was to declare that they would be the last he would exhibit 'because of the difficulty of vending such a number at once to any tolerable advantage'.

As a result of this disappointment, the prints of the later series were taken from drawings instead of paintings (but continuing to show the reverse of the prints), the exception being the *Four prints of an election*. The change was accompanied by an interest in more obviously moral subjects, a bolder style, and a reduction in price. *Industry and idleness* with twice as many pictures sold for half the price of *Marriage A-la-mode*, a sign that Hogarth was appealing to a more popular market. This series (engraved 1747) was supposedly 'calculated for the use and instruction of youth', but it is an ambiguous work and its narrative structure is at once reactionary and innovatory. The largely separate histories of apprentices are conjoined in one antithetical and panoramic series of twelve pictures, a consequence of which is a considerable increase of scope beyond that of *Marriage A-la-mode*. *Industry and idleness* also draws on the stock of cautionary apprentices' tales and plays from Dick Whittington onwards. Dryden's *Marriage à la mode* could have been the model for its split-plot because its parallel plots also only coincide twice.

The four stages of cruelty (engraved 1750/1) and the huge *Election* paintings, begun 1753 and eventually issued as *Four prints of an election*

[6] Oil sketches from the unfinished 'country marriage' series (p. 15) *c.* 1745.

[a] *The wedding banquet c.* 1745 (The Royal Institution of Cornwall, Truro). *Note:* variations on ideas in the fourth and, perhaps, the second picture of *Marriage A-la-mode*: a musical performance for a loving couple; an attendant concerned with the lady's appearance; others concerned with refreshment.

[b] *The wedding dance c.* 1745 (Tate Gallery, on loan from the South London Art Gallery). The dancers offer a continuum of shapes, from the fat and ungainly on the left to the slender and elegant on the right, an elaboration on the contrast between the Viscount and the lawyer in the first picture of *Marriage A-la-mode* (p. 39). *Note:* the crouching figure in the foreground recalls the black boy of the fourth picture; the shapeless clothes to the right recall those in the foreground of the fifth pictures; the presence of these elements adds weight to the possibility that an assignation is being arranged between the lawyer-like figure and the seated lady to the left.

(1755–8), are hybrid narratives. Tom Nero, as the personification of cruelty, is a recurrent figure, but the 'stages' are as much the exemplification of types of cruelty as they are the events in a personal history. The candidates in the *Election* are also recurrent figures, but they are submerged in the crowds and the election procedure is the unifying principle.

Hogarth's remaining narrative sequences are companion pairs: *Beer Street* and *Gin Lane* (engraved 1751); *The invasion: France and England*

(engraved 1756); the allegory of *The times, 1 and 2* (engraved 1762–3). Moral propositions provide the unifying principles: ostensibly that beer is better than gin; that English soldiers are better than French; that one political viewpoint is better than another.

CHARACTERS AND CARICATURAS AND HOGARTH'S APPROACH TO CHARACTERISATION

Hogarth sold his prints by the well-tried method of subscription in the manner outlined in the first advertisement. In return for a deposit, a subscriber was given a receipt, the subscription ticket. His tickets were customarily decorated with sketches which acted as ironic preludes to the series they introduced. *Boys peeping at Nature* (1730–1) suggests that *A harlot's progress* is an impudent investigation into the nature of (sexual) realism. *The laughing audience* (1733) draws attention to the comic operatic associations of *A rake's progress. Characters and caricaturas* (1743) implies that Hogarth's concern in *Marriage A-la-mode* is with characterisation.

The sketch consists of a small rectangle ($7'' \times 6\frac{1}{4}''$) crammed with a hundred profiles each with a distinct expression. The design draws attention to the variety of human expression underlying its general monotony. Hogarth confined himself to a flat and ugly view of mankind as if to imply his confident mastery over a wider range of full and angled faces in *Marriage A-la-mode*. The sketch also suggests that the series is about the dull and ugly, in spite of its stylish title and the concern for 'high-life'.

A row of heads beneath offers a visual caption. Three heads to the left are derivations from Raphael's cartoons for the tapestries in the Sistine chapel: St John from *The sacrifice at Lystra*; a beggar from *Peter and John at the Beautiful Gate at the Temple*; St Paul as Raphael shows him preaching at Athens.[23] The inclusion of the beggar is a reminder that even Raphael, the acclaimed founder of the historical sublime, was prepared to include figures of lowly rank in his most sublime art. Hogarth, following the example of Henry Fielding in his preface to *Joseph Andrews* (below), was citing the highest authority in art for including both a wide social range in his series and for treating its representatives in a life-like manner.

Four grotesque and deliberately clumsy heads to the right were modelled on caricatures by Pier Leone Ghezzi, Annibale Carracci, and Leonardo da Vinci. The Carracci brothers invented Italian caricature and as such could be regarded as the founders of a debased style (in Hogarth's view) to act in contrast with Raphael. Ghezzi's witty drawings probably started the vogue for caricature in England and Leonardo's experiments were being cited by contemporaries as an argument in favour of caricature. A fifth, crudely grinning head of Hogarth's own invention is tucked between two of the attributed caricatures. Its deliberately child-like design shows his contempt for an amateurish craze, made more despicable not only because of its Italian origins, but also because the figures in his own modern pictures were often mistaken for caricature. Caricature is produced more by accident than 'skill', he was to declare in the long caption to *The bench* (1758). It

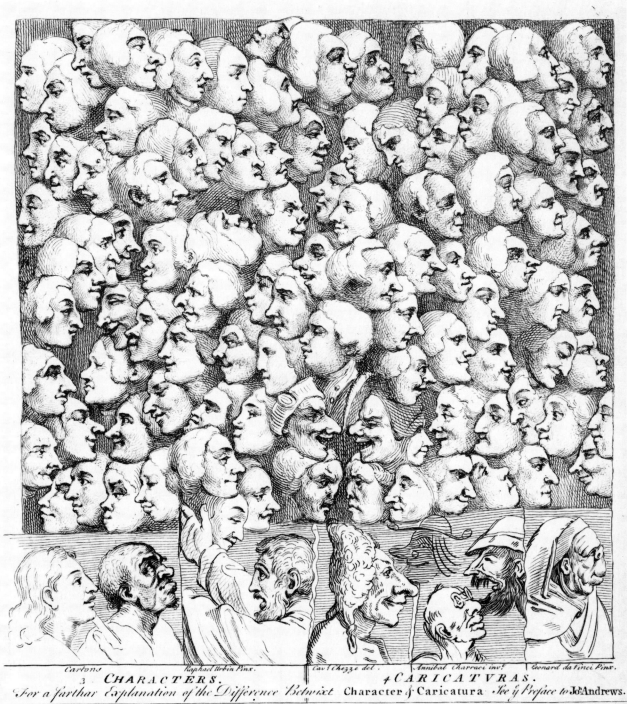

Cartons Raphael Urbin Pinx. Cav.t Chezze del. Annibal Carraci inv.t Leonard da Vinci Pinx.

3 CHARACTERS. 4 CARICATVRAS.

For a farthar Explanation of the Difference Betwixt Character & Caricatura See y Preface to Jo.s Andrews.

W Hogarth Fecit 1743

Rec.d of

Half a Guinea being the first Payment for Six Prints Called MARRIAGE

A LA MODE which I Promise to Deliver when finish'd on Receiving half a Guinea more.

N.B. The price will be one Guinea and an half after the time of Subscribing.

depends for its effect on 'the surprise we are under at finding ourselves caught with any sort of similitude in objects absolutely remote in their kind', whereas character 'requires the utmost efforts of a great master'.

The row of heads in *Characters and caricaturas* provides an irregular spectrum of types from the idealised head of St John on the left to the ape-like face to the right. The arrangement suggests that Hogarth thought that the differences between *character*, which continued to mean a literal *stamp* or *imprint*, and caricature (or for that matter the sublime as represented by St John) were more a matter of degree than of distinctions in kind. He was to make a similar point more systematically in the first plate of *The analysis of beauty* where the idealised head of an old man is transferred into caricature over a sequence of seven stages (numbers 97–105), the last of which, a barber's block, is a variation on the grinning caricature in the subscription ticket. The predominance of the ordinary faces in the rectangle indicates that Hogarth's main concern, particularly in *Marriage A-la-mode*, is with the middle ground, the 'intermediate species of subject for painting between the sublime and the grotesque'.[24]

In so far as the sketch has potential for narrative, St Paul in the

[7a] *Characters and caricaturas* 1743 (Whitworth Art Gallery, University of Manchester). The subscription ticket to *Marriage A-la-mode* (pp. 17–20).

[b] Sheet of caricatura heads 1594, Agostino Carracci (private collection). Originally in the Northwick collection. No engravings are known to the BM, but Carracci drew several such sheets and Tiepolo copied this example. It is likely that Hogarth encountered a version since caricature was so popular (p. 20).

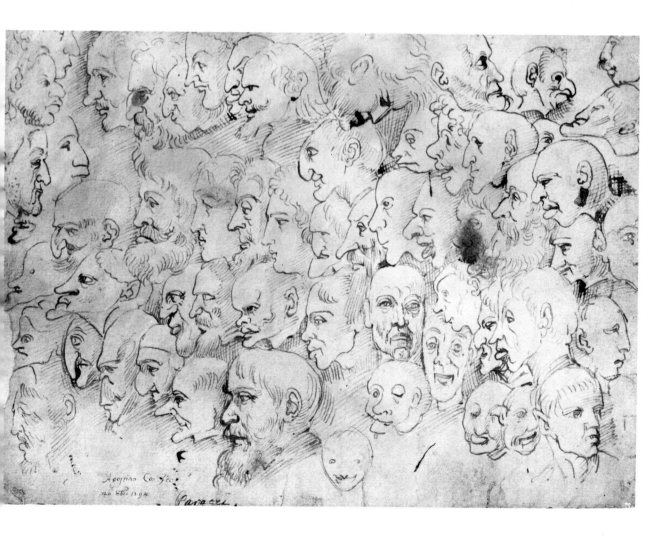

Agostino Ca
1594
Caracci

caption preaches to St John and the attentive beggar, but ironically, with one exception, the packed congregation of profiles disregards him. The lack of contact, a theme developed in the series, recalls the relationship between the lecturer and his bored audience in *Scholars at a lecture* (1736/7). It is the reverse of the situation in *The laughing audience* where the audience in the pit pays rapturous attention to the performance and only a critic looks on with dissatisfaction. *The laughing audience* is an ambiguous work which reveals the audience as both appreciative and brutal in its laughter. *Characters and caricaturas* is similarly ambivalent in that its effect derives from an obsessive and monotonous playing on a single theme. The design appears to have been based upon Agostino Carracci's *Sheet of caricatures* (1594), as if Hogarth wished to demonstrate his superiority over the caricaturist on the latter's terms. Although each profile is distinctive, the physiognomy has been exaggerated to the point where the 'characters' are sufficiently distanced from life as to border on caricature.

The inscription below the row of heads referred the interested subscriber to the Author's Preface to *Joseph Andrews* (1742). Hogarth was giving an impecunious friend some free publicity and graciously returning a compliment because Fielding in his Preface had praised him for representing the 'affections of men on canvas' and for making his figures not only appear to 'breathe', but also to 'think'.[25] Fielding's aim was to raise the status of prose fiction from the level of an entertainment to that of a serious literary form faithful to the moral truth of contemporary experience. Hogarth was recognised as a colleague with similar ambitions for modern painting. Fielding justified the inclusion of figures of inferior manners in his fiction by citing the precedent of Homer's lost prose epic, *The margites*, which reputedly had a fool or *margos* as the main character. Fielding defended *Joseph Andrews* as a 'comic epic-poem in prose' and identified Hogarth as a 'comic history-painter'.

A comic epic, according to Fielding, differs from a serious one in, among other things, its greater social range. Hogarth's figures range from an earl to an imbecile and he went beyond Fielding, who denied Lady Booby her conquest of a servant, in depicting an adultery between a countess and a lawyer. Fielding also distinguished between the comic, to him a profound moral concept, and burlesque, the province of 'exquisite mirth and laughter'. Comedy is concerned with the 'just imitation' of (human) nature, whereas burlesque is concerned with the 'monstrous and the unnatural', features in art which Hogarth also associated with caricature.

Fielding warned the writer of comedy that he had the least excuse for deviating from his purpose because 'life everywhere' furnished him, the accurate observer, with abundant material. Fielding had to point out, as a consequence of his reputation as a writer of burlesque, that he had obscured the sources for his characters 'by such different circumstances, degrees, and colours, that it will be impossible to guess at them with any degree of certainty'. He was to return to the subject in Book III of *Joseph Andrews* in order to make it doubly clear that his aim was 'to hold the glass to thousands in their closets' and not 'to expose one pitiful

Colour plates

[11] *The tête à tête*

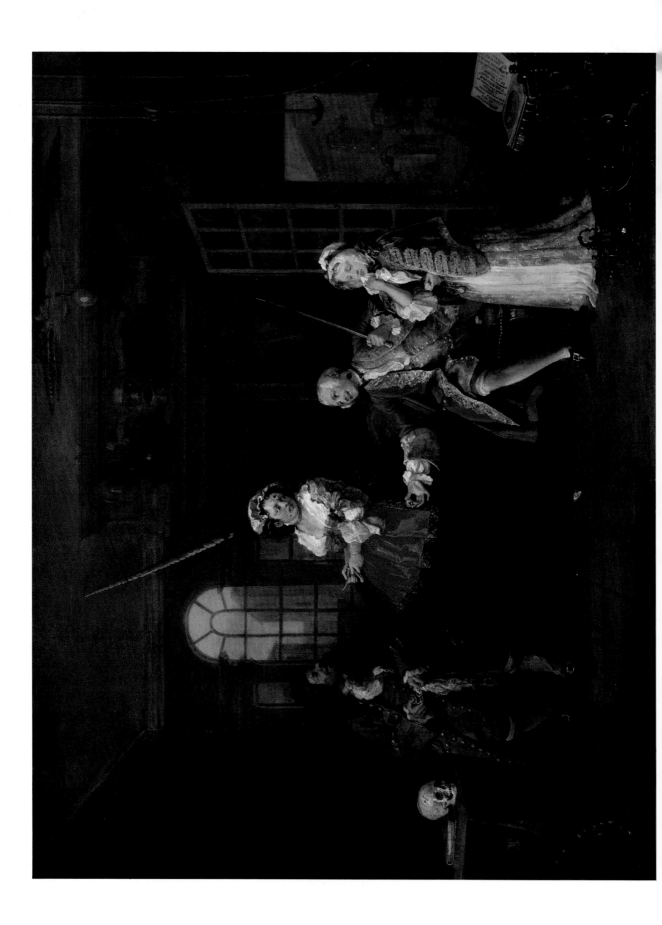

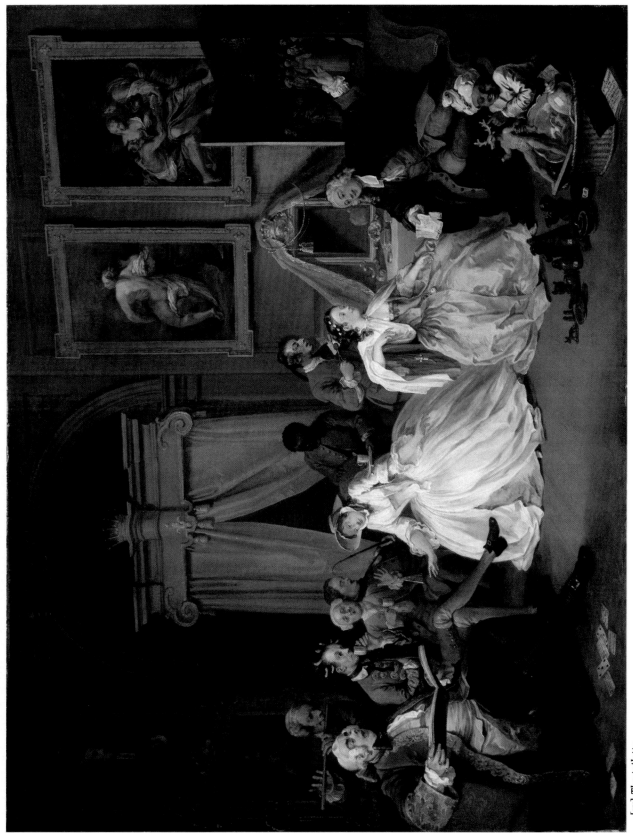

[IV] *The toilette*

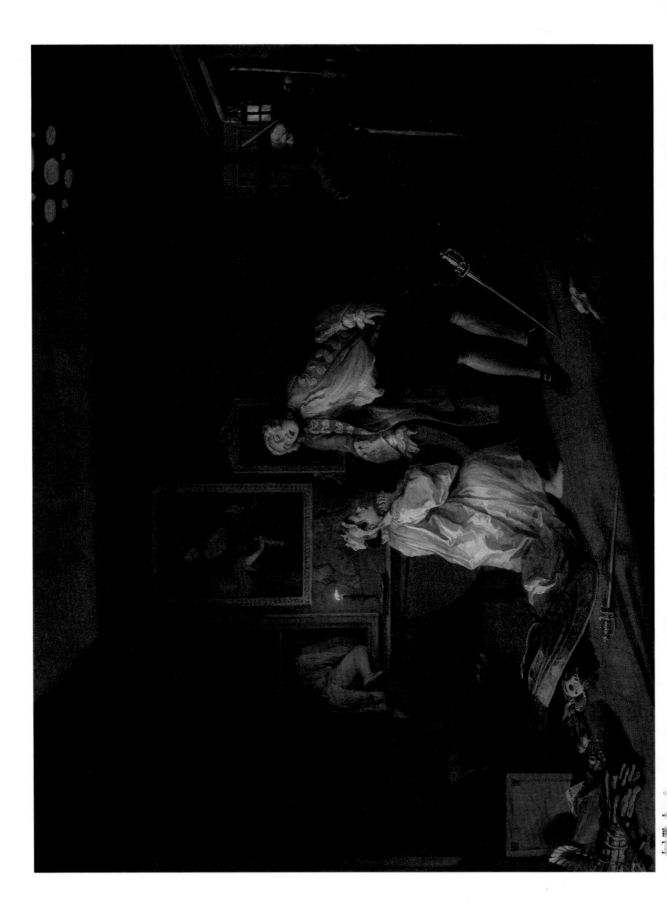

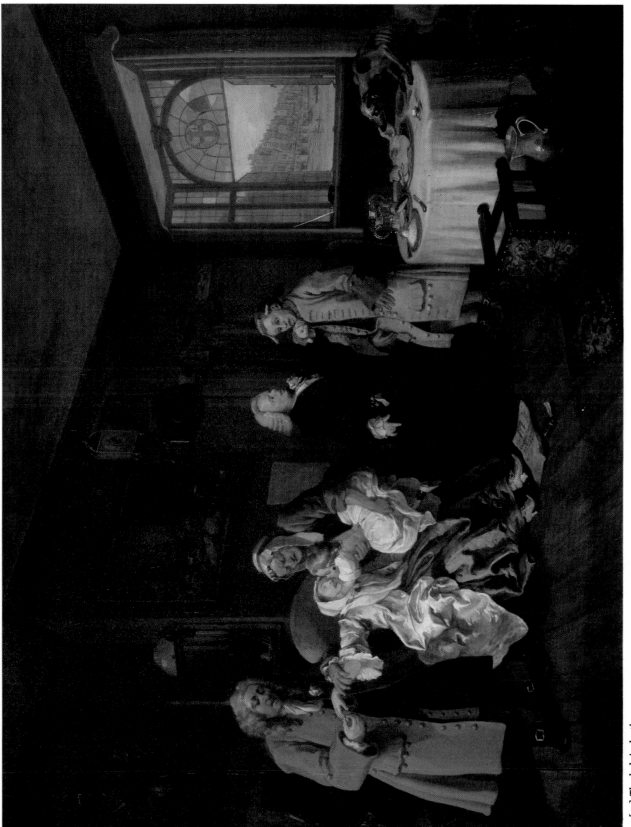

[VI] *The lady's death*

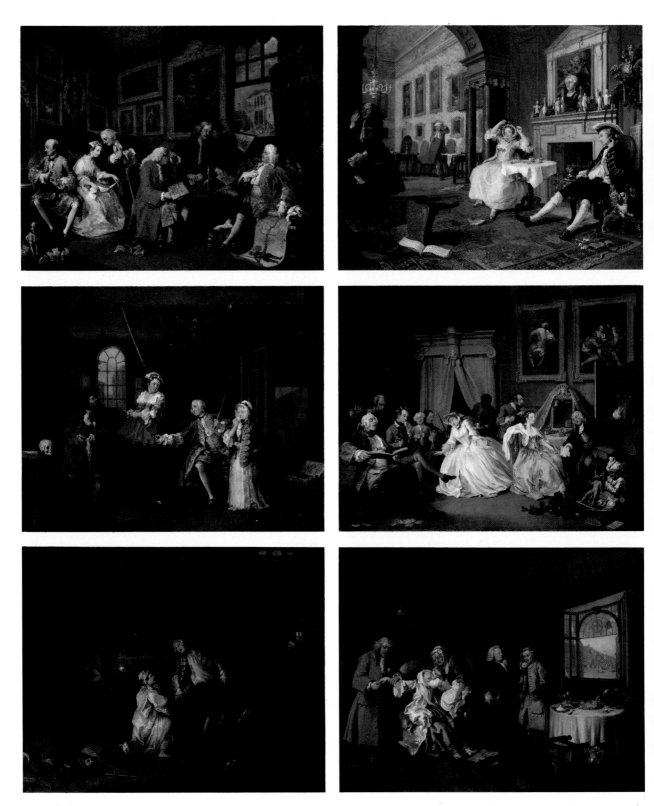

[VII] *Marriage A-la-mode I–VI*

wretch to the small and contemptible circle of his acquaintance'.[26]

The pastime of identifying Hogarth's sources, which had helped make *A harlot's progress* so popular, was only to become an embarrassment to him when, under Fielding's influence, he too wished his figures to be taken for make-believe. He was to make a point similar to Fielding's when he recollected that the faces in *Marriage A-la-mode* are as life-like as 'common portraits', but, because they represent no one in particular, represent everyone. He used the analogy of Sir Fopling Flutter, who 'represents you all' as Knight of the Shire.[27] Hogarth declared repeatedly that there were no 'personal applications' in *Marriage A-la-mode* and one purpose behind *Characters and caricaturas* was to encourage subscribers to consider the heads in the series in relation to the profiles, that is to match one form of fiction against another and not to compare them with people. The more insistent Hogarth was in his denials, however, the more his admirers claimed to have identified his sources, but their identifications rarely agree. The existence of counterclaims suggests that the figures in *Marriage A-la-mode* are rightly identified as make-believe.

Fielding regarded Hogarth as the master of the 'ridiculous' in art, a term which has lost its moral force because of its later associations with silliness or minor eccentricity. Ridicule was the mainspring of comedy for Fielding who defined it as the response which arises when a reader discovers the extent of a character's affectation. *Affectation*, in turn, is the manifestation of either vanity or hypocrisy. Both vices encourage people to distort their true personalities in order to gain undeserved approval or to avoid reproof. Fielding considered the discovery of hypocrisy (which he detested as much as Butler did) to be the more dramatic because the hypocrite pretends to be his opposite, whereas a vain man only exaggerates an established trait.

Affectation is thus a source of drama and a serious moral defect because pretence and exaggeration were regarded as threats to that principle of defensive subordination which moderate people, Hogarth and Fielding among them, thought held society together. Lord Chesterfield was not being small-minded in warning his son against appearing ridiculous. The dramatic turn of events and the depth of moral purpose in Hogarth's narratives are consistent with a theory of comedy based on the ridicule of affectation.

An example in the Preface to *Joseph Andrews* is the probable source for an important distinction between vanity and hypocrisy in *Marriage A-la-mode*. Fielding argued that:

> the affectation of liberality in a vain man differs visibly from the same affectation in the avaricious; for though the vain man is not what he would appear, or hath not the virtue he affects, to the degree he would be thought to have it; yet it sits less awkwardly on him than on the avaricious man, who is the very reverse of what he would *seem* to be.

Hogarth's graceful, but vain Earl and his awkward and seemingly generous, but really avaricious Alderman are the visible exemplifications of Fielding's argument.

Whereas Fielding could reveal the truth behind an affectation

through authorial comment, Hogarth could only approach it indirectly through appearances. In *The analysis*, he was to write approvingly of the standard work on physiognomy in art by Charles LeBrun (1619–90), the court painter to Louis XIV and Director of L'Académie Royal. LeBrun's treatise, *Le méthode pour apprendre à dessiner les passions*, had been translated in 1734 and described by Hogarth, a shade sarcastically, as a 'compendious view of all the common expressions at once'.[28] An attempt is made in this re-view to identify Hogarth's intended passions of the mind by reference to LeBrun's drawing book, but the range of expressions in *Marriage A-la-mode* goes so far beyond LeBrun's examples that the attempt is of limited value.

Hogarth was too experienced an observer to agree entirely with LeBrun that the '*whole* man is seen in the head' (italics added). The chapter in *The analysis* entitled 'Of the face', where Hogarth refers to LeBrun, is a critique of an over-reliance on physiognomy.[29] He thought it 'reasonable' that 'the natural and unaffected movements of the muscles, caused by the passions of the mind' could in 'some measure' mould the face of an adult according to his character and 'that a language [was] written therein'; but he also pointed out that there are 'so many different causes which produce the same kind of movements and appearances of the features, and so many thwartings by accidental shapes in the make of faces, that the old adage, fronti nulla fides, will ever stand its ground upon the whole'. He cited the example of a beggar whose intended grimace of pain looked like a joyous laugh. He was puzzled by the fact that 'nature hath afforded us so many lines and shapes to indicate the deficiencies and blemishes of the mind, whilst there are none at all that point out the perfections of it beyond the appearance of common sense and placidity'. Hogarth was never to claim that the face is the only 'index of the mind'; he included 'deportment, words, and actions' and was also to assert that we 'know the very minds of people by their dress'. His costumes, up-to-date and exact, as they vary from picture to picture offer another index of his figures' preferences, moods and affectations.

Fielding's 'Essay on the knowledge of the characters of men' (1742) shows why he applauded the thinking quality of Hogarth's figures and, in doing so, unwittingly drew attention to another fundamental index of character.[30] Fielding preferred to rely on the 'actions of men' before any other evidence as the 'best index to their thoughts'. Hogarth was to define action as a 'sort of language' which might even 'come to be taught by a kind of grammar rules'. Both knew that gesture was considered to be an exact art in the contemporary theatre. Aaron Hill, for example, in his 'Essay on the art of acting' (1753) claimed that the 'expression' of hands was as various as language as a means of conveying thought. LeBrun is supplemented in this review by reference to the acting manuals of Hill and Thomas Wilkes as a guide to the meaning of actions. Wilkes in *A general view of the stage* (1759) was to advise aspiring actors to study Hogarth in order to learn how to imitate behaviour.

Further reference is made to Gérald de Lairesse's enormous and comprehensive manual, *The art of painting* (translated 1738), which

Hogarth must have known. It exerted an influence comparable to LeBrun's on English art in the eighteenth century, according to Alastair Smart in 'Dramatic gesture and expression in the age of Hogarth and Reynolds' (1965).[31] De Lairesse's manual is a valuable source for canons of acceptable behaviour in life and art in the eighteenth century against which Hogarth's variations can be judged. As well as offering a guide to the meaning of Hogarth's expressions, gestures and poses, de Lairesse draws attention to a difficulty which Hogarth was never satisfactorily to overcome, that of showing more than one 'passion' at once in a figure. De Lairesse gave the example of a prudent, generous, valiant man who is depicted as acting with prudence. Because 'no passion can act in two places at once', the painter can only show the man's generosity and valour through emblems used naturalistically. Hogarth was also to declare that the ambiguous character of a hypocrite 'is entirely out of the power of the pencil, without some adjoining circumstance'. He followed de Lairesse who ruled that the only solution open to a painter was to 'have recourse to emblematic figures, which will clear the meaning'. De Lairesse also recognised the further difficulty that the emblems might not be understood because their meanings are 'inactive and mysterious'. Hogarth's figures habitually carry, point at, or overlap a variety of objects which acquire the force of semi-private emblems and so provide further knowledge of his authorial intentions. De Lairesse dismissed those who could not read the language of emblems because 'they who are deceived or misled should not perceive the least tittle of it', but Hogarth, to whom this esoteric language had become second nature as a result of his training as a silversmith, his study of paintings, and his enthusiastic participation in freemasonry, became exasperated when only a few followers responded to his veiled meanings. The passage of time has made many nuances in *Marriage A-la-mode* less accessible than they were in the 1740s.

Horace Walpole argued that the furniture in Hogarth's pictures represents a 'history of the manners of the age'. So 'fastidiously authentic' have the interiors of *Marriage A-la-mode* proved to be, that one twentieth-century historian of furniture, John Gloag, has based his commentary on them.[32] Walpole's remark draws attention to another index of the mind: 'the very furniture of [Hogarth's] rooms describe the characters of the persons to whom they belong'. In this re-view, *Marriage A-la-mode* is approached first through the examination of the *characteristic attitudes* of the figures, each a summation of a variety of revealing indexes, and then through their interaction with the diverse detail of their settings.

The psychology of humours survived into the eighteenth century in medical theory, popular belief and literature. In *Marriage A-la-mode* (after the example of *Four times of the natural day* 33), the physical elements were introduced in such a way that each interior is dominated by a particular combination, indicative of the prevailing humour or atmosphere. The elements are supplemented by the introduction of the physical senses in turn, again as in *Four times of the natural day*. This strategy would also appear to have derived from precedents like Bosse's

allegorical series *Les cinq sens* (1635?) and *Les quatre saisons* (1635?) and was used by Hogarth as a means of underpinning *Marriage A-la-mode* with an exact, if old-fashioned, psychology founded in the evidence of physical and, therefore, visible existence.

Characters and caricaturas was composed by an artist who knew from experience that the face is only one guide to character. Hogarth could afford to adopt an ambivalent attitude towards the profiles because the point of the subscription ticket is not that the face is the index to the mind, but that in art it is the ordinary face and not the beautiful or grotesque expression which is capable of infinite variety. Only the metaphorical usage of the term *character* can admit the variety of indexes which Hogarth employed. In acknowledgement of his intentions as declared in the subscription ticket and the first advertisement for the series, the figures in *Marriage A-la-mode* are referred to as *characters* in this re-view.

NOTES

1 William Hogarth, *'The analysis of beauty' with the rejected passages from the manuscript drafts and 'Autobiographical notes'*, edited by Joseph Burke (Oxford, 1955), p. 216 and p. 209, subsequently referred to as either *The analysis* (including the rejected passages) or *Autobiographical notes*.

2 *Autobiographical notes*, p. 229. Hogarth also referred to his series as a 'suite' of pictures in his proposals for the bidders' auction of *Marriage A-la-mode* (*Daily advertiser*, 28 May 1751).

3 Pierre Couperie, 'Antecedents and definitions of the comic strip' in *Graphis* 159, Volume 28 (Paris, 1972–3), p. 8 and p. 10. Surprisingly, Couperie makes no reference to Hogarth who exemplifies his thesis so well. For a full account of Hogarth's position in the history of the comic strip, see David Kunzle, *The early comic strip*, Volume I of the *History of the comic strip* (Berkeley, 1973).

4 *The analysis*, p. 106. Hogarth seems to have believed that we can recall images at will in the same way that we recall words when we look at their written images. Hence he argued that there is little need to make preliminary sketches from life provided the requisite images are firmly implanted in the artist's memory at the time of observation. There would then be no barrier between the event observed and its depiction. He did not distinguish between the images in a picture and those of a series.

5 The caption to *A rake's progress* is an additional and independent feature of the series which, on occasions, goes against the narrative line. The caption to *Four stages of cruelty* concerns itself primarily with pointing the moral.

6 *Autobiographical notes*, p. 201. This section and the re-view generally draw on Professor Ronald Paulson's comprehensive and indispensible biography, *Hogarth: his life, art, and times*, two volumes (New Haven, 1971), subsequently referred to as *HI* or *HII*, especially chapter 16, 'Marriage à la mode' I, pp. 465–497.

7 Vertue, George, *Notebooks III*, Walpole Society XXII (Oxford, 1933–4), p. 58. A. P. Oppé, *The drawings of William Hogarth* (London, 1948), pp. 11–12.

8 *The gentleman's magazine* (January 1842) pp. 70–72. Several versions of the series were in existence. A painting of *The marriage contract* ($27\frac{1}{2}'' \times 35''$) was sold by Puttick & Simpson to Larsen in 1932 for three guineas. The low price indicates that it was a copy. Versions of the second, third, fifth and sixth pictures were housed in the Royal Institute at Kingston-upon-Hull and destroyed in the Second World War. Only photographs have survived (Witt Library). They may have been much more finished than the oil-sketches as described in *The gentleman's magazine*. See note 20 for information about the cleaning of the National Gallery paintings in 1981.

9 Hogarth repainted favourite scenes: the climax of *The beggar's opera* at least six times and *Before* and *After* again in 1736. A monochrome oil-sketch was prepared for *The enraged musician* (1741) as a means of visualising the effect of a painting in monotone as a preliminary to engraving.

10 *Autobiographical notes*, pp. 201–2. Whether Hogarth engraved the heads of characters in *Marriage A-la-mode* or not is open to question. J. B. Nichols in his Catalogue of Hogarth's prints in *Anecdotes of Hogarth* (London, 1833), p. 216 claimed to have detected the signs of Hogarth's burin, but the present writer has failed to distinguish them. See Paulson's Catalogue to *Hogarth's Graphic Works, I* (revised edition New Haven, 1970), pp. 53–60 for a discussion of Hogarth's ability as an engraver. Paulson's Catalogue & Plates are referred to as *HGW I* and *II*.

11 Hogarth's self-portrait, *The artist painting the comic muse* (c. 1757), shows him before a canvas marked with thick chalk outlines.

12 *London evening post*, 31 January 1745, reproduced in *HI* pp. 490–91.

13 *London daily advertiser*, 8 November 1744, reproduced in *HI* p. 477. R. L. S. Cowley, 'Lost oil-sketches of Hogarth's *Marriage à la mode*', *Notes and Queries*, New series, Vol. 27, No. 5, p. 420.

14 Scotin's name appears beneath the second plate of *A rake's progress*, but in the case of the other pictures Hogarth omitted his usual claim to have engraved as well as having painted and published them.

15 These red chalk drawings were sold out of George Baker's collection as originals in 1825 and eventually passed into the Royal Collection in 1845. See A. P. Oppé, *English drawings: Stuart and Georgian periods in the collection of His*

Majesty the King at Windsor (London, 1950) nos 362 and 363, p. 66.

16 J. T. Smith, *Nollekens and his times*, edited and annotated by Wilfred Whitten (London, 1920) II, p. 273. Smith implies that the copyist was a protégé of Samuel Ireland. The variations in these drawings can be accounted for (a) by their being free-hand copies taken from the prints using a mirror for most of the work, (b) by their being adjustments forced on the copyist because he was left with too much or too little space usually at the top or bottom of the drawings, (c) by a need to avoid copying the contents of the more obscure interior pictures the contents of which could not easily be identified.

17 For a full account of Hogarth's unhappy experiences with auctions, see *HI* p. 490 ff. and *HII* p. 122 ff. For a detailed account of the history of the paintings, see Martin Davies, *The British school* (*National Gallery catalogues*) second edition revised (London, 1959), pp. 56–7, subsequently referred to as the *National Gallery catalogue*. Since references to this work are confined to pp. 51–63, page references are not provided.

18 Rouquet's *Explication* was published as part of a shilling pamphlet describing the earlier narratives by Robert Dodsley and Mrs Cooper.

19 The anonymous author is referred to as the *poet* and his work as the *poem* in this re-view. The text of the poem is included as an appendix to Wensinger, Arthur S. and William B. Coley, *Hogarth on high life* (Middletown, 1970).

20 William Hogarth, *Apology for painters* edited by Michael Kitson, Walpole Society, XLI (Oxford, 1966–8), subsequently referred to by title.

21 David Bomford's term; I must express my deep appreciation to the National Gallery and to Mr Bomford in particular for allowing me to examine the paintings over a period of two days during cleaning and restoration. His restoration has revealed the brilliance of the paintings. I have drawn extensively on his observations and the proofs of his recent article and that of Ashok Roy in 'The National Gallery Technical Bulletin' 6, 1982. The titles are: 'Hogarth's "Marriage à la mode": history, condition and treatment', David Bomford, and 'Hogarth's "Marriage à la mode" and contemporary painting practice', Ashok Roy. Ashok Roy's research provides a rare insight into the little-known subject of painting techniques in mid-eighteenth-century English pictures.

22 *HII* p. 15 ff. Paulson suggests that as many as seven sketches can be associated with *The happy marriage*, a number which suggests that Hogarth did not settle on a final structure. *The wedding dance* (*c.* 1745) shows the influence of Bosse's *La danse villageoise*. *Daily advertiser*, 28 May 1751, reproduced *HII* pp. 122–3.

23 The cartoons were in the Royal Library at Hampton Court and had been engraved as early as 1711 by Nicholas Dorigny. For a fuller account of the historical background to caricature and Hogarth's attitude to it, see *HII* pp. 472–5.

24 *Autobiographical notes*, p. 211. Hogarth was to repeat his view of the relationship between character and caricature as a matter of gradation in the spontaneous sketch of 1758, drawn for James Towneley (Oppé, Fig. 45, p. 63). It shows a 'realistic' profile in a medal similar to the drawing of Henry Fielding (1761) followed by two further profiles which reduce to caricature.

25 Henry Fielding, *The history of the adventures of Joseph Andrews, and of his friend Mr Abraham Adams* in 'Joseph Andrews' and 'Shamela' edited with an Introduction and Notes by Martin C. Battestin (London, 1965), pp. 9–10, subsequently referred to as *Joseph Andrews*. Quotations in this passage are from Battestin, pp. 7–12, unless stated otherwise.

26 *Joseph Andrews*, p. 159.

27 William Hogarth, MS (*c.* 1758), Fitzwilliam Museum. Hogarth may have meant that the heads in the series were taken from those in *Characters and caricaturas* but no one has identified specific resemblances, including the present author.

28 Charles LeBrun, *Le méthode pour apprendre à dessiner les passions*, (Paris, 1696), first translated 1701 and again in 1734 by John Williams as *A method to learn to design the passions proposed in a conference on their general and particular expression* (1734). References are to this edition which is subsequently referred to as 'LeBrun'. *The analysis*, p. 175.

29 *The analysis*, chapter XV, pp. 134–45. The quotations in this passage are all from this chapter.

30 Henry Fielding, 'An essay on the knowledge of the characters of men', first published in *Miscellanies* (1742).

References are to the Wesleyan edition of the *Works*, *Miscellanies I*, edited by H. K. Miller (Oxford, 1972); the quotations are from p. 174. *The analysis*, p. 149 and p. 183. Aaron Hill, 'Essay on the art of acting' in *The Works of the late Aaron Hill Esq. IV* (London, 1753), p. 109, subsequently referred to as 'Hill'. Thomas Wilkes, *A general view of the stage*, (London, 1759), p. 94, subsequently referred to as 'Wilkes'. Wilkes wrote approvingly of LeBrun for sketching a common quarrel in the street. This anecdote, apocryphal and used to compliment a number of artists, was the probable source for stories of Hogarth sketching the grimaces of a wounded man or the quarrels of harlots the moment he saw them.

31 Gérard de Lairesse, *The art of painting in all its branches, methodically demonstrated by discourses and plates, and exemplified by remarks on the paintings of the best masters; and their reflections and oversights laid open*, first published Amsterdam 1701, translated by John Frederick Fritsch (London, 1738), referred to subsequently as 'de Lairesse'. Alastair Smart, 'Dramatic gesture and expression in the age of Hogarth and Reynolds' *Apollo* (1965), p. 91. Smart demonstrates the extent of de Lairesse's influence. De Lairesse, p. 73 and p. 52. *The analysis*, p. 137. Paulson argues the case for Hogarth's debt to de Lairesse in *HI*, pp. 98–9.

32 Horace Walpole in *Anecdotes of William Hogarth written by himself and various essays* edited by J. B. Nichols (London, 1833, Facsimile Reprint, 1970), pp. 72–3. John Gloag, *Georgian grace, a social history of design from 1660–1830* (London, 1956).

33 In *Four times of the natural day*; not only does each picture depict a time, but also a season (in the order winter, spring, summer, autumn) and a predominant element (stone, air, water, fire). The conjunction of elements and seasons implies a prevailing humour which characterises the main figures: a chilly and phlegmatic prude; sanguine and promiscuous youth; an overheated and overburdened family; an elderly, choleric drunkard. Bosse's *Les cinq sens* is reproduced as plates 24–8 (Cat. Nos 1028–32) in *L'oeuvre gravé d'Abraham Bosse, documents d'art, L'oeuvre graphique du XVIIe siècle* by André Blum (Paris, 1924), subsequently referred to as 'Bosse'.

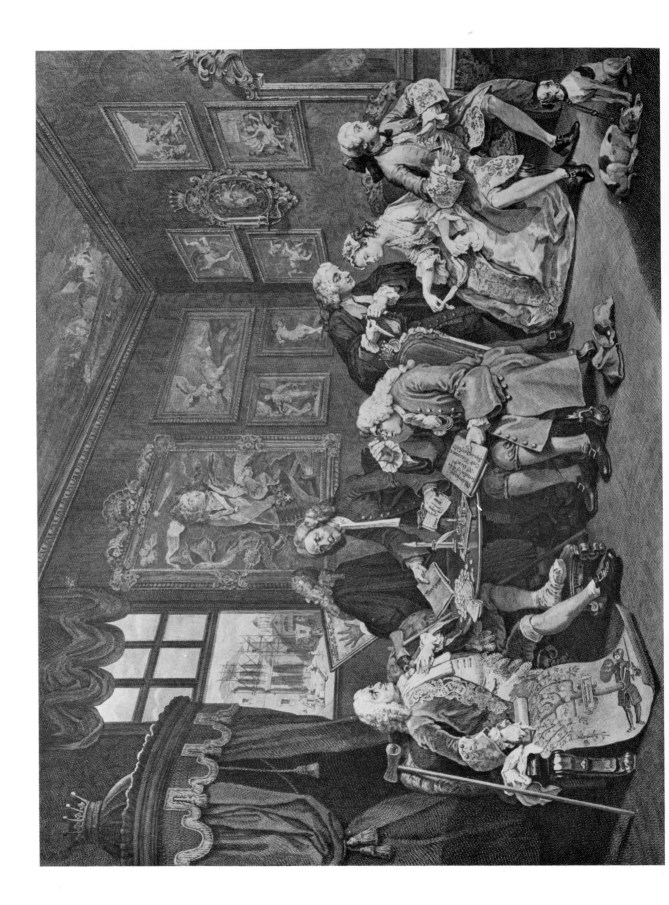

The marriage settlement[1]

The narrative begins with the concluding stages of the negotiations of a marriage agreement. One father examines the settlement, while the other receives a redeemed mortgage and sums of money as the dowry. The pens are being made ready for the signing ceremony. The betrothed couple sit together in the background and one of the attendant lawyers pays court to the bride.

THE CHARACTERS IN THE MAIN TABLEAU

THE EARL, THE FAMILY TREE, AND THE VIEW THROUGH THE WINDOW

The first character in the viewing sequence is also the largest; an examination of the interior confirms his ownership of the room and the primacy of his rank as a peer of the realm. The other characters are present at his invitation or command. The Earl fills a throne-like double seat big enough for two people of moderate size as the occupants of its counterpart on the other side of the room show. The placing of his gouty foot on its stool adds to the impression of regality (Hogarth was to declare in *The analysis* that a three-legged stool conveyed an impression of dignity and firmness[2]). The contrasting disposition of the Earl's hands defines his characteristic attitude in the language of gesture. The left hand (in the painting) points to the family tree as a sign of a pride in his own ancestry. The right rests lightly on his chest. Thomas Betterton in his advice for actors (1741) saw this gesture as a declaration of self-importance: 'when you speak of yourself, the *right* not the *left* hand must be applied to the bosom declaring your own faculties and passions' (quoted in *The history of the English stage*, 1741). The bent little finger is properly indicative of high birth and serves also to draw attention to the signet ring required to seal the contract. The Earl gazes sadly and impassively with what Wilkes would have recognised as the 'disengaged air' of a man of quality. He is too preoccupied with his own thoughts to be anything but indifferent to others or even to attend to an important dynastic event such as the arrangement of the marriage of his heir.

The Earl's short coat of gold lace and his waistcoat with long fringes are those of an old-fashioned courtier; the long cravat and wig are about ten years out-of-date for the early 1740s. Although his wig is not as long as the quack doctor's in the third picture, it is worth noting that Hogarth thought a full-bottomed wig to be noble and leonine, and as adding dignity and sagacity to the countenance.[3] Subscribers would

[8] *Marriage A-la-mode I (The marriage settlement)*, engraved G. Scotin, after William Hogarth (Whitworth Art Gallery, University of Manchester).

have regarded the Earl's pose as consistent with his rank and thought of him as formally and opulently dressed. His clothes are immoderate in style, but not ridiculously so.

The dignity is qualified by the heavily bandaged foot, the crutches and sweatcloth. Gout is now regarded as a comic disease, but the anonymous poet called it a 'P— almost worn out' and, pointedly, as a 'true nobleman's disease'. Both gout (the name given to a variety of rheumatic disorders) and venereal disease were common in the male population of the prosperous classes and gout was regarded as the consequence of excessive sexuality as well as gluttony.[4] The symptoms point to a family sensuality against which the events of the series are set. The Earl ignores his disabilities and is perversely proud of his gout as an affliction worthy of his rank because even his crutches are stamped with coronets. The viewer is invited to appreciate the irony that it is the earldom itself which is crippled, a twist which is to find literal expression at the end of the series in the person of the grandson and heir. The gout and crutches draw attention to a motif of the series, that of flawed magnificence.

A family tree is a clever means of supplying information about a distant, but relevant past, serving the same function as the miser's diary in *A rake's progress I*. The tree grows out of the belly of William the Conqueror, an apt source for the present Earl's gluttony. The duke's armour, although a typical heraldic detail, comments ironically on an elderly patriarch, who now has only the bravado of a warrior, and on his son who is to be a catastrophically unsuccessful duellist. The word order of the title reveals the family prejudice. 'William Duke of Normandy' ('Normandye' in the painting) is admired neither for his conquest nor his English kingship. It is significant that syphilis was also known in England as French gout.

The flawed magnificence has a source in the family tree itself. Twenty medals in the shape of fruit, surmounted with coronets, hang from the branches. The Earl's index finger is positioned close to an uncrowned fruit on the main branch to demonstrate the directness of his son's descent. But the tree is spoilt by the presence of a broken branch set to one side which signifies a previous alliance with a family of obscure origins. The present occasion, however, is the first on which a direct descendant is required to marry unfavourably. The scroll is partly rolled so that the topmost branches are hidden: the lineage is nearly at an end which is not to be the result of a natural growth, as events in the series are to prove.

Both the poet and Georg Christoph Lichtenberg in his famous *Commentaries* on Hogarth's engravings (1784–96) referred to the canopy behind the Earl as a canopy of state and introduced a confusion for others to follow.[5] It is only a bed canopy decorated in the French style with tesselations and valances fringed with gold. Fashionable bedrooms were used as sitting rooms in the eighteenth century so that it would not have been a surprise then to find a marriage contract being negotiated in an invalid's bedroom. The correct identification of the canopy is important because the regal associations are in its treatment

and not in the canopy itself. Hogarth ridicules the Earl's pretensions by making him appear to hold court without going beyond the possible.

A bed canopy is an appropriate inclusion in other ways: it is ridiculous that the most recent treaty of a family which claims descent from a conqueror should be drawn up in a bedroom. A bed in the French style anticipates another in the fourth picture in front of which a different kind of agreement is being proposed which is effectively to cancel the marriage contract. John Ireland in *Hogarth illustrated* (1791) first suggested that the bed and the furnishings are a burlesque of William Kent's designs.[6] The heaviness of the furniture and the picture frames may owe something to Kent, but the room with its flat, painted ceiling is closer to William and Mary in period. Sash windows appeared around 1700 and would have been a novelty at the time the house was supposed to be built. The oldfashioned interior supports the impression that the Earl's are the values of a preceding generation.

The coronets on the family tree are repeated throughout the picture in the manner of an extended literary image – on the furniture, a picture and the canopy. Those on his crutches are the *imprints* of both the Earl's literal and figurative character. The repetitions have led critics to reprove Hogarth for his tedium and bad taste, but the display was not excessive for an Earl's room furnished in the style of the 1730s or earlier. There is a story of a twentieth-century Member of Parliament whose son, within ten days of his father being elevated to the peerage, decorated his butter pats with coronets. The careful exaggerations not only reveal the extent of the Earl's vanity, but are also in accord with Hogarth's theory of character which required him to keep his figures within the bounds of probability.

The Earl's upward gaze is repeated in that of his similarly hatchet-faced lawyer (identified by his coif-wig and gown) who stands just behind his master. The X-ray of the painting shows him with the same outline, but facing inwards instead of gazing out of the window. Hogarth must have realised as an afterthought that it was more effective not to show a dutiful lawyer, but a neglectful one in the manner of the distracted clergyman in *A harlot's progress I*. Because the lawyer is the only other character with an uplifted head, he serves to redirect the force of his master's gaze out through the window. The link between the characters and the vista is strengthened by the lawyer's possession of the Earl's plan, 'A Plan of the New Building of the Right Hon[ble] . . .'. The connection suggests that the Earl is dreaming of his favourite project through the vicarious agency of a creature. In that the view through the window is the external expression of the Earl's dream, it is appropriate to include it in a discussion of his character.

The sash and curtain are raised as if on a stage-set which reveals a courtyard dominated by a Palladian façade. Its double portico is a muddle: three Corinthian pillars support four Ionic, a top-heavy misplacing of the classical orders in keeping with other forms of comic inversion in the series. The pediment is incomplete and the building supported by scaffolding. Both the Earl and his new building are defective and in need of propping up. The scaffolding is empty of

workmen and the Earl's servants in a lemon yellow livery lounge in the yard, evidence that the credit of an earl can run out and a sign that he needs financial support. The tasteless juxtaposition of the façade with the stables is a deliberate comment on the architect's incompetence. Lichtenberg appreciated the Pickwickian humour of a minor absurdity: beside the main entrance is a 'dark coach-house which admits some doubtful light through a round hole and has an arched entrance cut so low that the coachman and carriages, when entering, could not possibly escape being cut off, too'. The faulty design of the building is evidence more of the Earl's metaphorical short-sightedness than of his lack of taste or ignorance. He is interested in a monument for the sake of building it and is indifferent to the defects which are clear to see. The lawyer's flattering fingers spread over the plan in the shape of a coronet with a little finger crooked like that of his master, a sly metaphor which confirms his identity as the incompetent agent of a foolish man's crazy plan.

Clues to Hogarth's attitude to the façade are found in *The analysis*, where he held that the 'front of a building with all its equalities and parallelisms' is disagreeable.[7] He lamented the uncritical following of Palladio's rules which the Earl's architect has tried to follow and so clearly failed in. Hogarth preferred a house to reflect its purpose as his own choice of an unpretentious home at Chiswick shows. He complained that 'were a modern architect to build a palace in Lapland or the West-Indies, Palladio must be his guide, nor would he stir a step without his book'. The dislike of Palladio was sharpened by Hogarth's prejudice against the Burlingtonians of whom the Earl is such an inadequate follower. The vista provides an 'inconsistency and mixture of incompatible matter that causes involuntary laughter'. In contrast to the melancholy view from the window in the last picture, Hogarth begins his series in a relatively light-hearted mood. The window on this Earl's soul, however, does have the serious implication that his mania for building is the first link in the causal chain which leads to catastrophe.

The Earl is an original creation in Hogarth's art to be rivalled only in the engraving of the formidable bulk of *Simon, Lord Lovat* (1746). He is a descendant of Sir Epicure Mammon and, more immediately, of Garrick's choleric Lord Chalkstone in the interlude *Lethe* (1740, performed in 1742). He too is afflicted with gout and rheumatism: his legs cannot bear his body to his friends and the bottle waiting for him in Hades. He speaks a little French and admires French wines and food. He has been a duellist but, because of his infirmities, now settles his differences by wagers. He surveys the River Styx with the expertise of a landscape designer and offers advice in Hogarth's own terminology – 'you should give it a serpentine sweep'.[8]

The Earl's veneration derives in part from Hogarth's own attitude to the French, based on a mixture of aggressive respect and some awe. His mixed feelings reflected a more general uncertainty towards the French among Englishmen which may have been due to what Derek Jarrett in *England in the age of Hogarth* (1974) calls the 'long shadow' of French

culture.[9] The English reacted either by copying the French as Lord Chesterfield did (and as the Earl and his son are made to do) or by being as English as Hogarth himself affected to be. His ambivalence towards the French was only to swing strongly towards antipathy after his second, humiliating visit to France in 1748.

The Earl is as convincing and as psychologically complex as a non-recurrent character in a picture narrative can be. A handsome, regal gentleman, on closer examination, turns out to be arrogant, self-indulgent, metaphorically blind, and a sensual spendthrift, who boasts of his infirmity. Because the psychology is revealed only slowly through the study of accumulated detail, the 'scene' is justifiably 'delusive' as Fielding in his essay in *The champion* (1740) perceived Hogarth's pictures to be and in the relationship between the elements of a single picture as well as between one picture and another in a series.[10]

THE ALDERMAN AND HIS AGENT

The most important visitor is the bride's father. His exact status has been a matter of confusion. The poet assumed that he is an ex-Lord Mayor:

> His chain he never ceas'd to wear,
> To let you know he'd pass'd the Chair.

Rouquet referred to him as an *échevin*, the nearest in French to the rank of alderman. John Nichols and George Steevens in *The genuine works of William Hogarth illustrated* (1808–10) translated *échevin* back into English as *sheriff*. To add to the difficulty, the character wears a gold chain with fewer strands on his second appearance (in the last picture) than he does on his first. The gown hanging on the wall of his room in the last picture is that of a common councilman and not of an alderman. But it remains sufficiently close in style to the aldermanic gown worn by Francis Goodchild (*Industry and idleness X*) to suggest that Hogarth was unaware of the fine distinction between the regalia of an alderman and a councilman.

An alderman of the City of London wears a chain first when he serves his year as sheriff and again after he has served a term as Lord Mayor. In the last picture, Hogarth's alderman is about to drink from a silver loving cup. The Lord Mayor of London customarily elected or nominated his sheriff for the following year by drinking to him from such a cup on a public occasion. By the end of the series, this Lord Mayor has toasted his sheriff and uses his loving cup in private out of parsimony. He is an alderman and probably was meant to be serving as sheriff in the first picture, but, it is implied, he has 'pass'd the Chair' or served as Lord Mayor by the end of the series. The change in status accounts for the difference in the number of strands between the two chains.

The Civic Order of 1735 did not forbid the wearing of a chain in private, so eccentric though the Alderman's behaviour is, as revealed in the last picture, he is within his rights. Hogarth's point is that, in wearing his chain during a solitary meal, the Alderman is as vainglorious as the Earl. The signs are that Hogarth depicts a man of

standing whose sword also declares him to be a City gentleman or Knight, a worthy rival in his way for a Westminster Earl.

The campaign wig with its curls knotted over the shoulder and coats with their long skirts are even further out-of-date than the Earl's. The poet suggests that the clothes were 'made in the end of Anna's reign' and the Alderman's stock is arranged in a Steenkerk tuck, so-named after the battle of 1692 when it first became fashionable. The tuck seems to have been adopted by Hogarth as a sign of a particular Englishness in an older generation or a patriotism among immigrants who wish to demonstrate their new loyalties. Thus the Jew in *A harlot's progress II*, the French doctor and the sleeping countryman in *Marriage A-la-mode III* and *IV* respectively and the elderly husband expostulating with his wife in the second plate of *The analysis* all wear their stocks tucked. In their differing contexts, they are characters who might expect to command obedience in others, but do not achieve it. The Alderman's stock is also elaborately twisted, perhaps a sign of his particular pretension or deviousness. The clash of colours between the scarlet coat (associated with power in the language of colours) and the blue breeches, at a time when the fashion was for pastel shades, identifies the Alderman as the vulgarian of the series.

The Alderman sits in what a clumsy man might believe to be a genteel pose but, as de Lairesse makes clear, a peering look and a stooping posture with the feet set parallel were signs of an inferior social status in the language of deportment.[11] The crooked little finger of the hand holding the settlement is an affectation in the commoner. Lichtenberg listed the signs of his lack of social ease: he is 'tense, attentive and preoccupied. His legs do not even seem aware that he is sitting: the shins incline somewhat beyond the vertical, as if ready for a jump, the feet parallel, the stout shoes with their coarse Stock Exchange soles planted as firmly as his credit'. Hogarth's discreet ridicule is apparent in the positioning of the Alderman's sword: the chape juts awkwardly and suggestively from between his legs.

The Alderman's lugubrious, adenoidal expression suggests that he is unhappy about parting with so much money in spite of the aspirations which have brought him to the Earl's bedroom. While the Earl gazes abstractly, the literally short-sighted Alderman is hunched over the package of documents which he examines with exaggerated care. The forgotten coin in an otherwise splendidly empty money bag on the floor is a clever variation on the motif of spoilt magnificence. The oversight is a small carelessness in a careful man and perhaps a comic manifestation of the tragic flaw which has led him to make an injudicious alliance. He fails to note the imperfections in the family tree or the blemish on the neck of his prospective son-in-law.

The Alderman depends for his individuality on his full, smooth cheeks, his heavy underlip and thick fingers (contrasting beautifully with the Earl's tapering ones). The full extent of his vulgarity, meanness and inhumanity is reserved until the last picture where he is shown at home in his own dining-room. A clue to Hogarth's contemptuous attitude is found in his treatment of the monkey in the foreground of *Taste à la mode*: the animal is dressed in clothes like those of the

Alderman on his first appearance; adopts a similar myopic attitude; reads a French menu instead of a settlement through an eyeglass. Hogarth's originality lay in making a 'monkeyrony' (as Sheridan might have called him) out of a London dignitary instead of a youth about town and in placing him in the incongruous setting of a Westminster bedroom.

A sour-faced character acts as the go-between, a 'horrid meagre dun', the poet calls him. He proffers the mortgage to the Earl with one hand and holds some of the promissory notes in the other. Hogarth was so concerned to convey the idea of a 'dun' receiving money in exchange for the mortgage that he risked a distortion of the character's nearer arm. The Alderman is identified as the financier of the series in the last picture, so that the inference is (in the absence of other wealthy characters) that the Earl has borrowed money against property from the Alderman and that the 'dun' (the latter's agent) is returning the redeemed mortgage on his master's behalf. The large, tricorn hat under the agent's arm distinguishes him as a deferential visitor who expects to depart as soon as the financial stage of the settlement is completed.

A number of points support this reading – the expectation that intermediaries should be neutral arose only later in the century. The alignment of the tableau makes the agent closer to the Alderman than the Earl as if to indicate a bias in a particular direction. The agent's ugliness and meanness are consistent with the appearance of the Alderman's servitors in the last picture. His eyes stare and his mouth hangs as if to suggest that he is envious of the huge sums of money involved in the transaction, an attitude which contrasts with the marvelling lawyer immediately beside him. The three pins in the sleeve of the arm accepting the notes identify the agent as a miser (and demonstrate Hogarth's willingness to provide a characteristic detail even in a minor, non-recurrent figure). Pins were of modest value in the earlier part of the century because they had to be made by hand. John Gay's fable, *The pin and the needle* (1727), refers to pins being 'rang'd within a miser's coat' as a sign of his saving in small things'.[12] The presence of braid cuffs in an otherwise plain costume suggests that the agent too has his small vanities. That he is a personification or projection of the Alderman's own miserliness and vanity is confirmed in the last picture.

The agent has been associated, improbably, with Edward Swallow, a (later) Archbishop of Canterbury's steward (as is the steward in the second picture), and with Peter Walter, a grasping agent of the Duke of Newcastle and the original of Fielding's Peter Pounce in *Joseph Andrews*. There is no justification for these 'applications' beyond a generalised miserliness or elderliness and the existence of counter claims is a basis for arguing that the agent is derived from neither.[13]

THE TWO CITIES AND THE ARRANGEMENT OF MARRIAGE

A confrontation between an earl and an alderman had significance, especially for Hogarth's older subscribers. The social historian, David Allen, has explored the implications of an alliance between an earl's son

and a lord mayor's daughter, negotiations for which began in 1674 and were not fully resolved eight years later.[14] This alliance between Bridget Hyde and Lord Treasurer Danby's son became notorious because it involved representatives of the neighbouring and, at times, hostile cities of Westminster and London. The rivalry between the two cities had been politically important during the Civil War and immediately after the Restoration, but the Great Fire weakened the powers of the semi-independent oligarchy of London by destroying the merchant quarter from London Bridge in the east to the walls of the Temple in Fleet Street. The decline of London was further hastened by the consequences of the South Sea Bubble. By the 1740s, the rivalry persisted in diminished form as a matter of amusement with only undertones of seriousness in Swift's and Gay's fear of the town gangs or in Bishop Gibson's tactful wording of his pastoral letters addressed 'especially [to] the two great Cities of London and Westminster'. The rivalry was never a common topic in the theatre, but it surfaced occasionally in Jacobean and Restoration comedies as a local variation on that between town and country, and between wit and cit or rake and cuckold. Encouraged in part by Hogarth, it found variations in the eighteenth century as between rakish wife and stay-at-home husband, foreign tastes and native habits and ancient and modern values.

The rivalry was kept alive through gossip about marriage bargaining. Lord Keeper Guildford, for example, refused an offer of £6,000 to marry an alderman's daughter and refused again when the dowry was more than doubled. A scrivener's daughter was offered in marriage for £5,000 at the age of eight. When this latter arrangement fell through, she was married, at the age of thirteen, to Sir Thomas Grosvenor on condition that the couple did not live together for a year. A viscount was reported to have married a merchant's daughter with a fortune of £30,000, in 1731 an exceptionally good buy. Kitty Conduit, whom Hogarth had portrayed as a child-actor in *A scene from the 'Indian emperor'* (1731), was married with a dowry of £60,000 to an earl's son. The gold and promissory notes poised as if to fall into the Earl's lap add up to some thousands of pounds (excluding the undisclosed value of the mortgage). Financially, therefore, Hogarth's marriage is one of importance, if not the most costly.

Mercantile wealth was probably increasing in the eighteenth century (although not necessarily in the City) and heiresses were more likely to inherit the whole of their fathers' fortunes than the heirs of landed families because of the far-reaching authority of the marriage settlement which controlled the inheritance of property. The settlements were extraordinarily elaborate documents through which all sorts of possibilities were anticipated, often including provision for the (unborn) children of a marriage. The negotiations could be protracted, lasting for nearly a decade in the instance of Bridget Hyde. It is not surprising that the betrothed couple look bored in Hogarth's picture, that the settlement is a bulky document, or that two lawyers are required to supervise the transaction.

Hogarth thus combined two traditional antipathies to underlie the dislike of the bridal couple for each other and to subvert the claim to

modernity in the title. The mock-French of the title, *Marriage A-la-mode*, detracts from the Englishness of 'Smithfield bargains', as enforced marriages were called, a subject of perennial interest which must have both amused and perturbed an enlightened Hogarth who married his master's daughter for love against her father's wishes.

Fielding's social distinction between vanity and hypocrisy in the Preface to *Joseph Andrews* fits Hogarth's situation exactly (page 21). The Earl's absurd building project is the consequence of the vain man's 'affectation of [a] liberality' beyond his means. His affectation sits easily on him because his folly is a vanity characteristic of his class. The Alderman is an awkward man, but he is not immediately recognisable as avaricious in the first picture. At worst, he assumed a gentility which he cannot claim by birth and, at best, he appears foolishly generous in helping an impoverished earl. Only on his second and last appearance is he revealed in character. His generosity in the first picture is demonstrably hypocritical and his affectation is thus essentially ridiculous. Fielding would have regarded the Alderman's as the more dramatic sin because in the first picture he is 'the very reverse of what he would *seem* to be', but he would have regarded the Earl's as the more universal and greater evil because, as he was to claim later in *Joseph Andrews*, 'vanity is the worst of passions, and more apt to contaminate the mind than any other'.[15]

The Alderman is unnamed, but the Earl's family name is 'Squander', a fact withheld until the fourth picture. The bridegroom's courtesy title was withheld from the marriage settlement in the painting of the first picture in order to reserve an apt point for the buyers of prints. It reads: 'Marriage Settlem[t]. of The Rt. Hon[ble]. Lord Viscount Squander*field*' (italics added). Hogarth's are always type-names which for the most part come close to reality: Hackabout, Rakewell, Goodchild and Idle, Nero, Commodity Taxem. (Hackabout was the surname of a real prostitute and her highwayman brother which Hogarth had taken from newspaper accounts of their trials.) In *Marriage A-la-mode*, he was anxious to make his figures both life-like and fictitious: 'Squander-field' is the compromise. The suffix was chosen perhaps to extend the contrast between the Alderman, who squanders money, and the Earl, who has mortgaged land. The ploy, however, was only partly successful; followers continued to discover 'personal applications' for the Earl and the Alderman, but the variety of counter-claims again suggests that they represent everyone and therefore no one.[16]

The meaning of the verb, *to squander*, as *to spend money carelessly* was current in the 1740s, but its primary meaning was much wider. Dr Johnson defined it as *to scatter lavishly* or *to spend profusely* when *to spend* meant *to consume* or *exhaust* rather than *to pay out*. The word at its most general also meant *to scatter, dissipate* and *dispose*. A series concerned to show the self-determined downfall of an alliance between two prosperous families is about squandering in its wider meaning. Hogarth had little need to make financial bankruptcy a direct cause of his squanderers' downfall, as he did for the Rake; he had a universal evil in mind.

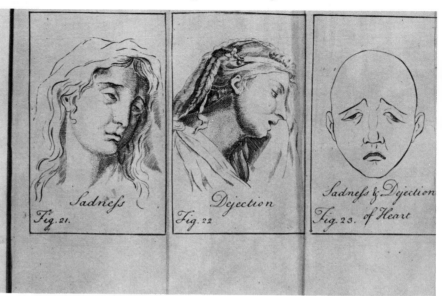

SADNESS.

SADNESS, as we said before, is a disagreeable, languid supiness, arising from the uneasiness the Soul feels at some evil or defect, which the impressions on the Brain represent to her.

And indeed this Passion is figured by such motions as seem to express the inquietude of the Brain and the dejection of the Heart; for the ends of the Eyebrows are more elevated towards the middle of the Forehead then towards the Temples; in a Person affected with this Passion the Pupils are cloudy, the Whites of the Eye yellow, the Eye-lids fallen and somewhat swelled, the Round of the Eyes livid, the Nostrils drawing downwards, the Mouth somewhat open and the corners down; the head seems negligently hanging upon one Shoulder, the whole Face of a wan lead colour, and the Lips entirely pale.

Sadness Fig. 21.

Dejection Fig. 22

Sadness & Dejection Fig. 23. of Heart

THE CHARACTERS IN THE MINOR TABLEAU

THE BRIDE AND THE LAWYER

The Alderman's daughter is the central figure of the minor tableau. Her cap, shaped like a folded handkerchief and decorated with flowers, and her virginal, probably satin gown trimmed with lace are just the sort of stylish French clothes a girl would delight in wearing for a wedding in the 1740s. They are too showy for a betrothal ceremony with its legal and financial emphasis, a sign that the Alderman does not know exactly how to present his daughter. He has determined, nevertheless, that she should compare favourably with the son of his Westminster rival by dressing her according to the latest fashion.

The bride's expression approximates to LeBrun's study of *Sadness and dejection of heart*. Wilkes stressed the importance of the 'right management of the eyebrows' in acting because they control the forehead.[17] The bride's contracted and down-pulled brows convey a mixture of anger and dissent. Her pout makes her the only character to show open disapproval of the transaction. Her handkerchief is so large that a commentator is to be forgiven for wondering where she is meant to keep it. Its size compares with the Earl's sweatcloth and through them Hogarth might have been hinting at an excess of feeling shared by both. She ignores both her future husband and her lover. Her pent-up feelings are directed only against the wedding ring with which she toys, the emblem of a marriage she does not want and the honour which she is to treat lightly.

The bride's status as the daughter of an alderman of the City of London has encouraged speculation about her supposed past. The poet imagines her as having already acquired a taste for fashionable life as 'th' Assembly's Queen' on Lord Mayor's Day at the Guildhall, but there is neither anticipation nor grace in her attitude. She sits as awkwardly

[9] *Passions of the mind*, engraved book illustrations after Charles LeBrun; from the 1734 English edition of his *Le méthode pour apprendre à dessiner les passions* (1696).

[a] *Sadness, Dejection, Sadness and dejection of heart. Note:* the similarity between this and the bride's expression in the first picture of *Marriage A-la-mode* (p. 36).

[b] *Pure love. Note:* the similarity between this and the lawyer's expression in the first picture (p. 38) and those of the lovers in the fourth (p. 103).

[c] *Fright. Note:* the similarity between this and the picture of *Medusa* (Illus. 12 and p. 46).

Pure LOVE.

THE emotions of this Paſſion, when pure, are very ſoft and ſimple; for the Forehead will be ſmooth, the Eye-brow ſomewhat riſing on the ſide where the Pupil is; which being turn'd ſoftly towards the beloved object, will appear elevated and ſomewhat ſparkling; the Head leaning the ſame way; the Eyes may be midlingly open, and the White of the Eye very lively and ſhining: The Noſe receives no manner of alteration, nor any other part of the face, except that of being filled with the Spirits, which, warming and animating the whole, give a lively vermilion to the complexion, particularly a blooming bluſh to the Cheeks, and redneſs to the Lips, which may ſeem bedewed with a moiſture occaſioned, probably, by ſome vapours ariſing from the Heart; the mouth muſt be ſomewhat opened, and the corners a little turn'd up.

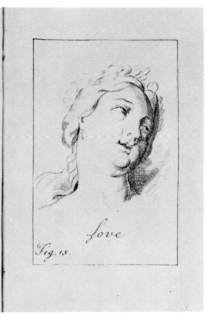

Love

Fig. 15.

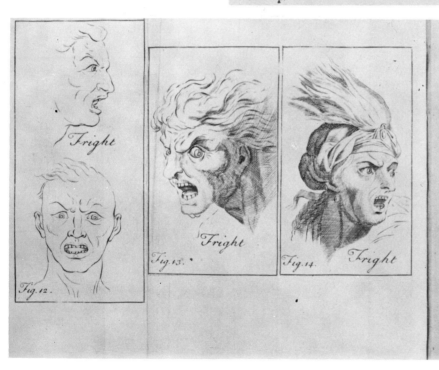

Fright

Fig. 12.

Fright

Fig. 13.

Fright

Fig. 14.

FRIGHT.

FRIGHT, when exceſſive, raiſes the Eye-brows exceedingly in the middle; the muſcles, that conduce to the motion of thoſe parts, are very viſible and ſwelled, preſſing againſt each other, and lowering towards the Noſe, which, as well as the Noſtrils, ought to appear drawing upwards; the Eyes muſt look wide open, the Upper-Eye-lid be hid under the Brow, the White of the Eye ſurrounded with red, the Pupil appear wild, and ſituate more to the bottom of the Eye than upwards, the lower Eye-lid ſwelled and livid, the Muſcles of the Noſe and Noſtrils alſo ſwelled, the muſcles of the Cheeks extreamly evident and drawing to a point on each ſide the Noſtrils, the Mouth wide open and the corners very viſible, the whole Countenance extreamly diſtorted as well in the Forehead as round the Eyes, the muſcles and viens of the Neck very much ſtretch'd and apparent, the Hair of the Head ſtanding an end, the colour of the face pale and livid, as alſo the tip of the Noſe,

in her fine clothes as does her father. Her shoulders are round and she leans forward instead of sitting upright as women were expected to do; she does not know or care about what to do with her hands (the elongated third finger of her left hand in the print projects particularly limply). Unlike Melantha in Dryden's *Marriage à la mode*, who accepts an arrangement of marriage willingly because she foresees the attractions of a fashionable marriage, Hogarth's bride looks only to the present, as she does throughout the series.

Hogarth's commentators have differed in their opinions of her, differences due to historical changes in attitude towards woman as much as to the difficulty of agreeing over the meaning of facial expression. The poet saw 'revenge and sullen discontent' in her face, but Rouquet thought she plays 'nonchalantly' with her ring. Lichtenberg was unexpectedly hostile: she is 'malicious, pig-headed, stubborn, and yet sly'. Contemporaries and near-contemporaries were reacting to a radical insubordination in the bride, a challenge to the basis of marriage itself. In contrast, Hazlitt, writing in the early nineteenth century, praised her against the evidence: there is 'the utmost flexibility, and yielding softness in her whole person, a listless languor and tremulous suspense in the expression of her face'.[18] Sadly, the couple are sufficiently handsome to have been attracted to one another in different circumstances. It is a measure of the folly of the Earl and his son that they do not take care of this nubile heiress.

The lawyer uses sharpening the Alderman's pen as an opportunity to approach his daughter. He bends solicitously over her and his parted lips suggest that he is whispering. His name and title, Counsellor Silvertongue, are withheld until the last picture, but the type-name conveys the feeling if not the substance of his sweet words. His expression corresponds to LeBrun's passion, 'Pure Love', especially in his big eyes, and full face and lips. His head is particularly close to hers, an over-familiarity which would be noticeable to those subscribers alert to the need for decorum. The situation is different from that in Bosse's contract picture in *Le mariage à la ville* where a responsible notary sits with the parents at the table.

Although the bride does not respond to the lawyer's audacity immediately, she is to remain naively loyal to a lover of inferior rank. The social distance between them may not have appeared particularly wide to Hogarth's contemporaries. The poet identified the lawyer as a 'spruce young Templar' and he would have come from a family rich enough to have supported him through an Inn of Court. He might well be the younger son of a merchant, physician or gentleman. In other circumstances, his status would have made him worthy of an alderman's daughter and he would have commanded a viscount's respect. So, although an approach to another man's bride on the day of her betrothal was audacious, the relationship itself would not have seemed improbable.

Satires on lawyers from Langland or Holbein onwards attack their cupidity and cunning. The lawyer is an epitome of self-interest in *Joseph Andrews*. Fielding saw the beaux of the Temple as but the 'shadows' of the others; they were 'the affectation of affectation'.[19] Hogarth's originality lay in making his lawyer a plump and fashionable gallant with little caution or forethought rather than a lean and guileful villain.

THE BRIDEGROOM, THE MIRROR AND THE DOGS

The bridegroom, Viscount Squanderfield, is last in the viewing sequence of the first picture. His back is turned towards the others, an arrangement which emphasises his isolation and his indifference to his bride, the prospect of marriage, and his father. All are equated with a

pinch of snuff. His lips are pulled back in resignation or exasperation (a grimace clearer in the painting than the print). His mournful eyes are suggestive of little more than a mild dissatisfaction at an early stage in the narrative, a mood reflected in the soft blue of his coat.

The pastel shades of his clothing indicate that he is dressed in the height of contemporary French fashion. The cuffs of the Rake's coat in *The arrest (IV)*, where he is dressed for the supreme event of his career, a visit to St James's Palace on the Queen's birthday, are longer than the bridegroom's multi-coloured ones as befitted the style of an earlier decade. The differences between the Rake's preposterous cravat and over-large coat and the groom's narrow cravat and well-fitting coat are measures of the latter's good taste. The red-heeled shoes are an old-fashioned touch, however. Addison in *The spectator* had called red heels 'little extravagances' and 'foppish and fantastic ornaments', and Gay also associated them with French foppery.[20] Both Addison and Hogarth were applying their 'remedies', as Addison put it, 'to the first seeds and principles of an affected dress'. Hogarth was prepared to tolerate a minor anachronism of dress for the sake of what had become a by-word for false taste.

The stylish clothes and smart tie wig with side curls are gently ridiculed in the angular arrangement of the bridegroom's bony arms and legs with the knees set just a little too far apart (his deportment otherwise is in accord with contemporary expectations). The angularity may derive from that traditionally associated with Sir Andrew Aguecheek, which was favoured elsewhere by Hogarth in, for example, the elderly fop who also wears high-heeled shoes in *Taste in high life* or the boy to the right of *The Graham children* (1742). The bridegroom's angled legs also anticipate those of a dancing figure in a red coat to the left of *The wedding dance* (c. 1745), one of the oil-sketches for the *Happy marriage* series. This figure reappears to the right of the second plate of *The analysis of beauty* (1753), which is referred to as the 'awkward one in the bag wig, for whom I had made a sort of an X'.[21] Other evidence of Hogarth's restrained amusement is found in the contrast between the angular Viscount and the rounded lawyer (both set with the same foot forward). Silvertongue's legs are similar to those of the 'amiable' figure dancing gracefully on the far left of the illustration to *The analysis of beauty*. Grace and ugliness form a dramatic contrast in *Marriage A-la-mode*. Hogarth recalled that he first thought of the line of grace in 1745 and his theory of beauty may have begun to formulate in this picture. At the comic level of *fat* versus *thin*, the contrast extends to the bulky and dignified Earl and the thinner and awkward Alderman.

The Viscount's physique has little in common with his father's, but there are telling similarities in matters of detail: they both gaze with a 'disengaged air'; advance the same legs and crook their little fingers (as was expected of men of their class); both wear big rings, the son's decorative, while the father's is purposeful. Whereas the father's dignity is spoilt by gout, his son's elegance is marred by a large plaster on his neck.

Scrofula attacks the lymphatic glands of the neck as a consequence of the malnutrition of the tissues which then become vulnerable to the

spread of tuberculosis carried in infected milk. The disease also attacks the nerves of the eyes (as Dr Johnson knew to his cost), a weakness which could conceivably lie behind the Viscount's fatal lack of perception. Scrofula was a baffling evil in the eighteenth century. Subscribers would have seen the son's sore as an inheritance of the father's excesses and many would have interpreted it as a sign of congenital venereal disease. The sequence is the wrong way round in the painting where the sin of the son precedes that of the father, an absurdity which confirms that the print is meant to carry the narrative line.

A pier mirror hangs immediately behind the bridegroom, the first of several mirrors in the series. It is surmounted by a coronet and both are cut in half by the margin of the print as if to suggest that the Viscount is to be but half an earl. A similar innuendo occurs in *A rake's progress I* where Hogarth positioned a complete escutcheon above the angry mother, but only half above her sorrowful, wilting daughter. A china jar, similarly reduced, is half hidden under the table beside the Viscount, perhaps meant as an ironic comment on his fragility. A similar jar, labelled 'varnish', is included in *Time smoking a picture* (1761); such jars are all surface by definition.

A shadowy reflection in the mirror encouraged the poet to typify the bridegroom as a 'young Narcissus' and, sharply, as a 'silly ass' who courts himself in a 'dull glass'. Ireland wondered whether the bridegroom is secretly watching events behind him in the hope that he might gather evidence for a divorce. Lichtenberg argued persuasively in reply to Ireland that it is a 'catoptric impossibility' for the bridegroom to see his bride in the mirror. Furthermore, the reflection (identifiable only in the print) is not that of the bridegroom, but that of the lawyer.[22] The mirror provides a glimpse of the man the bride might have chosen for herself if her father were not determined on a fashionable marriage. Only the privileged viewer, not the bridegroom, is positioned to see what the latter ought to see behind him. The groom is as close to observing the beginning of an *affaire* and so to be in a position to change the course of events as, for example, Romeo is to recovering Juliet. The nearness of discovery adds a touch of tragic poignancy to a lonely character who is not as calculating as Ireland would have him appear. The correct identification of the reflection makes the bridegroom's primary traits those of lack of foresight and self-indulgence (signified by the snuff) rather than narcissism – making him, in consequence, a more interesting character.

The contrasting poses of the game dogs below the bridegroom comment on the way the young couple also waits to be shackled in marriage. The bitch sits up and the dog lies down, whereas the X-ray shows that Hogarth first thought of them as both lying down. However, whereas the dogs accept their heavy shackles with composure, their human counterparts are to break their enforced bond. The contrasting attitudes of the dogs, appropriately *pointers*, also anticipate the psychological differences in the second picture where the wife's stretch

contrasts with the husband's downcast attitude. The bitch's gaze literally points the viewer in the right direction according to the viewing sequence of the prints.

Occasionally, Hogarth made use of the portrait painter's old trick of making a figure engage the viewer's eye from within the picture. The most unsettling example is in *A harlot's progress III* where the Harlot displays the watch she has stolen for the viewer alone to see. She involves him as a witness, an accessory, a prospective client, or a combination of these. The viewer's role in relation to the narrative is defined for him and he is thereby invited to regard himself as a participant in the action.[23] The dog's soulful eye engages the viewer's in the first picture of *Marriage A-la-mode*. The effect of the fixed gaze of an unassuming creature is disturbing: his awareness seems extra-sensory and an ironic criticism of the other figures in the picture who are too

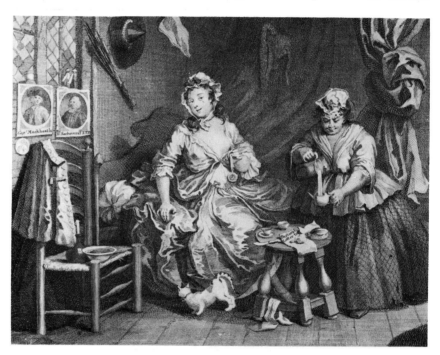

[10] The harlot and her watch (detail) from *A harlot's progress III* (*At her lodgings in 'Drury-Lane'*), engraved 1730–3.

engrossed in their own affairs to be aware of who overlooks them or to know who they themselves really are. The dog's composure indicates that the projected viewer makes no threatening move, but, nevertheless, needs to be watched. Wilkes claimed that 'cautious side-glances' signify resentment, in which case the implication is that the dog accepts the viewer's existence on sufferance.

The placing of the animals close to the Viscount indicates that they are his in the painting. In the print, Hogarth added a coronet as a brand mark to the dog's hide to make them the Earl's possessions. The brand spoils the sleek coat as the gout and the scrofula spoil the men's magnificence. The mark draws attention to the Earl's determination to impose his 'character' literally and metaphorically, on every object or being in the room. The gain in psychological insight justifies the addition of yet another coronet.

ELEMENTS OF THE SETTING

THE INTERIOR PAINTINGS

The ten interior pictures are clever imitations of examples of the 'historical sublime' (Hogarth's preferred term) usually with slight variations from the originals to maintain a thin disguise.[24] The group to the left of the corner line in the print is dominated by a large portrait of the Earl in his youth (probably after Hyacinthe Rigaud). A study of David killing Goliath (after Titian) is positioned to the right of the portrait. Companion studies immediately below are of Judith with the head of Holofernes (after Guido Reni, possibly from a print by Dupuis) and St Sebastian (the single, heavy arrow is similar to those in Titian's version).

The group to the left is dominated by an oval picture of Medusa painted on a mirror (Hogarth's father-in-law owned a copy of Caravaggio's original). Four smaller pictures make a square around the Medusa: *Prometheus and the Vulture* (after Titian) is in the top left quarter; *Cain killing Abel* (also after Titian) is immediately below; a picture of St Agnes (after Domenichino) is at top right; a *St Lawrence* (after Le Sueur) is below. Recent cleaning shows this picture to have unexpected depth, colouring, and delicacy. A ceiling painting of *Pharoah drowning* surmounts the groups (perhaps based on a woodcut by de la Grecche, again after Titian).

THE PORTRAIT OF THE EARL The picture functions as a measure of the pampered invalid's vanity because the bulky Earl admires a view of himself as a sprightly Jupiter surrounded by the machinery of aerial warfare. Hogarth also took the opportunity to ridicule, as Nichols and Steevens put it, 'the unmeaning flutter of Rigaud's portraits'.[25] They claimed with some justification that Rigaud's portraits, particularly those of Louis XIV, are no less extravagant than the parody so that Hogarth's satire remains within the bounds of possibility. Rigaud, incidentally, was to be criticised in *The analysis* for failing to use the serpentine line of grace in his portraits.

The Earl and his youthful counterpart contrast subtly: both have smooth, unlined faces and the Earl's jowls are only slightly more heavy. The whites of the Jupiter's eyes shine (especially in the painting) and his finer eyebrows are more arched creating a quizzical effect in keeping with his youth. Both underlips protrude as if in consequence of a Hapsburg jaw. The Jupiter's loose robe and curving cuirass give him an impression of size which is heightened because the Jupiter is larger than the figures in the flanking pictures. Both figures posture regally but, while the Earl draws attention to his pedigree, an appropriate concern for the elderly, the Jupiter points to his insignia, the rewards for youthful achievement.

The insignia, the French orders of the Golden Fleece and the *saint esprit*, are the most telling evidence of the Earl's vanity. It is noted in the *National Gallery Catalogue* that no Englishman had been awarded these prestigious orders of chivalry in the years leading up to 1743.[26] The Earl has no right to the medals and their presence is evidence of the

[11a] The Earl (detail) from *Marriage A-la-mode I*.

[b] Portrait of the Earl as Jupiter (detail) possibly a parody of the style of Hyacinthe Rigaud (p. 42). *Note:* the order of the Golden Fleece hanging on a ribbon around his neck and the *saint esprit* on its sash.

[c] The Viscount (detail). *Note:* the patch on his neck (p. 39); the head other than his reflected in the mirror (p. 40); the china jar under the table (p. 40); the coronet stamped on the dog's hide (p. 41).

Note: the rings worn by all three (p. 39).

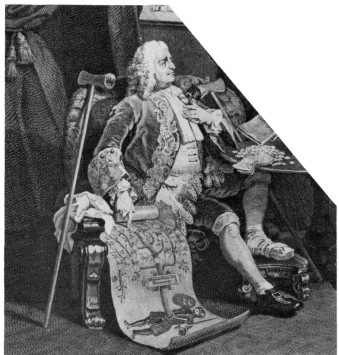

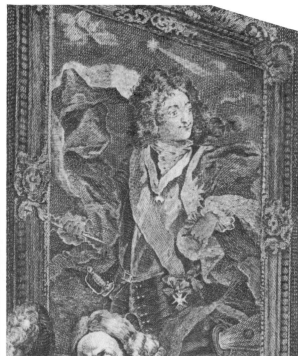

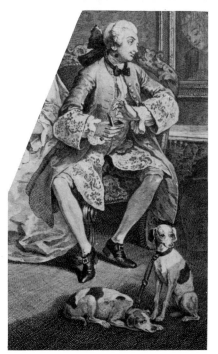

portrait painter's outrageous flattery of his subject and the Earl's own bad taste. Like the façade, this outwardly impressive picture is based on a false assumption and a number of stylistic contradictions: the sitter's head turns in one direction, while his body twists in another; the robes flutter one way, while his wig floats to the other; one hand holds pagan symbols, the *fulmen*, and the other points to a Christian emblem (suspended from a blue sash, the colour of deity and airiness); the sitter straddles a cannon which fires in the opposite direction to a soaring comet (added to the print); in turn, a zephyr puffs in opposition to the comet. Hogarth's dislike of such things is recorded in *The analysis*, where a cherub is described as 'an infant's head of about two years old, with a pair of duck's wings placed under its chin, supposed always to be flying about and singing Psalms'.

If the portrait is a flattering recreation of the Earl's self-view – omnipotent and martial, chivalric and frolicsome – then his son is its antithesis. He is a study in fashionable indolence whereas the portrait is of a restless, untidy cosmic being. The cannon is reduced to a pinch of snuff and the impression of swelling pride to one of frail angularity. The differences point to causes of the Viscount's subsequent failure in the duel, while the values implicit in a family portrait of Jupiter provide the heir with a fateful precedent for believing that he should triumph in a duel. He is unaware that the reflection in the mirror shows him Jupiter's truer counterpart, both amorously and martially.

Jupiter is an appropriate deity to preside over a marriage. He is the only god in the Roman pantheon with a specific moral responsibility – for oaths and treaties. Marriage ceremonies took place in the presence of his priest. Both the Jupiter and the Earl wear signet rings on their little

fingers as evidence of their duties but, instead of paying attention to the present negotiations, Hogarth's Jupiter allows himself to be distracted by the picture of Medusa at a moment when his good offices are most needed. Jupiter's role as a negligent marriage deity, supported by equally negligent 'priests' in the lawyers, supplies a reason for Hogarth's association of the second picture of *Marriage A-la-mode* with the Roman picture *The Aldobrandini marriage*.

The portrait is an astonishingly apt comment on the central situation in psychological terms. It is also one of the few pleasantly absurd and mock-heroic details in the series, but, like the view through the window with which it is balanced, it has the serious point to make that ridiculous causes can lead to catastrophic results.

'DAVID AND GOLIATH', 'JUDITH AND HOLOFERNES' AND 'ST SEBASTIAN' The *David and Goliath* shows David about to cut off the head of the Philistine. The essential moment anticipates the climax of the series in which a man of lesser status, a lawyer, kills one of greater status, an earl, also against the odds. The graceful Silvertongue (the equivalent of an agile David) is also to thwart the marriage plans of a big man and his maladroit son with the characteristics of Goliath. The analogy is limited because David's conquest of Goliath led him to kingship, whereas Silvertongue's success in single combat leads him to the gallows.

Silvertongue's bending over the bride is paralleled in the positioning of *David and Goliath* above the pictures of Judith and St Sebastian. The arrangement also anticipates events in the series where the lawyer with the hint of a Jewish nose (David's counterpart) is first to dominate the wife (the counterpart of Judith) and then to triumph over the husband (the counterpart, in terms of this analogous relationship, of St

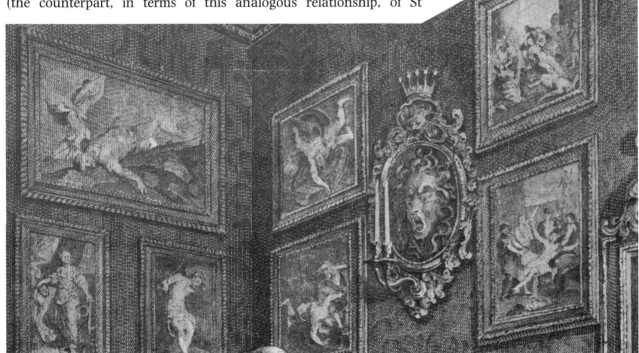

Sebastian). The resemblance between the curving backs of Silvertongue and the saint, however, provides an alternative analogy between a martyr, and the victor in the duel who is executed as a consequence of his victory. The lawyer's quill and knife, ominously turned towards himself, find a parallel in the arrow in St Sebastian's body. The analogy suggests that the lawyer is eventually responsible for his own martyrdom. At the same time, the picture of the saint recalls popular representations of Cupid shooting arrows at similarly helpless lovers. Those subscribers versed in emblem lore would have also remembered that Cupid and Death were often depicted as shooting with one another's arrows.

The close juxtaposition of the pictures creates a kinetic interaction similar in effect to those of *Before* and *After* or the bobbing cockerels in *A rake's progress II*. David prepares to cut off Goliath's head, while immediately below, Judith holds out Holofernes' head as if this were the immediate result of David's blow. (Caravaggio's original, incidentally, shows David holding Goliath's head.) Judith's deception of Holofernes, an enemy of Israel, acts as a comment on the deceit of a bride who is to betray her husband for the sake of a lover at the cost of his life.

'PROMETHEUS AND THE VULTURE' AND 'CAIN AND ABEL' Both Prometheus and Cain defied jealous deities by introducing fire and death into the world and their defiance led to severe and long-lasting punishments. Prometheus has become the archetypal sufferer and Cain the wanderer. Their contrasting experiences comment, respectively, on the Viscount's chronic disease, his fondness for snuff, and his mortal suffering in the firelight, and the lawyer's profession as a man who attends wherever he is called. The latter is also to be punished for deceiving his superiors and for commanding the fire which illuminates the crisis of the narrative.

'Cain and Abel warn Mr Silvertongue of fratricide', Lichtenberg observes. The apparent suddenness of Abel's murder, as told in *Genesis*, finds a parallel in the unexpected death of the husband at the hands of his 'brother' in love. Hogarth emphasised the closeness of the parallel between Cain and Silvertongue by superimposing his head on the picture frame. The biblical rivalry is between a miner and a herdsman, whereas the modern one is between a professional man and an aristocrat. This kind of antithesis may have influenced Hogarth's choice of names: a man with an eloquent tongue is opposed to the man who squanders his substance. The images are not necessarily consistent; in the same way that there are affinities between St Sebastian and both the lawyer and the Viscount, so there is a correspondence between Cain, the lawyer and the Viscount. Not only are Cain and the Viscount the first born, but the Viscount also carries the modern equivalent of the mark of Cain, not God-given on his forehead, but on his neck.

THE MEDUSA Hogarth had included a Medusa in *Strolling actresses dressing in a barn* (1738) whose eyes stare from the shield of a plump actress dressed as Diana. A similarly oval picture of an obscure subject, lit by one candle, is to the right of Bosse's second picture in *Le mariage à*

[12] Pictures decorating the Earl's bedroom (details) from *Marriage A-la-mode I*.

To the left of the corner line:
(above) *David killing Goliath* in imitation of Titian; (below, l.) *Judith with the head of Holofernes* in imitation of Guido Reni: a print by Dupuis was available; (below, r.) *The martyrdom of St Sebastian* probably in imitation of Titian.

To the right of the corner line:
(above l.) *Prometheus and the vulture* in imitation of Titian; (above, r.) *The martyrdom of St Agnes* in imitation of Domenichino (also Illus. 13); (middle) *Medusa* in imitation of Caravaggio: Hogarth's father-in-law owned a copy; (below) *Cain killing Abel* in imitation of Titian; (below, r.) *The martyrdom of St Lawrence* in imitation of LeSeur.

la ville, La rentrée des mariés. Hogarth may have drawn on both sources to produce his picture of the gorgon on a mirror. The reflections of the sconces and the tapers are discernible in the painting, although the effects are too delicate for the print. The twin points of light from the tapers would beam at a viewer from the mirror in an eerie and ill-omened imitation of Medusa's stare. One bracket twists under the other as if to comment on the crossed relationships. Similarly entwined sconces are found in *The lady's last stake* (1758–9), another study of a wife choosing between an absent husband and a gallant.

Medusa's expression is similar to LeBrun's passion *Fright*, an emotion conveyed by staring eyes and open mouth with the cheeks 'extremely evident' and the hair stood on end.[27] Hogarth was to write that a 'large full eye' is expressive of fierceness and astonishment. Medusa's fear and astonishment is a means of inflating the comic awfulness of a modern, fashionable marriage. If a gorgon is terrified, then a viewer's human and humane response should be correspondingly greater than a monster's fear. The difference in presentation between *Strolling actresses* and *Marriage A-la-mode* is an indication of how Hogarth had learnt to use a decoration as a telling authorial comment and *Medusa* is the first of a number of busts and heads in the series which react critically to events in the manner of a Greek chorus.

The gorgon's fear and remorse (implied in her snakes) prefigure the wife's penitential attitude at the climax of the series. The curling snakes and entwining sconces are not only comic variations on the bride's tight ringlets, but also anticipate her ultimate contrariness in that she is to kneel before her husband, but to kill herself for her lover's sake. The presence of a gorgon and her mock-heroic equivalent, the bride, invites a search for the counterpart of Perseus. The lawyer is the only figure to look directly into the wife's eyes (the fourth picture) and the consequence for him is death. The bridegroom, like Perseus, seems to be avoiding this fate in that he avoids looking at his wife throughout the series and he is protected, as it were, by a mirror in the first picture. Unlike Perseus, however, he is forced to marry the counterpart of a gorgon by stony-hearted parents and so the consequence for him of their callousness is also death.[28]

The analogies also connect one picture with another: the Jupiter in the portrait glances at Medusa as if he is considering adding her to the list of his loves; his cannon fires in her direction in a mixture of aggression and admiration; both their picture frames are surmounted by lion-like heads enhaloed with venus shells to represent the paradox of love and war conjoined; the golden fleece hangs on a red ribbon, the colour of power and love. The Jupiter's status as an indifferent marriage deity also makes Medusa an incongruous counterpart of Juno, the defender of motherhood. Instead of responding to Jupiter's interest as one of his loves should, however, Medusa ignores him and reacts with Juno's disapproval to the loveless ceremony taking place below. As an image on a mirror, she can be imagined to have the power to foresee the course of events in which a wife is first to neglect and then to desert her child. The relationship between Jupiter and Juno, Hogarth's original and comic variation on the traditional stories of the god and his loves,

[13a] *The martyrdom of St Agnes*, Domenichino (Pinacoteca, Bologna).

[b] Hogarth's imitation of the same picture (detail) from *Marriage A-la-mode I.*

finds its parallel in that of a smitten lawyer and an oblivious bride.

The presence of a Medusa helps identify the first picture as one dominated by the physical sense of sight: the Alderman adjusts his spectacles in order to read the title of the settlement; Silvertongue apparently falls in love at first sight with another man's bride who glowers at her wedding ring; the Earl and the Viscount gaze for the sake of it; the Jupiter casts his glance at Medusa, who surveys the whole scene. The shackled dogs presciently 'point', one at the viewer and the other in the direction of subsequent events. The lawyer by the window compares the façade with the plan and his attitude is reminiscent of the man looking out of a window with a spy glass in Bosse's *Sens: la vue* in which a mirror is the centrepiece. Hogarth's characters are metaphorically and disastrously short-sighted: the Earl is blind to the defects of his monument; indifferent to the fact that his portrait shows him wearing the wrong insignia; unconcerned by the inappropriateness of owning a study of Medusa's head. The myopic Alderman chooses not to heed the warnings of the mark on the bridegroom's neck and the family tree. The bridegroom fails to heed the mirror's warning and the lawyer looks only at the person he should not. The Medusa was a happy afterthought because the X-ray shows a tall rectangular shape to be underneath.

'ST AGNES' AND 'ST LAWRENCE' The pictures to the right of Medusa are concerned with saints who suffered in the hands of dictatorial Romans. Unlike her modern counterpart, Agnes refused, as a matter of principle, to marry the son of the Roman prefect and his cruel attempt to force her into marriage comments on the prefectorial attitudes of fathers in a modern equivalent of Rome. Agnes's humiliation in the brothel has its parallel in the wife's degradation in the bagnio (fifth picture). The sufferings of the saint who refused to marry and the sinner who does, Hogarth implies, are similarly pathetic. Paulson notes in *The art of Hogarth* that the upper part of Domenichino's original painting, showing Christ receiving St Agnes's soul, has been left out.[29] By means of cutting and juxtaposition, Hogarth replaced a vision of heavenly love and sympathy with the ceiling picture of Pharoah, an unyielding enemy of Israel (below), a device which makes Hogarth's vision harsher than his source.

The story of Lawrence, one of the seven deacons of Rome who distributed the treasures of the church among the poor in defiance of Emperor Valerian's decree, anticipates a situation in which a Viscount is to prefer a street-girl (third picture) to the wife chosen for him by an imperious father. Hogarth's point is that the death by burning of the martyr of the early church and that of the modern profligate are similar: both are squanderers in their differing ways.

The juxtaposition, one above the other, of St Agnes and St Lawrence seems to set out the steps of a single incident. St Agnes, first, is presented as being stabbed, the preliminary to her being burnt, and St Lawrence is then shown being roasted on his grid, apparently on the point of being turned over. A torturer stokes the fire, an act of renewal consistent with the beginning of a narrative in which the Viscount, immediately below, takes snuff. His wife is to be betrayed, metaphorically stabbed in the

back (as St Agnes literally is stabbed from behind) by his adultery and his planned confrontation of her lover in the bagnio. He dies from a sword wound, bathed (or roasted) in the firelight.

THE CEILING PAINTING OF 'PHAROAH DROWNING IN THE RED SEA' The furthest corner of the room is decorated with a naked figure reclining in a tilted chariot about to sink beneath the sea. The Pharoah raises his hand in salute, oblivious to the suffering of the men and horses who drown beside him. The absurd placing of a watery subject on a ceiling more properly concerned with airy themes, as Domenichino and Thornhill's son-in-law well knew, is further evidence of the Earl's lack of taste. The semi-naked figures in the little paintings immediately below are placed to float or struggle beneath the surface of the aptly named Red Sea. The fathers negotiate – as it were – in the depths, as oblivious to the happenings which threaten their plans as Pharoah is to the flood which ends his hopes of catching the fleeing Israelites. A particular analogy between the Pharoah and the Earl derives from the latter's ownership of the room. Hogarth gave Pharoah's crown four points and left room for a fifth as if to hint at the presence of yet another coronet. The younger generation is trapped like the Egyptians above them who drown at Pharoah's command.

The inclusion of an evocative subject in such an obscure corner demonstrates the inexhaustibility of Hogarth's imagination, supports the claim that every detail in the picture is relevant to the central situation, and provides the series with an image of a literally overriding fate, blind to his surroundings and superior even to Jupiter in his placing within the picture. This Fate is not detached, however, the arrow-like corner line seemingly directs his malign influence into the room.

[14] The ceiling painting of *Pharoah drowning* (detail) in imitation of Titian; a woodcut by de la Grecche was available. *Note:* the possibility of a fifth point to the crown (p. 48) and the white standard (p. 48).

De Lairesse, in considering which pictures should hang on the walls of which rooms, recommended that 'beautiful faces, and naked children, painted after the life' should hang in the master's bed-chamber.[30] Hogarth's monstrous face and naked, suffering martyrs painted in imitation of other artists instead of taken from life offer such an exact antithesis that it is clear that he was reacting deliberately against convention. The violence and the indiscriminate mixing of

biblical and classical subjects in works by French and Italian artists represent a sustained criticism of the Earl's degenerate taste. The pictures may be classified according to whether they are about oppressors or victims. The bias within the selection shows that the Earl prefers the oppressors. His interest is ridiculed in those he maltreats, neither martyrs nor heroes, but children and dogs. The pictures also reveal an underlying interest in sexuality: Judith uses her physical charms to lure her enemy; the vulture attacks Prometheus's liver, the seat of desire; the cannon in the portrait acts as a giant phallus; St Agnes is humiliated in a brothel. The Earl's personal involvement is now vicarious, but his liking for sex and violence can be seen to account for his son's lack-lustre promiscuity and ineffectuality later in the series.

The groupings also provide an interest partly independent of the narrative line in the manner of an inset story, such as the 'history of Leonora' or the story of Mr Wilson in *Joseph Andrews*. The Jupiter looks over his shoulder at the other pictures as if the general at the head of his troops to which the Medusa acts as a rearguard. David and St Sebastian (a commander of the Praetorian guard before his conversion) were formidable warriors. Judith's resourcefulness in a siege destroyed an Assyrian general. They are suitable lieutenants for a Jupiter, while the vulture, Cain, and St Lawrence's torturers are suitable comic aides to a gorgon. The mock-heroic army not only follows its leader, but also has factions within it: god and monster; warriors and torturers; male and female; rectangle and oval. They reflect the antipathies among the characters: Westminster and London; property and commerce; bridegroom and bride; angular Viscount and graceful lawyer.

The particular contrast between Egyptians (or Romans) and Israelites recalls Dryden's allegorical strategy in *Absolom and Achitophel* (1681).[31] Hogarth's Earl has a counterpart in Dryden's 'haughty' Pharoah of 'proud' Egypt'. Pharoah's white flag in the ceiling painting may allude to the standard of the Bourbon kings as well as a flag of surrender. The Alderman corresponds to Dryden's Shimei, whose neck 'was loaded with a chain of gold' and whose kitchen is cool, 'though his brains were hot' (a reference to Slingsby Bethel, a proverbially mean Sheriff of the 1680s). The lawyer and the Viscount find their parallels in 'false' Achitophel and Absolom who is 'goodly' in his person and 'mild' natured and 'warlike' by turns. The resemblances may not be deliberate and the possibility of an intentional parallel should not be overstated, but Hogarth was familiar with Dryden. He had used a scene from *The conquest of Mexico* as the basis of his most prestigious commission, the group portrait of the Duke of Cumberland's family (1732), and drew on Dryden's play, *Marriage à la mode* for the present series (pages 64–6). Whereas Dryden retold the biblical story in terms of a contemporary political situation, Hogarth used the stories allusively and less systematically to comment on a contemporary domestic situation. Hogarth may have read *Absolom and Achitophel* with particular enjoyment because he too delighted in a mocking interpretation of the modern in terms of the ancient. *A rake's progress* sets a precedent for the interaction of characters and the contents of the interior pictures: the Rake is a modern counterpart of King David awaiting his Bathsheba and the

conqueror, not of the Roman emperors themselves, but only of their pictures. *Taste à la mode* is a rehearsal for the first picture of *Marriage A-la-mode* in that the shapes of the seven interior pictures repeat those of the figures before them. None of the precedents, however, display the extensive ironies, multiple analogies and cunning prefigurations to be found in *The marriage settlement*.

THE VISUAL ORGANISATION OF THE PICTURE

The figures in *The marriage contract settlement* are arranged in Hogarth's familiar pattern of a major and a minor tableau, a grouping which in this picture may have been influenced by the precedent of Bosse's *Le contract*. The parents sit at a table in a large group to the left while the betrothed pair are seated together on the right. Hogarth's advance on Bosse was to connect the tableaux in a series of intricate interrelationships.

The family tree and the empty money bags balance at each end of the baseline of the major tableau. The heads of the lawyer at the window and the agent form a double apex. The Earl's crutches frame him in an inner triangle and his personal association with the shape is extended to the three-legged stool, yet another triangle within a triangle. The candlestick – the means by which the vivid red wax is heated to seal the agreement – is at the apex of another inner triangle at the centre of the picture with the mortgage (a document set above money) on the debtor's side of the triangle and the settlement (a document set above bank notes) on the redeemer's side.

The disposition of the broker back to back with the lawyer creates a division which accentuates the differences on either side of the unifying oval of the table. The heads on the Earl's side look upwards and outwards, while those on the Alderman's look downwards and inwards. The variation is indicative of the difference between an arrogant visionary and an avaricious materialist. Fingers spread and point on the Earl's side as signs of a carelessly giving personality and the hands hold on the Alderman's as evidence of a grasping outlook (a carpenter's vice is Hogarth's emblem of avariciousness in *A rake's progress I*).

The minor tableau consists of three, overlapping shapes. The bridegroom's figure is constructed as if out of triangles set base to base, a particularly appropriate association because he is to be a key figure in the eternal triangle of an unhappy love relationship. The pose may have been meant as an ironic exemplification of Giles Hussey's theory of proportion, which was based on a triangular principle supposedly deriving from the musical scale of harmonies.[32] In contrast, the lawyer and the bride share an oval design principally defined by the curve of the lawyer's back. The oval is a unifying motif within the minor tableau because each figure performs self-enclosing actions requiring the use of both hands: sharpening a pen; toying with a ring; taking a pinch of snuff. In that the shape is associated with the graceful lawyer rather than the ungainly Viscount, Hogarth's authorial sympathies would appear to be with the former. The interaction of triangular and oval forms in both tableaux may anticipate Hogarth's emblem of beauty, the

serpentine line set within a cone.

The sequence of enclosed actions in the minor tableau helps give prominence to the row of objects themselves. If the candle set at the focal point of the oval table is seen as the starting point, then the succession of semi-personal emblems, arrayed across the picture, offers a visual equation which correctly anticipates the sequence of events in the narrative (candle→pen + ring + snuff). The contractual arrangement of marriage leads to a wounding of the heart, a playing with the emblem of an unwanted marriage, which is equated with a pinch of snuff. In Shakespeare's time, a pen had sexual connotations and Hogarth may have intended Silvertongue to be sharpening the pen which signifies his desire for a woman who is prepared to treat her honour lightly. The lawyer and the bride's self-enclosing actions are unbroken, but the perimeter of the husband's oval is on the point of being broken by the lift of his fingers. He is the first character to be shown as unfaithful to the marriage in the succeeding picture and is the first to die because of it.

A number of other variations on the basic major-minor relationship link the tableaux. The Alderman is positioned at the unifying point of overlap: his function as a first-mover is enhanced by the out-growing effect of the agent and the lawyer who bend away from him on either side (the effect also supports the argument that they are his servitors). The coronet on the Alderman's chair is placed as if the earldom itself were a matter between the lawyer and him, which subsequent events prove it to be. The man who rescues the Earl from debt is also responsible for the eventual undoing of the marriage which he himself underwrites. The disposition of heads forms a wave-like movement across the span of the two tableaux. It passes from a large crest (the apex of the major tableau) through the lawyer to the bridegroom on the right. His head forms the crest of an incomplete wave directed towards the next print which creates an expectancy similar in effect to that of an *enjambment* at the end of a line of verse.

Other variations take advantage of pictorial depth: the agent, as befits his ostensible role as a middleman, is at the crosspoint of the diagonals of an irregular rhomboid with the Earl and his lawyer on one side and the Alderman and his on the other. This feature draws attention to an equipoise in the picture, a balance perhaps inherited more from the Augustan writers and theatrical traditions of tableaux and pageants than a pictorial tradition. An oval table set within a rhomboid repeats the arrangement (in another plane) of the Medusa flanked by the other little pictures. The X-ray shows that a square frame underlies the oval picture of Medusa and the change points to Hogarth's conscious awareness of the significance in the contrasting frames. The destructive power of the gorgon's stare has its counterpart in the modern table-talk which also has the power to harden men's hearts. A rhythm of advancing and retiring figures is also apparent: the socially superior figures are set in advance of the inferior. The lawyer and the bride are set back in a form of visual understatement appropriate to a discreet *tête à tête*. The reflection in the mirror provides an extra head so that the bridal couple are flanked, or bracketed, by the character and the image

of the character who is to destroy them.

As is suggested in the Introduction each picture is dominated by a combination of the four physical elements. The focal point of the first picture, the candle burning in a heavy stick on the table – the means by which the contract is to be sealed and the marriage enforced – defines the predominant element as fire, the element most closely associated with the sense of sight. The emphasis is maintained in the twisted tapers above the betrothed couple. They represent perhaps the affection in marriage which ought to grow with time, but which on their reappearance (in the second picture) evidently remains unlit. The Earl's glittering clothes, the exploding cannon and the comet in his portrait, the gilt statue which surmounts the cupola of the new building, associate him particularly with the element of fire. Gout and scrofula, both irritant diseases, can be regarded as the outward signs of an inner burning. Air is associated with fire through the implications of the sunlit, spacious interior, the window open on a day warm enough to satisfy an elderly and ailing man, the vista and the cosmic apparatus in the portrait. The combination of fire, air and warmth suggests that the predominant humour in the Earl's bedchamber is choler, the humour of warriors, drunkards and summer-time. The knowledgeable subscriber was placed to appreciate the tension in the atmosphere at this crucial moment in the narrative.

The opposing elements, water and earth, are also present, but in diminished forms. The gorgon's stare and the interplay of sunlight on the façade draw attention to the presence of stone or a metaphorical stoniness. The Earl as the principal representative of fire is drawn to his incompatible element and the unsoundness of the new building shows that he is out of sympathy with it. Water is present in the Red Sea of the ceiling painting, poised as if to engulf everything below. The Alderman, a riverside dweller, is associated with this element; both the Earl and he are drawn foolishly to their opposing elements with disastrous consequences for their families.

Sunlight falls diagonally into the picture from an undisclosed source behind and above the viewer's standpoint. The window in the back wall admits little light since the shadows in the courtyard show the sunlight falling away from it. The window functions as a silhouette in reverse, bringing the back wall closer to the frontal plane. The effect draws the viewer into a closer relationship with the painting than with the print where the effect of light and depth is virtually absent. A diagonal shadow representing the sill of an unseen window was added to the bottom right-hand corner of the print to make the source of light descend from over the viewer's right shoulder in a largely unsuccessful attempt to make the effect of light more marked.

The warm light in the painting is reflected in golden highlights on the glittering clothes, coins, coronets, furnishings and picture frames. They are dispersed haphazardly throughout the picture. The gold paint is applied spontaneously and with great confidence almost in a stylistic enactment of squandering. Furthermore, the interlocking of the tableaux creates a band of figures across the picture, an effect repeated

in the disposition of the pictures on the walls. The rigidity of this second band is accentuated because the bright lines of the gilt frames dominate the shadowy contents of the little pictures. The overall effect is of a picture divided into two horizontal layers and vertically by the corner line, the window and picture frames. The interaction creates a grid in which the highlights dance at random; an eye-catching, bewildering experience. The gentle light fails to soften the vibrant colour contrasts of the clothes: the Viscount's blue coat, the white bridal dress, the legal black, the Alderman's scarlet and green, the Earl's gold and brown. The scattered highlights and clashes of colour exemplify the contradictions in the painting. On one hand, they underly the antagonisms among the characters, but, on the other, they work against the pictorial unity of tone. Because the painting presents the reverse of the narrative line, the Earl loses his place at the beginning of the narrative; the sequence of significant objects lose its meaning; the Viscount and the pointer no longer direct their gazes, or the viewer's, towards the next picture. The painting should not be regarded as a failure, however; the delicate brushwork, the glowing colours and dancing highlights, its shadowy and mysterious corners, make it an animated and sensuous experience. But *The marriage settlement* suffers from the dilemma inherent in the paintings of all Hogarth's series. They cannot be judged as independent pictures and their success is qualified by their subordination to the purposes of the narrative.

CONCLUSION

The first picture of the series begins with a ceremony of initiation to which all the major characters contribute. The ensuing dramatic conflict derives from a settlement imposed on unwilling partners by family interests traditionally hostile to each other. Hogarth's dialectic is elegant in that a first-mover, the Alderman, introduces the agent of catastrophe, the lawyer, at the beginning of the narrative. His eventual role is to break the agreement he has been commissioned to negotiate. The crisis develops from a secondary subject in the expository picture, that of pleasure-seeking. The primary subject of dictatorial parenthood exerts a malign influence on the series, but reappears only as part of the resolution. Downfall occurs, however, as the consequence of a balance of factors because the bride and groom themselves are determined to disregard their arranged marriage instead of facing up to what was regarded as a serious responsibility.

The intention of this extensive examination of a single picture has been to explore the psychology of the characters and their interrelationships as introduced at the beginning of a sophisticated picture strip and to investigate their treatment in relation to a convincing and revealing setting. Hogarth's sympathies initially are with a non-recurring figure: the Earl's old-fashioned attitudes, degenerate tastes, arrogance and tarnished magnificence are to influence and perhaps dictate subsequent events.

NOTES

1 The chapter headings derive from the titles of the paintings as Hogarth listed them in the printed auction list for the sale of his earlier series in February, 1745 (BM MS 33402 f.62). They are as follows. The titles in brackets are those on the frames.

 I *The marriage settlement (The marriage contract)*
 II *The tête à tête (Shortly after the marriage)*
 III *The inspection (The visit to the quack doctor)*
 IV *The toilette (The countess's morning levee)*
 V *The bagnio (The killing of the earl)*
 VI *The lady's death (The suicide of the countess)*

It is worth noting that Hogarth's titles are marginally more expressive and less informative than the later ones.

2 *The analysis*, p. 38. The weakness of Hogarth's copying technique meant that the prints do not show his intended left and right handedness. Betterton's views are collected in a miscellany in *The history of the English stage* (London, 1741) by William Oldys and others, pp. 100–1. Wilkes, p. 115.

3 *The analysis*, p. 48.

4 C. D. O'Malley, 'The English physician in the early eighteenth century' in *England in the Restoration and early eighteenth century: essays on culture and society* edited by H. T. Swedenberg Jr (Los Angeles, 1972), p. 153.

5 Georg Christoph Lichtenberg (1742–99). *Lichtenberg's commentaries on Hogarth's engravings*, translated by Innes and Gustav Herdan (London, 1966), p. 86, subsequently referred to as 'Lichtenberg'. Because most allusions to Lichtenberg are drawn from the Commentary on *Marriage A-la-mode*, pp. 83–152, page references subsequently are not included.

6 John Ireland, *Hogarth illustrated*, three volumes (London, 1791). Quotations are from the third edition. Ireland's remarks on *Marriage A-la-mode* throughout the review are drawn mainly from volume II, pp. 18–30.

7 *The analysis*, p. 37, p. 62, p. 180. Hogarth's dislike of the Burlingtonians did not prevent him from owning Isaac Ware's translation of Palladio's 'book'.

8 David Garrick, *Lethe* in *The dramatic works of David Garrick Esq.* (London, 1748), Vol. I, p. 16.

9 Derek Jarrett, *England in the age of Hogarth* (London, 1974), p. 184.

10 'In [Hogarth's] excellent works you see the delusive scene exposed with all the force of humour, and, on casting your eyes on another picture, you behold the dreadful and fatal consequence' *The champion*, 10 June 1740, p. 317.

11 De Lairesse, p. 31, Plate XII, example 3.

12 John Gay, Fable XVI, in *The poetical works of John Gay*, edited by G. C. Faber (New York, 1926), lines 13–14, p. 248, subsequently referred to as *Poetical works*.

13 See note 13, Chapter II for doubts about Edward Swallow as a source. Although Walter was rich and dressed poorly, he was acutely conscious of his own dignity and status, unlike Hogarth's servile agent. The misapplication appears to be a case of a notorious miser being associated with a miserly character regardless of other considerations.

14 David Allen, 'Bridget Hyde and Lord Treasurer Danby's alliance with Lord Mayor Vyner' in *Guildhall studies in History II* (London, 1976), pp. 11–22. This section draws particularly upon pp. 11–14 and conversations with Mr Allen to whom I am indebted. The passage also draws on H. J. Habakkuk, 'Marriage settlements in the eighteenth century', *Transactions of the Royal Historical Society* (1950).

15 *Joseph Andrews*, Book III, Chapter III, p. 180.

16 An Earl R_____d (Ronald or Roland), according to the poet (p. 4). Other claimed sources are the Earls of Southampton, Scarsdale, and Portsmouth; 'Old B_____ks' (to rhyme with books) for the Alderman, according to the poet (p. 8) and Sir Isaac Shard.

17 Wilkes, p. 140.

18 William Hazlitt, 'On the works of Hogarth – on the grand and familiar style of painting', Lecture VII, *Lectures on the English comic writers with miscellaneous essays*, edited by W. E. Henley (London, 1910), p. 13. Subsequent references in the re-view are to pp. 134–6.

19 *Joseph Andrews*, III, chapter 3, p. 173.

20 *Spectator paper* 16, 19 March 1711 in *The spectator*, I, edited by Donald F. Bond (Oxford, 1965), p. 70 and John Gay, *Trivia* (1716), II, l. 56 in *Poetical works*, p. 66. Mary Webster notes that the wearing of red heels was a privilege of French courtiers, who

were known as *les talons rouges* (in *Hogarth* (London, 1979), p. 104).

21 *The analysis*, p. 10, p. 147, and p. 146.

22 A student drew Paulson's attention to the fact in 1975: see Paulson, 'William Hogarth's portrait of Captain Coram by Hildegard Omberg' in *The art bulletin*, LVII, 2 June 1975, p. 293. The pointed toupee of Silvertongue's wig and his rounded nose are apparent.

23 I am indebted to John Preston's stimulating book, *The created self: the reader's role in eighteenth century fiction* (1970). Although Preston includes a reproduction of *Characters and caricaturas* on the dust-jacket, he does not suggest that the viewer's role is predefined in Hogarth's narrative art as is the reader's in the fiction of the time. Wilkes, p. 126–7.

24 *Apology for painters*, p. 84. Martin Davies in the *National Gallery catalogue* first identified the pictures (p. 49). I am indebted to Paulson's survey of the interior pictures in *The art of Hogarth* (London, 1975), pp. 32–8.

25 John Nichols and George Steevens, *The genuine works of William Hogarth; with biographical anecdotes* (London, 1808–10), Vol. II, p. 180. *The analysis*, p. 8.

26 *The National Gallery catalogue*, note 14 to p. 59. Hogarth's training as a silver-engraver would have made him aware of armorial properties so there is little chance of a slip on his part. A *saint esprit* has religious connotations and a golden 'fleece' could have been intended as a punning comment on the negotiations; *to fleece* was current slang for *to swindle*. *The analysis*, p. 50.

27 LeBrun, Fig. 13, opposite p. 31 and *The analysis*, p. 138.

28 The poet saw the gorgon's head as a
Sure token of succeeding Horns!
Which worse than snakes will gall his ears,
And fill his soul with endless fears (p. 10).

29 *The art of Hogarth*, p. 37.

30 De Lairesse, p. 395.

31 John Dryden, *Absolom and Achitophel*, Part I, lines 283 and 843 (for Pharoah), lines 596 and 621 (Shimei), l. 150 (Achitophel), lines 687, 478, 221 (Absolom).

32 Giles Hussey (1710–88). He may have come to Hogarth's attention as an English artist who forsook his master, Jonathan Richardson, to study under an Italian, Vincenzo Damini. He completed

his training in Bologna and Rome under Lelli. He had returned to England and settled in London in 1742. His theories were largely ignored and do not appear to have been clearly argued. He was to attack LeBrun, however, for presenting 'ignoble caricatures of the passions'

(1756). See William T. Whitley, *Artists and their friends in England, 1700–1799* (London, 1928), Vol. I, pp. 127–8. Further variations on the emergent line of grace in *Marriage A-la-mode* may have been intended in the pigeon chested figures of the stewart (*II*), the

apothecary (*VI*), and details like the bulging chair legs (*IV*). The ovality in the tableau was first noted by Eric Newton in 'Marriage à la mode, No 1, signing the marriage contract' in *Round the National Gallery series 3 Art news review*, VIII, 22 (1956), p. 2.

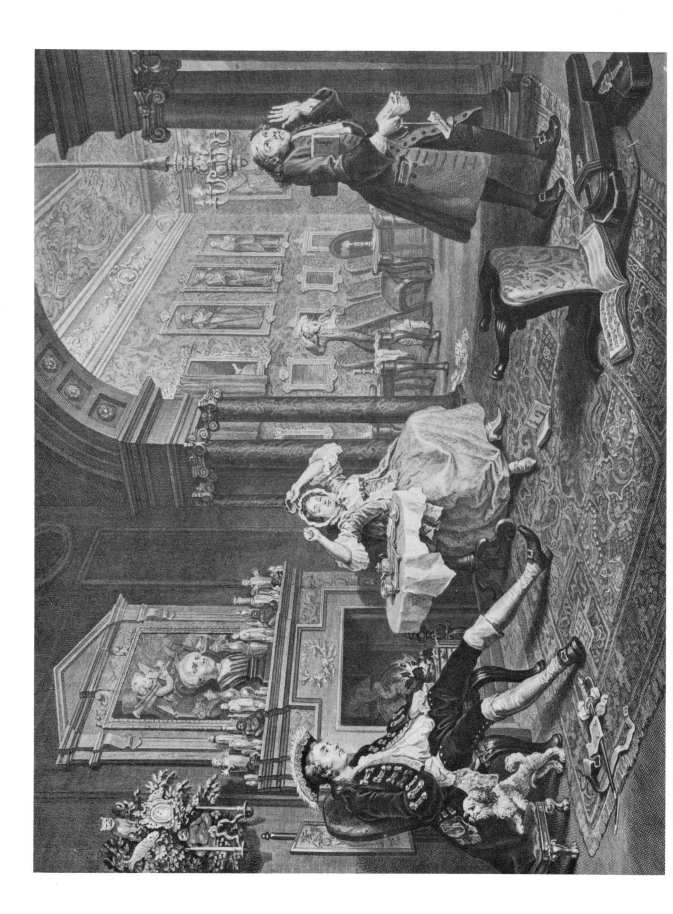

II

The tête à tête

The young couple, now married, are seated in their own rooms early one afternoon; the clock shows 1.20 (12.20 in the painting), but too much light illuminates the room for the time to be in the small hours. The husband still wears his hat and has his sword after a night out. He has been accompanied or followed into the rooms by his steward who departs having failed to interest his employers in their accounts. The wife has spent the evening at a card party which was held in the further room. Her being partly dressed, her table set for one, and her comfortable attitude suggest that she has had time to herself between getting up and her husband's return. The discarded violins and tune book suggest that she has also had time for a music lesson.

THE CHARACTERS

THE HUSBAND (LORD SQUANDERFIELD) AND THE LAP DOG

Although the husband is a recent arrival on the scene, he occurs first in the viewing sequence so that the second picture in the series begins with the character with which the first leaves off. Hogarth has changed his sympathetic viewpoint from the father to the son, so that the latter appears responsible for the situation before him rather than his father. No 'personal applications' have been found for him, but tradition has it that Francis Hayman posed for the Viscount (W. B. Nichols' *Catalogue*, p. 215). The self-portrait in Hayman's picture of himself painting Sir Robert Walpole (*c.* 1740–45) shows him to have been sufficiently long in the leg to pose for the Viscount. If Nichols can be relied on, then Hogarth's choice of a model comfirms that the character was meant to be fictional.

Lichtenberg claimed that the husband is one of Hogarth's finest studies and his admiration inspired a remarkable analysis of character:

> Nothing holds together in him through inner force. His position has been reached through force of gravity, through mechanical reaction, and, passively, through the shape of the chair. Waistcoat and stockings hang upon him just like his hat and his hair. The hair-bag is gone, the watch is gone and the money is gone. In place of money there are now empty hands which search for it and find nothing but a melancholy support for themselves, and for the long heavy arms which have become limp as leather through sleeplessness and excesses. What has suffered least in the tumult is the black seal of the Faculty behind the ear. On what does his gaze rest? Outwards it certainly reaches no farther than half-way towards the overturned chair; inwards it must look uncommonly deep

[15] *Marriage A-la-mode II (The tête à tête)*, engraved B. Baron, after William Hogarth (Whitworth Art Gallery, University of Manchester).

on this morn of domestic peace. Even through the mists of headache which hover round his brow, it is still possible to recognise some traces of deeper heartache.

Hogarth's treatment has its humour: the Viscount proves to be a lanky man; the tablecloth has been cut away to parallel and so accentuate the length of his legs; his face, as Hazlitt has noted, matches the yellow-whitish colour of the marble chimney piece.[1] The poet regards his behaviour as disorderly in 'th' modern way', as a reaction against his father's tyranny:

My lord now freed from the restraint
Which with the Earl he underwent.

As amusing indicators of the change in regime, the well-behaved pointers are replaced by an insubordinate lap dog with its paw, instead of the Earl's foot, on a footstool. The sweatcloth is replaced by a woman's mob cap stuffed in the Viscount's pocket and the stout crutches by a broken sword. The cap is decorated with a blue ribbon in the fashion of unmarried women of the time, such as are worn by Hogarth's susceptible girls, the Harlot, Sarah Young, the young woman of *Before*, and the likely owner of the cap, the street girl of the third picture. The wife, in contrast, wears the ribbonless cap favoured by married women of the period. The cap in a pocket is an emblem of infidelity, evidence of the breakdown of marriage before it has had time to become established.

The husband's downcast attitude encouraged earlier commentators to assume that he is drunk. The poet refers to drunkenness on four occasions and Lichtenberg's headache is intended as the result of a hangover. The orgy of spirit drinking, as Guy Williams has called it in *The age of agony* (1975), was at its height in the 1740s so that it is understandable that contemporaries would automatically assume that they saw a man who drank to compensate for an unwanted marriage to an ill-bred wife.[2] A comparison with Hogarth's earlier rake, unmistakably drunk in *A rake's progress III*, is revealing: both the merchant's son and the Viscount recline gracelessly; both wear tilted, feathery hats and fashionable dishevelled clothes; both have one stocking up and one down, a traditional sign of intoxication. The Rake's sword is a large, practical weapon with a leather holster, whereas the Viscount's is a beribboned dress sword. The Rake has recently used and sheathed his, whereas the Viscount's has been broken in its scabbard, proof that it has not been drawn. The tipsy Rake holds out his gin glass, Hogarth's emblem of drunkenness. His curious, sprawling pose was a well known metaphor of sexual intercourse in the sixteenth and seventeenth centuries and could have been known to Hogarth through its use in Bosse's *Sens: toucher* where a woman sits on the man's lap.[3] The Rake's pose is characteristic of drunkenness with only an undercurrent of sexuality, whereas the Viscount's is indictive of sexual exhaustion with only undercurrents of drunkenness and brawling. Wilkes interpreted downcast looks, a gloomy eye and a pulled-down eyebrow as signs of disappointment and sorrow, appropriate emotions for a character who is mild-mannered at least initially.

[16a] The Viscount (detail) from *Marriage A-la-mode II. Note:* the patch on his neck (p. 39).

[b] The rake (detail) from *A rake's progress III (At the 'Rose-Tavern'). Note:* the differences between the two misused swords (p. 59); the Rake's abandoned pose (p. 58).

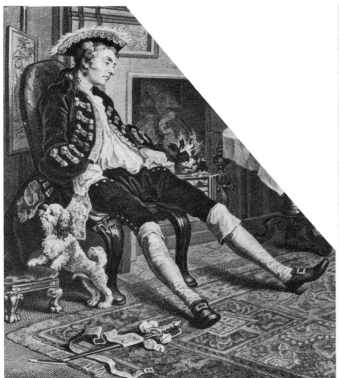 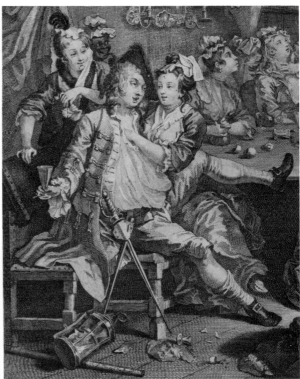

A sword which has been broken without being drawn is evidence of inadequacy or impotence in its owner. This interpretation is consistent with the constitutional weakness to be inferred from the scrofula, the Viscount's disregard for his handsome wife, in whose presence he wears his hat, and his preference for a feebler woman in the third picture. The Rake, whose sturdy sword implies a greater, if misplaced prowess, has acquired a proper man about town's trophy in the watchman's lantern, whereas his delicate counterpart has acquired no more than a girl's cap. Hogarth was careful to deny the supposed descendant of the Duke of Normandy any signs of martial prowess in anticipation of his inept performance in the duel; he does not bother to dismiss an impudent lap dog.

Hogarth's phrase for a hairy terrier was a 'rough shock dog'.[4] He thought such animals were 'extremely odd and comical', confirmation of his part-sympathetic, part-affectionate attitude towards his Viscount. The terrier's semi-aroused masculinity supports the view that the husband's exhaustion is due principally to post-coital depression. Its prurient curiosity is a projection of the wife's more discreet interest in her husband's doings. His tell-tale sniffing defines the predominant sense of the picture as one of smell (Bosse's *L'odorat* is characterised by hunting dogs who sniff the air). The association extends generally to the frowstiness of the rooms with their stale odours of the night. The blind bust with a mended nose on the chimney-piece confirms the pre-eminence of smell: noses were emblems of male sexuality. Swift wrote with mock authority that it is 'held by naturalists, that if there be a

protuberancy of parts in the superior region of the body, as in the ears and nose, there must be a parity also in the inferior'.[5]

THE WIFE (LADY SQUANDERFIELD), THE BOOK AT HER FEET, AND THE MUSICAL INSTRUMENTS

The awkward bride is here relaxed and comfortable as a wife at home in her drawing room. She stretches, 'warm with the adventures of the night', according to the poet. She glances sideways at her husband from under lowered eyelids, a glance which makes her immodest stretch a challenge to a husband exhausted by his interest in someone other than her. There is enticement, amusement, curiosity and some contempt in her expression, the prettiest in the series.

[17] *The lady's last stake* 1758–59 (Allbright–Knox Art Gallery, Buffalo). A gallant persuading a lady to use herself as a 'stake' in a game of cards represents a variation on the undisclosed situation in *Marriage A-la-mode*. The lady's dignity contrasts with the wife's relaxed posture in both the second and fourth pictures. *Note:* the venetian window as used in the third picture (p. 89); the scattered cards as in the third and fourth pictures; the lapdog under the table whose behaviour contrasts with that in the second picture.

She wears a pale pink, mottled underskirt, laced stays similar to those on the floor of the bedroom in the fifth picture, and a pale gold dressing jacket of a kind usually reserved for the bedroom. Subscribers would have thought her shameless for appearing before the servants with her lacings uncovered, her knees apart, and without her hoops. Hogarth was to argue that, for modesty's sake, a fashionable woman's 'body and limbs should all be covered, and little more than certain hints to be given of them through the clothing'.[6] *The lady's last stake* shows the dignity that a woman was expected to maintain even when under considerable emotional pressure.

The backward arching of the wife's body has encouraged commentators, aware of subsequent events and the expectations of marriage, to take up Ireland's tentatively presented suggestion that she is pregnant.

The tightly laced clothes work against the possibility and Hogarth was otherwise definite in signifying pregnancy as in the figures of Sarah Young and the ballad singer in *A rake's progress I* and *III*. The evidence of motherhood in *Marriage A-la-mode* is withheld until the fourth picture and a first thought for a painting in the inner room which implied motherhood was painted out.

The upraised pocket mirror enables the wife to inspect her face after the undisclosed events of the night before. The poet claims that it warns her that 'her person can't inflame' her husband. The mirror, however, is angled towards him as if to point out the reality of a *tête à tête* which shows him, via the mirror, no more than a glimpse of the back of his wife's head. Hogarth intimates, as if behind the backs of the characters, that the wife wears a cap to which the husband should attend. For the second time in the series the Viscount cannot see what a mirror has to show. The next one is to show the back of the head of his wife's lover and the last is to frame his own dying face.

The wife's enthusiasms are for the fashionable pursuits of gaming, music and collecting. 'Hoyle on whist' lies at her foot and a pack of cards is scattered by the pedestal behind her. Hoyle's manual, issued in 1742, changed a game for 'rustics' into a fashionable craze overnight. An anonymous, mock-heroic paean to Hoyle is preserved in *The book of days* which is worth quoting for its wit and unintended insight into Hogarth's series:

> Whilst Ombre and Quadrille at court were used,
> And Basset's power the city dames amused,
> Imperial Whist was yet light esteemed
> And pastime fit for none but rustics deemed.
> How slow, at first, is still the growth of fame!
> And what obstructions wait each rising name!
> Our stupid fathers thus neglected long,
> The glorious boast of Milton's epic song;
> But Milton's muse, at last, a critic found,
> Who spread his praise o'er all the world around;
> And Hoyle, at length, for Whist performed the same,
> And proved its right to universal fame.

Hoyle's manual may have had another purpose for Hogarth. In its primitive form whist was just a game of chance which Hoyle made appealing by adding an element of calculation. In response to its exhortatory title Dr Johnson was to define *whist* as a game requiring 'close attention and silence'. The discreet pointing of the wife's toe in the general direction of, but not quite at Hoyle, could be Hogarth's way of indicating that the wife is a woman who is prepared to take a chance, but who is sufficiently calculating to keep quiet about it.

Three square card tables, similar to that in *The lady's last stake*, are in the gaming room and the wall is hung with mirrors at head level to intensify the candlelight and to beam back the reflections of the players only to themselves. The candles in front of the clock in the nearer room have not been lit, evidence that the players were indifferent to the passage of time. The absence of bottles and glasses points to their single-mindedness and suggests that the wife is tired but clear headed. A pot of

tea is on the table, a fashionable and expensive drink in the 1740s. What looks like a napkin in the painting or a *billet doux* in the print lies on a plate beside her solitary cup. (The table cloth was added to the painting as an afterthought.) The simple refreshment cannot be called breakfast as some commentators have thought, but it serves to draw attention to her loneliness and to imply that she has little need of sustenance in her pursuits.

Boredom was a malaise in the eighteenth century for women in Lady Squanderfield's position with plenty of servants and little to do. Colley Cibber in *The provok'd husband* (1728), a sentimental comedy to which Hogarth alludes in the fourth picture, describes the dull routine of the responsible woman's vision of the ideal life:

> Why in summer, I could pass my leisure hours in riding, reading, walking by a canal, or sitting at the end of it under a great tree, soberly! in dressing, dining, chatting with an agreeable friend, perhaps hearing a little music, taking a dish of tea, or a game of cards, soberly! managing my family, looking into its accounts, playing with my children (if I had any,) or in a thousand other innocent amusements – soberly! And possibly, by these means, I might induce my husband to be as sober as myself. (III.i)

It is to be wondered how much sympathy there was, particularly among the women in a contemporary audience, for the rakish Lady Townley's ironic response to this smug account when she exclaimed, 'Under a great tree! O my soul!' As well as being a pastime for bored women of fashion, card playing was a popular symbol of insecurity to which characters like Pope's Belinda or Hogarth's Rake are drawn at the risk of their virginity or their sanity. *The lady's last stake* shows a fashionable woman who, having lost at cards to a gallant, wonders whether to use herself as a stake. In *Marriage A-la-mode* the wife's desires are channelled into dangerous pursuits due, it may be inferred, to her husband's neglect and indifference. Her stretch implies that she possesses a physical resilience greater than that of either her husband or the equally exhausted servant in the background, an ascendancy over men which only her husband's death is to end.[7]

[18] The tunebook (detail) from *The tête à tête*.

The wife's second enthusiasm is for the violin; music masters were well placed to provide fashionable women with opportunities for intrigue. In Hogarth's picture, it looks as if no serious attempt has been made even to open the instrument cases. The tune book has been dropped and the chair overturned as if pointing to a music master's hasty departure, presumably in response to an announcement of the husband's return. The cases are in line with his gaze and his melancholy may be explained in part by his own adventures which give him grounds for suspecting that his wife is intriguing in his absence. The fact that the music has not been tidied away can be put down to the wife's characteristic carelessness (initially suggested by her playing with the wedding ring) or a deliberate pretence if the allusion to whist was intended as a pointer to her attitude. Her stretch and slight smile are to arouse a latent suspiciousness in her husband which is to culminate in his following the lovers to the bagnio.

Circumstantial evidence supports the suggestion of a flirtation: Hogarth was to declare music to be the 'fashionable vice'. The husband sits on the twin of the overturned cabriole chair. The connection between the two sides of the picture is strengthened because the chairs are the only out-of-date details in an up-to-date room (they date from about 1728). The overturned chair anticipates the presence of the overturned stool upset during the duel which ends a love affair at the crisis of the narrative. *The pilgrim*, a popular song of the time, a phrase of which is quoted in the painting of the second picture (page 75), laments Corinna's betrayal of Strephon rather than the other way round. As no music master is present in the series, Counsellor Silvertongue, who has first claim to be the wife's mentor, is the most likely visitor in lieu of an actual music master. A silvery tongue can be musical as well as persuasive and he is to attend and make use of the wife's concert in the fourth picture for his own ends. In the first picture, the evidence of Silvertongue's overture to the bride is not quite visible to the bridegroom in the mirror. The instruments are now set before his eyes in a visual innuendo. His melancholy may be due to a combination of tiredness, sexual exhaustion and dissatisfaction with his robust and perhaps calculating wife, a hangover, the possible onset of venereal disease (the third picture) or, perhaps, resentment at the slight to his status as implied by the instruments before him. Hogarth's skill lay in preparing for the eventual destruction of the marriage through possibilities rather than probabilities and in making none of them exclude the others.

In the painting several bars of playable music are legible in the book which is similar in shape, binding and format to a dance book of the period. The facts that the music is written on only one side of a leaf and that it lacks a title suggest that it is a violin tutor book. The music is in the style of a popular song or dance of the period 1651–1750, similar to many in Playford's *The English dancing master* (1651) or d'Urfey's *Wit and mirth, or pills to purge melancholy* (1719). The tune, however, has not been identified and the three-bar phrasing is unusual and

impossible to dance to.[9] Hogarth could engrave music competently as is proved by the phrases from Huggins's oratorio, *Judith* in *A chorus of singers* (1732). It seems most likely, therefore, that he composed his own archetypal practice-piece full of deliberate mistakes as a joke to compare with those in the façade or the portrait in the first picture. It too has a familiar look to it, while, at the same time, being inherently unsound. The incongruity of a dance tune in a violin tutor is consistent with the taste of a citizen's daughter who, in learning to follow the fashion, prefers to play popular music on such expensive instruments. The contrast between the violins with their costly cases and their careless treatment, together with the faulty music, add to the form of spoilt beauty introduced in the first picture.

The stave in the engraving has four lines only; Hogarth permitted Baron to engrave a musical rigmarole which looks like, but is not, music. Did Hogarth lack confidence in his tune, did he come to regard its light-hearted associations as inappropriate, or did he wish to ensure that the beauty of the instruments was rendered pointless by their being required for a nonsensical purpose?

ALLUSIONS TO DRYDEN'S 'MARRIAGE A LA MODE' AND 'THE ALDOBRANDINI MARRIAGE'

DRYDEN'S 'MARRIAGE A LA MODE' The second picture shows the couple in a situation which approaches that of a normal marriage for the only time in the series. This is a convenient point, therefore, at which to consider Dryden's play as a source for the series. Dryden's *Marriage à la mode* was first published in 1663 and may have been performed as late as 1703.[10] The comic sub-plot had been included, unaltered, in one of Colley Cibber's dramatic revisions, *The comical lovers; or, marriage à la mode* (performed as late as 1722). Jacob Tonson reprinted Dryden's original version in one of his collections of old plays in 1734 so that Hogarth could have known of this play as well as *The conquest of Mexico*.

Dryden's romantic plot about a banished heir, a usurper and the usurper's daughter has little bearing on Hogarth's series, but the comic plot about the dissatisfied couple, Rhodophil and Doralice, is relevant. Palamede, Rhodophil's friend, begins the play be explaining that he has been ordered home to marry at his father's command. His description of the situation matches the Viscount's predicament in Hogarth's series:

> my old man has already marry'd me; for he has agreed with another old man, as rich and as covetous as himself; the articles are drawn, and I have given my consent, for fear of being disinherited; and yet know not what kind of woman I am to marry. (I.i. 117–22)

The mood remains light-hearted throughout; the threat of disinheritance quickly persuades Palamede to give up his pursuit of Rhodophil's wife and to 'conquer' his Melantha instead, the bride his father has in fact chosen for him. Here, a father's authority is used to resolve the plot happily instead of his being required to preside over a suicide as in Hogarth's series.

Rhodophil and Doralice married for love, but the play opens with

their being bored with one another. Doralice introduces herself by singing of the death of marriage, the decay of passion, and the attractive prospect of taking a lover. Rhodophil declares himself to be wretchedly married and as someone who avoids quarrels by allowing his wife to go her own way. The liveliness of their quarrels, however, is a major source of the play's appeal. One such quarrel may have been in the back of Hogarth's mind as he composed the second picture:

> *Rhodophil* Pox o' your full tune, a man can't think for you.
> *Doralice* Pox o' your damn'd whistling; you can neither be company to me your self, nor leave me to the freedom of my own fancy.
> *Rhodophil* Well, thou art the most provoking wife!
> *Doralice* Well, thou art the dullest husband, thou art never to be provok'd.
> *Rhodophil* I was never thought dull, till I marry'd thee; and now thou hast made an old knife of me, thou hast whetted me so long, till I have no edge left.
> *Doralice* I see you are in the husband's fashion; you reserve all your good humours for your mistresses, and keep your ill for your wives.
> *Rhodophil* Prithee leave me to my own cogitations; I am thinking over all my sins, to find for which of them it was I marry'd thee.
> *Doralice* Whatever your sin was, mine's the punishment.
> *Rhodophil* My comfort is, thou art not immortal; and when that blessed, that divine day comes, of thy departure, I'm resolved I'll make one Holy-day more in the Almanack for thy sake.
> *Doralice* Ay, you had need make a Holy-day for me, for I am sure you have made me a martyr.
> *Rhodophil* Then, setting my victorious foot upon thy head, in the first hour of thy silence, (that is, the first hour thou art dead, for I despair of it before) I will swear by thy ghost, an oath as terrible to me, as *Styx* is to the gods, never more to be in danger of the banes of matrimony.
> *Doralice* And I am resolv'd to marry the very same day thou dy'st, if it be put to show how little I'm concern'd for thee. (III.i. 41–72)

The balanced phrases and lines provide a precedent in words (among many such quarrels in post-Restoration comedy) for Hogarth's disposition of his characters side by side and for the pairings which underly the composition of the second picture.

Marital recriminations have been a source of comedy since Aristophanes, but they had their serious implications in the eighteenth century. A quarrel could easily turn into a breach in a prosperous family because the existence of separate suites of rooms in big houses and the ownership of other houses could make separate living a practical posssibility. As Jarrett has observed in *The age of Hogarth* (1974) angry husbands could take themselves off to town leaving angry wives to live at home and seek solace and affection where they would.[11] In some aristocratic circles it was considered a confession of weakness for a man to show feeling for a wife or child, so that reconciliation could be doubly difficult. The spaciousness of the wife's rooms, the indifference and open contempt of the servants, and the husband's withdrawn mood draw attention to the isolation of Hogarth's wife as a woman married out of her class. Her stretch and her glance suggest that she is prepared for some social contact with her husband – if only a quarrel. Jarrett suggests that the real moral of *Marriage A-la-mode* is not that husbands

and wives should have to suffer one another's company, but that wives should have to put up with loneliness or the company of their own sex. Hogarth's bride is determined to avoid either alternative.

Dryden took care that his characters' flirtations should remain playful, although Rhodophil becomes jealous and surly for a while. Doralice entices Palamede out of amusement, while Rhodophil declares that he could only force Melantha if she wants him to. Palamede, in an aside, sums up the exchange of partners as a 'pretty odd kind of game . . . where each of us plays for double stakes' (III.ii. 156–7). The game is played out of a desire for novelty, a dubious virtue in the eyes of both Dryden and Hogarth. The same desire motivates Hogarth's characters in the second, third and fourth pictures, but with catastrophic consequences.

Dryden avoided a tragic confrontation by making Doralice argue for chastity on the grounds that the 'only way to keep us new to one another is never to enjoy' (V.i. 302–3). Rhodophil, the potential cuckold, is saved from the consequences of a duel with his friend by his wife's foresight and maturity, and his own sociability and good humour, qualities lacking in Hogarth's characters. Dryden was aware that he had drawn back from the tragic implications of his comic plot. The Epilogue declares:

> But yet too far our poet would not run,
> Though 'twas well offer'd, there was nothing done.
> He would not quite the woman's frailty bare,
> But stript 'em to the waist, and left 'em there. (11–14)

The Epilogue presupposes that the audience is 'all for driving on the plot' and is disappointed when he 'came in to break the sport'. Dryden's apology for his happy ending is that the poor cuckold seldom finds a friend. He preferred to leave the harsher consequences of an arranged marriage to others:

> Some stabbing wits, to bloudy satyr bent,
> Would treat both sexes with less complement,
> Would lay the scene at home; of husbands tell,
> For wenches, taking up their wives i' the Mell:
> And a brisk bout which each of them did want,
> Made by mistake of mistris and gallant. (17–22)

Hogarth fits the description of a 'stabbing wit' so closely that his *Marriage A-la-mode* is a deliberately witty and bloody reply to Dryden's defence of restraint and sentimentality.

THE ALDOBRANDINI MARRIAGE When Hogarth issued his proposals for the bidders' auction for the paintings of his earlier series two months before the issue of the prints of *Marriage A-la-mode*, he provided a sketch as an admission ticket. *The battle of the pictures* (1745) shows the auction room of Christopher Cock on one side and Hogarth's studio on the other. In front of these houses, his modern pictures are shown in mock combat with a never-ending army of copies of old masters. *Shortly after the marriage*, the champion of the most recent series and the only one then not for sale, is matched against a copy of the *Aldobrandini marriage*.

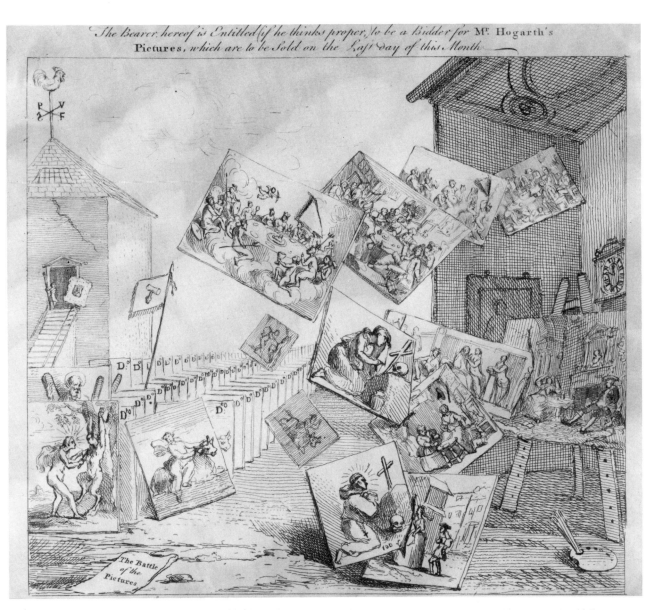

[19a] *The battle of the pictures* 1744/5 (Whitworth Art Gallery, University of Manchester). The bidder's ticket for the auction of the paintings of the early series. *Note: The tête à tête* is on an easel and the only painting then not for sale; it is being assaulted by a copy of *The Aldobrandini marriage* (Illus. 19b); the army consists of a myriad of pictures of St Andrew (p. 77).

[b] *The Aldobrandini marriage* (detail), late 1st century BC (Vatican Museum, Rome). The Roman bride also has to be encouraged to prepare for her wedding.

Because this picture was thought of as the only surviving example of Roman painting, Hogarth was pitting his most modern art against an acclaimed original of all painting. The *Aldobrandini marriage* depicts an ideal ceremony to contrast with his concern for the modern reality of marriage. The Roman bride's timidity and deference contrasts with the surliness of Hogarth's bride. The bride's mother in the Roman picture draws attention to the absence of mothers as potentially moderating influences in Hogarth's series. Significantly, in Bosse's *Le contrat*, husbands and wives sit together round the table. The intermingling of gods and mortals in the old picture provides a precedent for Hogarth's ingenious strategy whereby his fallible characters find their counterparts in the immortals and demi-gods of the interior pictures of the series.

In *The battle of the pictures*, the corner of the picture frame of the *Aldobrandini marriage* 'wounds' *The tête à tête* in a manner consistent with the climax of the series. In turn, *The tête à tête* is overlapped by a picture of a repentent Magdalen matched against *A harlot's progress III*. This cluster of warring pictures creates an elaborate analogy between the prostitute–saint of the New Testament and Hogarth's modern harlot, and, indirectly, between them both and the wife in *Marriage A-la-mode*, particularly as she kneels before her dying husband in the fifth picture. The presence of a Magdalen also supports the identification of the saint in the interior picture of *The tête à tête* as a Magdalen (below).

The battle of the pictures is Hogarth's first significant comment on *Marriage A-la-mode* after *Characters and caricaturas*. In choosing to represent his latest series with the second picture, he confirmed that *marriage* is the primary subject of the series and that he regarded the second picture as the champion, the best of the series.

THE STEWARD AND *REGENERATION* AND THE TIME SCALE OF THE SERIES

THE STEWARD AND 'REGENERATION' The steward marches out on his employers in disgust. Wilkes was to explain that shrugged or contracted shoulders were the signs of a 'mean, servile, designing air'.[12] The steward's shrug was to prompt Jarrett into recalling that servants could be as haughty as their masters and more grasping. The effect of haughtiness is increased by the steward's curved spine and swelling chest. His contempt for fashion is demonstrated in his not wearing a wig in public and his preference for plain, old-fashioned clothes. His long cuffs and square-toed shoes reminded Wilkes of the miserly scrivener, Moneytrap, in Vanburgh's *The confederacy* (1705).

The steward's nine or so bills and one receipt are the necessary evidence of the punishing cost of a fashionable way of life. The receipt is a clever variation in reverse on the oversight represented by the forgotten coin in the Alderman's money bag. The squanderers have allowed one bill to be paid, as it were, by mistake. If the bills, the ledger and the pen behind the ear are the badges of the steward's office and signs of his officiousness, then the book in the pocket of his great coat is the sign of his personal beliefs. *On regeneration* is the short title of the

most famous sermon of the dissenting Anglican minister, George Whitefield (1714–70), and not of Wesley as the poet suggests. The sermon, the full title of which is *The nature and necessity of our new birth in Jesus Christ* (1737), was published as a pamphlet, costing sixpence or two guineas a hundred to those who wished to give copies away. By 1743 Hogarth's reference to *Regeneration* would have been to Whitefield's widely known doctrine of rebirth rather than to the first sermon only.

Whitefield's rise to fame was unprecedented: thousands gathered to hear him preach and he was either loved or hated, but never ignored. According to James Downey in *The eighteenth century pulpit* (1969), he was the greatest extemporaneous orator in the history of the English church.[13] Even Fielding, who had no love for religious enthusiasts, referred to him with only a touch of sarcasm as a 'great man' in *Joseph Andrews*. Hogarth's ridicule of Whitefield's followers in the person of the steward may have derived from the example of Parson Adams's attack on the 'detestable doctrine of faith against good works', a doctrine which the rationalist in Fielding saw as licentious. Whitefield's sermons, letters and arguments return repeatedly to the subject of 'New Birth'. He recalled that the 'first quarrel many had with [him] was because [he] did not say that all people who were baptised were born again'. His account of his sinful youth and sudden conversion, *A short account of God's dealings with the Reverend Mr George Whitefield*, written in the manner of St Augustine's *Confessions* had been published in 1740. It was considered outrageous for a young clergyman to publish an account of his religious experiences and to emphasise the pre-eminence of personal communion with God over the authority of the established church. So aggravating was the *Account* that it was still being attacked from within the church in 1749 as a 'boyish, ludicrous, filfthy, nasty, and shameless relation of himself . . . shocking to decency and modesty'. The *Account* is on Shamela's reading list along with *Venus in the cloyster* and *Orfus and Eurydice*, a sign of its appeal to base emotions rather than reason in Fielding's view.

The *Account* reveals both Whitefield's honesty and his openness to a charge of hypocrisy: he admitted that 'as once I affected to look more rakish, I now strove to appear more grave than I really was'. He confessed his youthful and wicked delight in plays, cards, romances and roguish tricks, but was to revile dancing, dice, horse-racing and cock fighting in his sermons. The theatres were 'nurseries of debauchery' and thus even occasional playgoers did not hesitate to call him a hypocrite, a view which Hogarth, a habitual playgoer, could not avoid sharing. The emotional appeal of Whitefield's oratory caused moderate men to fear him. Bishop Gibson was forced to warn his two cities against '*extraordinary communications*' with God in his fourth pastoral letter (1739) in response to Whitefield's growing following.

Whitefield's oratory reads as a direct attack on Hogarth's rakes and squanderers:

> I will attack the devil in his strongest holds, and bear any testimony against our fashionable and polite entertainments. What pleasure is there in spending several hours at cards? Is it not mis-spending your

precious time which should be spent in working out your salvation with fear and trembling? ('Sermon on the folly and danger of not being righteous enough')

Without either of them being aware of the similarity, Whitefield and Hogarth were both energetic, radical, sensuous and in some ways naive men. Both were spurred to their finest oratory and art by the extreme behaviour which fascinated them and which they feared.

One remarkable feature of Whitefield's career, his association with the aristocracy, has bearing on *Marriage A-la-mode*. During the winter of 1742, the Earl and Countess of Huntingdon regularly attended his Tabernacle in Moorfields. At various times, the following were members of his congregations: the Duchess of Marlborough, Lady Hastings, the Duchess of Buckingham, the Duke of Cumberland and the Prince of Wales. Although the conversion of the Countess of Huntingdon was exceptional, the list is impressive and must have led to public comment. Whitefield (as Hogarth might have done) enjoyed the attention. In 1741 he wrote to a follower, 'I am intimate with the noblemen, and several ladies of quality . . . I am now writing in an earl's house, surrounded with fine furniture; but glory be to free grace! my soul is in love only with Jesus!' His detractors would not have needed the evidence of letters like this to be convinced of Whitefield's hypocrisy, made so much more dangerous in their view by his power to sway all classes with an anarchical doctrine which asserted the integrity of individual conscience.

The bad squint which gave rise to Whitefield's nickname, Dr Squintum, as in the Wollaston picture of him preaching (1742), is not apparent in the steward's face, although it is in the clerk's in *Credulity, superstition, and fanaticism* (1762). The steward is a disciple and not a caricature of the master. His ostensible motive for being in the household would be to 'attack the devil in his strongest holds', but his disappointment appears to stem from his failure to reform the accounts rather than to save souls. Against the background of a real countess's sincere patronage of Whitefield, it is appropriate that the pretentious wife of a fictitious Viscount should employ only an obscure follower.

The inclusion of the chandelier in the further room has bearing on Hogarth's attitude towards his character. Francis Watson drew attention to it by admitting that he had never seen such a light hanging in such a position.[14] A similar chandelier hangs in the chapel in *Enthusiasm delineated* (c. 1761), which Paulson reports is similar to that in Whitefield's tabernacle, and others like it are found in Anglican churches. The incongruous presence of a piece of church furniture and its close association with the steward's head suggests that the chandelier was intended as a comic metaphor of the steward's guiding light, towards which his eyes are, coincidentally, raised. The guttering candles make the vision a cloudy one and the chandelier is surmounted with a worldly viscount's coronet. As if to reinforce the joke, the sword in the interior picture immediately behind the steward is placed to stab him in the neck, a clever example of the way Hogarth used 'adjoining circumstances' to demonstrate hypocrisy (Introduction). In spite of his

compromised position the steward's departure does mean that a regenerative force quits the series with as unmistakable a look of disapproval as that of Medusa in the first picture. Whitefield's reiteration of the old belief that man is 'but half a devil and half a beast' is a measure of the degeneration of the steward's employers. If a gorgon and a follower of a man with so pessimistic a view of mankind cannot tolerate them, then the inference is that they belong to a lower order of being than either half a beast or a devil.

The steward is another example of a fascinating, non-recurrent character whose careful treatment and associations raise him to the status of an affected character, a hypocrite to contrast with the vain Earl. Hogarth's attitude is characteristically ambivalent: sympathetic in the depiction of a lugubrious man, critical in his reference to Whitefield and through his use of the chandelier and the sword. The ambivalence may have derived from Hogarth's attitude to Whitefield: a disapproval of his enthusiasm mixed with a modicum of envy for a younger man's following, especially among the nobility, which he himself was never quite to command. The departure of an agent responsible for balancing 'the profit and the loss' draws attention to the squanderers' living on borrowed time. The mock-portentousness of the steward's departure is conveyed through his dark clothes and bald cranium. A more serious skull confronts him and his employers in the next picture: the momentum of the steward's departure draws them towards the *memento mori* of the quack doctor's laboratory in the third picture.

THE TIME SCALE OF THE SERIES The steward's receipt reads 'Recd 1743' in the painting and 'Recd June 4, 1744' in the print, presumably the dates by which the versions of the second picture were finished. The date, however, also places the series on a realistic time scale. Hogarth paid careful attention to the supposed chronology of his earlier series: M. Hackabout dies in 1732 at the age of 23, according to her coffin plate. The date, 2 September, coincides more or less with the issue of the prints so that *A harlot's progress* functions as a kind of visual obituary. According to his father's diary, the Rake came down from Oxford in May 1721 so that he apparently lived in a period about ten years before the publication date of the series, June 1735. The distancing of *A rake's progress* may have been a defensive gesture because the series contained several allusions to the royal family and other well-known people and Hogarth may have preferred to demonstrate that his history could not refer to a living person. The 'day' in *Four times of the natural day* is 29 May, Restoration Day, a day of celebration and misrule. No reference is made to a particular year, an appropriate omission in a series wherein time is manipulated and subverted.

The date on the steward's receipt implies that the marriage would have taken place in the inauspicious month of May. The wife has yet to become the mother of the child, who is at the teething stage in the fourth picture and is shown to be a toddler in the last. The wife dies, therefore, at an unspecified moment in time supposedly well in advance of the eventual publication date of *Marriage A-la-mode* (June, 1745). Credulous people could have believed in the historical truth of the first

two progresses as they were reported to have believed in *Robinson Crusoe* or *Gulliver's travels*, but an attentive and sceptical viewer could have been in no doubt that *Marriage A-la-mode* was make-believe. By implying that the later events of the series take place in the future, Hogarth not only made *Marriage A-la-mode* appear more immediate than his earlier series, but also created an early example of futuristic fiction.

ELEMENTS OF THE SETTING

THE ARCHITECTURE AND THE DÉCOR

The poet assumes that the suite of rooms are in a 'mansion-house' and later commentators are agreed that it is modelled on the interior of one of two houses in Arlington Street in the fashionable West End which belonged at different times to Robert Walpole. Hugh Phillips in *Mid-Georgian London* (1964) argues that Lord Granville's house a few doors further south than either of the Walpole houses was the only one to have a sufficiently long wing, entirely lit from the south side.[15] Hogarth's interior is too badly constructed to be real, however, so it is perhaps unwise to try to be specific and the existence of counterclaims supports the view that he was avoiding identification with an actual interior.

The architecture dates from the 1730s or 1740s and, although the rooms are not Palladian in style, the dominant archway could have found a place in a contemporary Palladian interior. In the absence of an alternative, it is reasonable to suppose that the suite is meant to be in the Earl's new building; the arch, supported by four pairs of Ionic columns, is sufficiently misaligned and clumsy to fit in with the inconsistencies of his façade. The diagonal alignment of a curve is difficult to achieve in two dimensions so that the misalignment may not have been wholly intentional. Hogarth was to add a medallion at the top of the arch in the print in what may have been an unsuccessful attempt to bring the two sets of pillars into line. Another aspect of the problem concerns the rolled back corner of the oriental carpet. It has been cut as if to make room for the pedestal which supports the pillars. Ostensibly, the detail proves another beautiful object to be spoilt, presumably by the servants in a lax household who could not be bothered to pull a heavy carpet away from the pillars. Yet the cut corner is such a gratuitous detail that it may have resulted from Hogarth's determination to ensure that the heavy pillars were drawn well into the picture. The line of the pillars serves to make the chandelier, apparently just over the steward's head, hang unmistakably in the further room. The suspicion remains, however, that Hogarth was making the best of a difficult job.

Ireland first suggested that the décor of the second picture and some of the furnishings of the first were modelled on the designs of William Kent (1685–1748), especially the fireplace and its surrounds.[16] This suggestion has been taken as fact, probably because Hogarth detested Kent whom he called a 'wretched dauber'. Sir John Summerson,

however, sees the fireplace as more in keeping with the designs of James Gibbs. The rooms are in fact part of a rich man's suite which owes little to a particular designer. The humour derives from the tasteless mixing of styles: rococo (especially the Chinese ornaments and the ceiling of the further room); English (a pole screen like that behind the husband is illustrated in Chippendale's *Directory*); classical (the façades of the chimney-piece and the picture frame above it); French (the ornate clock); ecclesiastical (the chandelier); oriental (the carpet). Hogarth did not permit his dislike of Kent to predominate.

THE FIREPLACE AND ITS ORNAMENTS The fireplace and the picture frame fixed to the chimney-breast are a comic reduction of the double portico of the façade in the first picture. It is as if Hogarth used a camera eye first to delineate the portico and then to penetrate and enlarge upon it as the basis for the composition of the setting for the next picture. The reduction from a portico to a chimney-piece reflects the children's preference for the trivial over the Earl's for grandeur.

The ornaments aroused Lichtenberg's indignation:

> The whole mantelpiece here is covered with the most abominable works of art from north-east Asia: Chinese gods, apparently in an advanced state of pregnancy, sit there naked so that the folds of their garments should not come out of crease. Others have their hands outstretched from the shoulders wanting to make the sign of the horns but unable to. Vases stiff as railings and little bottles dumpy as corks alternate with curious objects of nature and with artefacts such as chance will sometimes produce. Most ludicrous of all is an antique bust. It is a pity that its head is new and the nose still newer than the head. It must have been bought for a Faustina. On the whole there reigns among this junk an admirable symmetry and the most meticulous order. Every little bottle has its counter-bottle and every freak its freak to match.

Hogarth was to refer to 'pagods', the contemporary term for Chinese gods, as 'absolutely void' of 'elegant forms', and he despised the mean taste of Chinese art.[17]

The stone bust, a modern imitation of a classical head as its bagwig proves, has its source in the similarly broken-nosed heads of *The marriage contract* oil-sketch. Restorers in the eighteenth century used to fix new noses to classical heads to sell what Hogarth called 'cooked up cop[ies]' to uncritical collectors. Lichtenberg's reference to Faustina is his own joke because the head is male and different from that of either Germanicus or Julia in the oil-sketch. Wilkes, in referring to its incongruous wig, assumed that the bust was of Scipio, the reputed founder of the Roman army. He was a suitably grand general to contrast with the exhausted Viscount, who is to be a disastrously inept duellist.[18]

The mended nose, as an organ with sexual connotations, acts as a reminder of Fielding's reference in *Joseph Andrews* to 'that part of the face where, in some men of pleasure, the natural and artificial noses are conjoined'.[19] A comic interplay of expressions connects the down-turned mouth of the husband and the snub nose of the steward who thus both share features in common with the bust. The emphasis on

noses (mended or otherwise) and the idea of sniffing out information indicates that the predominant physical sense in the picture is one of smell. It is an appropriate sense to anticipate the emphasis on touch in the third picture, a sense even more directly associated with sexuality and disease. Both the bust and the steward's head anticipate the pitted and, of course, noseless skull on the doctor's table in the third picture.

In this picture, the bust replaces the portrait of the Earl as Jupiter and shares, with the dismayed steward, the choric function of a fearful Medusa. Because the fate of those who gazed on the gorgon was to be turned to stone, the consequence of the Jupiter's glance at Medusa is comically realised in Jupiter's plaster counterpart. If the bust is of Scipio, then, as Jupiter's representative, he offers an ironic comment on the Viscount's present indifference or impotence. The string of analogies suggests that the children continue to live under the deadening influence of a callous and diseased paternity. Their admiration of a flawed, blind-looking ideal in the form of the classical bust is a comment on their own metaphorical blindness. The husband shows no awareness of his wife's gesture or her mirror, and neither of them heeds the steward's warning.

The overbearing archway, the top-heavy fireplace and the bust make stone the predominant element. Its incompatible element, fire, burns brightly in the hearth but, as an image, it is dwarfed by the chill of its marble surrounds. The cupid in the picture on the chimney-breast apparently serenades the bust from among the ruins of a classical façade, an ironic glimpse of the fate which may be foreseen for the Earl's new building. The association of cold, unlit tapers with a loveless relationship is reinforced in that on this, their second appearance, the tapers illuminate the face of a clock instead of Medusa and they are as far apart from one another as the length of the sconces permits. The intertwining of the sconces in the first picture is transposed to the candle-holders of the chandelier surmounted with a Viscount's coronet as if to suggest that the maintenance of unity in marriage is now the husband's remote responsibility. A candle in a heavy stick also reappears, but it is relegated to the gaming room to illuminate the wife's expensive pastime. In spite of the increase in the number of references to fire, flames burn smokily and ineffectually in a chilly room. The secondary emphasis on air in another spacious interior in which music and its associations play their part suggests a combination of cold and dry elements (earth and air), an appropriately melancholy atmosphere.

The importance of earth or stone is maintained in the collection of exotic ornaments on the chimney-piece. More ornaments are present in the fourth picture as the wife's purchases at an auction. They confirm that a third enthusiasm, in addition to gaming and music, is collecting. Gay's *Epistle to a lady on her passion for old china* (1725) refers to 'this *China*-buying rage' and warns that prudence counts for little in a woman 'who sets her heart on things so brittle'.[20] The freaks, as Lichtenberg called them, are primitive, child-like creatures and more of them, in the fourth picture, are set at the wife's feet. Their role as bizarre child-substitutes (to compare with card-playing as a substitute for

sexual satisfaction) points to the fact that the proper function of marriage is not being performed at this stage in the narrative. Bearing in mind that *Marriage à la mode* may derive from Bosse's *Le mariage à la ville*, it is significant that Bosse followed *La rentrée des mariés* with *L'accouchement*. Hogarth, the ironist, delayed making reference to the child of the marriage until the fourth picture and shows it only after the mother's death.

A picture of Cupid, an infant personification of desire, is positioned behind the bust. Hogarth's pet aversion, a background detail in the portrait of the Earl as Jupiter, is inflated in the second picture, whereas, conversely, the Jupiter is reduced to the emasculated bust. Cunningly Hogarth maintains the spatial relationship between them as in the first picture. As an outrageous anachronism, to match the modern nose of the bust or Jupiter's exploding cannon, Cupid plays on the bagpipes, instruments notoriously lacking in harmony. In so far as Cupid is a spirit of mischief, then his presence may offer an insight into the meaning of the wife's smile; she teases her exhausted husband with her sensuality in the same way in which Cupid teases the impotent bust with his droning which in the paradox of art has to be silent. Cupid's unstrung bow (no arrows are apparent) comments on the irrelevance of love to this marriage and he plays his 'melting air' (below) from amid the ruins of a classical building, the broken capitals of which are Ionic, like those of the archway.

A quotation in the painting shows that Cupid is meant to play a pastoral love song. 'O happy groves' is the opening phrase of a popular lament, *The pilgrim* (parodied by Gay in *The beggar's opera* as 'O cruel, cruel, cruel case!').[21] The first verse of the original runs:

> Oh, happy, happy Groves, Witness of our tender loves;
> Oh, happy, happy Shade, where first our Vows were made.
> Blushing, Sighing, Melting, Dying, Looks Would charm a Jove;
> A Thousand pretty things she said and all was Love;
> But Corinna perjur'd proves, and forsakes the shady groves.

The complaint goes on to develop the treachery of the nymph in contrast to the shepherd's innocence, an ironic comment on the marital relationships beneath. The reference to Jove can only be serendipitous, but it coincides with Hogarth's treatment of him as a being 'charmed' by Medusa in the first picture and the song anticipates the analogies between Jupiter and Silvertongue as a lover and the wife as one of his nymphs in the fourth picture. Hogarth's allusion to such a plaintive and predictable lament is further confirmation of the banality of the couple's taste. A parallel between the Strephon of the song and the husband may be strengthened by the design of the pole screen immediately behind the latter, a picture of a 'Corinna' with a parasol in a pastoral setting.

There is no clear reason why the allusion was omitted from the print. Perhaps the emphasis in the song on Corinna's treachery implied an unwelcome imbalance of responsibilities at an early stage of the narrative. It is not impossible, however, that, under the pressure of work in the later stages of engraving, Hogarth either forgot to check that Baron had inscribed it or left it out to save time.

THE DECORATIVE CLOCK The English clock face is surrounded by ornate, brass or gilt foliage. Although the clock is typical of the excesses which the Anti-Gallican Society was founded to oppose, it is within the bounds of possibility, being only slightly more elaborate than Chippendale's sample clock in his *Directory*.[22] As with houses, Hogarth preferred the beauty of functional clocks and was particularly contemptuous of a clockwork duck, a 'complicated, confused and disagreeable object'.

The incongruity of fish stranded high out of their element with a cat between them recalls the earlier incongruity of Pharoah drowning in a ceiling painting. Like the Pharoah, the relationship between the creatures comments on the situation below. The alignment of the fishes matches the inclination of the husband's body, an analogy which suggests that he is to be regarded as a cold fish. The cat and the contented wife sit upright; the cat is the mistress of the fishes, a fair comment on the marital relationship. As a composite image, the clock and its ornaments resemble a chimera with the body and head of a cat, leafy plumage, and fishy limbs, a grotesque comment on an unnatural marital relationship. A chimera is not a fanciful analogy because precedents are found in *Hudibras in tribulation* (1725/6), where the juxtaposition of sword, boots and pistols on the whipping post also resembles a ribald creature, and in both versions of *Hudibras and the Skimmington* with its scarecrow-like banners.

The largest pagod is set, smiling, in the shadow of the foliage. Hogarth was to claim that a 'little narrow chinese eye' suits a 'loving or laughing expression best'.[23] The smile associates the pagod particularly with the grinning cat and (by extension) the wife, who all contrast with the lugubrious husband and fishes. The pagod is representative of a double virility with the sconces sprouting from his loins. As such, he calls to mind the figure of the plump and absent lover of the series to complete a string of possible references to the three characters at the centre of the intrigue in *Marriage A-la-mode*.

THE INTERIOR PICTURES IN THE FURTHER ROOM

Five pictures hang on the walls of the gaming room. The nearest is almost completely curtained, presumably to hide a salacious picture. Only a supine foot shows, a glimpse which destroys any erotic potential the picture may have. In Shakespeare's time, the foot was associated with sexual intercourse as a punning derivation from the French verb, *foutre*.[24] If current in the eighteenth century, the association offers a comment on the adultery which is implied, but not yet fully revealed as having taken place at this early stage in the narrative. Hogarth may have taken the idea from *The marriage contract* oil-sketch where a picture of a foot is used as a gibe at contemporary adulation of relics of gigantic Roman statuary.

The other pictures are full-length studies of various saints. A halberd identifies the nearest as St Matthew, with his gospel or ledger. As a tax-gatherer, he gazes in the general direction of the steward as if in sympathy with the dissenter who has failed to bring home the 'good news' of their debts to a family of squanderers.

Hogarth's developed understanding of emblems prompted him to write of the next saint that 'the extended manner of St Andrew's crucifixion is wholly understood by the X-like cross'.[25] An infinite number of pictures of his martyrdom are lined up to fight Hogarth's pictures in *The battle of the pictures*. De Lairesse cited a painter who equated figures with letters in the manner of an alphabet (and who may have encouraged similar ideas in Hogarth), for example, an 'L' is a figure sitting on the ground and a 'T' a Christ crucified. St Andrew, like the martyrs of the first picture, was tortured by a Roman, the governor of Patmos. St Andrew's association with angularity connects him particularly with the awkward Viscount and Hogarth's modern counterpart of a martyr.

The third saint is usually taken to be St John the Evangelist whose emblem is sometimes a cup instead of an eagle. The smoother, pretty face, the long hair, and the bluish gown with a buff undergarment arranged differently from the brown clothes of the other saints, indicate that the figure is female. Mary Magdalen, wearing the purple of penitence and holding her pot of spikenard, is the most likely identification, especially in view of her relevance to the series as a whole. Her head is turned towards the St Andrew as if in imitation of the wife's glance.

The fourth saint (on the back wall) is partly obscured by the chandelier, but a hand holding a sword (withheld from the painting) identifies St Paul. His sword is to reappear in the coat of arms of the City of London set in the Alderman's window of the last picture. As a persecutor of heretics and the patron saint of London's leading Anglican church, St Paul's apparent stabbing of the steward's neck is an appropriate 'dig' at a follower of the reputedly most treacherous dissenting minister of the Church of England. The enactment of stabbing is transposed from Silvertongue's pen in the first picture to St Paul's sword in the second. Silvertongue's execution at Tyburn is the modern equivalent of the disciple's execution by beheading in Nero's Rome. Hogarth was fond of such sly *coups*: the sword of the tiptoeing lover in *A harlot's progress II* is positioned to stab her Jewish protector in the back; the persistent Sarah Young appears chained by her bottom to a madman's stone at the end of *A rake's progress*; the term of the fireplace grins behind the wife's back in this second picture of *Marriage A-la-mode*.

The pictures in the gaming room offer a second sequence of emblems which comments periphrastically on the chain of events in the series: an interest in a veiled sexuality→demand for the repayment of debts (St Matthew)→a personification of repentance and healing (Mary Magdalen)→a treacherous stab from behind (St Paul). A reading indicates that the Earl's underlying interest in sexuality is continued in the children and is to be a cause of catastrophe and remorse. The husband makes no attempt to hide the scented cap in his pocket or his lack of feeling for his wife so the mixture of shame and piety in the pictures is characteristic more of her taste in art than of his.

The X-ray of the second painting reveals Hogarth's first major

change of mind in the series. The curtained salacious picture was painted over a Madonna with child. Part of the picture extends behind the pillars to provide a glimpse of one of the shepherds. Hogarth's sense of incongruity prompted him to show only the shepherd's plump buttocks, a detail which was to be transposed to one of the pictures on the wall of the Alderman's room at the end of the series.

A number of reasons could have prompted a change of mind: first, Hogarth could have come to recognise the want of 'Decency or Elegancy' in including a Madonna and in treating her so irreverently. A strong parallel between a Madonna and the wife would have detracted from the analogy between her and a Magdalen, which is a recurrent one in the series. The inclusion of a Madonna would also have robbed the periphrastic sequence of saints of its meaning. A reference to an exemplar of motherhood would have introduced the subject too directly and too early.

The nature of the first thought and its replacement shows how strong was the influence of *The marriage contract* oil-sketch of 1733 on *Marriage A-la-mode*. The sketch, with its themes of bad taste, an arranged marriage and an infidelity, not only includes versions of the bust and the archway, but also pictures of a 'Madonna and child' and of a single, stone foot. It is typical of Hogarth's economy of imagination that, having changed his mind, he would find his alternative in a picture hanging immediately below the Madonna in the oil-sketch. All he had to do was to turn the foot through ninety degrees, transpose it, and draw the curtain.

THE VISUAL ORGANISATION OF THE PICTURE

The main differences between the interiors of the first and second pictures are a reduction in the number of figures and a corresponding extension in depth caused by the shallow angling of the side wall. The archway breaks up its monotony and makes the picture a study of contrasting rooms: marital disunity is associated with the nearer and the aftermath of an arid craze with the further. By implication, the nearer represents a cause of the further. The impression of emptiness at the centre comes about because the significant elements are set against the walls or along the margins of the picture. The effect is a visual expression of squandering in its universal meanings of *scattering, dissipating*, or *disposing*. The spoiling and despoiling of objects is maintained in the patch on the husband's neck and extended to the bust with a mended nose, the broken dress sword, the tear in the carpet, and the accidental payment of a solitary receipt. The indecorous mixture of styles is a continuation of the bad taste of the first picture only in more trivial forms: incompatible animals, pagods, freaks, a classical bust and chimney-piece, devout and erotic pictures, a rococo clock, and a pastoral screen. The floor is littered with discarded things which demonstrate the consequences of squandering in literal terms.

The tendency towards disintegration is controlled through underlying strategies. Most of the figures, real or decorative, face in the same direction. The interplay of downturned mouths and snub noses adds to the web of connections which dance across the picture. The wife is set at

a point of balance between the drawing room and the gaming room. The greater height and size of the departing steward seems to pull the seated couple towards their separate futures as represented by the third and fourth pictures, while the legs of the overturned chair point at them from the other side of the picture as if to confirm that the tune book and instruments are matters between them. A similar effect is found in *A rake's progress VII* where the legs of Sarah Young's overturned stool also point accusingly at the Rake and connect groups of figures across the width of the picture.

A cold light falls into the rooms from the left of the painting. Because there are fewer clashing colours and scattered highlights than in the first picture (most of which are grouped around the Viscount), the light has a cohering effect. A number of heavy shadows were added to the floor in the print, as was the shadow-sill in the first picture, in order to draw attention to the light which slants into the nearer and further rooms from undisclosed windows to the right. It has the effect of illuminating the heads and faces of the characters one by one. The heads of the terrier, the wife and the Magdalen in the interior picture are then turned to oppose the momentum of the viewing sequence as if to draw attention to their interrelationship, the terrier as the wife's emissary and the Magdalen as her counterpart.

The opposition of ideas extends to a pairing of details, an antithetical principle essential to the organisation of the picture: among others, nearer contrasts with further; one set of pillars with another; a downcast husband with an ascendant wife; rakish couple with puritan steward; broken sword with discarded instruments. The pairings translate into a see-saw rhythm: the dog steps up; the husband slumps, while the wife stretches and arches her body; the steward's one hand is upraised (as are the wife's arms), while the other is weighed down with bills (as the husband's are with his woes); the couple remain and the steward departs; the blind eyes of the bust upturn, while the Cupid directs his music downwards; the height of the walls and columns emphasises the vertical, while the length of the side walls and the flat plane of the carpet emphasise the horizontal. The effect of a grid, as in the first picture, is avoided because of the greater depth in the picture and the presence of the arch which break up the rigidity, but a control over the geometry of the picture remains. The crossed violin cases, appropriately placed at the end of the viewing sequence in the print, sum up the visual, marital and social disorders of the picture. *The tête à tête* shows the marriage on the point of disintegration, but, because the threat of fragmentation is checked by the underlying tensions, the organisation of the picture is brilliantly controlled. Hogarth was not unwise to choose this picture to do battle on behalf of modern art against the ancient in *The battle of the pictures*.

CONCLUSION

The pretensions of the fathers in *The marriage contract* provide a first cause of eventual catastrophe, but the son's neglect of his wife (implied in the first picture and evident in the second) is a secondary cause. His indifference and philandering give a more resilient character her

licence. Gay asked the relevant question of the irresponsible Viscount in another context:

> What Cit with a gallant would trust his spouse
> Beneath the tempting shade of Greenwich boughs,
> What Peer of France would let his Duchess rove . . .?[26]

The second picture marks the change from the preparations for marriage to a view of the marriage itself, the subject of the series as defined by Hogarth both in the title of the series and in *The battle of the pictures*. The family and city rivalries have been replaced as the dominant subject by one of pleasure seeking. The husband's adultery is as yet undisclosed, but its likelihood is established by means of visual innuendos. The wife has whole-heartedly committed herself to the unexpected delights of a fashionable marriage and the innuendo, represented by the music in the foreground, indicates the direction her interests are to follow. Her stretch and glance represent the only moment in the series when the opportunity for personal contact with her husband, even if only to quarrel, seems possible.

For all its pictorial brilliance and intricate wit, *The tête à tête* is a sad picture. The protagonists sit 'cheek by jowl', according to the ironic implication in the title, wearied by their pastimes, semi-aware of one another's infidelities, and beset by rude, unsympathetic servants.[27] Gloag refers to periodic waves of taste as 'washing over the fashionable world' and leaving the established background unaltered. Hogarth's second picture in the context of the whole series records the passage of such a 'wave', modish, confused and transient. The wife's lasting taste in the furniture of her bedroom in the fourth picture is to prove plainer and older-fashioned as is her final choice of a pastime.

The second picture is an interlude, a moment of rest between the couple's enforced association and the presentation of their separate lives in the succeeding pictures. The steward's gesture is ambiguous; from the couple's viewpoint it is one of dismissal, while from the viewer's standpoint it is an ironic benediction directed towards what happens next.

NOTES

1 Hazlitt, p. 135.

2 Guy Williams, *The age of agony, the art of healing c. 1700–1800* (London, 1975), p. 4.

3 David Kunzle, *The early comic strip* (Berkeley, 1973), p. 310. Wilkes, p. 132.

4 *The analysis*, p. 49. Earl R. Wasserman describes Belinda's 'Shock' as a 'theriomorphic husband-substitute' in 'The limits of allusion in *The rape of the lock*' in *Journal of Germanic philology*, LXV, 1966, p. 430.

5 Jonathan Swift, *Tale of a tub*, Section XI, p. 129 in Jonathan Swift: '*A tale of a tub*' with other early works *1696–1701* edited by Herbert Davis (Oxford, 1939).

6 *The analysis*, p. 53.

7 The tired and slovenly servant in the further room is a commonplace figure in contemporary literature, but he may have been inspired by Fielding's description of 'young Andrews' as a fashionable servant in Lady Booby's town house. He went abroad with his hair 'all the morning in papers' (*Joseph Andrews*, p. 20).

8 Gloag offers an insight into the history of the cabriole chairs: Hogarth 'was also devoted to the form of chair known as "bended back" with sturdy cabriole legs. He showed himself seated in such a chair in his self-portrait. It was a type that was in vogue during the

seventeen-twenties, and he used it so often that in late Victorian times it was described, with romantic inaccuracy, as a "Hogarth chair"' (*Georgian grace*, p. 93). If Hayman posed for the Viscount in the second picture, then he may have sat in his friend's other chair, while Hogarth sat in his own to paint.

9 I am indebted to Dr David Johnson (letter, 1.2.76), Mr Charles Cudworth, Mr E. S. Nichol, and the Dolmetsch Foundation for their help with a fascinating puzzle.

10 *The London stage 1600–1800* Part 3, *1700–29*, edited by Arthur H. Scouten (Carbondale, 1961), p. 32. Quotations are from John Dryden, *Marriage à la mode*, in *Four comedies*, edited by L. A. Beaurline and Fredson Bowers (Chicago and London, 1967), pp. 281–362. The edition is based on the 1763 version. Colley Cibber, *The comical lovers, or, marriage à la mode, a comedy* (London, 1707) in *Three centuries of drama 1701–50* (microfilm) edited by Henry H. Wells.

11 Derek Jarrett, *England in the age of Hogarth* (London, 1974), pp. 124–7.

12 Wilkes, p. 141 and Guy Williams, *England in the age of Hogarth c. 1700–1800* (London, 1975), p. 143.

13 The survey of Whitefield draws on Reverend L. Tyerman, *The life of the Rev. George Whitefield* two volumes (London, 1876), references are to volume I, and

to James Downey, *The eighteenth century pulpit: a study of the sermons of Butler, Berkeley, Secker, Sterne, Whitefield, and Wesley* (Oxford, 1969). In warning Adams against attempting to publish his sermons, Fielding made the point that in a saturated market only those of a Wesley or a Whitefield sold (*Joseph Andrews*, p. 66). Peter Pinder in *The gentleman's magazine* (LV, p. 347) claimed that Edward Swallow, Archbishop Herring's butler, was the model for the steward. A connection between a dissenter and an archbishop's respected servant is unlikely. The 'application' is further weakened by the fact that Herring was not appointed archbishop until 1747. It is possible that Swallow was associated with any steward-like figure in art, irrespective of whether he fitted the facts in the same way that the avaricious Peter Walter was. *Joseph Andrews*, p. 66 and p. 67.

14 Francis Watson, letter (10.1.57), National Gallery dossier. *HGW I*, p. 245.

15 Hugh Phillips, *Mid-Georgian London: a topographical and social survey of central London about 1750* (London, 1964), p. 70.

16 John Ireland, *Hogarth illustrated* (London, 1791) II, pp. 28–9. *Apology for painters*, pp. 86–7. Cleaning reveals a pleasing contrast in the painting between the plaster ceiling and the light grey wall hangings of the further room.

17 *The analysis*, p. 17. Dr Johnson defined a *pagod* as an idol first and as a temple secondly.

18 Several examples of busts with modern noses survive in Sir John Soane's Museum. Wilkes, p. 157–8: Scipio drove the Carthaginians out of Spain and defeated them in Africa.

19 *Joseph Andrews*, p. 219.

20 John Gay, *The Poetical Works*, p. 180, lines 50–52.

21 *The Pilgrim* (tune by John Barrett) in *Wit and mirth, or pills to purge melancholy*, edited by Thomas d'Urfey (London, 1719) IV, p. 310. John Gay, *The beggar's opera* (London, 1729) III. xiii. Air 58.

22 Francis Watson, letter (10.1.57), National Gallery dossier. *The analysis*, pp. 86–7.

23 *The analysis*, p. 138.

24 E. A. M. Colman, *The dramatic use of bawdy in Shakespeare* (London, 1974), p. 194.

25 *The analysis*, p. 146. De Lairesse, p. 57.

26 John Gay, *An epistle to the Right Honourable William Pulteney Esq.* (1720 and 1731) in *The poetical works*, p. 158, lines 110–11.

27 'Cheek by jowl' was Johnson's definition of a *tête à tête*. The phrase acquired its intimate overtones later. John Gloag, *Georgian grace* (London, 1956), p. 101.

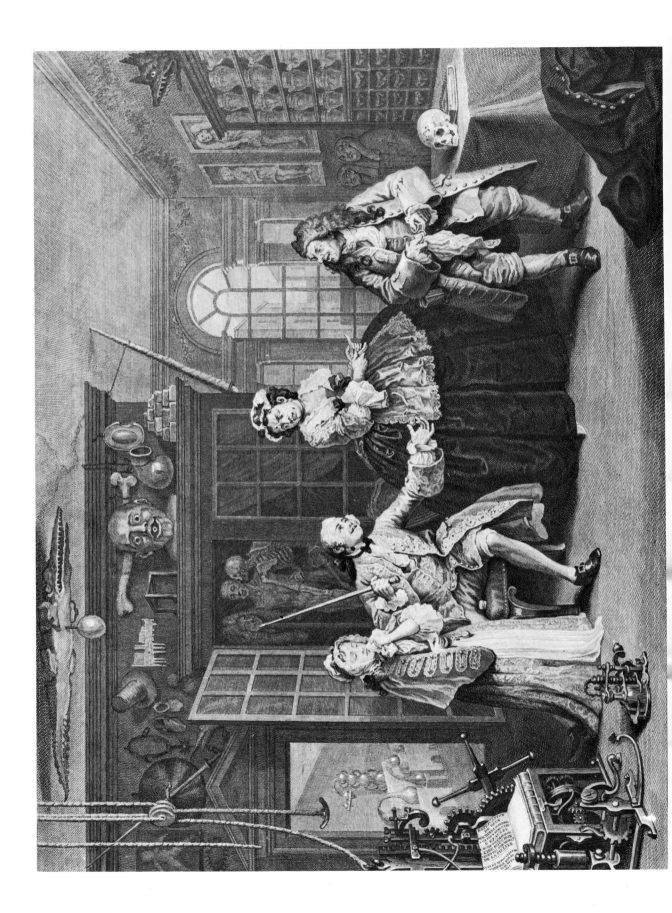

III

The inspection

The third picture is the first of two which show the separate lives of the husband and wife. In the first of these, he has befriended a young girl, presumably the owner of the mob cap in his pocket in the previous picture. He has taken her with him on a second visit to a quack doctor because he is complaining about the inefficacy of the pills. The meaning of the third picture is obscure largely because a working knowledge of medical practice is presupposed in the depiction of an eighteenth-century medical laboratory.

THE CHARACTERS

LORD SQUANDERFIELD AND HIS 'COMMON MISS'

The laboratory is the doctor's, but in so far as he is Lord Squanderfield's chosen consultant, he and his room offer insights into his patient's attitudes and needs, particularly because the Viscount continues to occupy the influential position at the beginning of the viewing sequence to the left of the print. His protegée, a 'common miss' as the poet jauntily calls her, precedes her patron in the viewing sequence but she is placed just within his leg in a discreet and perhaps more 'decent' version of the Rake's abandoned sprawl in the third picture of *A rake's progress*. Hogarth was prepared to exaggerate the length of the Viscount's leg in order to make his foot protrude protectively from behind her skirt. Consequently they are considered as a couple.

Lord Squanderfield, the Viscount, is the only seated character; his considerateness does not extend to allowing his mistress a seat, a courtesy which belongs to the nineteenth century. His modicum of vigour is reflected in the resumed tidiness of his clothes and the 'cinnamon' coat which provides a warmer contrast to the colder blue and black of preceding pictures.[1] His discontent has changed to a positive, even playful mood: he takes note of other characters, his eyes sparkle (in the painting), and his lips are drawn back in a grimace. His aggression is treated with humour, however; he brandishes his cane from a seated position at a safe distance from his target, a small, elderly, shortsighted man. The inclination of the Viscount's bony legs and cane are repeated in the narwhal's tusk above him, an emblem of sexual prowess. He proffers an open box of pills as fastidiously as he picks up the snuff in the first picture. The lid is on the chair close to his groin to indicate the exact nature of his present disability. The grin and the cane suggest that he does not take suffering from the 'nobleman's disease' too seriously.

[20] *Marriage A-la-mode III (The inspection)*, engraved B. Baron, after William Hogarth (Whitworth Art Gallery, University of Manchester).

The earlier commentators had little sympathy for the Viscount's pathetic mistress. Rouquet dismissed her matter of factly as 'une petite fille du commerce', and Trusler, usually sentimental, showed none of Mr Spectator's uneasiness when faced with a harlot on the street, in dismissing her as a 'Bow-street cully'.² Attitudes to child prostitution were beginning to change in the mid-eighteenth century, however, influenced in part by Hogarth. *Satan's harvest home* (1749), a satirical pamphlet which was to become notorious in the next century, was to denounce the rakes' preference for young girls, 'some of them hardly high enough to reach a man's waist-band'. It is remarkable in the context of the times that Hogarth's rakish Viscount should even bother with such a girl. (Indeed, his patronage of a street girl and not the countess's *affaire* with a lawyer is the fundamental improbability of the series.) She holds another box of the doctor's pills so that her protector's complaint is made as much on her behalf as on his own.

Hazlitt, not unexpectedly in view of his personal preferences, expresses a more sympathetic view. He was struck by the contrast between 'the extreme softness of her person, and the hardened indifference of her character. The vacant stillness, the docility to vice, the premature suppression of youthful sensibility, the doll-like mechanism of the whole figure, which seems to have no feeling but a sickly sense of pain – show the deepest insight into human nature.' At first sight, the miss's woeful expression and pallid face suggest that she is crying, but a close examination reveals no tears and the handkerchief is held to her lip instead of her eye, unlike the weeping harlot in *A harlot's progress V* and Sarah Young in *A rake's progress I*. In the painting a touch of red shows at the edges of the common miss's lips which might have been intended as the beginning of syphilitic sores. She stands sadly, submissively, and phlegmatically as women were expected to do.

Several details of her clothing and appearance are similar to those of other figures in Hogarth's pictures and the similarities help clarify his intentions. Her cap has a blue ribbon similar to that in the cap in the Viscount's pocket in the preceding picture, evidence that the miss was intended as his companion previously and as a probable cause of his melancholy. A strand of hair falls across her forehead, not dissimilar to that straying from beneath Lady Squanderfield's cap, a detail which was added to the print as a deliberate afterthought. Hogarth was to refer to a 'lock of hair', falling 'loosely' across the temple, as having an 'effect too alluring to be strictly decent, as is very well known to the loosest and lowest class of women'.³ The girl's blue, probably velvet cape is similar to one hanging from a chair in *A harlot's progress III*. The parallel suggests that the immature prostitute aspires to the status of a harlot at the height of her powers. It is typical of Hogarth's sense of the ridiculous that the cape, old-fashioned for the 1740s, the yellow and red brocade skirts (signifying youth in the language of colours), and cambric apron are too big for her frail body, while her slovenliness is evident in her wearing rich clothes without hoops; her affectation is vanity.⁴ She wears a watch at her waist, as does Lady Squanderfield in the fourth picture. The procuress, Mistress Needham, in *A harlot's progress I* also wears one and the Harlot herself holds one in the third

[21] The 'common miss' as a counterpart for the wife.

[a] The wife (detail) from *Marriage A-la-mode II. Note:* her pocket mirror (p. 61); the curl of hair across her forehead (p. 84); 'Hoyle on Whist' at her feet (p. 61).

[b] The 'common miss' (detail) from *Marriage A-la-mode III. Note:* she holds her handkerchief to her lip and not her eye (p. 84); the curl of hair across her forehead (p. 84); compare the watch at her waist with the wife's (Illus. 21c); compare her over-large cloak and her watch with those of Hogarth's harlot (Illus. 10 and p. 102).

[c] The wife (detail) from *Marriage A-la-mode IV.*

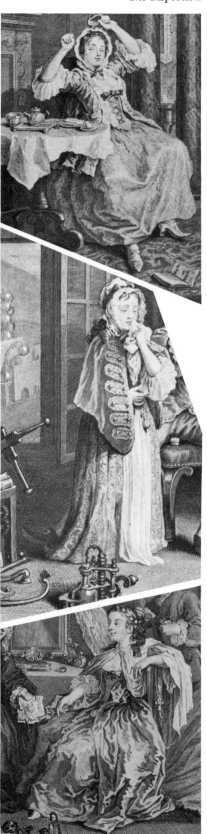

picture. Women steal men's watches in both *The theft of a watch* (1728) and *A Rake's Progress III*. In Hogarth's imagination, as in Pope's, watches were symbols of men's judgement. In Bosse's *Les vierges folles et les vierges sages* (1635?) women not only sing, play cards and look in a mirror, but wear watches at their waist so that woman's mastery of time may have been traditionally associated with folly.

The parallel between the common miss and the lady is Hogarth's first use in *Marriage A-la-mode* of one character as an ironic counterpart of another (as opposed to counterparts for characters in the interior pictures). They share an immodesty, a slovenliness, and an affectation. The miss represents what the lady might have been socially and is 'under the skin'. The husband treats the mistress with the care supposedly reserved for a wife; his earlier fastidiousness is proved to be selective and, therefore, an affectation. The reversal of roles adds to the topsy-turviness, a manifestation of insubordination in the series. The similarities add to the irony of the narrative without disturbing the credibility of the wife or the miss as distinctive characters.

THE TALL WOMAN AND HER KNIFE

The third picture has puzzled commentators from the beginning: Rouquet described it as 'entirely episodic'; Charles Churchill (1731–64), Hogarth's friend and later enemy, is reported as claiming that Hogarth did not know what he meant by it.[5] Paulson makes reference to four different interpretations in his catalogue to *Hogarth's graphic works* and it is suggested in *The National Gallery catalogue* that it is doubtful whether an acceptable interpretation has been made. Kunzle narrowed the problem down to the question of the role of the woman with the knife (without solving it).

A comparison between Hogarth's earlier study of a massive woman and the tall woman is a helpful means of arriving at an answer – namely, the procuress in *A harlot's progress I*. Both have straight noses, several beauty spots, and display peardrop earrings. Both wear beribboned, showy clothes with voluminous, perhaps satin skirts (the contrasts between the tall woman's absurdly dainty cap and bright red apron and black clothes would have appeared particularly loud to contemporaries). Their large hoops compare with those ridiculed in *Taste à la mode*, excesses which imply a shared vanity. The impractical aprons show that their wearers intend not to work, unlike the girls standing beside them. Mrs Needham, the procuress, is elderly, but the puckered brow of the tall woman has encouraged commentators to assume, rather unfairly, that she is older and uglier than she really is. Her hair is black and her skin is pink and clear in the painting.[6] The youthful effects are less obvious in the print, but her smoother skin, fuller cheeks, and fewer beauty spots make her the younger woman. The absence of an alternative procuress for the similarly vain common miss makes it probable that the tall woman was intended as one of Mrs Needham's successors of sufficiently high class (as her expensive clothes and vanity would suggest) to procure for a viscount. The lurid colour of her apron represents power and love conjoined.

Mrs Needham is concerned with the introduction of the Harlot to her

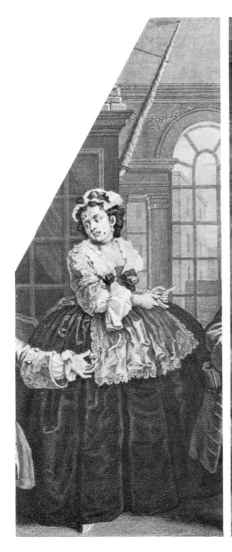

profession so her emblem is the dissembling fan. The tall woman is concerned with the occupational hazard so her emblem is the knife of suffering. Hogarth's assistant towards the end of the 1740s, Luke Sullivan, explained that the marks on the woman's chest are a gunpowder tattoo, the sign of a convicted prostitute (below). Sullivan was reading from the print because the marks are red in the painting, where they were probably intended as a brand. Hogarth's intention may have been to show that the tall woman had turned procuress after a conviction for prostitution: 'une de ces femmes qui perdues depuis long-tems, font enfin leur metier de la perte des autres', observed Rouquet. The poet took her to be the doctor's wife, 'a perfect scold' and she certainly wears her indoor clothes, unlike Mrs Needham who has her gloves and shawl outdoors. This explanation is unnecessary, however, because alliances of convenience especially between quack doctors and procuresses were commonplace. In Hogarth's picture, they are dealing with a difficult and important client so that it is to be expected that they give support to each other.

[22a] The tall woman (detail) from *Marriage A-la-mode III. Note:* the initial inscribed on her bosom (pp. 86 and 87).

[b] Mrs Needham (detail) from *A harlot's progress I (Her coming to town).*

The intention behind the knife, a folding scalpel or bistoury, remains to be explained. There is no evidence that it is intended for surgery, so that the tall woman, a haughty person, appears to have snatched up a convenient weapon in response to the Viscount's criticisms. Her eyebrows, 'contracted, and pursed into frowns', signified anger to Wilkes.[7] Hill defined the passion as 'Pride provok'd beyond Regard of Caution' and saw set teeth and extended nostrils as its characteristic signs. Hogarth was careful to set limits to the tall woman's anger, however. Her head, but not her body, is turned towards the Viscount. The scalpel is only partly open and the blade points towards the doctor. The Viscount's empty threat is directed beyond her so that her over-reaction is more a response to the Viscount's criticism of the doctor, which she takes as an affront, than it is a threat to be carried out. The probable cause of her anger would seem to be the insinuation that the common miss, presumably sold to her patron as a virgin, gave the Viscount the disease which the doctor's pills fail to cure, thereby proving them both to be false.

The discrepancy between the tall woman's unwarlike occupation and her threatening, but imprecise gesture is best explained at a thematic level. Her 'touchy' attitude is part of the emphasis in the picture on the physical sense of (hurtful) touch. Each gesture implies some kind of pain: the first handkerchief dabs at a sore; the cane promises a beating; the knife threatens; the second cloth polishes the spectacles in readiness for an inspection which can only lead to more pain. The bony and jagged objects and the purposes behind the machines (below) make the picture an essay in agony. The wolf's head to the right assumes the Medusa's choric role in regarding the situation with dismay. Like Medusa, his sharp teeth exemplify the predominant sense; the poet appreciated their significance:

> High o'er them stood a stuff'd wolf's-head
> To tell you, 'If you touch, you're dead'.

The brand or tattoo on the tall woman's bosom reads 'FC' or 'EC'. The mark is one of the obscure sets of initials occasionally to be found in Hogarth's series.[8] As the mark of a convicted prostitute, they stand for Female Convict or Criminal. Nevertheless, commentators have sought personal applications for them. The principal claimants were Fanny Cock and Elizabeth Careless but there are objections to both. Fanny's father, Christopher, was Hogarth's friend, the auctioneer who was to exhibit the paintings of *Marriage A-la-mode* in his Covent Garden auction rooms. Although he suffered a lot of leg-pulling over his name and quarrelled periodically with Hogarth, it is unlikely that he would have displayed the picture if he thought it contained an uncomplimentary reference to his daughter unobtrusive though the letters are. Elizabeth Careless was long past the peak of her fame as a beauty in the 1740s and she was popularly known as Betsey. Hogarth had called her 'Charming Betsey' in *A rake's progress VIII* and so had Fielding in *Amelia* (1752), when he referred to her as an example of the decline of beauty into old age. A flake of paint prevents the positive identification of the first letter in the painting. As if aware of the possibility of unwelcome

personal identifications, Hogarth had the initials moved in the print to a point where the tail of the first letter is hidden behind the frilly collar. Subscribers could not connect the letters with anyone in particular because they no longer formally existed as initials. He could have omitted the mark altogether, but there would have been neither an economical way of demonstrating the tall woman's antecedents and shameless vanity nor a means of showing another ostentatious and splendid exterior to be spoilt or flawed.

THE DOCTOR AND QUACKERY IN THE EIGHTEENTH CENTURY

The doctor is accurately described in the *BM catalogue* as a 'short, bow-legged, almost toothless old man, with narrow shoulders and wide hips, personal defects which his long-skirted and stiff coat exaggerate in appearance'.[9] His head is turned towards the Viscount, while his body faces the viewer, as if he too has had his attention caught by an unexpected remark. Fielding identified a 'constant, settled, glowering, sneering smile as the product of a compound of malice and fraud', an apt description for Hogarth's character. Dr James Parson's description of the passion *'scorn and derision'* in his lecture on 'Muscular motion' (1746), in which he paid tribute to Hogarth, may have derived from the doctor's expression: 'sometimes [this feeling] is attended with a grinning laugh which can have no real meaning, because there is no real cause for it; and the hypocrisy of the mirth is easily distinguished on the face'. Hill was also to characterise scorn as 'Negligent Anger', a definition which accounts for the doctor's lack of deference towards a client of rank.

His tangled hair is knotted to keep it out of the way, a common practice; Hogarth may have had his friend Martin Folkes in mind, a real-life antiquarian who is shown in his portrait (painted 1741, engraved 1742) without a wig and with knotted hair. The doctor's full-bottomed wig, customarily worn by lawyers, clergymen, and physicians, with its connotations of sagacity and prestige, hangs in his cupboard. Although his clothes are baggy, his coat buttons are gilt and his handkerchief is made of filmy, decorative material. His stock is tucked in his buttonhole in the old-fashioned Steinkirk tuck which draws attention to the commercially inspired patriotism of an Englishman by adoption who shares an attitude with the Alderman. The doctor appears unprepared as if he cannot conceive of someone making a complaint against his pill.

The doctor's stature is bound up in his name as recorded on the title page of the book to the left of the print, 'Monsr. de la Pillule'. M. de la Pilule (with one *l*) was the nickname of Dr Jean Misaubin who graduated from Cahors University in 1687 and practised in London during the 1720s and early 1730s. His arrogance and self-importance became a byword in his lifetime. Fielding, many years after Misaubin's death in 1734, was to recall in *Tom Jones* (1749) that the doctor used to say of himself that 'in the world' was his 'proper' address, so famous did he regard himself to be.[10] By 1743, Hogarth was alluding to the legend rather than to the man, especially since Misaubin was a genuine licentiate of the College of Physicians from 1719 and thus not a quack.

The altered spelling of the nickname is a small, but unmistakable, step into make-believe. Hogarth's source, technically at least, is obscured.

Trusler associated the doctor's rooms with Misaubin's house in St Martin's Lane, at number 96, the fourth house south of Cecil Court.[11] J. T. Smith, in supporting Trusler, refers to a particular room at the back, although his description of the house bears no resemblance to Hogarth's laboratory. It is likely that the allusion to Misaubin automatically invited an association with his home (his wife, incidentally, had moved from number 96 to another house in the same lane in 1739). The venetian window with the flat-topped side windows is the only distinguishing feature in the room, a feature which Smith did not mention. Isaac Ware in *A complete body of architecture* (c. 1735) had described such a window as 'very pompous' and of a 'kind calculated for shew'. The window is consistent with M. de la Pillule's characteristic pride and the Palladian style associated the room and its owner with the detested Burlingtonians with whom Hogarth's Earl is made to identify. Hogarth was to include a similar window in the fashionable, domestic interior of *The lady's last stake*, where it is less incongruous than in a professional laboratory.

The doctor is the third carefully treated, non-recurrent character who succeeds the vain Earl and the hypocritical steward. His affectation is a mixture of both vanity and hypocrisy.

The Royal College of Physicians was founded in 1518 to control the practice of medicine, but, because training at Oxford or Cambridge took at least thirteen years, there was only a small élite of licensed practitioners. Many conscientious students, frustrated by the length of training, took shorter, private courses in London, went abroad to qualify, or simply began to practise as quacks. Hogarth's quack doctor is typical of the majority of doctors in the eighteenth century, not all of whom were the shameless and impudent pretenders they have been made out to be. Significantly, Hogarth's title to the picture does not draw attention to quackery and the character is referred to as 'Monsr.' in his book.

The doctor's possessions were all purposeful, according to the medical standards of the time. A small preparation of narwhal's tusk, the nearest equivalent to a unicorn's horn, sold for up to fifty guineas as an aphrodisiac. The pile of tea bricks on the cupboard was a considerable investment in another well-known stimulant, worth tens of pounds sterling per pound weight at today's prices. The placing of these stimulants immediately above the tall woman not only comments on her aggression, but also strengthens the claim that she is a prostitute or a procuress. The rare and costly substance, mummy, was used to encourage longevity and to restore life – this quack has two mummy cases. The stone jars for ointments and the drawers for dry ingredients indicate a big stock of medicines. The furnaces in the far room are similar to those in Ambrose Godfrey's chemical works in Southampton Street and reveal the doctor's interest in experimental work or manufacturing. His glass stills and retorts are more valuable than Godfrey's cheaper, metal vessels.[12]

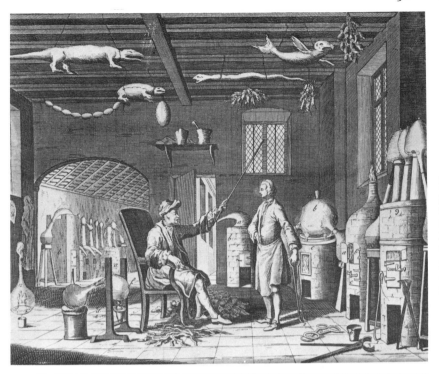

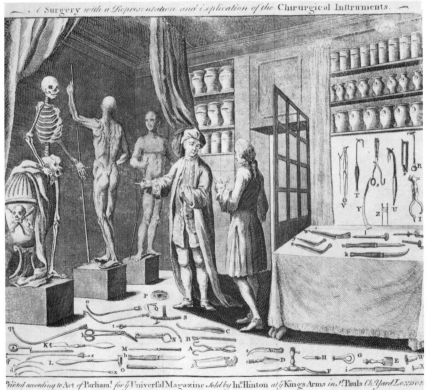

[**23a**] *A second view of practical chemistry* published by 'Chemicus' in *The universal magazine* (1748) engraver unknown (Trustees of the Wellcome Institute, London). The purpose of the print and the accompanying letter was to inform readers as to the true nature of chemistry, apparently by popular request. *Note:* the inner room with its retorts and furnishing is similar to that of *Marriage A-la-mode III* (Illus. 20, p. 82); the heavy commercial retorts and lighter glass ones (p. 89); the reptiles hanging from the ceiling (p. 91).

[**b**] *A surgery with a representation and explication of the chirurgical instruments* published in *The universal magazine* (1748) engraver unknown (Trustees of the Wellcome Institute, London). *Note:* the skeleton, the muscleman, and a third anatomical model (pp. 91–4); the stone jars and drawers for medicaments (p. 89); the glass door similar to Hogarth's cupboard door; the instruments some of which recall the tall woman's knife (p. 86); no bloodletting bowls are present.

The head with a black pill in its moveable jaws on top of the glass-fronted cupboard is a trade model for advertising the doctor's cure-all from the window or doorway of a shop. The quack's reputation is so

great, it is implied, that he finds it no longer necessary to advertise or work from a shop. He reveres his own advertisement as a curio in its own right. The model is gilt in the painting, a further sign of its owner's self-esteem. It may have been derived from Hogarth's own studio sign, the golden head of Vandyke. Sadly, he was to take this down in 1751, not out of pride, but out of bitterness because the paintings of *Marriage A-la-mode* sold so cheaply.

An outsize urine bottle for diagnosis, and a brass shaving and bleeding dish are also on display. The quack has practised as a barber-surgeon but, presumably as a result of the success of his pill, he has given up what he now regards as an inferior trade to practise as an unlicensed doctor. The narwhal's tusk is aligned like a barber's pole so that, while the quack may be seen to have risen in his own estimation, his creator has a more sceptical view of his achievements. Hogarth declared the femur to be the most graceful bone in the body, but the serpentine curve of the bone behind the model is deliberately clumsy and its line interrupted.[13] The bone is an exaggeration in keeping with other signs of giganticism in the picture, but it would have had credibility in the 1740s as an antediluvian bone. The existence of fossil bones led natural philosophers, Gay's Dr Fossile among them, to deduce that people before the Flood were giants. In 1718, the French Academician, Abbé Henrion, had calculated Adam's height as one hundred and thirty feet. The figures in the cupboard add teaching to the diversity of the quack's experience. The figure beside the skeleton is a 'muscleman', an anatomical model. Hogarth was fascinated by the muscular structure of the human body. He was familiar with Cowper's mould and argued expertly in *The analysis* that a knowledge of anatomy was a requisite for the successful artist. Two pictures demonstrate the medical antiquarian's interest in aberrations, the one is of a man whose head 'doth grow beneath his shoulders' and the other is of Siamese twins. Their frames are similar to the interior pictures of saints and martyrs in the preceding pictures of the series, a ridiculous analogy which draws attention to the exceptional quality of both. These oddities, together with a picture of a spreadeagled infant over the door, the animal's head, the stuffed crocodile and the ostrich's egg, prove the quack to be a collector of rare and valuable specimens. The collection makes him well-equipped to teach by eighteenth-century standards.

A modern forensic pathologist is in no doubt that skulls eroded by syphilis display strange configurations, such as the *W* shaped pattern of holes in the forehead of the skull on the table.[14] The poet was also sure:

> And tho' it was extremely thick
> The p___x ten holes did in it pick.

The superimposition of the delicately painted, but flawed skull on a book indicates that the doctor is an authority on venereal disease.

The contraptions (steely blue in the painting) show the doctor's interest in invention. The title page of the book on the larger machine reads in bad French: 'EXPLICATION/DE DEUX/MACHINES SUPERBES/L'UN POUR REMETTRE/L'EPAULES/L'AUTRE POUR SERVIR DE/TIRE-BOUCHON/INVENTES PAR MONSR./DE LA PILLULE/VUES ET APPROVEES

PAR/L'ACADEMIE ROYAL DES SCIENCES/A PARIS'. The X-ray shows that the upright screw of the machine would have originally obscured the last line of the inscription. Rouquet dismissed the quack as an inventor of extremely complex machines for simple purposes. There is some truth in this judgement, but bone setting was a physically demanding and excrutiatingly painful operation and cork-pulling was a chore for the apothecary. Hogarth was not going beyond the bounds of possibility with these inventions, although the quack takes pride in having interests which swing from the sublime to the ridiculous. Also L'Académie Royal des Sciences was an institute of international repute and did not give its approval lightly. Lichtenberg, a professor of physics, respected the accolade; the Académie's approval 'means something' for him. Two volumes are required to explain how the machines work and they and a third book under the skull suggest that verbosity is one characteristic of the quack's affectation (Self-esteem is another since the machines are 'superbes' in his own estimation). There are no signs that he has been working before the intrusion, although a roll of papers is stuffed in his pocket. His spectacles need cleaning, the furnaces are cold and the implements are arranged for display.

Hogarth's quack has had experience of medicine, apothecary and surgery. He is a teacher, an inventor of some repute and a theorist. By representing a dilettante with such a wealth of experience, Hogarth set out to provoke the College of Physicians, the Society of Apothecaries and the recently established Company of Barber Surgeons. These bodies were in dispute in the 1740s and only united against the outside competition that quackery represented. As a pox doctor, the quack should be regarded as a serious competitor in one of the most profitable, if despised, fields of contemporary medicine. In showing a quack embarrassed by his client, Hogarth was aiming to appeal to an expanding class of prosperous and professional men. He would have remembered how the likeness of an unpopular magistrate had sold *A harlot's progress* to the lawyers in the Inns of Court.

Ireland first suggested that Samuel Garth's well-known poem, *The dispensary* (1699), was a source for the picture. Garth describes a 'wight':

> Bold to prescribe and busy to apply.
> His shop the gazing vulgar's eyes employs
> With foreign trinkets and domestic toys.[15]

The wight's specimens include mummys, a tortoise, a shark's head, an alligator and some dried bladders. His stock includes poppy heads, other drugs and a tripod, while his inner room contains globes and books. Hogarth's much more sophisticated laboratory owes little to *The dispensary* or even a play like Gay's *Three hours after marriage* (1717). Comparisons were inevitable because Hogarth was operating in the same alchemaic tradition, but he must have 'inspected' at least one laboratory in order to create such a technically exact setting. As well as having parallels with Godfrey's chemical works, it also resembles a contemporary view of the ideal surgery, which contains similar jars, a grinning skeleton, a muscleman, a table and cloth, medical pictures and an array of instruments.

The quack's face shows the resentment of a self-important and well-to-do man who puts his whole career on display in his laboratory and who has to concern himself with a complaint against his name and reputation. Venereal diseases were generally grouped under derisory titles like *morbus gallicus* or the French distemper, Fielding's term in *Joseph Andrews*. With apologies to the French, therefore, it is apt that the heir of a Westminster family of squanderers which claims descent from a French duke and who is dressed in the French fashion should seek a cure for a 'French' disease from a myopic French quack who is out of touch with practical medicine. The war with France, which prevented Hogarth from having his paintings engraved in Paris, worked to his advantage in making his quack hateful. The Viscount's futile gesture of complaint against a popular and credible villain may have prompted as much sympathy as reproof for his behaviour at this point in the narrative. Sullivan was to describe the quack contemptuously and graphically as 'wiping his spectacles with his coarse muckender'.[16] Hogarth aroused the required feeling in his English engraver but it is to be wondered what the 'best masters' from Paris thought.

ELEMENTS OF THE SETTING

THE CONTENTS OF THE CUPBOARD AND THE CURIOS

The contents of the cupboard offer such a precise and extensive comment on the central situation that their arrangement has to be regarded as a kind of parody. The skeleton appears to caress the muscleman and whispers in his ear. The latter stands defiantly, hand on hip, eyeing the skeleton resentfully out of the corners of his eyes. The relationship implies that Hogarth's mildly resentful Viscount is also experiencing the first caress of a contagious death, a further justification for seeing the predominant sense as one of touch. The animation of gruesome objects is in the tradition of the *danse macabre* and the skeleton is conceivably a derivation from the amorous attitude of Death in *The Countess* in Holbein's *The dance of death* (1538).[17]

[24a] The countess from *The dance of death* 1538 edition, Hans Holbein the younger.

The tip of the Viscount's cane is superimposed on the wig block as if to confirm, in a circumlocutory way, that his quarrel is with the doctor. The wig block with a mustachioed face resembles a malefactor's head on a pole, perhaps indicative of the doctor's true worth. The muscleman is flanked by the alternatives of execution and the kiss of death. As if to invite the drawing of further analogies, the scientific tripod on top of the cupboard is the same shape as the three-posted gallows at Tyburn as Hogarth was to show it in *Industry and idlesness XI*. With grisly correctness, the cane points to an image of the undisclosed, but probable fate of the head of the Viscount's own executioner, Counsellor Silvertongue. The curios above the cupboard are images of exaggerated masculinity placed as if to comment on the Viscount's timid aggression: the narwhal's tusk; the long sword; and the big cockspur. Other images offer a catalogue of sterility and impotence: the huge scarab or dried 'louse' (the poet's identification); the stuffed alligator; the ostrich's egg; and a tortoise. The whalebone, or baleen, resembles a broken comb

placed apparently for use on the equally giant, but bald head of the trade-model.

The placing of the larger traction machine behind the squat corkscrew repeats the size relationship between the tall Viscount and his puny mistress. The machines resemble instruments of torture, the rack and the screw, one of which comments on an already lanky man who is to be shown as metaphorically racked with pain at his death. The common miss, it is suggested, is to be held and penetrated in a surgical operation in much the same way that the gin bottle, a female emblem, is held and pierced by the cork screw which overlaps her skirts. The analogy between the bottle and the anaemic common miss is reinforced by the fact that gin was used medicinally to relieve menstrual pain.

The viewer, having been eyed quietly by peripheral creatures in preceding pictures, is dramatically involved in the third. The goggle-eyed trade model, with an astonished expression like the Medusa's, stares directly at the viewer, who is thereby projected as a monster awesome enough to astonish a giant. He experiences the mirror effect of being stared at as if he is the curio in a collection. An underlying chain of comic causes and effects is apparent across the reach of the whole series: the result of Jupiter's glance at Medusa is the blind bust of his counterpart in the second picture. As if by magic, the bust is transformed into the trade model who redirects the gorgon's baleful glare towards the viewer. As an advertisement for a cure-all for a disease transmitted by kissing and caressing, it threatens to blow the pill into the viewer's face. Fielding favoured his 'fine' or 'sensible' reader with confidential flattery, but Hogarth's preferred method was to challenge his viewer in order to disturb the security of his role as an omniscient observer.

The trade model is the centrepiece of a string of allusions among the curios which mock at their owner's pretensions. The sword, buckler, and spur recall Don Quixote's and Hudibras's accoutrements. The barber's basin recalls Don Quixote's helmet, although the design is not

[**24b**] Frontispiece (detail) to *The honorable history of friar Bacon and friar Bongay* 1630 edition, Robert Green.

[**c**] The trade model (detail) from *Marriage A-la-mode III.*

quite the same as that in Hogarth's illustration, *The freeing of the galley slaves* (1738). The tall hat (red in the painting) resembles that of the squire, Ralph, in the *Hudibras* illustrations. He was a tailor whose way, like the steward's in the second picture, is through 'Gifts' and 'New-Light'.[18] Fourteen hats hang accusingly like cannons on the walls of the room in *The committee*, the tenth large illustration to *Hudibras*. Both Butler and Hogarth saw the 'saints' as too self-important and it is appropriate that their characteristic hat and emblem should gravitate to the walls of this boastful doctor's laboratory. The odd shoes recall that waiting to be thrown at Hudibras and Ralph in the stocks (present both in *Hudibras triumphant* and *Hudibras in tribulation*). The crocodile, the skeleton and the picture of a spreadeagled infant are inevitable variations on the specimens in the astrologer's cell in *Hudibras and Sidrophel*. The disproportion in height among the characters recalls that between Hudibras and his amazonian opponent in *Hudibras vanquished by Trulla*. The poet assumes that the tall woman is taking up the argument on the doctor's behalf: the positioning of the narwhal's tusk nearly, but not quite, arising from her forehead makes her a counterpart of the unicorn whose horn matches the Viscount's cane. A joust of lances between the modern counterparts of Trulla and Hudibras offers a comic prefiguration of the more serious duel between men of unequal rank in the fifth picture.

The trade model itself may have been inspired in part by Robert Green's old play, *The honorable history of Friar Bacon and Friar Bongay* (1589?).[19] The famous brazen head of the play stares at the reader from near the ceiling in the alchemist's cell as depicted in the frontispiece to the 1630 edition. Hogarth was bound to have known of the 'celebrated story' because of its popularity in the fair booths. Bacon was an alchemist of ambition whose 'monstrous head of brass' was manufactured in order to 'tell out strange and uncouth aphorisms'. Its inability to utter anything but the most obvious truths compares well with Hogarth's model whose universal message is only to display his master's ineffective pill.

The skull on a book would appear to be an ironic allusion to St Jerome (Hogarth may have had a copy of Caravaggio's version in mind which also has a *memento mori* on a book). The saint's benign wisdom is reduced to the level of a quack's butterfly thought whereas the quack, perhaps intentionally, equates his technical knowledge with an epitome of ancient wisdom. The playful Viscount, who suffers from the disease which killed the owner of the skull, is to pass beyond his equivalent of Golgotha, a prelude to as well as a *memento* of death. His next and last appearance in the penultimate picture of the series is to show him as both a destroyer and a victim. Hogarth added the *l* to Pi*l*lule, as he also added the *r* to 'Ma*r*riage' in the title. A *pill* was cant for one who lays waste as well as a popular word for a doctor. The skull is the predominant symbol in a museum which preserves relics of all the orders of being: creeping things and reptiles; fish (the horn and the comb); beasts and a bird (the ostrich's egg); the bone of an antediluvian man; a baby; a modern man (the muscleman); death himself (the skeleton). Only a representative of the gods is missing, but the trade

model and its pill are placed as if to substitute for Jupiter and his insignia.

The trappings of chivalry and puritanism, familiar polarities, with their comic equivalent in an alliance between a cavalier Westminster and a careful London, are reduced to the level of relics in a room where heroism and enthusiasm are treated with contempt. It is sad that Hogarth's perversely chivalric character should discover his modicum of valour and his Dulcinea in such a setting. The Viscount fails to appreciate that chivalry is outmoded in a world dominated by prostitution and disease. Events are to make his flamboyant attitude deepen into a sense of injured pride which is to destroy him in an outmoded ritual, a duel with swords.

The allusions in the third picture provide a satirical, literary dimension. Hogarth may have been responding to a significant proviso in the Preface to *Joseph Andrews* (a work in which a debt to Cervantes is acknowledged). There, Fielding conceded that a comic epic-poem in prose might contain 'parodies or burlesque imitations' in its 'diction', provided that the humorous treatment did not interfere with the 'just imitation' of nature in the 'sentiments and characters'.[20] Hogarth made the confrontation between patient and doctor or client and procuress mock-heroic without disturbing the seriousness of the event itself, as Fielding had tried to do in, for example, the comic-epic treatment of the cudgelling of the hounds by Parson Adams and Joseph.

THE VISUAL ORGANISATION OF THE PICTURE

The painting is atmospheric in a way that a print can never be. A subdued light falls from the left, sufficient only to illuminate the members of the single tableau who float before their indistinct background. The common miss is a glowing, ethereal figure, whereas the brown clothes of the quack on the other side of the picture make his a sinister figure merge into the shadows.

Firelight is absent in a picture concerned to demonstrate the breakdown of the marriage and the aftermath of an *affaire*. The unlit tapers, associated with a loveless marriage, disappear from the series. The heavy candles in single sticks, associated with the contractual basis of the marriage, are withheld from both the third and the fourth pictures which deal with the couple's infidelities. The heavy furnaces and enclosed stills in the further room maintain the idea of fire in a negative sense. Coldness is allied to dryness as exemplified in dead and dried or stuffed relics. The combination suggests that the atmosphere is dominated by the humour of melancholy. Surgeons and cutlers, traditionally makers of medical instruments, were thought of as bitter and gloomy men because of their professional association with the cold, cutting metal, iron. The Viscount, himself a melancholy man (page 126), has sought out a kindred spirit in the doctor who deals in the disease which is death to love.

The quack's laboratory is the condemned cell of Hogarth's imagination: the characters are set against the rigid lines of the cupboard and the cornice; the many crosspieces in the windows and the glass doors (highlighted in the painting); the rows of shelves and drawers; the lines

of swords, ropes, pulleys, and levers. Both the characters and the viewer are positioned to see the appearance, if not the reality, of the instruments of torture. The trade model is gagged by its pill and the muscleman is confined in an inner cell surmounted by the emblem of the gallows and guarded by a merciless gaoler. The print is less morbid than the painting because the details of the setting are clearer, full of exaggerations, incongruities, lewd jokes, and mock-heroic allusions. The *danse macabre* itself is a tragicomic metaphor and Viscount Squanderfield is a ridiculously defiant Everyman in a contemporary *danse* who has the temerity to sit in the shadow of death's pain-ridden laboratory and complain.

The disposition of figures represents a return to the triangular construction of the first picture. The taller woman's head forms the apex of a triangle and the Viscount and the doctor the base angles. The common miss is an appendage at right angles to, but just within the base line of the triangle. The tableau is surmounted by the tripod, an emblem of the gallows. Its association with Hogarth's triangular tableau in *Marriage A-la-mode* suggests that he saw the angular shape at odds with his sinuous line of grace or light and as redolent of death. The quack's figure, within the tableau, is constructed of one triangle set upon another, a variation on the Viscount's pose in the first picture which implies a particular parallel between them both as dealers in death.

The interaction of hands and arms creates an uneven movement across the line of the tableau. In the print it begins with the common miss's right hand holding the pillbox. Her upraised forearm, holding the handkerchief to her lip, abruptly changes the movement from the horizontal plane to the vertical, an inclination repeated in the line of the Viscount's uplifted cane. The uplifted elbows of the Viscount and his mistress are close to overlapping and the little fingers of their hands holding the pillboxes are crooked. The couple share an ailment and a mannerism (affected in the common miss). The movement is checked by the upraised cane before swinging across the middle of the picture along the curve of the Viscount's outstretched arm. It then transfers to the procuress's arm along the scalpel, towards the doctor. His angled arms focus attention from both left and right on the resting point of his spectacles. The chain of connections unifies the tableau and offers the underlying suggestion that the doctor is intended eventually to 'inspect' the common miss. The interaction is reminiscent of a similar, more sinuous arabesque of hands and arms in the marriage picture, *A Rake's Progress V*, which links the Rake both with the woman he

[25] The arabesque of hands (detail) from *A rake's progress V (Marrying an old woman)*.

marries and the woman he ought to have married across the width of the picture. The acute differences in height and angle in *The inspection* create a staccato rhythm more appropriate to characters engaged in acrimonious argument.

It is to be wondered whether this interplay is the nearest Hogarth was to come to representing the structure of a sentence in a picture. The nominals (the pillboxes, cane, knife and spectacles) provide a succession of emblems to which the skull functions as full stop. The periphrasis reads: misery (pills + handkerchief)→protest (cane + pills)→affront (knife)→(scorn) . (skull). The uplifted cane represents a pause in this visual sentence which links a subordinate phrase to the main clause in the contents of the cupboard, also concerned synonymously with the subject of contagious death. The momentum of the viewing sequence (in the print) forces the situation towards its conclusion that the vanity of human wishes ends in death.

CONCLUSION

The third picture, in presenting the evidence of the husband's infidelity, corresponds to that moment in a tragedy when events turn unmistakably towards catastrophe. The disclosure of the first infidelity makes a fitting initial climax, appropriately placed at the end of the first half of the narrative, to a series which has the breakdown of marriage rather than a history of an individual character as its subject. Although the husband's defence of his lugubrious mistress is quixotic, he, like Dryden's King David, imparts his 'vigorous warmth' to a slave rather than to a wife. His irresponsible behaviour acts as a precedent for her *affaire*, also with a social inferior. The third and fourth pictures thus parallel each other (page 120), but the third, in being concerned with the end of an *affaire*, and the fourth, in being concerned with the preliminaries to another, are correctly ordered. The third picture is 'episodic' only in that it does not provide a direct causal link with the fourth picture as might be expected of a history, but not necessarily of a narrative based on a situation.

The narrative line could have been clearer if Hogarth had provided an immediate purpose for the tall woman's scalpel, but the picture succeeds best at pathological, psychological and thematic levels. *The inspection* is an amalgam of serious and comic elements and a necessary component in a sophisticated narrative structure. Rouquet and Churchill were wrong: Hogarth did know what he was doing.

NOTES

1 The colours and style of the Viscount's coat are similar to the description of Bellarmine's in the 'History of Leonora', the difference being that the latter's coat is lined with pink. Bellarmine was also wounded in a quarrel over a fickle woman (*Joseph Andrews*, pp. 89–90 and p. 95). A 'bellarmine' was the nickname for a type of drinking jug, an association which may lie behind that between the Viscount and a china jar in the first picture, although it is not a drinking vessel.

2 Rev. J. Trusler and others, *The complete works of William Hogarth* (London, no date), p. 16. *Satan's harvest home* is referred to by Michael Levey in the caption to plate 3 of *'Marriage à la mode' by William Hogarth* (London, 1970), no page numbers.

3 *The analysis*, p. 52.

4 Contemporaries would probably have identified the clothes as cast-offs. A thriving trade in secondhand clothing was centred on Rosemary Lane and Monmouth Street long before Boz wrote his sketch on the subject.

5 Reported in J. Ireland II, p. 31. *HGW I*, p. 272: the interpretations of Rouquet, Trusler, Ireland and Rogers (after Luke Sullivan); Lichtenberg and the poet offer other variations. *The National Gallery catalogue*, p. 52. The picture is also criticised for its obscurity in the Introduction to James Heath's folio of prints (reprinted in *Anecdotes of William Hogarth written by himself and various essays*, edited by J. B. Nichols (London, 1833, Facsimile Reprint, 1970), p. 129. David Kunzle, *The early comic strip* (Berkeley, 1973), p. 315.

6 J. Ireland, 'haggard'; Frederick Antal, 'large, ugly'; Marjorie Bowen, 'a stout dame'; F. G. Stephens 'coarse featured' in *The British museum catalogue of prints and drawings* (London, 1877), hereafter referred to as the *BM catalogue*. John Nichols and George Steevens, *The genuine works of William Hogarth; with biographical anecdotes* II, (London, 1808–10), note to p. 178 (for Sullivan).

7 Wilkes, p. 132; Hill, p. 357 and p. 369.

8 'MH CU?' on the ceiling of *A harlot's progress V*, 'LE' and 'AE' in *A rake's progress VIII*. No satisfactory explanation has been proposed. Fielding ridiculed Christopher Cock by calling him 'Mr Hen' in *The historical register* (1736); *Amelia* I (London, 1962), chapter 6, p. 29.

9 The *BM catalogue*, p. 561. Fielding, 'An essay on the knowledge of the characters of men' (1742) in *Miscellanies*, edited by H. K. Miller (Oxford, 1972), p. 174. Dr James Parsons, 'Human physiognomy explain'd', *The Crounian lecture on muscular motion* (1746), a supplement to *Physiological transactions* 44 (1746–47), 'Scorn and derision' Table IV, p. 64 and figure 1. Hill, p. 357 and p. 376.

10 *Munk's Roll* (London, 1878) II, p. 67. Henry Fielding, *Tom Jones* (New York, 1963 edition), Book XIII, Chapter 2, p. 584 and *Joseph Andrews*, The Preface, p. 12.

11 Rev. J. Trusler and others, *The complete works of William Hogarth* (London, no date), p. 23. J. T. Smith in *Nollekens and his times*, edited by Wilfred Whitten (London, 1829), p. 163.

12 Fig. 187 in High Phillips, *Mid-Georgian London* (London, 1964), p. 136. Other glass vessels were originally included in the space occupied by the table. Their shapes have materialised now that the over-paint has become translucent with age.

13 *The analysis*, p. 71; a long, expert disquisition on muscular structure is included, pp. 70–6.

14 I am indebted to Dr B. L. Davies, forensic pathologist of the Birmingham Medical School, for his guidance on the medical detail of the third picture.

15 J. Ireland, II, p. 35. *The dispensary, a poem in six cantos* (London, sixth edition, 1706), Canto II, pp. 21–23.

16 See note 7 above.

17 *The dance of death*, 41 Woodcuts by Hans Holbein the Younger in *Complete facsimile* of the original French edition (1538) (New York, 1971), p. 49.

18 Samuel Butler, *Hudibras* I, Canto 1 (London, 1818 edition), p. 23.

19 Robert Green, *Friar Bacon and Friar Bongay*, edited by J. A. Lavin (London, 1969). Lavin reproduces the 1630 frontispiece, Plate XXXV. IV. 1. ls 18–20.

20 *Joseph Andrews*, Preface, p. 8.

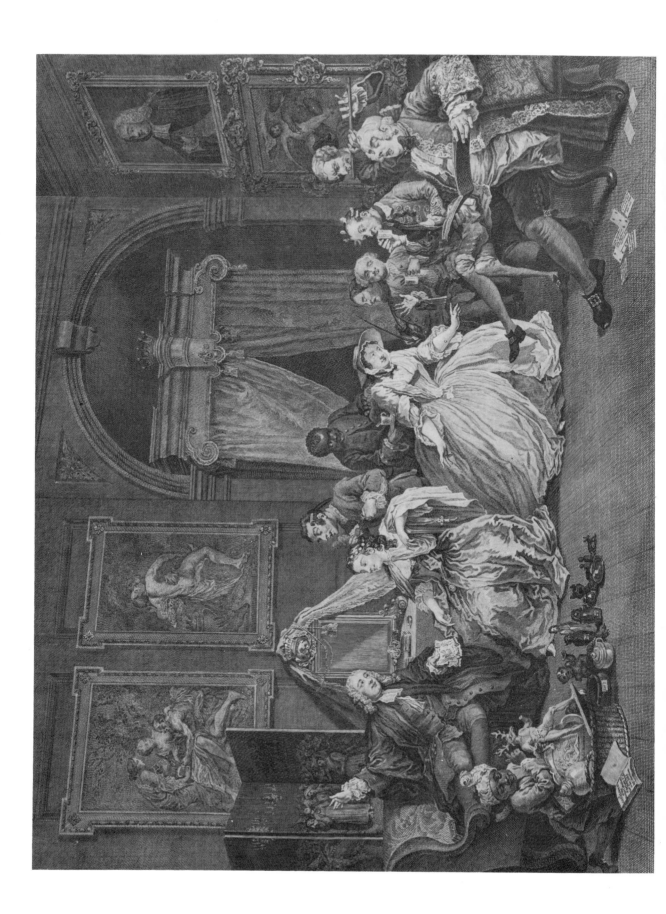

IV

The toilette

Important changes have taken place in the characters' status which imply the passage of a considerable period of time between the view of the marriage as depicted in the first three pictures of the series and the fourth. The presence of Earl's coronets on the mirror and the tester of the bed in the wife's bedroom prove the old Earl to be dead. The new Earl and his countess are now Lord and Lady Squander as the titles on the visiting cards indicate. The courtesy suffix, 'field', has been relinquished so that the name trait is unqualified, an apt preliminary to the supreme acts of squandering to come. A teething coral hangs from the wife's chair to show that a child has been born to the married couple and is some months old. The décor of the bedroom is closer in style to the Earl's than to the modish interior of the second picture: the simpler, elliptic arch, the spandrels and the heavy furniture date from about 1700. The family appears to have moved out of the wedding suite into the older building after the Earl's death.

THE CHARACTERS

THE LOVERS

In her husband's absence, Counsellor Silvertongue is established as the wife's favourite and, because the lovers form a coherent group within the parade, they are considered first separately and then as a couple in relation to the toilette, a key element as the title indicates.

AS SEPARATE FIGURES Silvertongue occupies the influential position at the beginning of the viewing sequence hitherto occupied by the Earl and his son. Because the levee takes place in the Countess's dressing room, the lawyer's position in the picture would suggest that the room is at his disposal as the quack doctor's laboratory would appear to be the husband's to command. Silvertongue's unvarying clothes suggest that he attends the levee during the course of his business or that he regards a change of clothes as beneath his dignity. His plumpness is presented as characteristic, being developed in the fullness of his jowls, the thickness of his legs, and the podgy balls of his thumbs.

The Countess's condescension in allowing an inferior to sit at her side on a semi-private occasion would have been regarded as a flouting of convention. Silvertongue's social elevation is depicted literally: he takes the liberty of sitting with his feet off the floor. The discourtesy would have prompted contemporaries to recognise that his initial gallantry is

[26] *Marriage A-la-mode IV (The toilette)* engraved by S. Ravenet, after William Hogarth (Whitworth Art Gallery, University of Manchester).

the means to the end of self-advancement in love rather than an unaffected quality.

Silvertongue holds a masquerade ticket in one hand and points with the other to a picture of a masquerade painted on Lady Squander's screen. The ticket is marked '1st Door, 2d Door, 3d Door'. Tickets in the eighteenth century were so marked to control admission to the dance floor and then to the inner rooms. Silvertongue's ticket would allow the bearer to pass all the barriers. Why the ticket is so torn is unclear: did Hogarth wish to imply that Silvertongue is a frequenter of masquerades and so well able to introduce the lady to what would be for her a novelty?

She reaches for the proffered ticket with an extended arm. A recipient was expected to accept a gift 'bashfully, with the arm close to the body'.[1] A recipient also took an offering with a 'full hand'. Lady Squander's fingers uncurl surreptitiously as if to reflect her willingness to agree to an assignation. Her interest in masquerades and auctions, other occasions on which lovers could meet secretly and yet in public, is established through her ownership of the screen, the auction lots at her feet, and the china ornaments on the chimney piece in the second picture.

Unlike her plainly dressed companion, Lady Squander has changed dramatically since her previous appearance. Although she continues to be seen in undress, her costume is much more elegant. She wears a gold dressing jacket and a light pink undergarment, like that of the second picture, but with a less stiff and more discreet bow. She wears a white *peignoir* to protect her shoulders while her hair is being attended to. She has had sufficient modesty in public, however, to cover her lacings with a stomacher. Her physical attitude has changed from an easy-going stretch to a mannered pose, a consequence of which is that the texture of her rich clothes flows smoothly or *melts* as if in harmony with the musical theme. Only one toe peeps from beneath the underskirt instead of two awkward feet. She sits shamelessly facing her lover with her knees apart and sufficiently close to him for the edge of his legal gown to fall between her feet. (Silvertongue was once closer to the screen than he is in the finished painting and he may have been sitting rather than lounging on the sofa.)

A letter written by Lady Jane Coke includes an account of the fashions at the French Ambassador's ball in 1751. It gives an idea of how Lady Squander's appearance might have been received by members of an older generation even in the early 1740s.[2] Lady Coke drew attention to the immodesty of a woman baring her neck in public, of her wearing pink, and of her not wearing a cap. Lady Squander's hair is being arranged in flowing curls instead of the tight ringlets of her first appearance, a sign of her greater sophistication and freedom as a married woman of fashion. The crudely alluring strand of hair which falls across her forehead in the second picture has disappeared. The change is from a clumsy, disgruntled novitiate to a poised and shameless hostess.

Lady Squander has a watch at her waist which recalls that of the common miss (page 84). It acts as a reminder of the parallel between

them and prompts the thought that the lady's present grace is an affectation. In so far as watches were symbols of judgement to Hogarth, this watch, on which no time can be read, suggests that the lovers regard themselves as beyond the reach of time and its consequences.

The child's teething ring with its coral charm hangs from the back of the mother's chair on an appropriately coral pink ribbon. It is to be supposed that there is an unreproved nurse in the background who has forgotten to collect the ring. Coral was believed to be the Christ child's protection against evil. Hogarth had recently represented one of the Grey children as holding its coral in a happy and innocent picture (1740). The mother is more interested in her lover and the ornaments at her feet than in her child. The separation of the absent child from its amulet is an ill omen to be realised only when its deformities are revealed at the end of the series.

TOGETHER IN RELATION TO THE TOILETTE The couple gaze into each other's eyes as lovers should. A 'blooming blush' is apparent on their cheeks, a requirement of 'Pure Love' as LeBrun defined the passion.[3] Their mouths are appropriately bow-lipped and 'a little turned up'. The stippled shadowing around the Countess's chin in the print is similar to that in 'Fig. 15' (*Pure Love*) in the edition which Hogarth would have seen. The roundness of Silvertongue's nose has been diminished so that it now resembles the tilt of Lady Squander's nose. His lips are again parted as if to suggest that he is whispering. It is possible that Hogarth had Romeo's effusive declaration in mind:

> It's my soul that calls upon my name:
> How silver sweet sound lovers' tongues by night
> Like softest music to attending ears.

Lady Squander's relaxed pose anticipates that of the princess in Hogarth's *Moses brought to Pharoah's daughter* (painted 1746, engraved 1752) and Silvertongue's that of Thomas Idle reclining on the tomb in *Industry and idleness II* or the statue of Silenus leaning on his wineskin in the first plate of *The analysis* ('No 107'). The lover's poses imitate those of Roman patricians, but their pretensions are mocked by the sprawl of the lawyer's legs and by the fact that the lady sits in the grand manner only to have her hair curled.

They are drawn into a particularly close relationship with the toilette behind them. The line of its drapery emerges from behind Silvertongue's back and passes behind the mirror to merge with the line of Lady Squander's *peignoir*. The absence of colour in the print makes it easy to mistake the drapery for an extension of the *peignoir*. The lines of the outstretched arms below the mirror and the drapery above combine to enclose the mirror and the lovers in an irregular oval. The arrangement has heraldic associations: the lovers are set like supporters, the one *couchant*, the other *sejeant*, before the *escutcheon* of the mirror, *ombre* and divided *per bend*. The coronet surmounting the mirror resembles a crest with a *casque*, its *gard-visure* empty and placed *affrontée*. The drapery is a fringed and corded *mantelle*, the objects in the countess's hair a coronet *triumphant*, and Silvertongue's paper a ragged

motto. Hogarth learnt the art of emblemature during his apprenticeship and had designed at least one coat of arms, the large and small versions of *The Kendal arms* (1723?). The arrangement also resembles a bookplate; that designed for George Lambert (*c.* 1725) could have provided a model. The poet responded by parodying *The rape of the lock*: the line, 'And, now, unveil'd the toilet stands display'd', for example, becomes 'the toilette is at large display'd'. The lovers are set before their altar in a mockery of an exchange of vows. The drapery is like a bridal veil, drawn back from where a head should be. In the painting the back of Silvertongue's head shows in a corner of the mirror, harking back

[27] The 'anti-betrothal' (detail) from *Marriage A-la-mode IV*. *Note:* the coral hanging from the back of the lady's chair (p. 103) and Crébillon's book, *Le sopha*, on the seat behind Silvertongue.

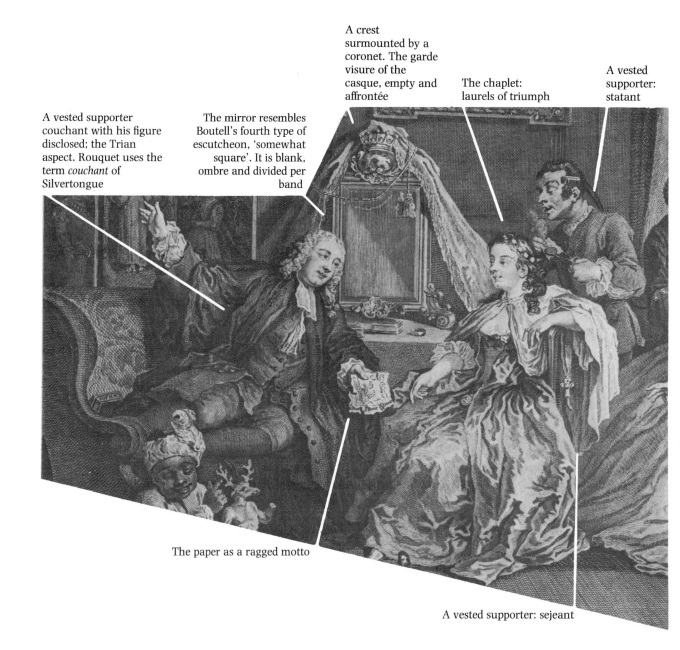

A vested supporter couchant with his figure disclosed; the Trian aspect. Rouquet uses the term *couchant* of Silvertongue

The mirror resembles Boutell's fourth type of escutcheon, 'somewhat square'. It is blank, ombre and divided per band

A crest surmounted by a coronet. The garde visure of the casque, empty and affrontée

The chaplet: laurels of triumph

A vested supporter: statant

The paper as a ragged motto

A vested supporter: sejeant

ironically to the pocket mirror of the second picture, which shows a glimpse of the wife's cap. The reflection was withheld from the print as if to emphasise the emptiness of the mirror and the vanity of this anti-betrothal. The heraldic treatment of the lovers' poses contrasts with Hogarth's satirical treatment of the contents of the cupboard in the preceding picture. In the same way that the Viscount's quixotic gesture is elevated to a mock-heroic plane, the lovers' blissful moment seems set in an artificial, atemporal world.

SILVERTONGUE'S BOOK, 'LE SOPHA'[4] The word, 'Sopha', is legible on the top edge of a book tucked between the lawyer's back and the English equivalent of his sopha. The author of *Le sopha*, Claude Prosper Jolyot known as 'Crébillon fils', first attracted attention in France with his satires on the monarchy and the church. They caused such uproar that he was imprisoned in the Bastille and subsequently exiled from Paris. *Le sopha* was published in defiance of royal decree in 1740 and translated into English in 1741. It became the sensation of the day because of its matter of fact discussion of sexual behaviour. Lady Henrietta Maria Stafford was reported to be so taken with the 'delicacy' of Crébillon's mind that she set off for France to become his mistress, the mother of his children, and only then his wife. She seems to have been Lady Squander's real-life counterpart who turned convention up side down to her advantage.

Le sopha is a parody of the Tales of the Thousand and One Nights; Crébillon's Sultan is the grandson of Scheherazade who, like his supposed grandfather, calls for stories. He prefers tales which are 'a little sportive', but a running joke is that the story-teller, Amanzei, supported by the Sultana, refuses to listen to his pleas. Amanzei is a young Brahmin who has undergone metempsychosis and in a previous existence was a woman. As a punishment for indolence, Brahma transposed his soul to the sopha on which Amanzei had spent so much of his life and decreed that he should only be released 'when two persons with [himself] as opportunity should render each other the first fruits of mutual affection'. The tales are the recollections of an ever hopeful, but disappointed voyeur. They are disquisitions on the strategies of persuasion, delay and refusal, but are neither as titillating nor as explicit as their reputation would suggest.

The first tale in particular anticipates the general situation in *Marriage A-la-mode*: Fatima is desired by her husband, but he is too much in awe of her to declare his feelings. She yields to him only when she is thinking of someone else and in order that she can more easily take her own complains to him so bitterly of women who take lovers that he keeps his distance . She is described as sensuous, unrefined and born with that 'duplicity which incites women to disguise their natures and yet long to be honoured'. Fatima's lover is a young Brahmin who 'spoke so sweetly . . . [that] he made the taste for virtue steal so gently over erring souls'. A silvery tongue is necessary in the preacher, lawyer or seducer; Hogarth would appear to owe a small debt to Fatima's lover as well as to the tradition of sweet-talking schemers from Romeo onwards. The end of the *affaire*, as observed by Amanzei, is sudden and

brutal: the outwardly meek, but suspicious husband catches Fatima with her lover and strikes them both dead. The cuckold's revenge draws attention to Hogarth's ironic variation; he too was to withhold evidence of the cuckold's jealousy until the climax of his narrative in order to create an effect of surprise in a medium (that is the picture strip) where surprises are not easily achieved, and then to arrange for the cuckold to be defeated.

The attitudes of women towards their own sexual behaviour interested Crébillon: virtue is defined as 'denying ourselves the things which most delight our senses'. A subscriber who had read *Le sopha* would have appreciated that such a Comus-like argument is being put forward in Hogarth's *tête-à-tête*. Crébillon drew attention to the pressures on bored wives to be unfaithful: 'it is not easy for a man to stand out against love: everything prompts a woman to yield to it'. One (female) character complains that a woman 'has only got to be less than frightful and everybody at once imagines that she is more amenable to love than she ought to be'. Doralice, Cibber's Lady Townly, Lady Squander, and the real Lady Stafford are in sympathy with Crébillon's enlightened hedonists. Those who regarded *Le sopha* as the shocking *dernier cri* from France would have recognised that Silvertongue identifies himself with a moral work which would appear, nevertheless, to put the gratification of desire before other considerations for those who sought such justification. The mock-oriental flavour of the tales makes an assignation at a bagnio associated with a Turk's head a glamorous proposition. Hogarth's moral is that the actuality does not live up to expectation.

THE SCREEN AND THE HAIRDRESSER The leather screen and the figure of the hairdresser balance each other on either side of the lovers, serving to isolate them further from the other figures in the parade. The screen is decorated with a low-life picture of maskers dancing to the music of an orchestra on a balcony. A Punchinello occupies the nearest panel, a nun, a friar and a Turk occupy the middle panel, and a man disguised as a woman, his hair cut short around the neck, the furthest panel. Hogarth was to refer to Punch as an epitome of ugliness and to declare that, like the pagods of the second picture, he is 'droll by being the reverse of all elegance, both as to movement, and figure, the beauty of variety is totally and comically excluded from his character in every respect'.[5] Silvertongue's pointing fingers draw particular attention to a friar and a nun. In the context of a masquerade the costumes recall the tradition of bawdy tales, and his gesture makes his intention plain. A Turk was a popular emblem of sensuality which, with *Le sopha*, helps make the next step in the narrative appear more probable. The transvestite, who completes the sequence of disguises on the screen, may have been inspired by Amanzei's Tiresias-like role and anticipates the ironic placing of the picture of a harlot before a soldier which gives the series another bi-sexual figure.

The fourth act of Dryden's *Marriage à la mode* centres on a masquerade where the characters dance, arrange assignations, and mistake one another's identities. Rhodophil's definition of a mas-

querade may have supplied Hogarth with ideas: 'I believe it was invented first by some jealous lover, to discover the haunts of his jilting mistress; or, perhaps, by some distressed servant, to gain an opportunity with a jealous man's wife' (IV.i.122–5). The Prologue explains that a masquerade was included in the play in order to draw an audience to a remote theatre. By the eighteenth century, a masquerade was a sufficiently commonplace event in the theatre for Hogarth to reduce it to a detail. Dryden's characters were drawn to the novelty and mystery of the pastime: a woman in disguise is 'all *terra incognita*' (IV.i.140–1), but Lady Squander as the owner of the screen is attracted by an outmoded novelty which enables Silvertongue to take advantage of her naivety.

Under the influence of the music, the other members of the audience let their public faces slip. Whereas the lovers mask their intentions behind relatively bland exteriors, the others posture, grimace, or sleep open-mouthed. The private selves of Lady Squander's fashionable acquaintances are as ugly as her taste in ornaments or as the masquerade characters on her screen. As an emblem of the deceit which in the theatre is inevitably discovered, the screen raises a question about the nature of illusion: whether the illusion is the supposed reality of the levee, the lovers' moment of knowing communion, the spell of the castrato's song, or the masquerade on the screen. It is a false question in the sense that all are of similar value in a picture, which in itself is an illusion on a canvas.

The hairdresser's trade is indicated by the comb tucked into his elaborately arranged hair, which the X-ray shows to have been preposterously piled up in a bird's nest. Fashionable hairdressers in London would attend their customers in their homes at a price. The early commentators unhesitatingly identified him as a Frenchman, but Ireland was responsible for weakening the consistency of Hogarth's approach. In order to make the joke that the hairdresser is the 'complete Canton' of *The clandestine marriage* (1766), Ireland had to imply that the hairdresser was Swiss and the misidentification has persisted (George Colman's play was to draw on *Marriage à la mode*). The hairdresser concentrates on the task of testing the heat of the curling tongs and implanting what appear to be flower buds or excessively large jewels in Lady Squander's hair. The poet describes him as a 'flatt'ring, tattling, busy wretch', a reproof which seems excessively harsh until it is remembered that hairdressers were thought to be notoriously vain and talkative. Lady Squander's attendant is well-placed to pass on what he sees or hears to an absent husband. Only circumstantial evidence can be put forward to suggest that he should be regarded as a spy, but the proposition takes place under his prominent nose and he is balanced with an emblem of deceit in the screen.

THE SINGER AND HIS ACCOMPANIST

The singer is considered out of viewing order because the audience's behaviour is dependent on his song and he is the next in the sequence of character studies in various types of affectation. Hogarth presented a

French butt in the quack doctor to attend the husband and an Italian to perform for the wife. Hogarth had already referred disparagingly to the huge sums of money which were squandered on the most notorious castrato, Carlo Broschi known as Farinelli, in *A rake's progress II*. Fielding's Mrs Slip-slop hated the thought of the '*mophrodites*' singing in English opera.[6] Ireland was to complain of a '*musical mania*' among the 'greatest part of our nobility' which acted as if it had been 'bitten by a tarantula'. He lamented that the money 'lavished upon exotic warblers would have supported an army, the applause bestowed on some of them would have turned the brain of a saint'. The unnamed singer is probably a conflation of Farinelli, who had become a legend by the 1740s, and his successors, Senesino and Carestini, without being intended as an 'application' for any of them. Farinelli reputedly earned up to £5,000 a year so that the cost of hiring his equally grand counterpart and an accompanist just to sing during a levee can be imagined.

One of the least vituperative and most accurate descriptions of the castrato is found in the *BM Catalogue*:

> He is sitting in one chair, and lolling with his left arm supported by another chair which he tilts up. His person is very fat; his features are heavy and blunt; he has a vast mass of fat at his jowl, the jaw being small, and the lips full, thick, and flabby, but, apparently endowed with great mobility; his nose is big and thick at the base, with large wide nostrils; his eyes are very small, his eyebrows thick and black.[7]

Although the poet dismisses him as a 'beardless thing' and his singing as a 'eunuch's squall', he observed his costume carefully. He noted the pendant earrings, the cross which 'binds' the bow, the four rings on his fingers and the diamond buckles on his shoes and at his knees. The matching jewelry, the buckles, earrings and the pin, is typical of the expensive gifts which fanatical admirers bestowed on their favourite singers. The Italian bow, the curly wig, the frilled shirt and the trailing, heavily embroidered coat with dazzling, multi-coloured cuffs are yet more extravagances in an epitome of vanity.

It is no small part of Hogarth's ridicule that, although he conveys the glorious complacency of the singer's appearance, the presumably, contralto voice, like Silvertongue's, cannot be heard. The castrato's affectation is also ridiculed in little details: his little fingers are crooked; his feet are set one before the other with exaggerated care; his legs were thickened in the print to emphasise his grossness; the buttons and their loops at his knees fail to meet. The soberly dressed lawyer and the florid singer compare in ways other than in their silent voices: they are allowed to take up more room than their social superiors; the legs of their seats bulge beneath their weight; both possess books with erotic associations. The parallel is limited because Silvertongue's plumpness is evidence of a characteristic sensuality, whereas the singer's is that of emasculation which proves another magnificent exterior in the series to be flawed.

The flautist has been identified with an English musician, John Lewis, who was known to Hogarth, and a German, Karl Freidrich Weidemann.[8] Wilkes was to provide the probable explanation for the latter

identification; in another context, he was to refer to the 'mellow warblings of a German flute' as being more effective than a bassoon in moving the 'tender passions'. The existence of counterclaims once again implies that the flautist is a conflation of sources or a character without personal application.

The concert defines the predominant sense as that of hearing, as music does in Bosse's *Sens: l'ouïe*. The room is unexpectedly noisy in other ways: characters giggle, sip, swoon, snore and, the *raison d'être* for the inclusion of this sense in this picture, one character listens to another's whispering under cover of the music.

THE MEMBERS OF THE AUDIENCE

The music reveals the other members of the audience as a spectrum of psychological types. The foremost is a woman in white morning undress, pale blue underskirt and a straw hat with a wide brim and a flat crown. Her old-fashioned and rustic costume contrasts with Lady Squander's equally informal, but flamboyant clothes. The latter sits with easy dignity, while the 'die away' lady leans towards the singer in the unnatural pose which inspired Ireland's delightful epithet. Wilkes was to associate the elevation of both hands with an expression of superlative admiration. She would appear too overcome to raise her hands very far and the fingers of her hands extend limply, but her exaggerated rapture indicates that she is one of the gentry who succumbs to the 'musical mania'. The differences between the women, back-to-back, distinguish an English country cousin from a blasée town cousin who ignores the singer. Peter Quennell in *Hogarth's progress* (1955) refers to the die away lady's 'dead-white complexion and nearly invisible eyebrows that often accompany flame-red hair'. Hogarth combined fiery and vaporous attributes in order to present a choleric personality, the one most likely to over-respond to an Italian's 'tender' song. Her wide hoops, like the tall woman's in the preceding picture, recall those ridiculed in *Taste à la mode* so that excessive haughtiness is balanced with excessive rapture. The lady's behaviour is also mocked in the wide-eyed stare and the embarrassed grin of the African servant. The chocolate stick in the cup he holds for her is appropriately *melting*, a visual pun repeated in several ways.

The lady is customarily identified with a Mrs Fox Lane whose ecstatic cry, 'One God, one Farinelli', had made her notorious as the subject of a famous sonnet, *On a raptur'd lady* (1735). Although the identification is attractive in view of the lady's name and the rustic appearance of Hogarth's character, the existence of at least one counterclaim suggests that she too is a fiction (the poet refers to her as Lady B___b). The sleeping countryman with the riding crop and his coat comfortably unbuttoned is usually identified as the die away lady's husband, pressed into unwilling attendance at the levee. His Steinkirk tuck proves him to be old-fashioned in outlook and English in a way consistent with a phlegmatic man's disregard for the concert. Amusingly, his rubicund face is almost as deep a pink as the bed curtains.

The thin and melancholy character beside the die away lady also concentrates on the music as he waits his turn to have his hair taken

out of its curlers. His eyes, even larger than Lady Squander's, gaze absently and his outstretched leg and withdrawn elbow imitate those of the castrato in unconscious flattery. Hogarth was willing to distort the thin man's body in order to achieve the effect; his pelvis and legs, separated by the line of the songbook, do not match. The poet saw him as absurdly lean, hungry, and lethargic:

> A long, thin, gawky, awkward figure,
> Depriv'd of body, strength, or vigour;
> Dull eyes in low-sunk sockets stare,
> But all must praise his curl'd up hair;
> Musing he sits in thought profound,
> And meditates upon the sound;
> But gladder than the rest to eat
> Wisely drinks up his chocolate.

The busby behind his head and the military bars of lace on his coat have prompted commentators to identify him as a Prussian envoy.[9] Hogarth allowed the incongruities in the picture to accumulate: a frail Prussian soldier is waiting to have his hair curled by a French hairdresser in an English countess's bedroom, while he listens to an Italian castrato singing to the accompaniment of a German flute.

Nichols and Steevens took the envoy to be Lord Squander on the grounds that he, the envoy, stares at the antlers of the statuette in front of him. Hazlitt was also to note that the curl papers look like a '*cheveaux-de-fris* of horns'. But Lord Squander is a much more substantial figure, seriously and carefully treated, and his presence is otherwise always indicated by the patch on his neck, a characteristic perhaps included deliberately as a means of avoiding such misunderstandings. Both he and the envoy derive from the solemn, thin beau in *Taste à la mode* and the differences between the source and the counterpart and Lord Squander indicate the care Hogarth took to make him a credible character rather than a caricature which the others are inclined to be.

The remaining member of the audience is distinguished by an upraised hand in a gesture which denoted surprise in the manuals of acting. Hogarth was to use a variation again in his painting of David Garrick in the part of Richard III (1745). The appreciative response is spoilt by an ugly smirk and a patch on the character's lip. The fan hanging from his wrist suggests that his admiration is assumed rather than genuine and its association with effeminacy suggests that he is perhaps intended to admire the singer for his person rather than his song. His sympathy with the music in the absence of other traits marks him out as a sanguine personality.

THE BLACKBOY AND THE AUCTION LOTS

The blackboy in charge of the auction lots at the feet of the lovers is one of several fashionable boy servants in Hogarth's modern moral pictures. The boy in *A harlot's progress II* responds with naive surprise to his mistress's strange behaviour in kicking over the morning tea table. The little boy in *Taste à la mode* enjoys being tickled under the chin by his intent mistress. Lady Squander's boy is at home in a fashionable bedroom and is very well aware of the innuendo associated with the

[28] A prototype and a counterpart for the husband.

[a] The angular beau (detail) from *Taste in high life* (Illus. 2).

[b] 'The Prussian envoy' (detail) from *Marriage A-la-mode IV*. *Note:* his paper curlers (p. 110) and his arm tucked in his coat (p. 115).

[c] The bridegroom (detail) from
Marriage A-la-mode I

[d] The Viscount (detail) from *Marriage
A-la-mode III*. *Note:* the Viscount's is a
much fuller figure than either the
angular beau or the envoy (p. 110); the
patch on his neck (p. 110); the pill box
lid between his legs (p. 83).

horns of Actaeon. The directness of his communication with the viewer
not only suggests that he has exceptional awareness, but also that the
viewer should pay particular attention to the statuette and the auction
lots. Such rhetorical gestures were a familiar device in didactic art. In
Bosse's *Mariage à la ville*, for example, the father in *L'accouchement* and a
boy in *La visite à la nourrice* draws the viewer's attention to the presence
of the baby. Hogarth's blackboy regards the projected viewer as a
sympathetic conspirator who is expected to respond to an impish joke.

An open book in front of the boy's basket reads: 'A CATALOGUE of
the Entire Collection of the Late Sr. Timy. Babyhouse to be sold by
Auction'. Rouquet supplied the background information for foreign
buyers: Lady Squander has returned from one of the auctions of
'second-hand furnishings, pictures and a hundred other old tatters,
which take place so frequently in London, and where many people of
quality go to be duped'. He also referred to the auctions as affording
opportunities for unaccompanied people to meet in public without
arousing suspicion. The lovers have bought lots between numbers two
and one hundred, an indication of the time spent in the bidding room.
The purchases include a tray, a china jar and a shallow bowl decorated
with a picture of *Leda and the swan* which Hogarth attributed to Julio
Romano on no other grounds than his reputation as an erotic artist.
The statuette of Actaeon to which the viewer's attention is particularly
directed is also in the basket. What Ireland was to describe as a
'fantastic group of *hydras*, gorgons, and chimeras dire' is lined up beside
the basket. Their grotesqueness recalls that of the collection on the
chimney piece in the second picture (page 73). In the fourth picture the
child-substitutes are set at the wife's feet instead of above her head in a
miniature tableau, the ordering of which is reminiscent of Tudor family
portraits. The association of the ornaments with children is strength-
ened by their having belonged to a man called '*Baby*-house' whose
christian name, Timothy, was also a euuhemism for a child's penis.

Actaeon's story made him the archetypal cuckold as the poet was to
indicate:

> an emblem aptly made,
> To suit his Lord; Actaeon's head:
> And grinning as in's hand 'tis borne,
> He slyly points towards the horn.

The cuckold-to-be in Hogarth's series is to spy on the lovers as Actaeon
watches Artemis and he is killed as a consequence of his own action as
Actaeon is torn to pieces by his own hounds. The weapon hand of the
statuette is broken off, another sign of impotence and an ironic
prefiguration of the husband's defeat in the duel. The statuette also tilts
backwards as if a comic pre-enactment of his collapse.

The grouping of the lots in and around the basket offers another
periphrastic sequence of significant objects: china jar + bowl +
statuette→collection of freaks. The title page of the catalogue provides
an ironic gloss on the sequence. The old Earl, the only character to have
died as yet, is 'late'. He is proud of his pedigree and 'Babyhouse' is a
witty synonym for a family dynasty. The Earl has 'sold' his 'Entire

Collection' to the highest bidder, the Alderman. A 'Sir Timothy Treat All' was a current synonym for a foolish spender and Hogarth was to use 'Sr.' as an abbreviation for *Sir* in *The analysis*. The Earl, so the gloss runs, is responsible for putting his son (the china jar), his bride (a compliant Leda) and a lawyer (Jupiter in the guise of a swan) in one basket. The consequence of the purchase is a broken cuckold, an adulterous wife and a deformed progeny. The line of descent concludes with a mouse which, unlike the child of the marriage, however, is positioned to run away. A detail in Fielding's *The historical register* (1737) could have encouraged Hogarth in his personification of the auction lots. In Act II, the *beau monde* bids not for material objects, but for a 'curious remnant of political honesty' (Lot 1), small quantity of 'true French modesty' (Lot 3), and so on.

ELEMENTS OF THE SETTING

THE NOTES OF INVITATION AND COLLEY CIBBER'S PLAY, *THE PROVOK'D HUSBAND*

The scattered notes beside the singer read, in what Swift disparagingly dubbed 'beau spelling', as follows: 'Lady Squanders Company is desir'd at Miss Hairbrains Rout'; 'Lady Squanders Com is desir'd at Lady Heathans Drum Major on next Sunday'; 'Ly Squanders Com is desir'd at Lady Townlys Drum Munday next'; 'Count Basset begs to no how Lade

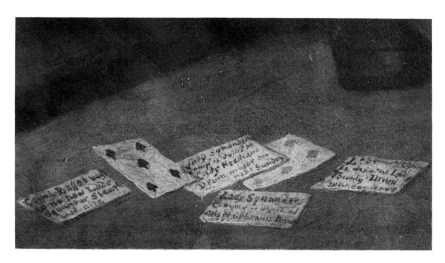

[29] The visiting cards (detail) from *The toilette (Marriage A-la-mode IV)*

Squander [in the painting] sleapt last nite'. Visiting cards were often improvised on the backs of playing cards so that those on the floor may have been meant as more invitations rather than signs of recent gaming. The repetition of the courtesy term, 'desir'd' is an ironic accompaniment to and a comment upon a situation in which Lady Squander's company is being desired in a way other than that intended in the cards.

A Lady Townly and a Count Basset are characters in one of the most popular comedies of the period, Colley Cibber's revision of Vanbrugh's *A*

journey to London, retitled *The provok'd husband* (1728).[10] The play was performed over eighty times in twenty-six seasons and over twenty performances took place between 1741 and 1744 so Hogarth could not have failed to know of it. The other type names referred to in the notes could have been drawn from other popular plays of the period, but a search has failed to find them. It is probable that Hogarth made them up for the sake of the jokes in the invitations. Lady Heathen has her drum on the predictable day and, appropriately, the most scatterbrained acquaintance forgets to name a day.

In *The provok'd husband*, Sir Francis Wronghead comes to town to seek preferment as Member of Parliament for the 'famous borough of Guzzledown', a name Hogarth was also to use for his borough in the *Election* series. A 'mask' identifies the characters at a masquerade in Lady Townly's house: 'There's Lady *Ramble* – Lady *Riot* – Lady *Kill-Care* – Lady *Squander* – Lady *Strip* – Lady *Pawn* – and the duchess of *Single-Guinea*' (V.i.). Lady Squander neither appears nor is her name repeated in the play. If it were not for Hogarth's references to Lady Townly the heroine, Basset the villain, and to Guzzledown, the conclusion of a reference to a Lady Squander would have had little significance, but the combination of references, together with the fact that Cibber was a popular target for satirists, especially for Fielding in *Shamela* and *Joseph Andrews*, makes it likely that Hogarth was making deliberate reference to a well-known play. *The provok'd husband*, therefore, is worth considering as illuminating context for *Marriage A-la-mode*.

The main plot is constructed around a running argument between Lord and Lady Townly over her rakish way of life. Her catalogue of the daily round anticipates Lady Squander's enthusiasms. Lady Townley enjoys gambling and she also invites both men and women to her levee in the absence of her husband. Her thought of a flirtation with a 'pretty fellow' not only anticipates Lady Squander's *affaire*, but also recalls Doralice's encouragement of Palamede in Dryden's play. But, while neither of these adventurous characters pursues the idea seriously (Lady Townly is never allowed to talk to a man other than her husband), Hogarth's heroine fails to acquire a sense of responsibility and catastrophe results. Lord Townly, like Rhodophil and unlike Lord Squander, declares that he married for love. Like Rhodophil, he is only a latent cuckold whose wife is in love with the idea of a fashionable life and not with a particular man. Lord Townly differs from Lord Squander in that he chose his bride for himself instead of having her forced on him. In so far as Lord Squander's initial dislike is for a low-bred bride, the moral is that an arranged marriage is likely to succeed if the prospective husband chooses a bride for himself. Lord Squander is to discover a pride in his marriage only when it is too late to master his hitherto neglected wife. The poet disapproved of women who 'run lewd', but was tolerant of an erring wife if a husband failed to set her a good example. Cibber's Epilogue also makes a plea for the sympathetic reception of a reformed wife, in a play at least.

Cibber placed most of the responsibility for the potential breakdown of the marriage on Lady Townly, but Hogarth widened his circle of responsibility to include the husband, a gallant and both parents. Lady

Townly is supported by a sympathetic family and understanding friends. The aptly named Lady Grace and Mr Manly offer advice at every turn, but Lady Squander's isolation and vulnerability is hinted at in the suggestive tone of Count Basset's note. His name is a variation on the Italian card game faro, in which bets are laid on upturned cards. It is a risky game because stakes are easily and quickly raised. Since squandering is the inevitable accompaniment to the game, Cibber's count and Hogarth's countess are well-matched. In the play, Basset is a cardsharp, a dissembler who plays one gullible woman off against another, and a confidence trickster who has no right to his rank. The allusion to the game had social implications: the paean to whist quoted in the second chapter refers to Basset's popularity with the 'city dames' and not with the ladies of the court who preferred ombre and quadrille (page 61). Lady Squander's origins show in her choice of a low-life picture on the screen, ugly acquaintances and a game. Count Basset's intimate question suggests that he regards himself as a suitor. If Silvertongue were to fail, then a notorious successor awaits his turn.

The references to Dryden's and Cibber's plays align *Marriage A-la-mode*, a tragic work, with the dramatic tradition of sentimental City comedy. Hogarth's characters exist in a moral vacuum within the bounds of the series, but the references call into mind more kindly views of marriage in other works by other writers against which the tragedy can be set. Having lashed the 'follies' of marriage, as Cibber called them, Hogarth, a fair-minded and happily married man, did intend to give it its 'due econiums' in *The happy marriage*, even if the intention was not realised.

THE INTERIOR PICTURES

The cedar-panelled walls of the bedroom are decorated with four large pictures: a portrait of Silvertongue (possibly after Vanloo) is set immediately above a *Ganymede and the eagle* (after a sketch by

[30] The origins of an allusion: *Ganymede and the eagle*. These pictures show the stages in the development of an example of Hogarth's allusive technique.

[a] *Ganymede and the eagle*, drawing after Michelangelo (Royal Collection, Windsor). Michelangelo's sketch is known only through copies in the Fogg Museum and the Royal Collection (above). It is unlikely that Hogarth knew of these versions.

[b] *Ganymede and the eagle*, engraved by Quirin Bol, after Michelangelo. Of the several engraved versions known to the BM, Bol's is the closest to Hogarth's designs (Illus. 30d). Bol was a Flemish engraver who worked with David Tenniel. The derivation of the landscape is not known.

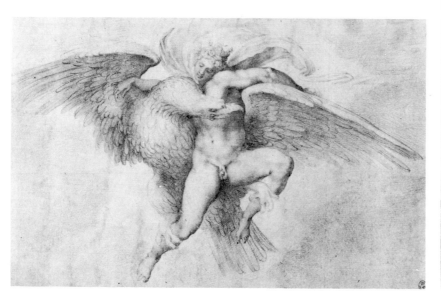

Michelangelo). Two pictures in matching frames hang above the lovers: a *Jupiter and Io* (after Correggio) above Lady Squander and a *Lot and his daughters* above Silvertongue (from a painting then attributed to Caravaggio, but now known to be by Bernard Cavallino).

SILVERTONGUE'S PORTRAIT AND THE 'GANYMEDE' The Earl's likeness is a flattering view of his youthful self, but his daughter-in-law's is a faithful likeness of her favourite. His portrait hangs shamelessly in her husband's house beside her bed at a level customarily reserved for gods, heroes and angels. 'Jupiter *furens*' is replaced by a Silvertongue *concupiscens* who eyes the nymph in the picture opposite instead of Medusa.[11] The substitution is particularly appropriate to a situation involving a masquerade because, as Sheridan was to point out, Love had been a masquerader since the days of Jupiter.

Silvertongue's likeness has his hand tucked in his coat, a mannerism anticipated in that of the tired servant in the second picture and repeated in the envoy's pose below. Hogarth was to use the mannerism again in *Industry and idleness XI* where the gingerbread seller, Tiddy Doll, also has his hand in his coat. He was known for affecting the white and gold lace clothes of a person of rank. Similarly John Broughton's portrait shows the champion pugilist of England in such a pose. The mannerism would appear to have been associated with pretension and bravado, qualities absent in the feeble envoy and Counsellor Silvertongue who is to beat a panic-stricken retreat in the next picture.

The poet suggests that Silvertongue's portrait is in the manner of the French portrait painter, Jean Baptiste Vanloo, who had come to England in 1743 and whose work had become the rage in fashionable circles. His success caused envy and some hardship among his English competitors. Hogarth himself may have been forced to leave off portrait painting in 1742 because of Vanloo's success. Hogarth's contempt for the Frenchman's furious output was to persist long after his death in 1745: Vanloo was to be associated with 'brazen serpents' in the *Autobiographical notes*.[12] There is no internal evidence on which to base the attribution, but it is apt because Vanloo was just the sort of expensive 'face-painter' that Lady Squander might have been expected to patronise. Cleaning shows that in comparison with the Countess's other pictures, Silvertongue's portrait is particularly flat. Hogarth may have had personal motives for making the picture of his lover-villain look like a Vanloo. A parody in miniature is a kind of revenge and a demonstration of superiority.

The *Ganymede* is positioned as if to suggest that the eagle is flying the boy up to Silvertongue, in the position of a Jupiter. The ornate, arrow-like knot surmounting the frame overlaps the portrait as if to emphasise the connection. The immediate source is again the *Marriage contract* oil-sketch of 1733 which contains the *Ganymede* as a picture among the other *bric-à-brac*. Both are derivations from Michelangelo's sketch, several engraved versions of which were available to Hogarth (caption to Illus. 30). The eagle's prominent beak threatens the boy's genitals, a gibe at the castrato which prompted Lichtenberg to suspect that the

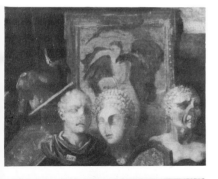

[c] Ganymede and the eagle (detail) from *The marriage contract* oil sketch (Illus. 1). *Note:* the line of the plinth belonging to the headless torso may have given Hogarth the idea for the flute (Illus. 30d).

[d] Ganymede and the eagle (detail) from *Marriage A-la-mode IV. Note:* the eagle's beak angled to threaten the boy's genitals (pp. 115–116); the prominent talons are replaced by the flautist's hands.

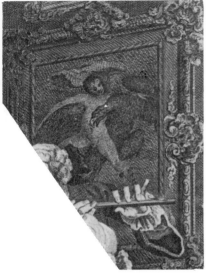

eagle would have the singer too. The placing of the eagle behind
Ganymede parallels that of the flautist behind the singer, a parallel
strengthened by the similarity between the bird's hooked beak and the
flautist's hooked nose. The analogy is extended by means of the eagle's
talons which grasp the boy's leg in a parody of the way the flautist
fingers his instrument. The latter, metaphorically, lifts the castrato's
song to the level of the gods as Ganymede is lifted by the bird. A
spreadeagled Ganymede (the pun may have been in Hogarth's mind) is
one of a sequence of vulnerable infants in the series which begins with
the appearance of the martyrs in the little interior paintings in the first
picture and includes that of the monstrous infant in the quack doctor's
laboratory. The sequence continues with the figure of the threatened
child in the mural of the fifth picture (page 134) and ends with the
person of the deformed child in the last. The allusions to Prometheus,
Ganymede, and Actaeon warn of the fates of youths who experience the
arbitrary and destructive power of the gods. In the manner of classical
tragedy, the warnings go unheeded by the characters.

'JUPITER AND IO' AND 'LOT AND HIS DAUGHTERS' Hogarth's copy of
Correggio's painting of the naiad seduced by Jupiter in the guise of a
cloud is an accurate rendering of the original in terms of its contents,
proportion and colouring.[13] The similarity is astonishing in view of the
fact that Hogarth's source was an (unidentified) copy of an original he
could never have seen.

The blackness of the cloud in Correggio's picture in the context of
Hogarth's series acts as a clever variation on the lawyer's black gown
and the god's disguise coincides with Silvertongue's role as a secret
lover and a dissembler, although at a commonplace and fallible level.
The bent head of the hind in the bottom corner of Correggio's picture
becomes an emblem of the naiad's submissive role which in the context
of Hogarth's picture implies that acquiescence is an attitude which the

[31a] *Lot and his daughters*, date
unknown, Bernardo Cavallino (private
collection).

[b] *Lot and his daughters*, engraved as a
Caravaggio by Louis Guernier (British
Museum, London). The print was
dedicated to Lord Halifax. The painting
was in the Halifax sale (March 1740)
when it could have come to Hogarth's
attention.

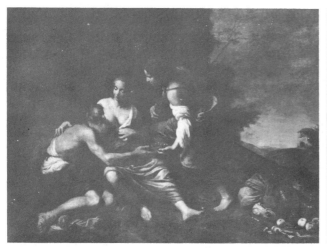

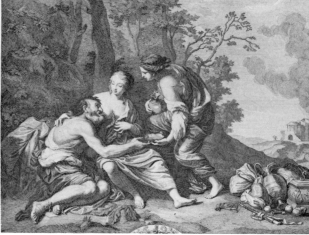

owner, Lady Squander, admires in a woman. The hind's antlers, in conjunction with Actaeon's, acquire an association with adultery to balance with cuckoldry. The urn beside the hind acquires significance in relation to the china jars associated with the bridegroom (the first picture and the black boy's basket).

Perhaps the most important in the series of significant coincidences which lies behind Hogarth's inspired choice is the inclusion of the elements of air and water combined in the love of a cloud for a naiad. The combination was traditionally associated with love because Aphrodite was supposedly conceived of the foam of the sea. The concert also provides an association with airiness and passionate feeling, and a moment of harmony for the only time in the series. Warmth is implicit in the heat of the curling tongs, the melting chocolate, the presence of a protective screen and the African servants. The atmosphere in Lady Squander's bedroom is moist and warm, indicative of her sanguine temperament, a personality also reflected in the soft pinks and golds of her clothes. The predominant humour is psychologically right for the wilful daughter of a stolid father who marries into a choleric family. Sanguine personalities were often the victims in Renaissance tragedy because they were regarded as hopeful, courageous and trusting, and therefore vulnerable to the machinations of the villainous. Her temperament accounts for lady Squander's impatience at her betrothal, her willingness to respond to a flattering approach, and her disregard for her husband's melancholy. In the fourth picture, her temperament helps to account for her neglect of her child, the irresponsible display of her favourite's portrait, and her heedless acceptance of a proposition under the nose of a hairdresser.

Counsellor Silvertongue, whose name associates him with speech, air, the moon and night, is of the same temperament. Contemporaries would have recognised that, where the lovers are concerned, like is drawn to like, while a sanguine wife and a melancholic husband are joined incompatibly in marriage. An *affaire* may have been regarded as inevitable since sanguine people were believed to form the strongest bonds of affection. The sanguine personality seems to have approximated to the ideal type in Shakespeare's plays and Hogarth's elevated treatment of his lovers' moment of ecstasy would suggest that in his sardonic way he thought this was so. A superabundance of blood, however, was believed to turn people towards a melancholy characterised by deceit, lust and passion. An excess of blood accounts for the lovers' desire, lack of foresight, Silvertongue's determination on a secret assignation and Lady Squander's resort to suicide at the end.

The picture of *Lot and his daughters* (caption to Plate 31) hangs beside the *Jupiter and Io* and directly above the figure of Silvertongue. The association of Silvertongue with Lot points the warning that the lawyer is to be betrayed by his patroness as Lot is patronised by his over-friendly daughters. They come to their father in the role of lovers intent on preserving their dynasty, whereas the children in *Marriage A-la-mode* betray their fathers' intentions by taking a mistress and a lover outside marriage. The reference to incest draws attention to the means

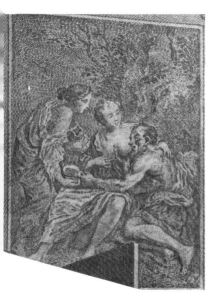

[c] Lot and his daughters (detail) from *Marriage A-la-mode IV*. *Note:* Hogarth's omission of the landscape (including Sodom burning) and the still life to the right. The face and hands of Lot's daughter are much more sensual in Cavallino's painting than in Guernier's print.

whereby an aristocracy based on primogeniture is threatened from within by an act of profound subordination. The characters fail to note another warning, namely, that if the just and righteous man of the Old Testament is fooled by his own family, then they, a family of modern squanderers, need to take far greater care.

Lot, the father, is represented in the comfortable attitude of a suckling child, a father–lover–baby to his daughter–mistress–mother. The daughters vie for his attention in the manner of the harlots in *A rake's progress III* who also make the Rake drunk in order to steal from him. By means of a transposed pun, the auction lots in the Babyhouse collection, numbers 4, 7 and 8 among them, are the comic equivalents of the hapless progeny to which Lot's daughters gave birth. The picture of Lot and his daughters, along with the mural of *The judgement of Solomon* in the fifth picture (pages 134–6), provides a key to the multiplicity of shifting analogies which underlie the narrative through which doubts are raised about the notion of fixed identity. Significantly, *lot* in Old Hebrew means a *veil*.

Hogarth omitted the view of Sodom which burns to one side of the original picture. The knowledgeable subscriber was invited to appreciate that the picture of the seduction of a naiad by a cloud, and perhaps by extension the fashionable bedroom itself, substitutes for the biblical exemplar of urban wickedness. The tactic is the same as that in the first picture where the view of Pharoah drowning replaces a vision of heavenly pity in Domenichino's *Martyrdom of St Agnes* (page 47).

The stories behind the interior pictures, including that of Leda on the bowl, are concerned with victims whose experiences of rape or seduction lead to emnity and suffering. Io was to be the mother of Epaphus, the mythological founder of Egypt and another enemy of Israel, one of whose descendants, the Pharoah, presides over the first picture of the series. Lot's daughters gave birth to the Moabites and Ammonites, other enemies of Israel. Leda's eggs hatched personifications of love and war. The original artists preferred to ignore the fateful consequences of the stories and to concentrate on the pleasurable moments. Lady Squander's selection implies a similar short-sightedness in her and a propensity to self-delusion. She has inherited her father's interest in pictures, but her taste is influenced more by her father-in-law's preference for biblical and classical subjects. Her pictures are less crowded and bloody than his, but sexually more explicit. The inappropriateness of her taste can be judged by comparing her choice with the list of subjects which de Lairesse thought fit for a lady's visiting room: fruit, flowers, landscapes, fine thoughts, virtuous representations and 'the most clothed and modest histories'.[14]

THE VISUAL ORGANISATION OF THE PICTURE

A soft light falls into a shadowy picture, again from the left. No windows provide alternative sources of light and the clothes are mostly fashionable pastels so that the overall tone is subdued with the exception of the glowing pink curtains. The delicate, flowing textures of

the women's garments are tonally appropriate to a picture which represents the effects of a love song on its hearers.

The fourth is the most crowded picture of the series; ten characters parade in a compact line across its width. An eleventh, the black boy at the feet of the lovers, substitutes for the game dogs in the first picture. The parade is organised around a series of largely vertical pairings: the lovers are insulated in their oval shape to one side. The screen and the hairdresser connect with them in an above-and-below relationship which is repeated in that of the African servant and the die away lady. The back to back pairing of the two women and their exotic attendants not only creates a hiatus between the lovers and the rest of the audience, but also makes the relationship between the women an antithetical one. Further along the parade, the die away lady balances with the envoy, the two people who respond most deeply to the music. She leans towards him in a more or less face to face relationship and his foot overlaps her skirts. The countryman and the man with the fan are set framed between them. Attention is drawn to the antithetical function of this pairing through the Janus-like overlap of their heads. The envoy's stance is an ironic reflection of the singer's and the above-and-below relationship is repeated in the positioning of the flautist who looms over them both. The pattern is repeated in the miniature tableau at the lovers' feet. The blackboy oversees the objects, some of which in turn stand, lean, or crouch over others.

A series of underlying motifs connects apparently disparate details across the width of the picture. The withdrawn elbows of the singer, the envoy and the countess offer an impression of shared negligence. The elbows interact with the outspread arms of the die away lady and the lawyer to create a see-saw rhythm. A motif of distinctive noses dances across the picture. It begins with the hooked nose of the punchinello, is transferred to the hairdresser, and then to the flautist and the eagle's beak. Lady Squander is overlooked by her husband's spy or *nose* (the term may have been current) as attentively as the singer or Ganymede is overlooked by the flautist and the eagle. In contrast, the lawyer's and the countess's *retroussé* noses are linked with the singer's thicker one to provide an underlying association between the singer and the recipients of his song. These alliterative effects and others, like the *melting* chocolate being offered to those most moved by the music or the punning on the word, *lot*, supplement the pairings and give the parade its underlying comic unity.

CONCLUSION

The third and fourth pictures depict the separate pleasures of the married couple, the husband abroad and the wife at home. Both show the consequences of the unhappy marital situation in the second picture, but the events in the third picture seem to follow on more immediately from those of the second than do those of the fourth. The temporal link between the second and the fourth pictures is made more tenuous partly by the constraints of a monolinear structure and partly because the development between the two is a matter of psychological and social enlargement: the wife's sideways glance at a withdrawn

husband, for example, changes to the joyous contemplation of an attentive lover and her undisciplined stretch to a mannered pose. The relationship between the pictures represents a form of reflexive symmetry: the third is mock-elegaic in tone because it marks the end of the husband's *affaire*, whereas the fourth is mock-ecstatic because it marks the approach to the wife's. Her downfall is to succeed a zenith of social success so that in consequence she is pathetically unprepared for catastrophe, whereas her husband, who has undergone the experience of a hell on earth, seems grimly prepared. The antithetical function is strengthened by the presence of counterparts for the absent partner in each, the common miss for the wife and the envoy for the husband. In addition, the French quack and the Italian castrato act as contrasting studies in affectation. The counter-movement is sufficiently marked to suggest that it might be worth hanging the third and fourth pictures in parallel (see diagram). Hogarth claimed that 'ocular demonstration carries more conviction to the mind of a sensible man, than all the world could find in a thousand volumes'. This rearrangement might be the best answer to the objection that the third picture is episodic and might offer a reminder that the structure of *Marriage A-la-mode* is based on a situation and not a personal history.

Silvertongue is returned to the series to direct the Countess's attention towards thoughts of adultery and to conduct her through the sequence of undisclosed events which lead to the crisis. The bed arch dominates the background of the fourth picture: what appears to be only a sprig of acanthus in the print is a *fleur de lys* in the painting, a modification which Hogarth may have thought prudent to make in view of the war between France and England. Lichtenberg was to wonder in mock innocence what the French emblem was doing on an English bed (a shocking thought to staid contemporaries). The situation in the fifth picture is Hogarth's answer – a consequence of *le mariage français*.

NOTES

1 De Lairesse, p. 50. Hogarth's design for the ticket is unclear and some overpainting suggests indecision. His difficulty may have been due to the fact that many tickets were finely decorated in a way which did not lend itself to reproduction in miniature.

2 Quoted in Anne Buck, *Dress in eighteenth century England* (London, 1979), pp. 34–5.

3 LeBrun, Figure 15 and p. 34.

4 'Crébillon fils' (Claud Prosper Jolyot), *Le sopha*, translated and introduced by Bonamy Dobrée (London, 1927).

5 *The analysis*, p. 159.

6 *Joseph Andrews*, p. 34.

7 *BM catalogue*, p. 569.

8 *National Gallery catalogue*, p. 53 and note 65. Lichtenberg called him 'our countryman' (p. 119). Wilkes, p. 111. Peter Quennell, *Hogarth's progress* (London, 1955), p. 175.

9 Lichtenberg (p. 119), followed by the *BM catalogue* (p. 570), and Paulson, *HGW I*, p. 273. The inevitable counterclaim associates him with Lord Tylney (*Anecdotes of Hogarth*, p. 215).

10 Sir John Vanbrugh and Colley Cibber, *The provok'd husband; or, a journey to London* (London, 1728) in *Three centuries of drama 1701–50* (microfilm), edited by Henry H. Wells.

11 Paulson's felicitious phrase, *H.I.*, p. 485.

12 *Autobiographical notes*, p. 217.

13 Correggio's *Io* is reproduced as plate XV, *Correggio*, Masters, 34, ed. Kurt W. Foster (Knowledge Publications, 1966). The original is in the Kunsthistorisches Museum, Vienna.

14 De Lairesse, p. 395.

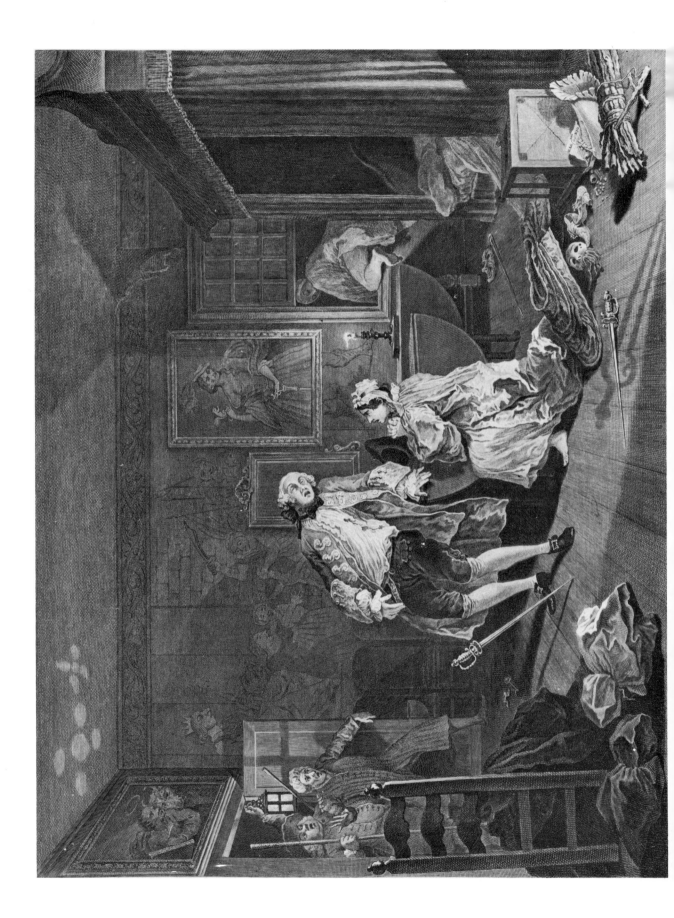

V

The bagnio

The interval between the fourth and fifth pictures carries so much undisclosed information that it is necessary to set out the implicit steps in the narrative. The lovers, having agreed to a rendezvous, have met. The poet assumes that they have attended the public masquerade at the Opera House. He imagines them to have taken a 'round or two/The diff'rent characters to view' before going on to the bagnio. The bedroom has been hired for the night because the master of the house has been roused from his bed by the noise of the duel. The room has not been used for its other purpose as a dining room because the leaves of the gatelegged tables are folded down and they and the roundback chairs are pushed back against the wall. The lovers had locked the door on the inside because the key and the burst lock lie on the floor inside the room. The well-burnt candle suggests that they have been there for some time. The X-ray shows that light once shone beyond the window as if Hogarth had in mind to suggest that dawn was breaking.

Meanwhile, it is to be assumed, Lord Squander has learnt of the assignation, perhaps through the agency of a spy like the hairdresser. He has sought out the lovers with the intention of forcing a duel on Silvertongue because he brought the matching épées with him. He has broken down the door and has surprised the lovers in flagrante delicto. The confrontation, challenge, and the choice of weapons would appear to have taken sufficient time for the master of the house to have summoned the constable. The duel seems to have been a clumsy, short-lived affair because Lord Squander appears to have fought with the firelight in his eyes. Silvertongue's inexperience shows in that he has killed rather than maimed his opponent. The essential moment is represented as happening just after the fatal sword thrust because Silvertongue has had time to flee to the window. The inference to be drawn is that in his fear he tries to escape from an upper window and so is to be quickly cornered and arrested.

The picture is remarkable in its revelation of narrative depth. Its complexity can be judged from the fact that it presents the evidence of three separate sequences of events involving the lovers, the husband and the witnesses.

2] *Marriage A-la-mode V (The bagnio)*, engraved by B. Baron, after William Hogarth (Whitworth Art Gallery, University of Manchester).

THE CHARACTERS

LORD SQUANDER AND THE MIRROR

Duelling was still a means of settling quarrels between gentlemen in the middle of the eighteenth century, although the pistol had come to replace the sword as the preferred weapon.[1] For all his smartness of dress, Lord Squander chose outmoded weapons, those most appropriate for a descendant of the Duke of Normandy, but which require a dexterity and a quickness he lacks. Hogarth turned the old saying upside down; the man of words proves mightier with the sword than the man who has a right to a sword by birth. Although Hogarth was reputed to swagger about town wearing a sword, his attitude to duelling was as enlightened as that of Addison and Steele; they saw it as a self-destructive folly.

Lord Squander is shown on his feet, although leaning for support on the table behind him, for the only moment in the series; Hogarth raised him up in order to emphasise his downfall. His figure is enlarged in a way which anticipates a cinematic close-up and the details of his suffering are brought into sharp focus in the powerful 'flood' of the firelight. His expression approximates to LeBrun's twin passions of *Extream bodily pain* and *Acute pain* except that the tightness of the features in LeBrun's example is more relaxed in Hogarth's character.[2] His face glows in the firelight, a colouring which, for Wilkes, was consistent with the passions of dread and fear.

Lord Squander's hat and épée are suspended in mid-air like the maiden's apples in the outdoor version of *Before* or Sarah Young's workbox in *A rake's progress IV*. In their differing ways, they signify

[33a] *Extream bodily pain* and *Acute pain* after LeBrun (Illus.9) *Note:* Alastair Smart has drawn attention to LeBrun's debt to the *Laocoön*. The derivation casts doubt on LeBrun's reputation as an observer of human behaviour.

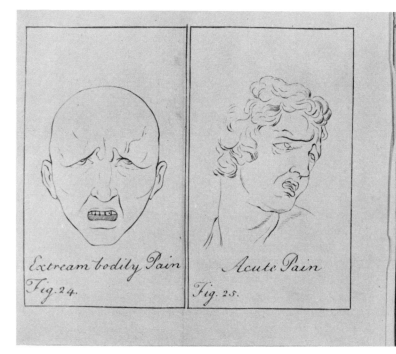

BODILY PAIN.

IF Sadnefs be caufed by a fenfe of Bodily Pain, and that Pain be acute, all the motions of the Face will appear acute : for the Eye-brows will be ftill more elevated than in the preceding Paffion, and come nearer to each other ; the Pupil will be hid under the Brow ; the Noftrils rifing up and forming wrinkles in the Cheeks ; the mouth more open than in the preceding Action, and more drawn back, making a kind of fquare figure. All the parts of the face will be more or lefs full and diftorted, in proportion to the violence of the Pain.

irreversible change. The empty crown of the hat is positioned close to Lord Squander's head. Its empty *O* mocks at the open mouths of the couple and reinforces their silent cries of suffering and remorse. Hogarth may have had Antony's speech in mind as a source for this special effect of synaesthesia in view of the bright blood on Lord Squander's shirt:

> Woe to the hands that shed this costly blood!
> Over thy wounds now do I prophesy
> (Which like dumb mouths do ope their ruby lips
> To beg the voice and utterance of my tongue).
> (*Julius Caesar*, III.i.259–62)

Ann Gill's wounds in *Cruelty in perfection* were to be a closer rendering of Shakespeare's multiple image. The crisis picture in *Marriage A-la-mode* is a consummation of the emphasis on physical sensation in the series: the hat *cries* out on its owner's behalf; the agony is *felt*; the eyes *stare*; the brawl has been *heard*. Only a sense of taste is missing, reserved for the resolution of the series.

Lord Squander's heavy coats would have hampered him in the duel unlike Silvertongue's lighter garment. The bars of lace are similar to those decorating the envoy's coat in the preceding picture, as if the man of mode has affected the supreme vanity of wearing a military coat for a duel. The blue-grey coat, the pale shirt and the black breeches are appropriately sombre shades for a crisis which leads to the death of all the main characters. Silvertongue's shirt is the same colour so that the rivals appear brothers under their outer clothes, a fulfillment of the prophetic implications of the interior picture of Cain and Abel in the first picture.

Hazlitt viewed Hogarth's treatment of Lord Squander's collapse unfavourably: 'the attitude of the husband, who is just killed, is one in which it would be impossible for him to stand or even to fall. It resembles the loose paste-board figures they make for children'. Joseph Burke, the editor of *The analysis*, in his introduction to *Hogarth, the complete engravings* (1974), sees the pose as 'an exquisite parody of the rococo serpentine line of grace', a recent view which also casts doubt on the naturalism of the pose.[3] The X-ray shows Hogarth to have changed the position of the Earl's head and legs and his body may have been twisted at a slightly different angle; signs of a difficult problem. The charges have to be answered because they suggest that Hogarth failed to confine burlesque only to his 'diction' at the most critical moment of his series. In his own defence he could have advanced the arguments that Lord Squander is well-established as being of ungainly physique and that he would therefore be likely to collapse awkwardly rather than fall. It should be remembered that the example of the contemporary theatre would create an expectation of the highly stylised enactment of an event which would be treated much more naturally in the twentieth century. There is little reason to suppose that the contemporary viewer would have regarded Lord Squander's dying as unnatural. Hogarth was one of the few men to have made the imaginative effort to reconstruct the suspended effect of a physical collapse. He even appreciated that the suspense of 'even the most

[b] Lord Squander dying (detail) from *Marriage A-la-mode V*. *Note:* the recurrent patch on his neck; the placing of the mirror behind his head.

elegant dancing' appears 'unnatural and ridiculous'. The pose is neither more nor less stilted than those in photographic stills from realistic films or plays.

Hogarth positioned the mirror on the wall behind his character's head as if to suggest that it is framed. The immediate source for this curious arrangement is in *Taste à la mode* where the shorter woman's head is also set against a mirror. Her attempt to make herself look beautiful is thus a caricature of the beauty which a mirror is traditionally supposed to reflect back at a viewer, especially one surmounted by a venus shell. Lord Squander's head is framed in a mirror surmounted by the same emblem as if to confirm that he dies as a result of a more serious, but comparable, vanity.

The reflection in the pier mirror beside the bridegroom in the first picture is that of the victor in the duel. In fulfillment of its prophecy the vanquished husband, who is placed not to see the warning in the pier mirror, is shown at his death in the process of, metaphorically, becoming a reflection of his own portrait. His father's portrait is surmounted by a lion's head set in a venus shell, but the son's anti-portrait and ironic epitaph is surmounted by the shell alone. It is set beside the picture of a harlot hanging immediately above his repentant wife. The sleight-of-hand with the mirror is such that Lord Squander's head substitutes for the viewer's reflection as he looks into the picture. In that a viewer is anyone or everyone, Lord Squander at his death is again a representative of Everyman as he can be seen in the third picture. 'Sooner or later the time will surely come when your mirror will look back at you like this one', warns Lichtenberg. The device invites the viewer, vicariously, to enter into a closer relationship with a character and to consider his affectations as a reflection of his own. Hogarth's device is a literal enactment of Fielding's declaration of purpose in *Joseph Andrews*: 'to hold the glass to thousands in their closets, that they may contemplate their deformity, and endeavour to reduce it, and thus by suffering private mortification may avoid public shame'.[4] In case a viewer should chance to feel superior in consequence of his detached position as an observer, the harlot in the picture on the wall beside the mirror leers in the viewer's direction; the permanence of her gaze seems to deepen her worldly knowledge – of him.

The occasion of a character's last appearance provides an opportunity to review his contribution to the narrative. Lord Squander's characteristic traits of indifference, depression, irascibility, latent suspiciousness, bad luck and perverse pride are consistent with black choler, the most miserable kind of melancholy. His physical ungainliness and modish clothes make him a pathetic and ridiculous character in the profound meaning of the term. His preference for pastels and blacks reflects his temperament, an appropriate humour for the inadequate son of a choleric father. His melancholy is deepened by his idle existence and his debilitating diseases. He is forced to marry a low-bred woman of sanguine temperament whose energy he cannot match. In spite of his fastidiousness, which events prove to be affected, he patronises a frail and phlegmatic street girl, a *mésalliance* which could

[34] Satirical masquerade ticket, 1727, William Hogarth (British Museum, London). *Note:* Heidegger's face appears on the clock face; compare the dancers with those on the lady's screen in the fourth picture.

only be miserable. His empty gesture on her behalf brings only scorn and derision from the quack doctor and his haughty partner.

The melancholic was believed capable of oscillating between the extremes of periods of depressed, but not phlegmatic, quiet and moments of choleric violence which could turn towards madness. The early pictures in the series show Lord Squander in a quiescent, but potentially dangerous mood which threatens to erupt in the third picture. He only discovers a sense of honour when his cuckoldry is in danger of becoming public knowledge. His false pride forces him into a drastic and outdated solution to a marital problem, the consequence of his own potentially explosive temperament. He is the solitary character of the series, a scapegoat, framed in a mirror at his death as a martyr for everyman. The openness of his clothes as he dies demonstrates the truth of man's fallibility under a modish exterior.

LADY SQUANDER AND THE PUBLIC MASQUERADES
In 1713, John James Heidegger had taken over the management of

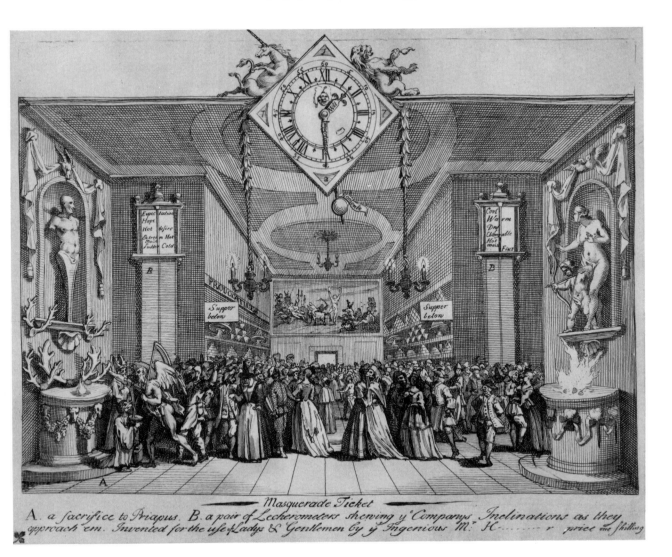

Masquerade Ticket

A. a sacrifice to Priapus. B. a pair of Lecherometers shewing y.e Companys Inclinations as they approach 'em. Invented for the use of Ladys & Gentlemen by y.e Ingenious M.r H————r price one shilling

the Opera House in the Haymarket. As a means of making it pay, he introduced a regular programme of public masquerades to alternate with the unprofitable operas. Admission was by ticket, so women could attend unchaperoned. The masquerades often lasted from nine at night until seven in the morning. The mask on the Harlot's toilette (*A harlot's progress II*) suggests that she has been caught with her lover by her keeper on the morning after attendance at an all-night masquerade.

Hogarth's satirical *Masquerade ticket* (1727) reveals his dislike of and fascination for Heidegger's entertainments. The grotesque masks in the sketch on the ticket draw attention to the animalism of the masquerades. It includes an altar to Priapus decorated with the goats' horns of lust and the antlers of cuckoldry. A pair of 'Lecherometers', supposedly invented by Heidegger, measures variations in the air pressure of desire. A clock shows the time to be half past one in the morning with hands marked 'wit' and 'impertinence'. Hogarth's followers could have had little doubt that Silvertongue's proposition is equally impertinent and lecherous. The public masquerades were doubly disliked because they shared the same building with the Italian opera. The association would have made it more probable that a countess who hires an Italian contralto to sing for her would also agree to attend a masquerade.

Most of the clothing scattered about the room is Lady Squander's disguise. Its identity does much to establish the sequence of events leading up to the visit to the bagnio. She wears a pale blue bed-nightgown, the colour of which echoes the deathly colours of her husband's and her lover's shirts (significant similarities regrettably absent from the print). In Queen Anne's time, it was fashionable for 'night rails' to be worn over day clothes so that Lady Squander's undergarment could have served the double purpose of a disguise and a bedgown without drawing attention to its wearer. The long, pale gold overgarment is part of her domino, the loose, originally Venetian cloak which was worn to masquerades by people who preferred not to attend in character. A large fringed curtain-mask lies beside the hooped petticoat. Lady Squander's cap with a (shocking) pink tie, like the bedgown, could have doubled as a night cap and could have been easily hidden under the shoulder capes on the floor. Shops near the Opera House hired out costumes for the masquerades; Widow Hughes in Covent Garden advertised 'Venetian masks and dominies'.[5] Subscribers could have readily imagined that Lady Squander had slipped into Mother Hughes' shop to borrow a particularly heavy and nondescript disguise. The only distinguishing features are the embroidered shoes with silver buckles which could have betrayed her to a suspicious husband or his spy. The ordinariness of the lovers' disguises is consistent with their preoccupation with each other rather than with the 'novelty' of dressing up. Thus Silvertongue's domino, perhaps worn under the shapeless clothes flung on to the chair to the left of the print, is little more than a bedgown. None of the disguises is that of a friar or a nun (page 106). Hogarth introduced these characters on the screen of the preceding picture to comment more on the relationship between the lovers than to anticipate exactly the disguises they were to assume.

The line of Lady Squander's domino disappears behind the discarded petticoat as if to merge with it. The downwards movement and the apparent merging with the clothes on the floor suggest the stripping away not only of a disguise but also of an illusion. Women characters are shown to have removed their stays on two other occasions in Hogarth's narrative art: the posture woman in *A rake's progress III* has removed hers in preparation for her lewd dance and, more subtly, the young woman in the engraved version of *Before* has removed hers and resumed her dress before she protests at her lover's advance. The removal of stays seems associated with moral as well as physical restraint. Significantly, no stays are apparent in the pictures where the Harlot is undressed or where Idle is in bed with his whore (*Industry and idleness VII*). Lady Squander has been, but is no longer 'stayed'; a pun which comments both on her adulterous behaviour and the motives behind her suicide.

She ignores her husband in the first picture, eyes him in the second and humiliates him in his absence in the fourth. At the crisis, her shamelessness, self-reliance and careless grace are replaced by contrition. Her hands clasp in a gesture which signifies imploring in the manuals of acting. The impression of staginess would have appeared not unnatural to contemporaries conditioned to a grand style of acting. They would also have recognised a belated act of submission in her kneeling before her husband and, more ambiguously, in a plane of the picture below that of her fleeing lover. The earlier commentators are mixed in their attitudes to her behaviour, a sign of the even balancing of responsibilities. The poet, superficially, is more tolerant of the man than the woman:

> My lord, who did not dote upon her,
> Yet could not brook insulted honour;
> He still consider'd that for life,
> She was and must remain his wife;
> And tho' he might sin sometimes,
> 'Twas hard to brand him with her crimes.

In his Preface, however, the poet draws attention to the modish husband's 'mistaken conduct' which 'drives his wife to be false to his bed' (p.iv). Ireland in his dual role as an observer and an expressive poet (he composed the epigraphs to each chapter over the initial 'E') mixed sympathy with disapproval. 'E' referred to her 'contrite sigh', her 'poignant agony', and 'deep corroding care'. The observer, aware of how the narrative ends, claimed that there is reason to suspect that the tears flow (one shows on her cheek in early states of the print) 'from regret at the detection, rather than remorse for the crime. Cleaning has revealed a striking and delicately painted interplay of highlights in the shine on the wife's nose and in the corner of her eye, and of the tear on her cheek, the gleam of which is repeated in the double highlight of the pearl earring. In so far as a pearl is an emblem of flawed beauty, Hogarth's choice of a jewel, carefully repeated, is his comment on his character's sincerity. The shining face, the homely cap, and scattered underwear make her an incongruously domestic, pathetic, and

unheroic figure. She lacks the fortitude of a St Agnes and is more credible as a character as a result.

Women's attitudes towards sexuality in eighteenth-century literature have been examined by Patricia Spacks in '"Ev'ry woman is at heart a rake"' (1974): 'not all male poets, playwrights, and novelists', she claims, 'supported Pope's dictum . . . but many hinted their belief in – or their hope or fear of its truth'.[6] Women as well as men of the upper and middle classes assumed that a submissive role was the correct one for women, but some did regard themselves as beings capable of a positive sexual life and their writings testify to the 'energy and complexity of their sexual attitudes'. Eliza Haywood's *Love in excess; or, the fatal enquiry* (1724) is typical of the way female sexual experience was treated in contemporary fiction: 'she had only a thin silk nightgown on, which flying open as he caught her in his arms, he found her panting heart beat measures of consent'. Lady Squander's tragedy is due partly to the fact that she is a passionate woman married to a man of tepid feelings (the poet on several occasions suggests that he is impotent). Although Eliza Haywood's description continues by being more explicit than any of those in *Le sopha* and more daring than was permitted on the stage, her readers knew that an interruption would invariably spoil the moment. Hogarth, as he promised in his advertisement, was careful to avoid indecency, but he was impatient with the timidity of playwrights and authors, the rakishness of whose heroines was never more than a matter of words. The more accustomed his subscribers were to the conventions of sentimental entertainment, the more they would have been shocked by the brutal honesty of his resolution.

SILVERTONGUE, THE ONLOOKERS AND THE BAGNIO

Silvertongue is little more than an outline figure on his last appearance. He is recognisable only by the plumpness of his thighs and his staring eyes. Lichtenberg observed that 'we can almost see Mr Silvertongue in his entirety up to his silver mouth, which is concealed here by his shoulder'. His domino is 'the robe of innocence, [viewed] from an angle which even innocence would regard as double nakedness'. Silvertongue's clambering figure is the nearest Hogarth came to indecency among the characters in this series. They are always covered and never touch one another, but with typical irony he was to present sexual behaviour explicitly in the pictures which hang from the walls. The *Io* and the *Lot* are more frank than any of Hogarth's own pictures with the exception of the first painted version of *After*.

The reduction of characters to a minimum of clothing is an important means of exposing vanities in Hogarth's narrative art. A naked youth 'stripp'd of all his substance' was the emblematic ordonnance of folly for de Lairesse.[7] The Harlot was modelled on an account of a woman who was so blind to the reality of her situation that she wore her finery in prison. The Rake is dressed to the height of fashion at the moment of his arrest for debt. They are covered by only a sheet and a loin cloth as they die of disease and madness. Silvertongue, whose every day clothes are conspicuous by their plainness, is punished

more for his presumption than his personal vanity. He scrambles away as nakedly as the promise in Hogarth's advertisement allowed.

The prophecy implicit in Silvertongue's turning of the dagger-like pen against his heart in the first picture is fulfilled. He is referred to again only as the subject of a dying speech in the last picture. He is the visitor of the series, ingratiating himself into other people's houses and making himself at home on someone else's double seat or bed. His profession as an adviser, the absence of information about his background and his insubstantial name-trait add to the impression of rootlessness. Although his is the role of a villain with unexpected powers of swordsmanship, he too is an unlucky victim of chance, the marriage game, the code of honour, and the penal system.

The intruders cluster in the doorway in the manner of seconds to the duel which has just taken place. The master of the bagnio is homely and prosperous, dressed incongruously in a quilted gown and a night cap. The plump constable, identified by his decorative stave, shelters behind the master of the house. The watchman is well to the rear and only his lantern shows, suspended at the end of a stiff arm. The onlookers react in the way that Hogarth may have expected his viewer, also a kind of witness, to react. At the most serious moment of his narrative, he was to allow counterparts of Dogberry and Verges to intrude. Their treatment confirms that Hogarth is the author of a tragicomic work.

The master of the bagnio is the nearest in the crisis picture to one of the detailed studies of affected characters in the series. Like the quack doctor he gains in interest through his ownership of the bedroom. He raises one hand in a gesture of surprise and holds the edge of the door with the other as if he has to pull himself into the room. The brothel-keeper's is a 'hold-door trade' in *Troilus and Cressida* and the curious grip may be Hogarth's clever visual exemplification of what may well have been a familiar saying. A reference to painted cloths in a brothel occurs in the same passage of the play (V.x.50) and one such cloth also hangs beside the master of this bagnio.

Although most houses in mid-eighteenth-century London did have tap water, piped through oak conduits from reservoirs and pools in the surrounding hills (the dried out end of one shows in *Evening*), there were few private baths. People who wanted to wash went to the public bathhouses. Richard Haddock was the foremost respectable bathhouse or *bagnio* keeper in London and kept the Turk's Head bagnio in Charing Cross for the purposes of sweating, bathing and cupping. Back ways were provided for modest people who preferred not to be seen going in to wash. Mrs Needham was the most notorious procuress of the 1720s (pages 85–8). Her death as a result of being stoned in the pillory drove her successors underground and brothels were disguised as seraglios or bagnios. Rouquet was to describe them for the benefit of foreign buyers of the prints: their principal purpose is to receive 'any couple, well-matched or ill-matched, that seeks a room or a bed for an hour or for a night in pursuit of promiscuity'. He listed the tariff as ranging from five shillings to half a guinea and sarcastically praised the disreputable bagnios for their discretion, decorum and cleanliness. The

poet identified Hogarth's bagnio with Mrs Earle's Turk's Head bagnio in Bow Street, an address at a convenient walking distance from the Opera House. But Hogarth was careful to make his an anonymous house: the title of the picture and the advertisement on the floor refer only to 'The Bagnio' and the Turk's Head emblem refers to its truer purpose. The shabby interior, however, is a scathing comment on the impoverished imagination of the reader of *Le sopha* and reveals the gulf between the lovers' intentions and the actual circumstances of their assignation. The advertisements for the honest bagnios drew attention to their permanence and the professional integrity of their owners. The master of the bagnio is a hypocrite by trade whose surprise has to be a mixture of the sincere and the assumed. The promptness with which he has found the constable suggests that he is involved in a familiar pattern of events from which he, in his carefully buttoned gown, is detached.

[35] *The judgement of Solomon* and the picture of the harlot (detail) from *Marriage A-la-mode V. Note:* the cross-like smudge on the harlot's cheek (p. 132).

ELEMENTS OF THE SETTING

THE INTERIOR PICTURES

Three pictures hang in the background: one of a harlot hangs in front of part of a mural of *The judgement of Solomon* and a picture of St Luke hangs over the door. They do not appear to be imitations of known pictures so they deserve particular attention because in them Hogarth was free to interpret his subjects as he wished.

THE PICTURE OF THE HARLOT The woman in the more favoured picture, pretentiously framed in gilt, wears a tightly laced dress, which accentuates the uplift of her large bosom. A bronze stole, worn off the shoulders, offsets the blue-black of her billowing skirts in the painting. The flat hat, worn at a rakish angle, completes the costume of a city 'nymph' or 'shepherdess'. Her face is not as ugly as the crude style of the picture would suggest, although her cheek is marred by a cross-like smudge in the print which may have been meant as the brand of a harlot. She smiles foolishly as she eyes the viewer in the sideways glance which Wilkes was to associate with the tormenting passions of envy, rancour, and malice. Her expression bears some resemblance to Lady Squander's in the second picture and her hair hangs in a loose curl rather like the lady's in the fourth picture.

The deliberately pretentious, yet awkward, placing of the harlot's bare forearms draws attention to the fact that her body is as much out of alignment as the Earl's in his portrait as Jupiter. She holds a squirrel in one hand and a parrot perches in a ring to one side of her head in a parody of domestic portraits in which sitters liked to be painted surrounded by their pets. In the same way that the cosmic details surrounding the Earl as Jupiter represent a catalogue of his martial and amorous attributes, the harlot's pets represent hers: a *squirrel* was a contemporary catchword for a harlot because she too was supposed to cover her back with her tail. A parrot is a lascivious and chattery bird and its presence offers a hint of the way in which the harlots of the bagnio could be imagined to spread the news of the scandal through the

streets. The handle of a parasol dangles suggestively in front of the harlot. The legs of a Jewish soldier, as solid as Silvertongue's, protrude below and from behind the harlot. The superimposition creates a male–female figure in a gross parody of a sexual act, which contrasts with the idealised view in Io's seduction and which offers a crude comment on the lovers' undisclosed behaviour. Lady Squander fails to experience the ecstacy of the nymph and fails to respond to the situation with the hardness of a professional.

Nichols and Steevens claimed that the harlot's picture was taken from a 'coarse picture of a woman called Moll Flanders'.[8] None of the early editions of the novel was illustrated, but it is not impossible that Hogarth had Defoe's heroine in mind (the harlot's costume and long hair were old-fashioned for the 1740s). The suggestion is apt because Moll Flanders, in surviving the hazards of prostitution to live to a complacent old age, is as much the harlot's ideal as is an ecstatic naiad for a fashionable hostess. Lady Squander, however, is destroyed after only one experience of the prostitute's way of life; hers is the luck of Io rather than Moll Flanders.

'THE JUDGEMENT OF SOLOMON' The brickwork of the bedroom is hidden by a painted cloth (over which the picture of the harlot is hung). Canvas wall hangings decorated with pictures and moral sentences, were often used as cheap substitutes for figured tapestries by those who aspired to live in the grand manner. A biblical story is an apparently

incongruous subject to find on the walls of a room in an illicit bagnio, but the harlots who may be supposed to frequent it would sympathise with a moral tale involving their own kind with the authority of the Old Testament behind it. The placing of a most unmaternal harlot in front of the personification of wisdom implies a justification for the harlot's way of life and a triumph over authority. Where the cloth has fallen or worn away, the picture has been repainted on the brickwork. Even the pictures in a bagnio are cared for and the choice of pictures and their arrangements confirm the ever-optimistic occupants in their delusions. Bad art in Hogarth's view conditions the lives of a social range from lords, ladies, and an alderman to harlots. Biblical stories about harlots underlie a number of the series: the prodigal son is a prototype for *A rake's progress* and *Industry and idleness*, while Mary Magdalen's story is behind both *A harlot's progress* and *Marriage A-la-mode*. The introduction of King Solomon in a brothel may seem incongruous, but is to be expected.

King Solomon sits on his throne to the left of the print; his nose is exaggeratedly bulbous and its 'preposterous size' may have been inspired by Fielding's complimentary reference in the Preface to *Joseph Andrews* to Hogarth's ability to distinguish between burlesque and the life-like.[9] The faint outline of an open-mouthed lion or mastiff is set beside the king. He is the last in the succession of unhappy beasts in the series and the sketchiness of his presentation suggests that the force of their disapproval is losing its effect. Immediately beneath the throne, the harlot–mother reaches out to stay the execution of her child. The true mother in the story is a sympathetic figure, but Hogarth makes her eyes turn towards the viewer in a knowing look similar to that of the harlot in the picture. The consequent effect of which is to undercut the overt moral of the story. The spreadeagled dangling body of the child, turned up side down, is threatened by a scimitar, instead of an eagle's beak, in a comic variation on the duel itself.

By means of the paradox which makes the figures in the pictures on the walls as real or as unreal as the characters in the series, King Solomon is positioned to judge Hogarth's couple as well as the mothers in his own story. The ambiguity of his role is emphasised by the lack of a picture frame to separate him from the characters and by the fact that only his head and shoulders are highlighted, a treatment which also helps to make him stand out among the other figures in the mural. Thus his eyes appear to stare as much at the dying husband as at the threatened child.

The situation in the judgement story, as it relates to the characters, adds to the extensive web of shifting analogies in the series. The true mother is resigned to the loss of her child in the face of the deceitful harlot's lying: 'O lord give her the living child and in no wise slay it'.[10] Lady Squander kneels before her husband–judge (and Solomon by extension) in the role of a supplicatory mother, but she is to cling to life until she knows that her child–lover is finally lost to her. The last picture shows the desolation which it may be imagined the false mother feels as a result of the carelessness which leads her to kill her own child and the deceit which leads her to lose the one she steals. Paulson

suggests that, by means of a 'curious redistribution', the mural makes Silvertongue the equivalent of Solomon; Lord Squander a sacrificial baby; Lady Squander the harlot–mother or, doubly ambiguously, both mothers. The viewer is encouraged to juggle with the analogies because the superimposition of the picture of the harlot on the soldier makes a bizarre hermaphrodite. It the 'redistribution' is considered from the lovers' viewpoint, then Silvertongue's judgement on the baby–husband tests the loyalties of the mother–wife: her immediate preference is for her baby–husband, but the last picture of the series proves that her lasting preference is for her lover. The harlot–mothers in the judgement story have to be tested only to the point of the child's death. Silvertongue, as the modern counterpart of Solomon, miscalculates and flees from the catastrophic consequences of his judgement. Alternatively, he has won his baby–mistress, the counterpart of the true mother by defeating his rival before Solomon. In doing so, he loses her attention and is never to know that she prefers him to her husband. She is placed as if to choose between her husband and her lover, but, because she too lacks the ingenuity of Solomon, both her suppliants die. Although suicide remains as the solution open to her, her ailing child survives the judgement with neither a true nor a false mother to comfort him. Conversely, she kneels before her husband–father in the attitude of a contrite daughter and thus can be seen to assume the role of the child herself. She is the witness to the death of her husband–parent at the moment when her lover deserts her. The last picture of the series shows that her mind, child-like, has changed once again.

The variations seem endless: is the husband a cuckold–judge who, having been involved with harlots himself, is faced with making an impossible decision? He too has proposed a risky ordeal, the consequence of which rebounds on him. The lack of a one-to-one correspondence between the three figures at the centre of the series and the four in the story generates the possible shifts in identity. Hogarth's point is that the biblical epitome of wisdom is helpless when faced with the consequences of a modern arrangement of marriage and, in making his point, he questioned the arbitrary and dangerous morality of a trial by ordeal.

In spite of its sentiment, theatrical comedy provided Hogarth with his stock in trade: type characters, acts of comic chivalry, marital conflict, disguise and role-playing. A fundamental assumption of criticism is that plays are studies in the nature of appearances and reality. The pairing and re-pairing of the characters in Dryden's *Marriage à la mode*, for example, would appear to provide a precedent for the bewildering shifts in identity which the pictures of Lot and his daughters and the judgement of Solomon reveal. Doralice plays the mistress, but remains true to her role as a wife and Rhodophil is both a philanderer and a jealous husband. The romantic plot is even more confusing: a usurper believes that he has found his lost son who is replaced by a lost daughter. The supposed son then turns out to be the rightful heir to the usurper's throne, while the daughter changes from the heir's sweetheart to his sister and back to his sweetheart. Even the names confuse:

Argaleon and Leonides; Palemede, Polydamus, and Palmyra; Amalthea and Melantha. In painting six versions of *The beggar's opera*, Hogarth showed himself to be fascinated by a play which masqueraded as an opera and in which rogues behave like gallants and wherein only the wicked win reprieves. Hogarth's pictures of the opera involve a complicated playing off of the characters one against another, in the parts of lovers and the actors against members of the audience, also as lovers. Lavinia Fenton in the part of Polly is set both against Macheath and her real lover in the audience, the Duke of Bolton.

ALLEGORICAL FEATURES

The shifts of identity, the use of ironic counterparts, and the association of characters with an incongruous mixture of gods, saints, heroes, monsters and nymphs are evidence of a fundamentally ambiguous attitude to existence. One class of associations is so persistent and consistent within itself that it provides the effect of an allegory to which the figure of the dying husband is the key. Paulson argues persuasively that the husband's pose is typical of a Christ in a deposition or a burial picture.[11] The claim is bold in view of its implications at a time when sacrilege was still punishable by death.

There were precedents, however, in contemporary literature and art: Swift's *Tale of a tub* is a satire on the fundamentals of the major Christian denominations. Pope made Theobald analogous to Christ in *The dunciad*. Fielding drew parallels between Abraham Adams and the acclaimed fathers of mankind and Israel, and between Joseph and the man who fell among thieves. Richardson represented Clarissa as a St Agnes or a Mary Magdalen. Portrait painters not only represented their sitters as Jupiter, but also as graces, saints and even the Virgin Mary. In the *Marriage contract* oil-sketch, Hogarth had depicted a transubstantiation machine which turns Holy Infants into wafers and had seriously considered constructing an analogy between the countess and a Madonna in the second picture. His Presbyterian antecedents would have encouraged him to view the corporeal world as a metaphor of the spiritual life. His training in emblemature and his active participation in freemasonry would have conditioned him to think allegorically. Significantly, the central gesture of *Boys peeping at nature*, the subscription ticket to the first series is the emblematic gesture of lifting a veil. In the *Battle of the books*, Hogarth pitted his modern pictures against an infinite army of Christian saints and classical gods. LeBrun, de Lairesse, Wilkes and others drew on religious art for examples in explaining the languages of expression, stance and gesture. The possibility of religious allegory in Hogarth's narrative art is a real one. It can readily be imagined that Lord Squander's body is being lowered to the ground by invisible helpers. The rectangular frame of the mirror behind him acts as an ironic halo, not of heavenly light, but of earthly vanity. Hogarth had used innocent objects as haloes frequently in the early progresses to mock-sanctify his characters. A hat on the wall behind one of the harlots who mourns for M. Hackabout in *A harlot's progress VI* makes hers the role of a sorrowing magdalen. The posture woman's platter is set behind her head to make her a counterpart of

[36a] *The entombment* (detail), Michelangelo (National Gallery, London). *Note:* The serpentine line of the body of Christ may have drawn Hogarth to Michelangelo's *Desposition picture* (p. 125). Compare Illus. 33b, Lord Squander dying.

[b] The dying rake (detail) from *In Bedlam (A rake's progress VIII)* (Sir John Soane's Museum, London).

[c] The dying rake (detail) from *A rake's progress VIII* (Whitworth Art Gallery, University of Manchester). *Note:* the replacement of the loin cloth (Illus. 36b) with breeches (Illus. 36c); the ways in which attendants in the print (Illus. 36c) are superimposed on the rake's body as if to make it less prominent (p. 000); the placing of the crucifix in the religious maniac's cell in relation to the main tableau.

Jezebel or the 'Mother of Harlots' in *A rake's progress III*. The glory on the pulpit cloth behind the Rake's aged bride makes her an ironic bride of Christ (*V*). A diagram of the sun behind a solicitous warder's head makes him a counterpart of Joseph of Arimathea.[12] Lady Squander kneels in the position at the feet of the deposed Christ often occupied by Mary Magdalen in deposition pictures. Mary's story is a prototype for Hogarth's character: she was born of a good family, was deserted by her husband, turned to prostitution, and was possessed of seven devils which led to repentance instead of suicide.

The lantern throws an improbably large shadow of a cross on the door to make the shape, but not the substance of the cross from which Lord Squander would appear to have been deposed. A less obvious cross, ostensibly part of the furniture of a madman's cell, leans towards the dying Rake in the last picture of *A rake's progress*. The mystery of the lantern in *Marriage A-la-mode* is increased because only the watchman's arm is seen. De Lairesse described the emotional associations of a lamp: it is 'melancholy, faint and gloomy, and therefore proper for *burials, prisons, near sick and dying persons*, and on other

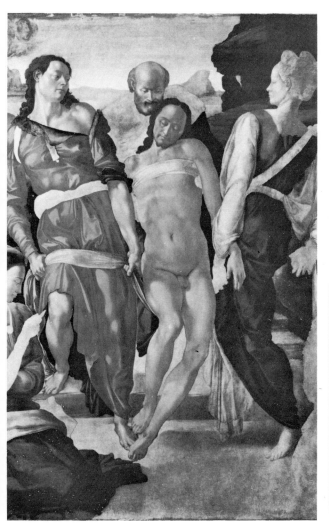

mournful occasions'.[13] In some of the old emblem books, a lamp burning in a room is a symbol of the faith of Christ. Hogarth frequently used a lantern as a quasi-religious symbol, perhaps for the Word of God. The watchman's lantern in *A rake's progress VI* is surmounted by a triangle of decorative pinholes. A lantern with a key hanging beside it lights the way for the tyler as he guides the drunken mason through the streets on 'Restoration' day in *Night*. They pass a shop sign marked 'Ecce Signum' and a vulgar benediction pours onto the mason's head. In *Industry and idleness IX*, large lanterns with prominent crosspieces flank the arresting magistrate. The accompanying motto is from *Proverbs*: 'the adulteress will hunt for the precious life' (vi.26). The quotation invites the viewer to see Idle as an Antichrist being betrayed by his judas–whore. Tom Nero's arrest in a country churchyard, also illuminated with heavy lanterns, recalls events in the Garden of Gethsemane. Prominent lanterns only appear at critical points in the series when the protagonists have put themselves beyond redemption.

The onlookers in the doorway with their staves and lantern belong to the same order of righteous men as those that arrest Nero. Both groups are comic reductions of the great multitude bearing swords and staves which arrested Christ. King Solomon and St Luke (identified by the presence of his ox) in the picture above the door look down on events from the level customarily reserved for angels in the deposition pictures. The gospeller and patron saint of physicians is the only observer not to look appalled by what he sees. He is in the act of writing down the 'good news' with a quill as it happens. Hogarth would have had a special feeling for St Luke, the patron saint of artists; his alert eye, heavy brow and jaw are not dissimilar to Hogarth's depiction of himself in his self-portraits.

Various innocent details in the room acquire significance in the context of an ironic deposition: the soldiers in the mural, the obscure dice-like objects scattered on the floor, and the shapeless garment on the chair recall the casting of lots. The shoulder capes act as reminders of the shapes, but not the substance of the figures of Mary and her comforter. The point of the falling épée, just striking the ground, recalls Simeon's address to Mary, 'Yea a sword shall pierce through thine own soul also' (*Luke*, ii.25). Lady Squander kneels as if an agonising truth is being revealed to her and *ground* was cant for a *woman*. Silvertongue's fallen and bloodied épée, the bowl on a chair partly hidden by the door, and the ladder-back of the chair recall the emblems associated with the wounding of Christ. The tear in the tapestry recalls the rent in the veil of the Temple. The equivalent of St Peter's key is set at the feet of the master of the bagnio, a keeper of the door of an anti-heaven who betrays his master to the constable. The shanks of the shadow tongs, which overlap the épée as if to re-enact the fatal sword thrust, resemble the handles of a pair of pincers with the handle of the tongs resembling a nail pulled from the cross. The watchman's lantern throws a roseate pattern of light on the ceiling which in the context of a crucifixion is an image of the Holy Spirit. Hogarth was to adjust the pattern in the print, as he was the *fleur de lys* on the tester of the bed in the preceding picture, perhaps because he thought the pattern represented too overt an

allusion.[14] The pattern is divided into a larger and a smaller group, a size relationship which repeats that of the husband and wife. Hogarth may have been toying with the notion of a departure of souls.

Lady Squander's discarded stays lie across the faggot, which in turn is overlapped by two crossed sticks which have fallen from the fire. The word, *faggot*, was a cant term for a *baggage* and, as a verb, *to faggot*, meant *to frequent with harlots*. A faggot was also the emblem that repentent heretics were required to wear on their sleeves as a sign that they had foregone the fire. The cluster of objects in the corner invites a particular reading: the results of the wife's release from moral restraint (the discarded stays) is a combination in one detail of the behaviour of a harlot and a penitent heretic (the faggot). The limits of allusion have not necessarily been reached: the faggot is to replenish the fire of hell or sacrifice which illuminates the suffering of a latter-day anti-christ. The crossed sticks resemble a toy sword, St Paul's emblem, associated by Hogarth with Silvertongue. Its point overlaps the bundle as if it, like the épée and the shadow of the tongs, re-enacts the fatal sword thrust. The haft glows red and a wisp of smoke rises in the painting. The colour is similar to the blood on the Earl's shirt. A *faggot* had yet another familiar meaning as a *recruit* and the long bundle of sticks is an appropriate object to represent the lanky husband who is a novice with a sword. A stay tape dangles over the faggot and its end disappears behind the glowing hilt of the sword as if to emphasise the closeness of the unhappy relationship between a husband who is an ironic sacrifice, a repentant wife and a fearful lover. It is amusing to note that a *scorched stay tape* was a contemporary catch word for *bad health*.

The crossed sticks are carefully placed in the bottom corner as if to encourage a search for hidden meanings. Their presence in one picture justifies an allegorical reading of the whole series: in the first picture, the Earl is a counterpart of the jealous god of the Old Testament, surrounded by the pictorial equivalents of old Israelites and their enemies, and confronted by a morose Shimei in the Alderman. The bride and groom, as counterparts of saints and martyrs, sit unwillingly instead of joyfully before the throne of their god. This Earl's demiurge is a pagan version of himself who points to his insignium of the Holy Ghost. He is also a counterpart of Lucifer in his pride, aggression and desire. The characters correspond to the Deadly Sins (a supplement to the spectrum of elements, senses and humours in the series): the Westminster Earl is over-proud of his lineage and his gout points to his gluttony; the Alderman of London and his sour agent share avarice and envy between them; the slothful bridegroom is to be united in unholy wedlock to a personification of anger; the lawyer who pays court to the bride represents lust and the lawyer gazing out of the window flattery. Fielding's attack on vanity in *Joseph Andrews* may have encouraged Hogarth in the working out of his allegory, if encouragement were needed; for Fielding, avarice was the handmaiden of vanity and lust her pimp.[15]

The fireplace in the second picture is an altar to marital discord. The cupid plays angel to the blind bust which is an impotent and flawed substitute for the virile Jupiter. Below them the ornaments on the

chimney piece are an assemblage of demigods. The pictures of saints hang in a side chapel dedicated to gaming. The anti-priest and priestess sit with their backs to the altar and ignore the ostensibly religious man of the series as he walks out on their heresies.

The husband assumes responsibility for the suffering of his bride of Christ and for everyone in the hell on earth of the third picture. In the fourth picture, his wife amuses herself as an inhabitant of a modern Sodom. She and her preferred consort negotiate before another altar dedicated to an empty vanity in poses which are the travesty of a betrothal between a Magdalen and a silver-tongued son of Belial.

After witnessing the anti-crucifixion of her husband, this apparently penitent Magdalen retreats to the spiritual wilderness of her father's house in the last picture. Instead of being lifted to heaven in a glorious dormition, she takes her own life, leaving her son behind in the company of another parade of the sins: the Alderman's dog is a personification of greed; the imbecile servant, envy; the apothecary, anger; the old woman, sloth (the ease which her age would appear to warrant); the child, infant desire; the Alderman, avarice; the physician, pride.

Hogarth's earlier narratives also reveal allegorical features. Paulson has shown how the iconographical tradition of devotional art is introduced into the secular structure of *A harlot's progress*.[16] The first picture corresponds to a Visitation, the third to an Annunciation, the fifth to a Death of the Virgin, and the sixth to a Laying Out. Tom Rakewell's career as Antichrist begins with his entering his inheritance (his head set against the veiled crosspiece of the window behind him). The third picture is the equivalent of a Descent into Hell, the fourth an Anointment and the fifth a Marriage. He dies in the arms of Sarah Young, surrounded by images of the Apocalypse, in the manner of a pietà.

Contemporaries did not identify Hogarth directly as an author of allegories, but there is evidence to suggest that they were at least aware of his intentions. De Lairesse understood the dilemma facing the artist who wished to convey hidden meanings. The use of emblems was 'very liable to censure, but yet few understand it, because the facts being always couched under uncommon appearances, are secrets to the vulgar, without explanation; nevertheless they should be so handled that people of judgement at least may know their meanings and the artist not be reproved'.[17] De Lairesse's unnamed painter, who interpreted the poses of figures in terms of letters of the alphabet, saw action in terms of other painters': a 'decumbent' one from Caracci; a runner from Raphael; a flying figure from da Cortona. Fielding took up the special term *ingenious* which Hogarth used of himself in his advertisements and he was followed in this usage by the anonymous poet, Theophilus Cibber, Joshua Reynolds and others. Jarrett's book, *The ingenious Mr Hogarth* (1976), was written to show that Hogarth was within the medieval tradition of 'ingenious' men skilled in the use of the esoteric languages of symbols and emblems. Jarrett's book implies that people of 'judgement' understood Hogarth's intentions and used the term deliberately of him. Paul Sandby in his burlesques of *The analysis*

accused Hogarth of stealing figures from the prints of old masters. Contemporaries may not have appreciated the extent of Hogarth's allegories because they were perhaps more accustomed to works of contemporary fiction, which approached allegory only occasionally, or to single allegorical paintings. Hogarth may have responded to the general lack of appreciation by providing the pictures of *Industry and idleness* with mottos from ironically appropriate texts of the bible and by decorating them with emblematic borders which reinforce the meanings.

THE VISUAL ORGANISATION OF THE PICTURE

The fifth is one of Hogarth's boldest and yet most deceptively simple designs with few figures and no intricate parades of characters or overlapping tableaux. A single path of light shines into the room from an unseen source in the close foreground. Because the source is below the viewer's eye level and to one side of him, the effect is to make the couple stand out from their background as if floodlit on a darkened stage. Ironically, the oval which encloses the lovers in the first and fourth pictures, encloses the husband and wife at the moment of their final separation. The sense of space between and before them in the second picture surrounds them in the fifth. Their isolation as individuals and as a pair is emphasised because the other figures and much of the detail are pushed back towards the walls of a particularly untidy room. The explosive tendency enacts the notion of squandering in its universal sense in a way which recalls the patterns of the second picture.

Whereas the tendency towards disintegration in the second picture is controlled by an underlying pattern of contrasts and pairings, the path of light in the fifth brings details successively into focus in an enlarging sequence. It begins with the glowing sticks in the bottom left hand corner of the painting and beams light across into the picture towards the shadow of the cross on the door. It plays over the litter in the foreground, the embroidered shoes and the discarded clothing. It picks out the highlights of the delicate folds of the crumpled domino, the pearls in the earring, the tear and the glittering braid of the military coat. As the effect of the light fades in the far corners of the room, the lantern refracts a cooler light on to the wall and door sufficient to illuminate the heads of the onlookers and to cast its shadow on the door. The diagonal path of light is balanced across the other diagonal, on the nearer side, by the shining blade of the falling épée (and perhaps the highlights on the shoulder cape in the close foreground) and, on the further side, by the light from the candle on the table. It casts a pool of light sufficient to show the misty shape of Silvertongue and the legs of the soldier behind the picture of the harlot. The couple are held at the centrepoint of a St Andrew's cross, a shape repeated in the wickerwork of the seat of the overturned chair in the corner beside the pointing sticks. In that Lord Squander is associated with the shape, both the design of the seat and the picture itself reflect on his downfall.

A loss of control, depth and mystery is evident in the print where the only gains are in terms of narrative information and clarity. The

interplay of light and shadow is replaced by a twilit monotone. Hogarth is reported as having quarrelled with Ravenet over a need to play down the details of the background. It is doubtful whether either was wholly satisfied with the resultant flatness.

The fourth and fifth pictures are the only two in the series where the narrative line makes as much sense in the paintings as in the prints. In the fourth, the singer is on the left so that the audience to the right responds to his song, the appropriate way round. The masquerade screen finds a place adjacent to the fifth picture where it refers more effectively to the next step in the narrative. Lady Squander, the more important character, turns to face her 'future' instead of Silvertongue. The movement of his uplifted arm readily encourages the viewer's gaze to pass on. In the fifth painting, the onlookers, who represent the next step, the arrest, are on the right; Lady Squander is again turned towards her future, while Silvertongue on his last appearance disappears to the left. Hogarth may have prepared the designs for these pictures at a period when he did not know whether Ravenet, the engraver least known to him, would be prepared to dispense with a mirror in copying.

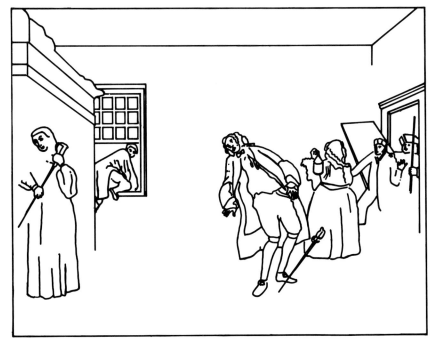

[37] *The bagnio (Marriage A-la-mode V)*: a reconstruction, line drawing after David Bomford. A reconstruction of Hogarth's first thoughts based on tracings of the X-ray and infra-red photographs. Bomford's account of Hogarth's intentions reads, 'at the left the Countess runs or turns open mouthed, with the sword clasped in both hands; Silvertongue climbs through the window; in the centre the Earl dies along; at the right the ladlady, lantern in hand, leads the men of the watch in past the wrecked door'. Note that the hint of an outstretched arm belonging to the figure on the right is not reproduced. Although it is impossible to say which stages of development these figures represent, it is virtually certain that they belong to *Marriage A-la-mode* because the fifth picture was painted on one of the five canvases Hogarth bought in for the purpose and was not the odd one out (p. 8).

The X-ray of the fifth painting shows that Hogarth changed his mind considerably before settling on his eventual grouping. Two figures are discernible under the paint, one on either side of where the main tableau now is. The figure to the left bends towards the margin of the picture. The head and eyes are down turned and the mouth is open. The right hand appears to be held to the forehead as if in thought. The left hand holds a sword by the blade, just below the guard, and the sword is angled across the body. The infra-red photograph shows the figure to be female with a cap and flowing robes. The other figure, also female, stands between the onlookers and the husband with her back to where

he is now. Her left arm seems outstretched towards the doorway in a gesture of surprise like that of the outraged servant in *A harlot's progress V*. The right forearm is raised and her clenched fist probably holds a lantern.

These figures could be relics of an earlier painting on the same canvas, but such widely spaced figures carrying such significant objects are much more likely to be first thoughts for *Marriage A-la-mode*. The figure to the right could have been intended for one of the detailed studies in affectation, which appear elsewhere in the series on the left of the prints. The figure to the left in a pose suggestive of remorse could only have been meant for the wife, the only character to show regret.

Several reasons could have made Hogarth change his mind: if the figure to the left were intended for the wife, then the trend whereby she is positioned between her husband and her lover or their counterparts would have been disturbed; the irony of her beseeching her husband only as he dies would not have materialised; views of the wife holding presumably the sword which killed her husband and a figure, presumably the mistress of the bagnio who was well-advanced into the room, would have added to the lack of synchronisation between their actions and the main event. As it is, the wife and Silvertongue would have had to move very quickly to occupy their present positions before the husband collapses. A large figure in the middle ground would have detracted from the main event in a way that the unobtrusive figures of Silvertongue and the master of the bagnio do not.

The X-ray provides a tantalising glimpse of Hogarth's first thoughts. The existence of these figures in this picture especially is the best evidence we have for arguing that he did work out his compositions directly on the canvas. Why he decided on such fundamental restructuring in this picture, when the others reveal only relatively minor adjustments, remains a mystery.

CONCLUSION

The climax of the narrative is built round a series of paradoxes in which the expectations of the various characters are turned back on themselves.[18] The husband came for revenge and dies unaware that it will be taken. As the victor in the duel and Jupiter's representative, the lawyer runs away from the scene of his amorous and martial conquests. The wife, who came to fulfil an ideal, humiliates herself at the feet of the husband whom she has disregarded. The onlookers, who represent the forces of law and order, arrive too late to alter the course of events.

The causal chain is almost complete: the husband's melancholy has deepened as his wife's and lover's expectations have increased. At first sight, the crisis offers a moment of reconcilation, but the wife fails to make her husband respond as she does in the second picture and, on this occasion, her lover deserts her. Only a first beginner is absent; the Alderman is reserved 'with calm of mind' to resolve the narrative.

The recurrent imagery of fire comes to its fulfillment at the crisis, while the counterbalancing effect of water is absent. The analogy between fire and pain coalesce in the one portentous image of the crossed and burning sticks. The prophecy implicit in the bridegroom's

pinch of snuff in the first picture is realised (*to take snuff* meant *to take offence*) – a trivial act produces consequences of a tragic magnitude. Lord Squander dies in the heat of a fire which is expressive of the cuckold's anger and injured pride. The heavy candlestick on a round table returns to the narrative. The flame flares in the draught caused by the exit of Silvertongue, who is responsible for the dissolution of the marriage contract which he drew up in the first place. As the character who introduced air and heat into the room (he presumably hired a room with a fire), he is a cause of its predominantly choleric atmosphere. He escapes from the glow of his opposing element into the darkness which is his own.

Added significance is given to the candle in the heavy stick in that the block on which it is set in the print is a book in the painting. No lettering shows, so a re-viewer may be forgiven for wondering what latter-day Gideon Bible would be present in this room. The link between a book and a flaring candle on the point of blowing out as an image of impending death recalls the *memento mori* of the third picture. Another ironic prophecy is realised, although not directly, through the disease which is predicted in the skull.

Hogarth thought fire to be the most beautiful element.[19] In the penultimate picture of his most ambitious series, its irradiance is the means of perception itself, through which St Luke, the patron saint of artists, records what is to be seen. Hogarth's artistic sympathies are with his squanderers bathed in firelight and not with the moral order and the light of the onlookers' pallid lantern (a similar bias is repeated in *A rake's progress VI* and *Industry and idleness IX*). In the last resort, his preference is for the immoderate, the disorderly, and the romantic.

NOTES

1 Derek Jarrett, *England in the age of Hogarth* (London, 1974), p. 103.

2 LeBrun, Figs. 24 and 25, opposite p. 41. Wilkes, p. 141.

3 Joseph Burke and Colin Caldwell, *Hogarth, the complete engravings* (London, 1974), p. 20. *The analysis*, p. 147.

4 *Joseph Andrews*, Book III, chapter I, p. 159.

5 Hugh Phillips, *Mid-Georgian London* (London, 1964), p. 277.

6 Patricia M. Spacks, '"Ev'ry woman is at heart a rake"' in *Eighteenth century Studies VIII* 1 (Berkeley, 1974), pp. 27–46. She refers to the fiction of Jane Barker, Eliza Haywood, Lady Montagu, Mrs Thrale and Mary Wollstonecroft.

7 De Lairesse, p. 119.

8 John Nichols and George Steevens, *The genuine works of William Hogarth; with biographical anecdotes* (London, 1808–16), II, p. 184.

9 *Joseph Andrews*: 'he who should call the ingenious Hogarth a burlesque painter, would in my opinion do him very little honour; for sure it is much easier, much less the subject of admiration, to paint a man with a nose, or any other feature, of a preposterous size . . . than to express the affectations of men on canvas' (Preface, p. 9).

10 The quotations in this passage are from I Kings 3, 16–28 in the Authorised Version. *HI*, p. 488.

11 *The art of Hogarth*, pp. 38–40. Paulson lists seven possible sources, but it would be consistent with Hogarth's general approach to the series that the pose is archetypal.

12 Robert L. S. Cowley, 'An examination and interpretation of narrative features in *A rake's progress*', MA thesis (Birmingham University, 1972). For a discussion of the allegorical elements in the earlier progress, see especially pp. 185–8.

13 De Lairesse, p. 242.

14 The X-ray reveals more spots of light. In the last plate of an *Election*, which is based on Christ's entry into Jerusalem, a white goose flies above the victorious candidate instead of a dove, and a drain, like Hell Mouth, gapes below.

15 *Joseph Andrews*, Book I, chapter XV, p. 57.

16 *HI*, p. 270–1.

17 De Lairesse, p. 7 and p. 57. Derek Jarrett, *The ingenious Mr Hogarth* (London, 1976); it is impossible now to distinguish between those contemporaries who used the term deliberately and those who followed the trend.

18 The setting of the picture is one of Hogarth's favoured garret pictures: an enclosed room, a curtained four-poster bed, and scattered stools and tables. It is introduced in *A garret scene* (before 1731?) and repeated with variations in *A harlot's progress III* and *V, The discovery* (c. 1743), and *Industry and idleness VII*. The ladderback chairs of *Marriage A-la-mode* echo those in *A harlot's progress III* where a similar crowd of onlookers enter the room. The device of illuminating a room by means of an unseen fire below eye-level was first tried in the cellar picture, *A rake's progress III*.

19 *The analysis*, p. 6 and p. 135.

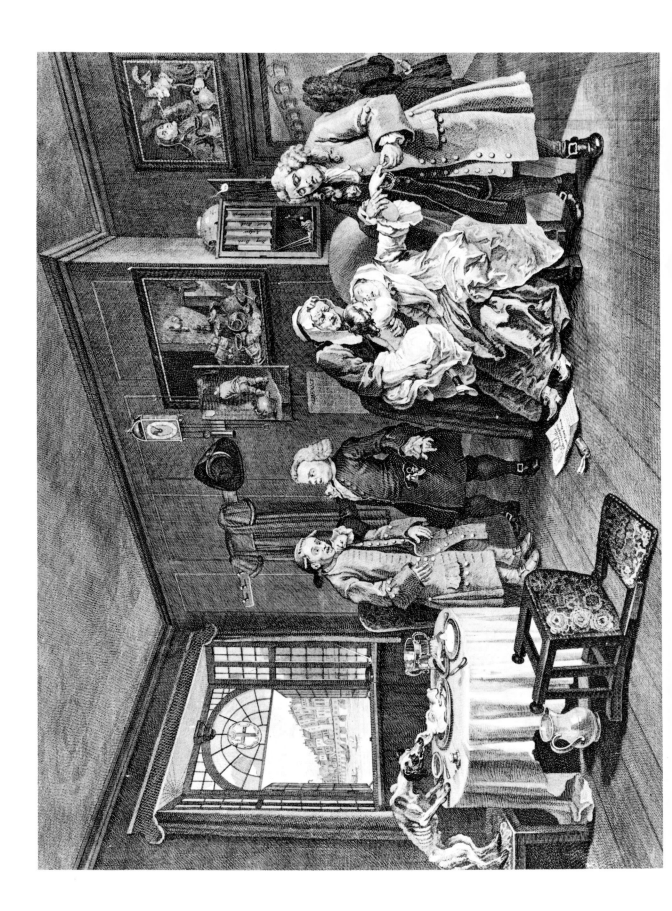

VI

The lady's death

The necessary steps, the funeral, the trial, and Lady Squander's return to her father's house, are not shown. Hogarth resumed his narrative at the point where she has just received news of the execution of her lover. The poet imagines that she has heard the street sellers crying their wares, Silvertongue's dying speech, along the water front. The servant, it is to be supposed, had been sent to buy the speech and the poison.

Lady Squander committed premeditated suicide just as her father was about to eat his midday meal. He, presumably, arose from the now overturned chair to summon the physician and the apothecary. After their failure to revive the mother, the child was brought to say farewell to her corpse. Meanwhile, the father has opened the cupboard to put his daughter's ring in a safe place. As he removes it, the physician departs and the house dog, who has sneaked into the room during the confusion, seizes the prize.

THE CHARACTERS

THE MINOR CHARACTERS OTHER THAN THE PHYSICIAN

THE HOUSE DOG The house dog's position to the left not only suggests that his behaviour is a comment on what occurs to the right, but also that he is the peer of the figures in the series set in a similar position – the Earl, his son and the lawyer. His elevation to the middle plane of the last picture completes the trend whereby animals progressively assume human roles: the pointers are obedient, whereas the shock-dog presumes; the wolf's head passes judgement; the stag has a man's body; the house dog takes the place of a diner at his master's table.

The dog is a mongrel as his long back legs and short front ones prove and, as a representation of man's natural self, he is Hogarth's comment on his Alderman's lack of pedigree. A hungry dog is a permanent threat to the food in a household and a public advertisement for its owner's miserliness. The dog's hunger comments on its master's eagerness to take possession of the ring regardless of opinion, to seize the metaphorical pig's head (the similarity between the eyes and the cheeks of the pig and the dead woman make a gruesome analogy). The old saying, 'folly is a bony dog' may have been at the back of Hogarth's mind.

The dog's pose as a diner gives visual expression to another saying, 'flesh stands never so high, but a dog will venture his legs'. The implied

[38] *Marriage A-la-mode VI (The lady's death)*, engraved by G. Scotin, after William Hogarth (Whitworth Art Gallery, University of Manchester).

speed of the theft recalls the simile, 'to be as fast as a dog can lick a dish'. A dog was a popular hero of proverbial lore and several jingles comment on the triumph of the miser's dog over his master. This comic reversal is typical: 'Rank misers now do sparing shun/And dogs thence with whole shoulders run.' Hogarth is reported by Vertue as having painted Sir Isaac Shard, a notoriously mean alderman and sheriff of London, sitting in judgement on a 'great hungry dog who had stolne from his Honours kitching a piteous lean scraggy shoulder of mouton'.[1] A stray dog, who has slipped into the room unnoticed, steals the poet's last chop in *The distrest poet* (1736/7). A popular moral tradition identifies the Alderman's essential characteristic.

THE IMBECILE SERVANT AND THE APOTHECARY The imbecile prompted a sympathetic response in Hazlitt:

> the fine example of passive obedience and non-resistance in the servant . . . whose coat of green and yellow livery, is as long and melancholy as his face. The disconsolate look and haggard eyes, the open mouth, the comb sticking in the hair, the broken gapped teeth, which, as it were, hitch in an answer, every thing about him denotes the utmost perplexity and dismay.

His hair is gathered into thick twists, a ludicrous imitation of a fashionable servant's paper curlers (as exemplified in the tired footman of the second picture). His feet, like his master's in the first picture, are set parallel in the clumsy manner which de Lairesse identified with people of inferior rank. His coat is so large that it has had to be cut down: there is only room for six buttons between the hem and the top of the pocket instead of the usual eight. Not only is the coat green, the colour of servitude, and incorrectly buttoned, a sign of maladroitness, but Hogarth may also have had in mind the saying that to be 'short of buttons' meant that a person was not as sharp as he might be. At first sight, the coat appears to be the master's cast-off, traditionally a personal servant's perquisite but the sickly colours differ from the Alderman's preferred reds and blues. It is in too good a condition to have been given away by a man who starves his dog, employs the cheapest servants and is already wearing his second-best clothes. The imbecile, like the common miss, perhaps, would have been seen as having bought the coat at the second-hand stalls, in a pathetic attempt to appear fashionable. Hogarth's general point is that a social range from an earl to an idiot or a countess to a street girl has its pretensions.

The servant's staring eyes and bemused expression recall the other perturbed faces in the series. The baleful effect of Medusa's stare is realised metaphorically in the last picture: the daughter is dead; the father's expression is stony and his behaviour callous; his servant is mentally empty. The servant is not harmless, however, because he has introduced laudanum into the series (the empty bottle lies at his mistress's feet), a situation prefigured in Medusa's snakes which find their ultimate counterpart in his clumsy twists of hair. The presence of a clumsy, idiotic and yet affected servant, whose hair also evokes the horns of cuckoldry, is an *outré*, but not grotesque counterpart of the

dead husband. Both characters are maladroit, unlucky, melancholy and dangerous. Hogarth's living epitaph for Lord Squander is cruelly incongruous.

The apothecary is identified as such by the nosegay in his buttonhole and the clyster syringe and bottle of julep in his pocket (the label is illegible in the painting). The syringe was used for purging and the julep for sedation, absurdly contrasting treatments which Lady Squander, a character who has been torn in two directions, requires no longer. The apothecary is an achrondoplastic dwarf whose disability adds another form of the *outré* to the parade. A malformed apothecary would have been unlikely to charge high prices so he is another of the ugly – and therefore cheap – servants on whom the Alderman prefers to depend.

The sayings 'to talk like an apothecary', meaning to prattle, and 'as proud as an apothecary' indicate a proverbial self-esteem. This apothecary's little finger is crooked like those of the other affected characters in the series. His feet are arranged in imitation of the supposedly elegant attitude with one heel turned towards the inner ankle of the other foot. The attempt at gracefulness is ridiculed in the heaviness of his legs and his rough behaviour. His stance would have dissatisfied de Lairesse who declared that the feet of a mannerly person ought not to be more than a few inches apart.[2] To have been fooled by an imbecile servant can be taken as a blow to the apothecary's characteristic pride and as a goad to his officiousness.

A precept laid down in the Preface to *Joseph Andrews* may have prompted Hogarth to treat these unfortunate characters in a ridiculous way. Fielding argued that the comic writer ought not to ridicule ugliness, infirmity, or poverty for the sake of it, but 'when ugliness aims at the applause of beauty, or lameness endeavours to display agility, it is then that these unfortunate circumstances, which at first moved our compassion, tend only to raise our mirth'.[3] The contrasting idiosyncrasies of both servile characters are further evidence of Hogarth's determination to make every character distinctive, to have bearing on the narrative, and to be consistent with his theory of comedy.

THE OLD WOMAN, THE CHILD, AND THE TIME SPAN OF THE SERIES The old woman is customarily identified as a nurse in spite of her awkward handling of the child. As such, she represents further evidence of the Alderman's unwillingness to spend more than a minimum. Her downcast head, contracted eyebrows, and 'rueful, aged face', as the poet sees it, make her ruling passion one of pity, as defined by Hill for whom it is 'active Grief for Another's Affliction'.[4] She makes the moral point that a servant in whom there is no evidence of affectation feels more for a child than its parents have done or its grandfather does.

Some doubt exists over the sex of the child; both Austin Dobson and Paulson, Hogarth's most recent biographers, have identified her as a girl, but the poet and Nichols and Steevens assume that he is a boy.[5] Small girls customarily wore bonnet-like caps even indoors. The Rake's daughter, only a little older, wears a frilly cap as do the girls in all

Hogarth's conversation pieces. The child in *Marriage A-la-mode* has no cap and infants of both sexes wore skirts – the boys until they were breeched at three or four. Although there is irony in the thought of the dynasty dying out with a girl, the fact of an infant earl surviving in the care of a disappointed maternal grandfather is a more bitter consequence of the arrangement of an ambitious marriage.

The boy has a sore on his cheek, a depressed forehead, blubber lips, an enlarged head, a weak leg and a stunted body. The weakness would be a sign of rickets or, more probably, tubercular osteitis caused, like his father's scrofula, by infected milk. The patch is not directly over the child's lymphatic glands so that it may have been meant as a symptom of a congenital disease rather than scrofula. A depressed forehead can also be a symptom of either rickets or a congenital defect. Hogarth should not be expected to answer to such precise diagnosis, but, as the third picture shows, he had more than a layman's familiarity with disease. The symptoms are consistent with each other and a range of common disabilities which contemporaries were likely to regard as inherited 'sins' and this must be Hogarth's essential point.

The unfavourable omens consequent upon the forgotten coral in the fourth picture are realised. The child is more diseased than either his father or his paternal grandfather. The English alderman's family is now contaminated by the French *malaise*, physically as well as spiritually. The disabilities suggest that the child will not survive to a potent manhood so that the direct line of descent is prolonged for a limited period only. The introduction of a deformed heir is both the fulfilment of the theme of spoilt magnificence and Hogarth's final indictment of an aristocracy based on primogeniture and maintained through alliances with rich citizens. The decadent cities, he seems to be saying, were better off apart.

The pathos should not be overstated, however; about two-thirds of the children born in metropolitan London in the eighteenth century died before they were five. J. H. Plumb has calculated that in the country as a whole twenty-five per cent died before they were a year old.[6] What may be regarded in the twentieth century as the inhuman treatment of a child was unexceptional in 1743; a show of affection was disapproved of in many families as being bad for children. Samuel Johnson's mother used to visit her child in secret when he was with the wet-nurse because she felt guilty about the strength of her maternal feeling. The heir is receiving kindly treatment, according to contemporary standards: his leg is supported, he does have an attendant, and his guardian allows him to say goodbye to his dying mother.

Plumb's article, 'The New World of Children' (1976), was written to show that 'a new and magical world' had begun to open up in the 1730s when attractive toys, books and entertainments were produced for the first time on a large scale. The Foundling Hospital opened in 1741 and Hogarth, a benefactor and governor, was a leader in the movement which called for greater sympathy and care for the young. Only an enlightened subscriber, however, would perceive that in the depiction of a weak and lonely child, unloved by his family, there was a demand for enlightenment.

The individual pictures of a series as complex as Hogarth's can give the misleading impression that each approximates to the passage of a day. The characters seem to disintegrate in a frenzy of activity comparable to the experience of events in a speeded-up film. The variety of temporal detail always undercuts the impression that life is only a matter of days. In *Marriage A-la-mode*, the contract is signed on a summer's day, but the duel occurs on a night sufficiently wintry for a big fire. The concluding picture shows another day warm enough for a window to be open in a chilly house, a hint of the false spring which succeeds a bitter winter (spring was the season of suicides and pig's head was a lenten dish).

The tempo, however, is not as even as a seasonal cycle would suggest. The first four pictures imply a succession of protracted events: negotiation, recuperation and perhaps recrimination, courses of lessons and medical treatment, and attendance at a concert. Events move rapidly between the fourth and fifth pictures, but the tempo slows considerably in the interval between the fifth and sixth.

The passage of a year is insufficient; the presence of children in all Hogarth's early narratives extends their span to a period of years. It begins in *Marriage A-la-mode* in the early summer 1743 or 1744 (according to the two versions of the stewart's receipt) and extends in time according to the individual viewer's estimate of the age of the child in the last picture. Hogarth took advantage of his delusive structure: a first impression conveys the effect of a swift and terrible passage of time. Closer examination reveals the extensive chronology with the child as a key.

LADY SQUANDER'S SUICIDE

Lady Squander has made a qualified recovery from the experiences of the bagnio, a measure of which is found in her renewed clothing, her simple cap, white house dress and dull green petticoat. The colours, signifying servitude, are reminders of her enforced subservience to her father's regime. The loosened dress is only remarkable in the continued absence of stays and hoops, a lack which suggests that in her father's house she has cared little about her appearance and has failed to recover a sense of moral responsibility or modesty.

She appears to have dropped the laudanum bottle and Silvertongue's dying speech together, an indication that, in spite of her subservience, she has committed suicide at the news of her lover's death rather than from regret for her husband's murder. Stephens' description of her death in the *BM Catalogue* is moving in its observant quality: 'she is in the languid stupor of dissolution. Her eyes are lightless; their dim pupils are visible between the relaxed lids that are half-closed by defect of action; her lips have parted, her lower jaw has fallen, and her limbs are loose and unnerved.'[7] Jarrett sets the suicide in its contemporary context: 'visitors from Europe were amazed and appalled at the prevalence of suicide in England'. By the 1750s, it had become a matter of jest; *The gentleman's magazine* carried a mock advertisement for 'Stygian spirit', a preparation which cost a guinea, but which was given free to men of pleasure who wished to commit suicide without fuss.

In spite of Dr Johnson's reputed claim to the contrary, the malign influence of London, its crowdedness and competitiveness, was thought to be the cause of many of the suicides and the reason for the existence of three hundred lunatic asylums. Doctors advised patients to leave London if they wanted to shake off the desire for death. John Armstrong's poem, *The art of preserving health* (1744) shows how topical Hogarth's resolution was:

> Fly the rank city, shun its turbid air,
> Breath not the chaos of eternal smoke
> And volatile corruption from the dead,
> The dying, sick'ning, and the living, would
> Exhal'd to sully Heaven's transported dome
> With dim melancholy.[8]

Foreign buyers of the prints would have noticed other trends which point to the likelihood of a suicide in addition to the loss of a lover and a husband: the emptiness of a fashionable life and a lack of religious conviction (in a non-Catholic country); the dampness of the climate which was believed to encourage melancholy; the depressing effect of the company of a disappointed father, a demanding infant, an aged nurse and an imbecile. Armstrong would have been perturbed by Lady Squander's lonely existence in a riverside house; he approved of living in the hilly suburbs, but not the Essex marshes. Her tragedy is due partly to the fact that Lady Squander, a sanguine personality who has succumbed to melancholy, has nowhere else to go.

The Alderman's daughter comes from a spartan, repressive home and is consequently thrown off balance in a libertine household in much the same way that her supposed acquaintance, Lady Townly, is, but in a far more caring situation. Both Cibber and Hogarth criticise the imposition of marrriage on immature girls and Hogarth points to the folly of excluding the marriage partners from the decision-making. Suitable advisers (such as mothers or sisters) are conspicuous by their absence. In making her a sanguine personality, Hogarth chose the one temperament least likely to be satisfied with a melancholy husband. Because she questions the assumption that a married woman should accept a domestic life, she dies in a state of social alienation. Hogarth's representation of suicide as the consequence in part of extreme changes in social status is in accord with Durkheim's theory. Hogarth's lady dies from what was known by foreigners as the 'English malady', a self-inflicted, spiritual disease which balances perfectly with the presence of various forms of *morbus gallicus* in the series. As a concluding irony, Lady Squander, like Hogarth's Harlot, is the victim of the sad paradox that more people make claims on her as she dies than they do when she is alive.

THE ALDERMAN AND HIS MEAL TABLE, THE PHYSICIAN

The Alderman has been turned through ninety degrees from his first appearance so that his heavy features are open to inspection and the true rather than the assumed personality is revealed. He is the only recurrent character to stand securely and his is the only viewpoint to be enlarged over the span of the series. His forehead 'somewhat raised', his

[39a] The Alderman (detail) from *Marriage A-la-mode I. Note:* the number of strands in his chain (p. 31); the chape of his sword protruding between his legs (p. 32).

[b] The Alderman (detail) from *Marriage A-la-Mode* VI. Note: the number of strands in his chain (p. 154); the change of coat, the loss of buttons, the absence of spectacles, the jewel in the ring he removes from his daughter's finger (p. 153).

[c] The meal table (detail) from *Marriage A-la-mode VI.*

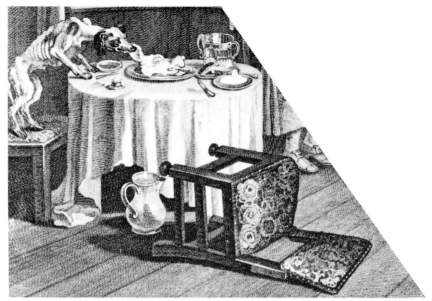

large, heavy eyelids half open, and his aspect 'settled and calm' fit de Lairesse's description of a person in authority, but without pity, Hill's dramatic passion of 'active grief'.

The removal of a jewelled ring (not the wedding ring) from the forefinger of the corpse of his daughter is carried out in unsentimental contemplation of the task in hand. The property of suicides was forfeit and would have had to be removed promptly before *rigor mortis* set in by someone concerned to outwit the law. The midwife in *A harlot's progress V* rifles the Harlot's trunk as she dies so that Ireland's suggestion that he secures the ring against the depredations of the nurse is another reason for 'careful Daddy's' heartless forethought (the poet's phrase).

The disappearance of his spectacles (present in the first picture) is accounted for by the fact that the Alderman is not required to read, but the omission also implies a continuing, metaphorical short-sightedness. A settlement requires closer attention than a daughter's death. On the first occasion he overlooks a coin in the money-bag and evidently does not intend to make a similar mistake. By turning a tragic situation to his material advantage, a minor oversight is transformed into a major defect of feeling.

The Alderman's clothing is much the same as that of his first appearance, but there are significant differences in detail. He wears three coats instead of two so that his increase in stature is accompanied by a corresponding increase in physical coldness. He lives on, a warmly dressed man, while the children of the series squander their warmth in dying loosely and partially clad. The red top-coat and first under-coat differ from those in the first picture; this top-coat has buttons down to the hem of the skirt, whereas the first has not. The mid-blue under-coat has cloth buttons instead of gold, a change which shows that he wears his older clothes at home. The imbecile is clearly 'short of buttons' but his master's topcoat is also short of one or two. One has been painted out and now shows through the paint as evidence of Hogarth's

deliberate intent. The Alderman ignores the defects of the Squander family in the first picture and the loss of a button in the sixth comments on his continuing lack of good sense.

It is an exceptional man who hangs his civic garb in his living-room, drinks water from a ceremonial cup, and wears his chain of office in the privacy of his own home with no awareness of the incongruities. Although a careful man is relieved of the worry of leaving the chain in a safe place by wearing it, this man's private life is dominated by a love of civic office to the point of having the coat of arms of the City of London let into his window. It is as vainglorious to eat 'hog's face' (the poet's phrase) while wearing an aldermanic chain and to toast onself in a loving cup as it is to brand a hunting dog with a coronet.

A character's choice of food can be as revealing an 'index of the mind' as other forms of behaviour. The first course is a boiled egg set in a pile of rice. Some crusts on a side plate are placed immediately in front of the loving cup, the chasing of which makes them look like cutlets in the print. The table-cloth is conspicuously egg-stained. A miser was said to dress an egg and give the (non-existent) offal to the poor. 'To be as full of knavery as an egg is full of deceit' is typical of the many sayings on the subject and the relevance of the proverb is extended to the spider's web on the ceiling, another traditional emblem of deviousness.

The main course is a plate of pig's head for which a smaller plate and fork are made ready, placed to make it appear as if the dog is to eat from his master's plate. A pig's head with an apple in its mouth was a popular festive dish, but the Alderman's is miser's food because it has not been dressed. As a salted or 'standing' dish, it could be brought many times to the table. The lack of discrimination in a man who can eat such crude food is commented on in the saying 'hungry [or scornful] dogs will eat dirty puddings'. 'Some cannot abide to see a pig's head gaping' draws attention to the Alderman's lack of fastidiousness. 'To eat boiled pig at home' means to be master of the house, but the master's authority has been challenged by his daughter's suicide and his dog's theft. Even a man of resolutely coarse taste would be thirsty after eating salted meat and salt from the cellar with his egg. The jug of water is ready to quench his thirst and its substantial capacity suggests that a miserly man is prepared to be generous at home only with what is cheap. Even after cleaning, the water in the jug remains discoloured. Londoners would have had little knowledge of clear water, even if their drinking water were drawn from the reservoirs in the oak conduits. The Alderman's preference for water, when he could afford other drinks, also underlines the coarseness of his taste. Ireland accounts for the discrepancy between the frugal food and the Alderman's well-fed appearance by supposing that he gorges himself at City feasts in order to save on food at home, a common complaint against the City dignitaries. The supposition also gives point to the offensive gluttony of the diners at the sheriff's banquet in *Industry and idleness VIII*.

The overturned dining chair has a broken upright on its further side (in the print) and appears to have been mended with a fillet on the nearer side as if to indicate that the Alderman has risen angrily on some previous occasion. In the absence of other causes, his daughter's

disobedience is a possible cause. Falling objects in Hogarth's art signify profound change as *actually* taking place, while overturned things are the signs of irreversible change having recently taken place (examples of the way tense can be manipulated in art). In *Marriage A-la-mode*, the overturned chair in the second picture and the stool in the fifth act as accompaniments to views of a disintegrating marriage. The overturned and broken dining chair resolves the theme and the defects in an otherwise sound chair also completes the motif of flawed or spoilt things in the series, visual reminders perhaps of the tragic flaw. The fusion of two motifs in one final image is an appropriate concluding statement to a series in which everyone proves fallible.

In the first picture the broker is the obvious miser, whereas his presumed employer, the Alderman, seems a generous man. His private and comprehensive meanness, evidence of which is reserved to the last picture, makes him the exemplification of hypocrisy in the series according to Fielding's definition in the Preface to *Joseph Andrews*. The Alderman is also in the style of Hogarth's earlier skinflints, the study of the Rake's father (*I*) and the money-lender in the gaming house (*VI*). He is more than a stock figure, however; his return to the narrative enabled Hogarth to develop his awkwardness into a particular heaviness of person and to give him a pretentiousness, a vulgarity of taste in food and art, and a callousness which are wholly convincing. An insight into Hogarth's contemptuous attitude to such hard, ambitious men is found in *The apology for painters*. He was to ask what was the point of studying to be a painter when a neighbour, 'perhaps a brewer 〈 or porter 〉 or 〈 an 〉 haberdasher of small wears shall accumulate a large fortune become Lord Mayor member of Parliament and at length get a title for his heirs'.[9]

The concern with 'high-life' has encouraged the view that *Marriage A-la-mode* is exceptional in terms of the imaginative development of Hogarth's narrative art. He was fascinated by the career of his hypothetical neighbour, however: *A rake's progress* is about the thriftless son of an avaricious City gentleman or Knight whose progress down St James's Street to the palace is halted by his arrest; *Four times of the natural day* is concerned with the amusements of a master-dyer and his family and a justice who is also a freemason; *Industry and idleness* shows how a weaver's apprentice rises to be sheriff and Lord Mayor. In the *Election* series, the City Knight bribes his way into Parliament as member for Guzzledown.

In *Marriage A-la-mode*, the despised, but also envied neighbour, a City gentleman, a banker, alderman and ex-Lord Mayor, is an integral element of the narrative. He makes a more successful advance on Westminster than Tom Rakewell and the series shows the consequences of the liaison for his family. *Marriage A-la-mode* is not an interlude, but one of Hogarth's City narratives. The moral tone and homely atmosphere of the last picture make it an immediate prelude in terms of style, subject and morality to *Industry and idleness*. The unfinished happy-marriage series about country people would have been the interlude.

Hogarth's attitude to his sources of inspiration was ambivalent; they

had to be disliked, feared, and yet admired a little. The strain of reconciling the many opposites which are unified in *Marriage A-la-mode* was to tell on him. The split-plot of *Industry and idleness* was to keep the protagonists apart except for one dramatic moment of 'living contact between man and man'. Even at that moment, Goodchild and Idle do not look at each other. After *Marriage A-la-mode*, Hogarth effectively withdrew from close involvement with his *characters*; subsequently they are only *figures*, swamped by crowds at the end.

A licensed physician is included in the sixth picture to balance with the apothecary and to contrast with the quack in the third picture. The physician's (supposedly sagacious) wig, his fashionable cane and sword identify him as a Westminster physician, whom the poet names 'Sir Glysterpipe'. Hogarth's Viscount consults a French quack, but the City dignitary properly consults a member of the College of Physicians. Unlike the quacks and the apothecaries, the licensed doctors did not practise medicine so the summoning of a physician was a costly and futile gesture on the Alderman's part. A physician of repute could earn the then enormous sum of £7,000 a year so his prompt departure is consistent with one who feels that he is too far East and who might suspect that the Alderman would be inclined to argue over his fee.

A hint of professional rivalries may also have been intended in his early departure. The gentleman physician leaves a sordid and common-place form of death to be dealt with by an ugly, socially inferior member of a rival society. The physician sniffs the vinaigrette at the end of his cane out of contempt. Unlike the apothecary's nosegay, vinaigrettes were no longer used as a protection against disease so the physician's gesture is one of affectation. Hogarth's personal dislike of physicians shows in the painting where the physician is no more than a flat black silhouette with the haft of the sword and the tip of the cane carelessly touched in in gilt.

The strange effect of a *doppelgänger* arises from the positioning of the physician back to back with the Alderman. The emblems of the latter's pretension in the first picture, his sword, his wig and the tricorn hat, which actually hangs on the peg to the left of the last picture, are repeated in the physician. The trappings of 'gentlemanliness' are being transported out of the house, leaving the Alderman in his true character. Conversely, the Alderman stands in the attitude of a physician feeling for a patient's pulse, but to a different end. The momentum of the viewing sequence of the whole series culminates in a view of affected pride and rejection in the person of the physician. The impetus is redirected, through him, into the undefined and empty corridors beyond, decorated only with fire-buckets, effective dampeners with which to conclude the series.

The meal table with its emphasis on taste introduces the last physical sense into the series. Supporting evidence is found in the water, the tobacco, the dog's hunger, and the food and drink in the Alderman's pictures. Bosse's *Sens: le gout* shows people *à table*, a servant with a jug, and a dog eating from its bowl on the floor. The father is positioned at

the end of Hogarth's narrative, metaphorically, to consume what is left to him of his daughter as he was or is about to eat the only other dead thing in the room.

The river view defines the predominant element of the last picture as water, an element which is also introduced in the jug and the contents of the loving-cup, the interior picture of an urinating man, and the patches of damp on the ceiling. Lady Squander, having undergone an ordeal by fire, dies in her father's damp house by swallowing liquid. The room is chilly as is implied by the cold food and drink, the need for extra coats, the window open on to the river at a cool time of the year, and the presence of death. The combination of elements suggests a phlegmatic atmosphere, the most material and stupefying humour. The Alderman's limited vision, his passivity, and the stolidity of his servants are indicators of his temperament. Egg was reputedly a stimulant which only a coldly gluttonous man could eat avidly and remain unmoved by the death which arouses others to anger or sorrow.

The minor characters, like the audience at the concert, provide an accompanying parade of the basic psychological types with which to conclude the series: a melancholy imbecile; a choleric apothecary; a phlegmatic nurse; a sanguine child. *Marriage A-la-mode* is supported by a widely accepted and long established psychology which is worked out with care and logic. Humour-psychology was ideal for Hogarth's purposes because its roots in physical existence enabled him to analyse fine variations in mood and personality without recourse to language. Behaviour in the series is thus accountable and Hogarth's claim, in the subscription ticket, to be primarily concerned with the middle ground of character and not caricature, is vindicated. He had reason to be aggrieved when contemporaries dismissed his figures as grotesque or were content not to seek beyond personal applications.

Partly as a result of this kind of reception as well as his own attitudes, Hogarth was not to develop the psychology of his subsequent series to the same extent as he did in *A rake's progress* or *Marriage A-la-mode*. His recurrent figures were to be subordinated to the requirements of the plot or the moral. Historical change may have also encouraged him to recognise that in an increasingly scientifically minded period humour psychology was out-dated. Hogarth's references to and criticisms of LeBrun's catalogue of passions and his interest in Parson's theories concerning the anatomy of expression were signs of his recognition of a need for a modern approach that, paradoxically, favoured his theories less.

ELEMENTS OF THE SETTING

THE ALDERMAN'S HOUSE

THE VIEW THROUGH THE WINDOW The panelled interior is austere, well-lit, and in the venacular style in which the City was rebuilt after the fire of 1666. The Alderman is sufficiently proud of his house to have had it insured against fire as the buckets marked with a red *S* in the

[**40a**] Bụck's print of the waterfront of the Thames near London Bridge, from the Croce Collection (British Museum, London). This version of a popular vista does not show the house with a round-topped window on the corner of Swan steps. *Note:* the force of the tide running through the arches; all the boats are going with the tide.

[**b**] The view through the Alderman's window (detail) from *Marriage A-la-mode VI*. *Note*: how Hogarth makes the buildings totter crazily (Buck's print makes the structure appear more solid than it actually was); the escutcheon with St Paul's sword (p. 159); the spider's web and the spider (p. 160).

corridor prove. The precaution is somewhat excessive, however, in that the ceiling even of a room well above water is stained with damp. Phillips in *The Thames about 1750* (1951) identifies the Alderman's home with the small corner-house on the east side of Old Swan Stairs. It is the only house in Buck's print of the water-front near London Bridge with round-headed windows similar to, but not quite the same in design as the Alderman's.[10] Hogarth depicts a typical house on the edge of the merchant quarter with one special feature to distinguish the Alderman from his peers. As was his practice throughout the series, Hogarth adjusted the salient detail to avoid an exact application.

London Bridge was effectively a dam because the tide was forced to pass through channels the equivalent of a sixth of the river's width. The pressure gouged out the river bed, weakened the wooden starlings, and so caused the structure to vibrate, as Gay explained: 'for late the winter's flood/Shook her frail bridge and tore her piles of wood'. Thomas Pennant's recollection of the street and life on the bridge is particularly vivid:

> I well remember the street on London Bridge, narrow, darksome, and dangerous to passengers from the multitude of carriages: frequent arches of strong timber crossed the street, from the tops of the houses to keep them together, and from falling into the river. Nothing but use could preserve the rest of the inmates, who soon grew deaf to the noise of the falling waters, the clamour of watermen, or the frequent shrieks of drowning wretches.

The misery was not exaggerated; boatmen tried to shoot the rapids between the arches and over the years thousands of people lost their lives. There is a delusory calmness about the river at low tide as shown through the Alderman's window, the appropriate state for the end of a gloomy narrative. The fatalism of the inhabitants coincides with the character of the man whose admired view it is. The arms of the City of London surmount a vision of dereliction. The hidden weakness in the structure comments on the discrepancy between the Alderman's public life and his private one.

The heads of criminals were displayed on poles on the south gate of the bridge (across the river from the Alderman's house). Although the poles cannot be seen from the window, Lady Squander dies within sight of the structure which, it would have been assumed in the 1740s, was decorated with her lover's head, and within earshot of the rushing waters which were redolent of death. In so far as Silvertongue's personal emblem is the sword, St Paul's Sword of the Spirit in the top left quarter of the escutcheon (in the print) is a discreet reminder of the character who is called upon to make a marriage and then is punished for destroying it with the sword, as it were, on behalf of the City of London.

Hogarth could not have found a more appropriate structure with which to conclude the series, a necessary evil from medieval times to balance with the Earl's Palladian folly. There may have been some family animus behind Hogarth's choice of a man who admires such an abhorred bridge. His uncle, Edmund, kept a grocer's shop at the southern end and he gave his nephew only grudging support when he was in need of assistance.

THE SPIDER'S WEB AND THE RIVER DAMP ON THE CEILING A cobweb with
a spider at its centre festoons the top left corner of the window frame. A
spider is a symbol of transience, deceit and hypocrisy in the Old
Testament: 'and the hypocrite's hope shall perish: whose hope shall be
cut off, and whose trust shall be a spider's web' (*Job*, 8. 13–14).[11] The
spider in Swift's *The battle of the books* possesses a 'good plentiful store of
dirt and poison' in its breast and an 'overweening pride, which feeding
and engendering on itself, turns all into excrement and venom'. It
'produces nothing at last, but fly-bane and a cobweb'. Hogarth, who
made *The battle of the pictures* a variation on Swift's satire, may have had
a particular passage in mind. The bee accuses the spider:

> Erect your schemes with as much method and skill as you please; yet if
> the materials be nothing but dirt, spun out of your own entrails (the guts
> of *modern* brains) the edifice will conclude at last in a *cobweb*: the duration
> of which, like that of other *spiders'* webs, may be imputed to their being
> forgotten, or neglected, or hid in a corner.

In some states of the print, the spider can be seen at a distance from its
web as if to suggest that even a spider can no longer support itself in a
barren household.

The Alderman is one of Swift's 'other spiders' with little left to feed on
other than himself. As the 'modern' man (of commerce), he contrasts
with the property owner of the first picture who reveres an ancient past.
The Earl's favoured tradition is alien, exotic and cruel, while the
Alderman's is homely, proverbial, and distasteful. The triumph of the
Alderman's way of life, as has been suggested, leads directly to *Industry
and idleness*.

Some viewers perceive a meaningful shape in the configurations of
damp on the ceiling, a consequence of the 'pictures-in-the-fire' effect. If
the print is rotated through ninety degrees, as Holbein's *The am-
bassadors* is meant to be, the patches seem to form a figure. The context
of *Marriage A-la-mode* suggests that it is a woman, her smeared face
encircled by a shawl, or a cloak of disguise, or a shroud. The last
possibility is consistent with the idea of an ascension of an anti-Virgin
(page 140). The configuration is not present in the painting and the
shape was literally to fade like a spirit might be imagined to do from the
later states of the print as the copper plate itself wore away.

COUNSELLOR SILVERTONGUE'S DYING SPEECH
The broadsheet which lies close to the laudanum bottle is entitled
'Counfeller Silverto[ngue's] last Dying Speech'. A similar sheet occurs
at the end of *Industry and idleness XI* which reads 'The last dying speech
& Confession of Tho. Idle'. The omission of 'and Confession' from
Silvertongue's dying speech suggests that Hogarth may have intended
to convey a hint of defiance at the end in keeping with the character's
initial boldness and gallantry.

Idle's speech lacks decoration, but Silvertongue's is headed with
three woodcut emblems. The largest, in the middle, is the triple gallows
of Tyburn prefigured in the treatment of the tripod in the third picture
and shown itself in *Industry and idleness*. The jobbing printers cus-

tomarily used only one decorative block per broadsheet and had a stock of blocks ready to suit a variety of crimes and criminals.[12] Only notorious criminals called for special treatment, like Jonathan Wild whose death was reported in an elaborate account with several specially commissioned blocks. The inclusion of three decorations implies that Silvertongue's trial would have been recognised as a minor *cause célèbre*. Hogarth also deviated from normal printers' practice in order to make a concluding comment through emblems of his own choosing. The gallows, a commonplace emblem, is flanked by a bust in a medal to the right, traditionally the 'good' side of a page or a stage. The figure on the sinister side is less clear, but, under magnification, a horned or winged creature is apparent. The murdered husband is ironically sanctified by the medal and Silvertongue is the demon-lawyer.

The broadsheet is as effective an agent of the plot as the family tree in the first picture. It supplies the main reason for the suicide in defiance of convention for the death of a lover. The speech is an ironic epitaph for a recurrent character: Silvertongue has stood, sat, knelt, been lifted to be hanged and (to complete the reduction) ends as a piece of paper 'whirled by the cold wind'. The pattern of movements is an apt expression of the decline of a character whose crime is the consequence of *his* presumption and a lady's condescension. His character trait is only discovered in a *dying* speech at the *end* of a narrative *after* he has made his exit from the series. A viewer is prevented from hearing his whispers, but his persuasive voice and professional skills have failed to win him a reprieve. The name was left incomplete in the painting, 'Silverto . . .'. Only subscribers were to learn his full name and weigh up its implications.

THE INTERIOR PICTURES AND THEIR GENERAL FUNCTION IN THE SERIES

The Alderman is the most active collector of the series. A full-length picture without a frame, showing a man with his back to the viewer, has been hung in front of a still life. A carousal scene hangs to the right. Their frames are standard Dutch, that is ebony with gilt beading along the inner edge. The three pictures are in the same style and show some duplication of contents as if they were meant to be by the same artist. They are generally in the spirit and style of the *Hudibras* illustrations and the portrait of the Rake's father counting his gold, and so fit into a well-established pattern of low-life subjects in Hogarth's art.

The order of discussion follows what appears to be the Alderman's preferred order beginning with the carousal scene to the right and ending with the newest picture.

THE CAROUSAL The last interior picture of the sequence in a progressively more pathetic series is the most jovial of them all: a toper solemnly lights his pipe from the bibulous nose of his drinking partner. There is a dustiness about their faces which suggests that the topers are millers, thirsty men by occupation. The sayings, to have a 'nose to light a candle at' and 'one may know by your nose what pottage you love'

also combine in a metaphor the pleasures of smoking and drinking. Lichtenberg wondered whether Hogarth was alluding to Falstaff's gibes at the expense of Bardolph's nose. Falstaff calls it an '*igniis fatuus*', a 'link light', a 'salamander' and 'a death's head or *memento mori*'. The jokes show that Shakespeare was playing on the idea of a red nose as a multiple symptom of sexual disease, alcoholism and death, associations also relevant to the themes of Hogarth's series. A nose had phallic connotations, as was noted in connection with the blind bust in the second picture, and there was a long-standing belief that tobacco could cure syphilis. The unhealthy whiteness of the topers' faces also adds to the rich diversity of meaning.

The passing of fire from one person to another is an exemplification in the form of a visual parable of the way influences work on the characters of the series: the inclusion of a smoker in a tradesman's leather cap, who draws his fire from the deformity of a colleague in a feathered cap, comments on a situation in which an alderman takes advantage of an earl whose excesses have forced him into a humiliating alliance. The Alderman, the only smoker and drinker (of water and gin) in the series, owns a picture which sums up the alliance from his viewpoint. The amused admiration of fire implicit in the choice of the picture suggests that the Earl's enthusiasm for collecting passes to the Alderman: London has been 'fired' to follow Westminster's example.

THE STILL LIFE Ireland argued that the only point of a still life, the Alderman's second most-favoured picture, was as an exercise in futility, merely to show how highly a Flemish artist could '*finish*'. Ironically, cleaning shows that even Hogarth's burlesque of a still life has its glowing colours: the meat is fleshy, the carrots red, and a pan is coppery. It shows an untidy corner of a cold store (perhaps a Shimei's 'cold kitchen') where the bulkier supplies of food and lumber have been discarded or thrown away. De Lairesse would have disapproved of the subject, especially for a living room, in that he claimed that the most agreeable subjects for a still life were flowers and fruit, gold, silver and other rich things, and musical instruments.[13]

The plentiful supply of useless meat and vegetables contrasts with the frugality of the Alderman's meal and offers him, a well-fed man, a vision of carelessly treated delights which he denies himself. The other objects seem to be recapitulations on some of the significant details of the narrative. An empty stable lantern with its window open to show two crosspieces recalls the watchman's lantern of the fifth picture, while a pair of shoes or clogs recalls those among the curios on the wall of the quack's laboratory and the embroidered shoes of the bagnio, their equivalents hung up in the last. An empty candlestick recalls those associated with the contractual basis of the marriage. A clay-pipe and a feathered cap (similar to that worn by the toper) are left on a chopping block. They suggest that the Alderman's pretensions and small pleasures are under threat. The upturned barrel, the tilted copper pan, and the empty tureen are ironic counterparts of his daughter's lifeless body.

The ugliness of taste and meanness of mind characterised by these

[41a] The urinating peasant and the still life (details) from *Marriage A-la-mode VI.*

[b] The carousal scene (detail) from *Marriage A-la-mode VI.*

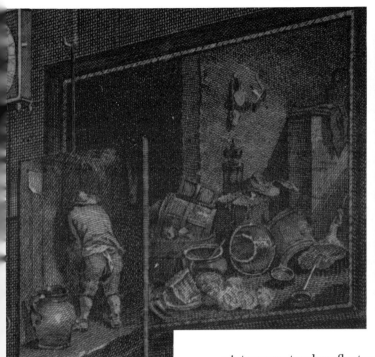

pictures not only reflect on their owner, but make his daughter's suicide seem inevitable once the sanguine woman's last hope of a brighter life has passed. Hogarth was to declare that the greatest grace a picture can have is motion. A still life was a symbolic representation of imaginative death to him as an artist and in his series the ultimate consequence of a Medusa's stare.

THE PICTURE OF A MAN MAKING WATER The Alderman is sufficiently enthusiastic about his newest picture to have hung it without waiting to have it framed or moving the picture behind it. (The picture was literally Hogarth's last thought too, because he painted it on top of the still life. The vertical line of the frame now shows through.) It shows an untidy peasant who, having put down his pitcher (of similar design to the topers' jugs), relieves himself against the wall of a barn. The hayloft is lost to the painting because of damage. Hogarth has exaggerated both the curves of the peasant's buttocks and the sides of the richly brown pitcher to make a visual simile (a 'pitcher man' was slang for a toper). 'He shall not piss my money against the wall' was the protest of the careful man who would not let his money be spent on drink. The Alderman has been drawn into a family of squanderers and his experience still leads him to admire a variation on the theme in spite of his disappointments.

At the same time, the picture is a symbolic representation of 'The End'. The last potential observer and commentator on the action is turned away in a gesture of supreme contempt. The vulgarian of the series, who has his own jug full of water ready for drinking, takes pride in the most material and least dignified of human activities involving an element closely associated with his own humour. The pitcher man's action is a deliberately derisory response to the exploding cannon in the

portrait of the Earl as Jupiter. Hogarth chose to end his series with a literal anti-portrait of no one in particular – and so of everyman. The likelihood is that Hogarth transposed the backview of the adoring shepherd, taken out of the background of the second picture, to a picture without the potentially sacrilegious connotations of a Madonna and child.

A urinating boy or man is a popular motif in genre painting and common in Hogarth's comic art. It makes its appearance in *Hudibras in tribulation* where a boy urinates in Ralph's boot. Swift's equally robust humour encouraged Hogarth to repeat the idea because *The punishment inflicted on Lemuel Gulliver* (1726), another picture with a gross subject, shows a Lilliputian urinating on Gulliver's hat. Incontinence is associated with delusion in the madman who thinks he is king in *A rake's progress VIII*. An embarrassed monkey urinates into a Roman helmet to the right of *Strolling actresses dressing in a barn* (painted 1736–7), another picture concerned to show the mundane reality behind the illusion. A boy makes a noisy puddle, much to the cross-eyed girl's amazement in *The enraged musician*. The motif is ribald, mischievous and deflating, but in *Marriage A-la-mode* it represents a more serious comment on the characters. Hogarth seems to have had a measure of contempt for his own achievement, part of a painful duality of attitude which was to deepen over the years.

De Lairesse provides a measure of the Alderman's vulgar taste in pictures. He complained of beautiful houses or fine apartments being decorated with 'pictures of beggars, obscenities, a *Geneva*-stall, tobacco-smokers, fiddlers, nasty children easing nature, and other things more filthy'.[14] Such things were 'too low and unbecoming subjects for ornament', especially for people of fashion whose conceptions ought to surpass the vulgar. Hogarth set out very deliberately to make the Alderman's pictures recognisably fit only for the kitchen.

Thirty pictures decorate the rooms in *Marriage A-la-mode*, twice as many as in any other series. Most are accurate copies of works attributable to artists known to Hogarth through oil copies or engravings of the originals. The use of pictures with a recognisable subject as a form of authorial comment derives from the seminal third picture of *A harlot's progress* where a picture of the angel staying the hand of Abraham invites an ironic comparison between Isaac, the 'burnt offering', and the Harlot. The strategy of making the interior pictures react critically to the events of a series was first used in *Taste à la mode* and *Marriage A-la-mode*; Hogarth was to return to *A rake's progress* (c. 1747) to replace the faceless head of Julius Caesar with one of the tavern keeper who surveys the mess in his cellar with a disgruntled expression. The ploy of making the characters in the series engage with the contents of the pictures on the walls also appears in *A rake's progress III* where a bored harlot assumes the role of Helen in setting afire a map of the world and a little carving of King David on a harp is superimposed on a picture of Nero. In the series after *Marriage A-la-mode*, authorial comment of this kind is transposed to papers, inscriptions and signs. The change of tactics would suggest either that Hogarth felt he had exhausted the possibilities of this device, or that he found his followers

failed to recognise the subjects of the little pictures and so the ironies were lost on them.

Much of the wit in *Marriage A-la-mode* derives from the clever selection of relevant works and the way the figures react to the situation either in character or entirely out of character. St Luke is properly attentive, the Jupiter is suitably sprightly, and the Harlot hard and knowing, but, ridiculously, Medusa is appalled and Solomon loses his dignity.

The contrasting styles (Italian or French baroque and low-life Dutch) chart the ebb and flow of the principal influences in the series. A decadent Westminster is associated with violent and airy examples of the historical sublime, and mundane and material London with vulgar examples of low life. The Earl's taste reveals an interest in sadism with an undercurrent of morbidity; the Alderman's a joviality and an underlying interest in forms of waste, deformity and excretion. His daughter's disorientation shows in her choice of pictures: first her interest in saints and a veiled eroticism; and then her preference for a grander style (closer to her father in law's taste) and a blatant sexuality. The influence of her father's meaner taste is never far away: it shows itself in the style of the masquerade screen in the fourth picture and is anticipated in the crude picture in the bagnio. The daughter dies before the father's newly acquired study of a urinating peasant, a view of the most contemptuous gestures of rejection that a man can offer a woman.

The interior pictures not only provide some access to the inner lives of the characters, but also interact with them: St Paul's sword threatens the steward's neck; King Solomon judges the characters in Hogarth's narrative; Lord Squander is being sucked into the mirror. The identification of characters with martyrs (by analogy) suggests that their fates are determined. The effects combine to suggest that, for Hogarth, identity is a profoundly ambiguous and shifting concept. The analogies invest the metropolis and its inhabitants with values beyond themselves and, conversely, reduce the heroic to a mundane level. The allusive framework in *Marriage A-la-mode* reaches to the centres of classical and Christian myth and in so doing makes it a mock-heroic and allegoric work without disturbing the credibility of the characters.

De Lairesse characterised the 'poetic' in art by the intermixing of deities and mortals; as '*fictions only*'; as signifying little else but the course of the world through the four elements.[15] Hogarth's choice of subjects enabled him ingeniously, but legitimately, to intermix the mortal and the immortal, the 'natural' and the 'emblematic'. The systematic introduction of the four elements enabled him to make *Marriage A-la-mode*, certainly a work of fiction, poetic, according to the letter of canons of contemporary practice. He was able to counter de Lairesse's argument that the 'ingenious *Mode*-painter ought to take care, not to meddle with the *antique*, or to mingle the one with the other; for that would be an unpardonable mistake; since he may be sufficiently furnished with a *modern matter* for his study'.

The crowding together of the interior pictures and, twice, the hanging of one in front of another is in itself an expression of the subject of squandering. Hogarth copied his sources with astonishing care, yet

weakened their effect by placing them in obscure corners, a dismissive attitude to his own talent. His attitude to the original artists is also ambivalent: he reproved them for their choice of sensational subject matter explicitly treated. He was, decorously, to avoid such treatment in his own serious history painting. Imitation in miniature, nevertheless, is a form of flattery; their work was an education and a source of inspiration and some fear.

Hogarth's attitude to the copyists, dealers and false connoisseurs is clearer: he was to complain bitterly of 'wonderfull copies of bad originals [imported and] ador'd for their names only and the dealers'.[16] Imitation in miniature is also a special form of ridicule whereby superiority is achieved through accurate representation of the object within a larger work. Hogarth was demonstrating that he could compete with the copyists under more difficult conditions than theirs and for purposes incidental to his main one. Ironically, the fact that the interior pictures are accurate renderings of originals which he could not have seen is an unintended compliment to the skill of the intermediaries on whom he depended for his encyclopaedic knowledge of art. In composing the first picture of *Marriage A-la-mode* alone, he must have considered and rejected innumerable works before settling on the combination which suited his purposes best. His last words on the subject show the extent of his contempt for the connoisseurs who underestimated his work because they knew far less about art than he: 'they ⟨ say ⟩ that he [meaning himself] abuses the great masters let me put a case & then let it be judged who abuses the great masters ⟨ he or they ⟩ ?'[17]

THE CORNER CUPBOARD, THE CLOCK AND THE ALMANAC

Five books fill the top shelf of the cupboard, their spines reversed to save wear. The titles of a day book, a ledger, a receipt book and a compound interest book have been inked in on the fore-edges. The titles were not included in the painting in order to withhold the information that the Alderman is a usurer and perhaps a merchant banker. A day book was used either as a record of financial transactions or for invoicing goods. Hogarth would have been more likely to have intended the former since a usurer would be disinclined to deal in goods which could be stolen or burnt.

The presence of the receipt book draws attention to the absence of a payments book. The smaller book remaining in the row could have been intended as the pay book and the absence of a title suggests that the Alderman prefers not to read the word *payments* each time he opens his cupboard! The inclusion of this little book not only spoils the evenness of the row (it was full size at one stage in the painting), but also suggests that the Alderman makes few payments and, by discouraging his borrowers from repaying capital, this 'spider' earns more, it may be presumed, and avoids the necessity of re-investment. The thickness of the compound interest book pays tribute to his cunning, hardheadedness, and success. There is no evidence of a 'cash flow' problem or that the alliance with a personification of squandering has impoverished the avaricious man. His eagerness to possess his daughter's

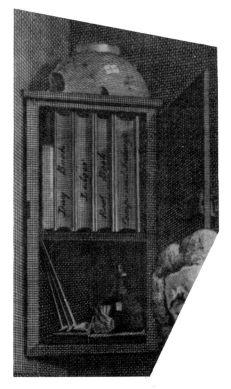

ring, therefore, is all the more degrading.

The bottom shelf of the cupboard contains the careful man's small pleasures: a stock of clay pipes, a gin bottle, and a soft leather bag for minor valuables such as a ring. The cupboard is kept locked as the Alderman's means of keeping his books and his pleasures to himself. One pipe with a red tip and an oval, probably lead tobacco box are ready for his post-prandial smoke, perhaps a means of dulling the pangs of hunger and evidence of foresight in little matters if not in large. The upturned and chipped punchbowl on top of the cupboard recalls the bowl set the right way up on the chair in the preceding picture and that locked away in the cupboard of the Rake's father (*I*). Festivity has been a feature of the household but, in being reversed, the bowl signifies the end of the pleasurable life.

The almanac (spelt 'ALMANCK' in the painting) and the wall clock with its large alarm bell draw attention to the regularity of the Alderman's way of life. Although Hogarth disapproved of his character, it is likely that he preferred the functional design of the English clock to the over-elaborate French one in the second picture. One effect of the recent cleaning is to show that the shape and colour of the almanac are repeated in the paper pinned to the wall of the barn in the picture of the urinating peasant. Time in both the Alderman's room and the world of his paintings is being wasted. A similar almanac in Mr West's counting-house (*not* in his living room) is decorated with a motto of youth taking time by the forelock (*Industry and idleness IV*). In *Marriage A-la-mode* the old woman, unlike the moon or Father Time, holds only a representative of deformed youth in her arms.

[42] The contents of the corner cupboard (detail) from *Marriage A-la-mode VI.*

The Alderman's clock is the last of a number of clocks or watches in the series. Hogarth, like Defoe, Swift and the contemporary novelists, acknowledged the importance of time by making use of dates, numbers and hours to govern the tempo of his narratives, as the steward's receipt in the second picture shows. His titles often draw attention to the passage of time (from *Before* and *After*, via *A-la-mode*, to *The tailpiece*) and the terms *progress* and *series* themselves imply an interest in advance through time.

The appearance and disappearance of clocks in *Marriage A-la-mode* is significant: the Earl lives in a timeless room, surrounded by monuments to a heroic past. Time is ridiculed in the absurd clock of the second picture and its passage is ignored by the married couple as it has been ignored by the gamblers. The plain watches of the common miss in the third picture and Lady Squander in the fourth suggest that time and the ordering of life in a topsy-turvy world are subservient to women rather than men and women of similar outlook in spite of the wide difference in their ranks. The associations of time are again absent from the bagnio in view of its ironic associations with the birth of Western chronology. Time returns to rule all at the end in the images of the sonorous alarm, the almanac, the accounts books and, particularly, the *day* book. It is apt that the Earl who venerates timelessness should die within the span of the narrative, whereas the man of business should survive, as it were

immortal, at the end. Lady Squander's suicide at dinner-time (five minutes to one in the painting, just after eleven in the print) can be construed as an escape from her father's unendurable regimen into a state of timelessness.

THE IMAGERY OF FIRE AND THE POETIC ANALOGY

The predominant image of the series is present in the last picture, but, like water in the first, it is subordinate to its opposing elements. The Alderman's pipes, the discarded lantern and candlestick in the still life, the toper's pipes and red nose maintain the theme in diminished form.

In the first picture, fire is alight in the flame of the candle ready for the sealing of the contract. The wax melts unevenly, a sign of the presence of an impurity, or 'thief' as it was called, which squanders the tallow. As the focal point of the picture, the candlestick on a round table signifies that the contractual basis of the marriage is flawed and wasteful. The image of flame is transposed to the smoking candles and chilly fire of the second picture, which suggests that there is little regard for duty in marriage. The idea of fire is maintained only in dead forms in the third picture, but reappears in the fourth, subordinated to appearances in the curling tongs. The candle on the table blows out as the series reaches its fulfilment in the irradiant firelight of the fifth picture; the wastefulness of tragedy given visual expression. The images extend and vary, reappearing in literal and metaphoric forms each providing an insight into the central situation: the unit tapers of the first and second pictures (signifying a lack of light or life in the marriage); the snuff; the forms of irritant disease; the melting chocolate. No fire burns in the last picture; the pig's head on a charger substitutes for the single candle and the dangers of fire are minimised by the dampness of the room and the presence of fire buckets. The carousal picture typifies Hogarth's method in a twentieth century sense of the term. The old joke is a comic enactment of the Imagist principle whereby a theme passes from one statement to another is without explanation.

The question to be asked is whether Hogarth was consciously aware of the poetic quality of his narratives. Firelight is encountered in his series, frequently coinciding with the climax pictures. As the Harlot dies from a metaphorical form of the burning, a pot overboils on the fire and her mourners in the next picture examine themselves for signs of the 'burning' which continues among the living. The imagery of fire is most pervasive in *A rake's progress*. A fire is on the point of being lit as the Rake begins his spendthrift life. A climax is reached in the firelit cellar where he enjoys his orgy (*III*). His paroxysm of rage is accompanied by the burgeoning of a mysterious fire from beyond a panel (*VI*). The transfer to a final coldness in the last picture is prepared for in the enclosed fire in the alchemist's furnace (*VII*). In *Before*, the lovers' desire is transposed to an image of cupid lighting a rocket which then hangs spent in *After*. The fire in *Night* is an expression of the mason's belligerent mood which the cascade is about to douse. The arrest and betrayal of Thomas Idle occurs in another cellar illuminated by a roaring fire and Tom Nero is arrested by the light of huge lanterns. Hogarth's heightened responsiveness to the physical nature of

existence and his developed sensitivity to the dynamics of light would have made it impossible for him not to be aware of the power and role of fire in his art.

There are iterative images other than fire in the narratives. A miscellany of containers and rectilinear shapes recurs throughout *A harlot's progress* and combines in the resolving image of the Harlot's coffin. Cruciate forms and mock haloes interact with the fire imagery in *A rake's progress*. Crossed and flawed objects recur in *Marriage A-la-mode*. A variety of gallows-like structures recur throughout *Industry and idleness*, offering underlying connections between the separate plots and resolving in the contrasting images of Tyburn Tree and the Lord Mayor's coach at the end. Mutilated bodies provide a gruesome motif throughout *Four stages of cruelty*.

The process which required Hogarth and his engravers to labour over the paintings and copperplates of a series for many months would have forced an awareness on them of the ways in which details can relate one to another and to the purposes of the narrative whole. It should not be a cause for surprise that a play, novel, or picture series should have recurrent, poetic features. The study of iterative detail is a means of studying the nature of imagination itself, irrespective of the narrative mode in which it is found. In Hogarth's narrative art, the terms, *image* and *imagery* can be returned to their origin and used anew.

THE VISUAL ORGANISATION OF THE PICTURE

A subdued light from the window sets the tone for a sombre picture. The light picks out the pallid tablecloth, the cold sheen of the nurse's cap and the delicately crumpled clothes of the mother and child. The clothes make a sympathetically treated cluster of lighter colours and richer textures which contrast with the plainer textures and sicklier colours of the other clothes. The wooden floorboards are uncovered and few objects enliven the panelled walls. The masses are given space to themselves, adding isolation to the general effect. No patches of river damp enliven the monotonous ceiling in the painting. The shadows around the pictures, clock, and cupboard lose their effect in the print and the depth in the painting is replaced only by a gain in clarity. The light once again falls from the left in the painting and from the right in the print, a variation characteristic of all the narratives. By making the flow of light challenge the momentum of the viewing sequence of the prints, Hogarth attempted at least to ensure that attention is drawn to its effect in a medium which relies on variations in line and shading alone.

The disposition of highlights offers one measure of the difference between the first and last pictures. They are scattered haphazardly in the last picture as in the first, but are fewer in number as befits the more modest interior. They draw attention to some of the more telling detail in the painting: the white of the dog's eye and the lines of his protruding ribs; the gleam of the loving-cup (painted with extraordinary impressionist skill); the curves of the water jug; the weights of the clock.

As in the first picture, the parade of figures is set against an inclined corner with a large, partly open window in one wall. There are fewer,

well-spaced figures and their grouping is arranged according to different principles. The ordering in the painting begins with the largest figure and diminishes to the smallest, a literal tailing off. The viewing sequence of the print, however, begins with the smallest and ends with the largest, an arrangement which gives dramatic emphasis to the conclusion and contributes to its sense of balance in the contrast between the father who begins the series and the one who ends it. The other figures in the last picture lean towards the Alderman so that the left to right movement of the viewing sequence is reinforced and the impression of all things converging on him is strengthened. The organisation of the last picture helps confirm the view that Hogarth composed his paintings as *modellos* for the prints.

The gradations reflect the placing of the characters in the traditional hierarchy of being, beginning with the animal and ending with the supposedly superior man in possession of his full faculties. In between is a spectrum of partial beings: the imbecile and the dwarf, as types, are more than the beast, yet less than the man; the nurse and the child are at the extremities of age and youth; the corpse of a suicide is at a subhuman level. A gentleman physician would rank highly, but a back view is an artist's definition of half a man so that the Alderman is surrounded by inferior forms of being which reflect on his own moral and psychological deficiencies. The picture is characterised by acts of insubordination: a dog seeks to rival its master; a feeble servant has outwitted his mental superiors on his mistress's behalf; a dwarf berates another man's servant; age lifts youth; a countess by marriage has degraded herself; the father robs his daughter's corpse. Not only do the characters parade as the sins in a modern guise before an anti-dormition, but their defiance is of mock Luciferan proportions.

The parade divides into pairings which link aggressive and submissive figures: the dog *grabs* the pig by the ear; the apothecary *seizes* the servant's collar; the nurse *clasps* the child; the child *clings* to its mother's neck. Only the most grasping character, metaphorically, holds his daughter's wrist with delicacy as he withdraws the ring. The Rakewell family's heraldic emblem, a carpenter's vice, provides a clue to Hogarth's intentions in the later work, a study of the extent to which man is unremitting in his desire for repayment. The Alderman's delicate gesture also recalls that of the Rake in the marriage picture (*V*). The movement of Rakewell's hand is contrary to the momentum of the viewing sequence and so attention is drawn to the ring as he slides it on to the bride's finger. The Alderman withdraws the ring with the momentum of the viewing sequence so that his is the less conspicuous act. The arrogance, gallantry, defiance, melancholy, love, pleasure, violence and remorse lead to and resolve in one small unobtrusive act of inhumanity.

CONCLUSION

The last picture reverses Shakespeare's tragic pattern in that it shows male characters dying before the female, conventionally a more pathetic and less forgiving effect. A first-mover returns to the narrative outwardly in the role of a sorrowful Capulet, but, whereas Shakespeare offers a prospect of at least a 'glooming peace' at the end of his play, Hogarth completes his narrative by placing the human on a par with the bestial. Events seem to prepare only for another cycle of misery and loneliness. Not unlike a Shakespeare play, the series is set between the polarities of the West and East ends. The balance recalls the see-sawing of events between Orsino's and Olivia's houses in *Twelfth night*, one on either side of the stage. Intervening events occupy the middle ground of central London in *Marriage A-la-mode* so that the orderliness of the path from the mansion to the water-front adds to the elegance of the design and the verisimilitude of the series.

An underlying rhythm of stronger and weaker moods is apparent in the interaction of humours and senses. The series begins with a dominant, choleric atmosphere associated with the Earl's supposedly all-seeing authority. A chilly atmosphere redolent of melancholy and frowstiness succeeds. Images of painful touch predominate in the aggressive and scornful atmosphere of the quack's laboratory. An aura of complacency pervades the sanguine, melodious atmosphere of the fourth picture. A consummation of sensual experience dominates the fifth and the quiescence of death resolves the series in the phlegmatic atmosphere of the last picture in which one being feeds off another. The emphasis on strong succeeded by weak suggests a dissonance appropriate to a work concerned with disintegration.

The issue of prints for one of Hogarth's series was an eagerly awaited event in the 1730s and '40s. The appeal of *Marriage A-la-mode* lay in its enlightened disapproval of a range of social iniquities: the abuse of rank and status; the arrangement and casual treatment of marriage; irresponsible parenthood; presumptuous womanhood and foppery; manias for building, gaming and various forms of collecting; child-prostitution and quackery; forms of xenophobia; the double standards of an enthusiast: the fashion for suicide and duelling.

The popular appeal of a work, however, can obscure its erudition. *Marriage A-la-mode* reveals Hogarth's mastery over an equally wide range of forms of art: the historical sublime; fashionable portraiture; classical engraving; pious and erotic works; low-life drolleries; tapestry; the woodcut tradition; emblemature. The selection of only the most apt examples of attributable works in the interior pictures implies a wider knowledge beyond those represented. In addition, the series both exemplifies and demonstrates the limitation of current theories on the nature of art as proposed by LeBrun, de Lairesse and others.

Hogarth's erudition extends beyond art: the series reveals a familiarity with popular drama, with John Dryden as a positive influence, and the craft of acting; up-to-date fiction, serious and scandalous; myth and legend; religious symbolism and biblical wisdom; masquerades and operas; mock-epics and satires; the practice of medicine and accounts;

physiognomy, anatomy, and popular psychology; contemporary cant and proverb lore; regalia and the latest fashions in clothing, furnishings and architecture. The range shows Hogarth to have been as much interested in a response to art, drama and literature as he was to the foibles of life.

The intellectual and artistic achievement lay in making unity out of this medley of encyclopaedic reach. By transposing the skill, cleverness and informality of style from the conversation pieces to a relatively cheap and accessible medium, Hogarth invented an original form of domestic art at a level of verisimilitude otherwise found only in portraiture. He could visit Paris in 1743 not as a deferential pilgrim, but as London's most radical, knowledgeable and up-to-date practitioner with a growing international reputation. So confident was he in his own powers and the resources at his disposal in London that *Marriage A-la-mode* had no need to be modified as a result of the visit.

Hogarth's contemporaries responded by paying tribute to his originality and ingenuity, but they also misunderstood his intentions, were affronted by the physical power of his imagination, and were awed by the harshness of his conclusions. The anonymous poet, for example, recognised his achievement as a 'dramatic painter', but underestimated the subtlety of the characterisation so accustomed was he to thinking of character in terms of the imprint of a ruling passion. Churchill and Rouquet failed to identify the essential structure of the work. Ireland's plaintive remark is typical of the bewilderment which was to persist to the twentieth century: 'I do not know in what class to place his pictured stories. They are too crowded with little incidents, for the dignity of history; for tragedy, are too comic; yet have a termination which forbids us to call them comedies.'[18] Even when Hogarth did make serious enemies out of friends in later life, as was the case with John Wilkes and Churchill, they showed an uncharacteristic reluctance to attack him. The tone of the criticisms which followed the publication of *The analysis of beauty* suggests that contemporaries were relieved to find that a formidable intellect could be found vulnerable.

The unsettling effect of *Marriage A-la-mode* is based on a tension between the subject matter and its treatment. Hogarth's vision is negative: supposedly respectable and responsible people end by being murdered, hanged, committing suicide and raiding a corpse. They associate themselves in their choice of pictures with forms of sadism, masochism, rape, torture, murder and incest. Hypocrisy, avarice, vanity and enthusiasm are pervasive evils. Affectation is a destructive force of universal potential. The characters are made out to be personifications of the deadly sins. The search for self-gratification endangers health, status and prosperity and drives characters ruthlessly, heedlessly, or disdainfully to subordinate each other to their own ends. A glutton risks the future of his family for the sake of an unsound monument. An apparently shrewd investor lays out a fortune on a marriage pact with squanderers. The middle generation is heavily punished for the risks it takes: a bored and despised husband involves himself in prostitution and quackery and gambles in a duel with unsuitable weapons; his wife amuses herself with a glib lawyer and

stakes her life against the chance of an impossible reprieve; the lawyer's philandering arouses the wrath of the powerful and he is swept aside.

Although the characters act as if they are free from restraint, they are circumscribed by their own desires: the Earl is immobilised by the consequences of his own gluttony; the Alderman rules himself and his household with a harsh regularity; the husband's promiscuity brings disease and public humiliation; the wife's family makes impossible demands on her after death. Even potentially redemptive gestures in the series, the wife's sideways glance, the husband's protective gesture, the lawyer's escape go unnoticed by others or are rendered futile by the course of events. The skeleton which leans to kiss the muscleman in the most prison-like setting of the series sums up Hogarth's pessimistic view that to be alive is to be the prisoner of death.

The force of this negative vision has diminished with the passage of time because the wider meanings of *to squander* are no longer immediately recognised. The vitiation of taste, the greed, the misuse of power are the diverse manifestations of a single theme. It is characterised by a fundamental dislike of wholeness: beautiful beings or things are cut, flawed, diseased, branded, threatened, badly designed as if on purpose, clumsily mended, rickety, turned upside down and scattered. The effect is one of universal 'pillage' expressed in domestic terms. A similar loss of understanding has reduced the significance of the rivalries between the two Cities. It is easy now to overlook the bitter irony in a resolution which leaves the helpless heir to a Westminster earldom in the care of a London alderman.

The vision may be nihilistic, but it is never ugly, the supreme contradiction of Hogarth's narrative art. Folly is treated in glowing colours and arranged in patterns of kaleidoscopic intricacy. Affectation is regarded with amusement and treated with inexhaustible energy. The wit is by turns malicious, sardonic, devious, absurd and derisory. A narrative mode which can present the span of an adult life in six pictures gives the impression that life even at its most pathetic is an undignified scamper. The most phlegmatic and melancholy characters appear mercurial. When Hogarth came to try a happy subject, he grew bored with it. He came to recognise that 'even stories of the utmost horror' could by means of 'ridiculous connection' become 'matter of laughter and jest' and that the appreciation of intricacy in form is the experience of a '*wanton kind of chace*'.[19] It is his preferred and developed awareness of incongruity rather than the attention to detail (as Ireland suggests) which prevents the series from having the 'dignity of history' and the 'ridiculous connection' makes his work an unequalled form of pictorial melodrama.

Joshua Reynolds was to recognise the uniqueness in Hogarth's art and was to use his influence to ensure that it remained so in calling for a renewed emphasis on academic skill and restraint. In the fourteenth *Discourse* Reynolds was to identify Hogarth's purpose with the 'ridicule' of life and to acknowledge his mastery of the 'domestic and familiar'.[20] He used the anonymous poet's phrase in summing up Hogarth's achievement as having 'invented a new species of dramatic painting in which probably he will never be equalled', but he reproved Hogarth for

leaving his own sphere and presuming to attempt the 'great historical style'. The passing reference to Hogarth's narrative art occurs in a eulogy to Gainsborough who by way of contrast knew his limitations and kept within them. Reynolds failed to perceive that Hogarth's imagination in his 'domestic and familiar' art could reach back 'two thousand years' as Poussin's was admired for doing and that he could

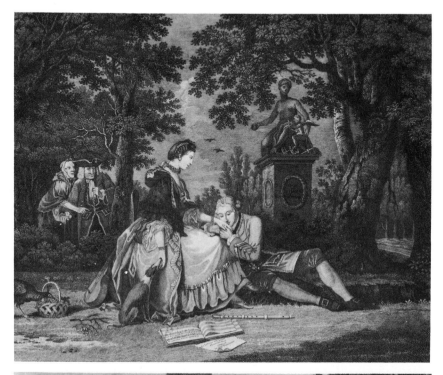

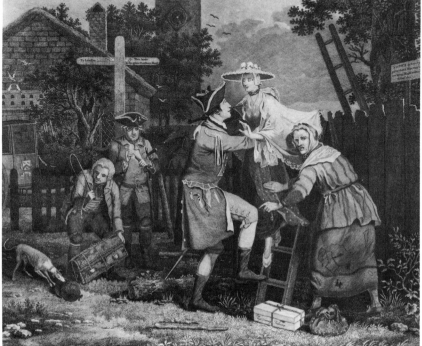

[43] *Modern Love*, 1765, John Collet, engraved by J. Goldar 1782 (British Museum, London).

[a] *Courtship. Note:* the discarded tunebook on the grass which may have been taken up from Hogarth's second picture; the parallel between the dog licking the woman's hand and the lover kissing her other is a less subtle use of a dog to comment on the central situation than in Hogarth's *The tête à tête*.

[b] *The elopement. Note:* the lady's name, Miss Fanny Falsestep, is written on the box in the foreground. Collet was a neat punster: the notice behind the fence reads 'Notice is hereby given that a man trap is set every night within these piles'.

align the antique and the universal behind the modern and the particular and account for the relationship between them in remarkable effects of comic enlargement. Ironically, it is not impossible that Reynolds' use of heroic poses in his own high art, portraiture, owed a debt to Hogarth's practice of presenting his characters in mock-heroic contexts.

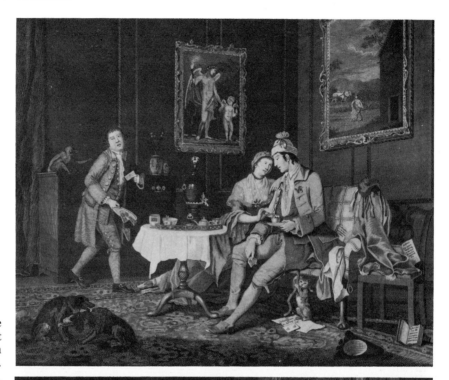

[c] *The honey-moon*. The lovers are close to one another and the attendant approaches them rather than withdraws, the reverse of *The tête à tête*.

[d] *Discordant matrimony*. Many points have been taken up from *Marriage A-la-mode*: a disenchanted couple set before a fireplace; china ornaments on the chimney piece; shackled pointers; a neglected and broken musical instrument on the floor; a nursemaid brings unwanted children instead of a departed steward with unwanted bills.

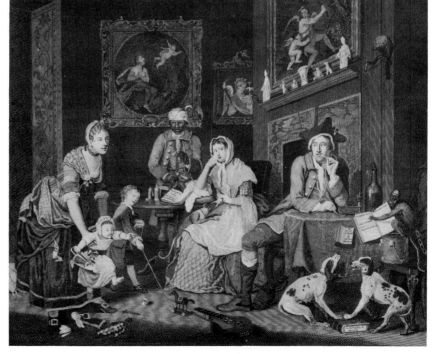

The insistence on the separateness of the classes in painting meant that there were few serious attempts after Hogarth to combine the 'domestic and the familiar' with the heroic in what had proved for him to be an adaptable and profitable form. John Collet published a variation on *Marriage A-la-mode* in four pictures called *Modern love* (painted 1765, engraved 1782). It shows courtship, elopement, the honeymoon and the discordant marriage. Collet knew how to make the details of a realistic setting reflect on the central situation, but the work lacks imaginative resource and he failed to resolve his narrative perhaps, as David Kunzle suggests in his history of the early comic strip, because harsh conclusions in the art of someone other than Hogarth were not acceptable later in the century.[21] John Hamilton Mortimer composed a sequence in neo-classical style, *The progress of virtue* (painted 1755), which also was influenced by Hogarth, but it was not engraved and the experiment not repeated. Reynolds' assistant, James Northcote, painted *Diligence and dissipation* (1796), a series in ten pictures contrasting the lives, not of apprentices, but of serving girls. Kunzle refers to Northcote's brave, if misguided attempt to build a bridge between the realistic narrative of the past and the sentimental neo-classicism of the new age. Although Hogarth's prints continued to sell long after his death, Northcote failed with both the engravings and the paintings of his series. Part of the difficulty lay in the fact that Hogarth left little to be said.

By 1758, when Hogarth made his last, angry attack on those who confused his characters with caricatures in the caption to *The bench*, the vogue for caricature had transformed the market for popular prints. Caricature shops took over the trade in prints from the book sellers and the fashionable caricaturists were amateurs, the Marquess Townshend and Henry Bunbury, instead of professionals like Hogarth. The fashion encouraged a trend away from complexity towards simplicity and away from the considerable products of the labour of years towards the ephemeral. Ridicule began to lose its profound associations. Setting diminished as a major influence upon the central events of narrative sequences and consequently the potential depth was lost. This last trend was encouraged by Hogarth's own change of direction after *Marriage A-la-mode* whereby his recurrent figures were made subservient to the moral or the crowd.

Understandably, Hogarth's influence was most positive and lasting on the writers of prose fiction. No other narrator analysed so fully or so deeply the relationship between man and the environment in which he finds himself or manufactures for himself. Setting, for Hogarth, was an active principle and not merely a matter of sympathetic background. *Marriage A-la-mode* in particular is a milestone in the history of fiction in its difficulty, its ambiguity, its concern to give make-believe figures a well-found psychology and in its movement of events from an imagined present to a demonstrably hypothetical, but chronologically consistent future.

So close were Hogarth and Fielding in the early 1740s that it is impossible to decide who was the greater influence on whom. Fielding responded to the intellectual and physical conviction of Hogarth's

characters in *Joseph Andrews*. Hogarth adhered to Fielding's theory of the ridiculous and gave it visual exemplification in *Marriage A-la-mode*. They shared a love of comic irony and possessed a turn of mind which delights in incongruities, extended analogies, ambiguity and allegory. Both used the humours as a basis for the presentation of character and were united in their calculated dislike of caricature and burlesque. Poetic recurrences, particularly the interaction of the diabolic and the angelic, can be detected in *Tom Jones* as in Hogarth's series. The differences between them lie in Hogarth's uncompromising refusal to admit sentiment or to flatter his viewer as his more benevolent friend, Fielding, did his reader.

Other eighteenth-century writers tended to follow Fielding's example in making deferential reference to Hogarth's characters as a substitute for description without translating his visual effects into verbal terms. Dickens, however, was unmistakably to respond to Hogarth in associating everyday objects with the personal idiosyncracies of recurrent characters; by animating the inanimate in presenting characters; in making dispersed details isolated within themselves play upon single themes and, by so doing, imbue the 'domestic and familiar' in prose with a pervasive poetic quality.[22]

What makes Hogarth unique in a way that Reynolds did not foresee was the coincidence of talents: those of an instinctive and masterly painter, a skilled engraver, an ingenious narrator, and an accurate observer, supported by the knowledge of a polymath. *Marriage A-la-mode* is the zenith of expression in a narrative medium unused to such comprehensive authority.

NOTES

1 Reported in *HI*, p. 228.

2 De Lairesse, p. 23.

3 *Joseph Andrews*, p. 11. Lord Chesterfield had proposed a similar argument in *Common sense* (3 September 1737): 'a hump-back is by no means ridiculous, unless it be under a fine coat; not a weak understanding, unless it assume the lustre and ornaments of a bright one'.

4 Hill, p. 357.

5 John Nichols and George Steevens, III, p. 55. The misidentification probably derives from George Augustus Sala's careless reading in *William Hogarth, painter, engraver, and philosopher: essays on the man, the work, and the time* (London, 1866, Ward Lock Reprint, 1970), note, p. 294. Austin Dobson, *William Hogarth* (London, 1902), note to p. 102, *HI*, p. 484 and *HGW* I, p. 275.

6 J. H. Plumb, 'The new world of children', *Listener* (26 February 1976),

95, No 2446, pp. 232–3. Walter Jackson Bate, *Samuel Johnson* (London, 1978), pp. 6–7.

7 *BM catalogue*, p. 582. *England in the age of Hogarth*, p. 211; the passage draws on Chapter 8, 'The vale of tears'.

8 Quoted in *John Gay's London: illustrated from the poetry of the time*, William Henry Irving, (Cambridge, 1928), p. 86.

9 *Apology for painters*, pp. 89–90.

10 Hugh Phillips, *The Thames about 1750* (London, 1951), p. 51 (Phillips reproduces Buck's print). This passage draws on Phillips, *HI* pp. 25–6, and William Kent, *Encyclopaedia of London* (London, 1937), p. 62 (Kent reproduces Pennant's account). The lines are from Gay's *An epistle to the earl of Burlington* (1715) lines 19–20.

11 Also *Isaiah* 59, 4–6. Jonathan Swift, *The battle of the books* in *A tale of a tub with other early works 1696–1707* edited by Herbert Davis (Oxford, 1965), pp. 149–51.

12 Robert Collison, *The story of street literature: forerunner of the popular press* (London, 1973), p. 34.

13 De Lairesse, p. 548.

14 Ibid, pp. 129 and 395.

15 Ibid, pp. 89 and 148.

16 *Apology for painters*, p. 104.

17 Ibid, p. 109–10.

18 J. Ireland I, p. cxviii.

19 *The analysis*, p. 80 and p. 42.

20 Joshua Reynolds, *Discourses delivered to the students of the Royal Academy* with Introduction and Notes by Roger Fry, (London, 1905), pp. 383–4.

21 David Kunzle, *The early comic strip*, (Berkeley, 1973), p. 319. See particularly chapter 11 'Narrative art after Hogarth' for the account of narratives in pictures after Hogarth on which this passage draws.

22 See Christopher J. Embleton's 'Dickens and Hogarth', unpublished M. Phil. (York, 1970) for a full account of the relationship.

Select bibliography of recent works

Antal, Frederick, *Hogarth and his place in European art* (London, 1962)

Bindman, David, *Hogarth* in 'The World of Art Library' (London, 1981)

Davies, Martin, *The British school*, National Gallery catalogues (London, second edition, 1959)

Hogarth, William, *'The analysis of beauty' with the rejected passages from the manuscript drafts and 'Autobiographical notes'* edited by Joseph Burke (Oxford, 1955)

Apology for painters edited by Michael Kitson, *Walpole Society* XLI (Oxford, 1966–8)

Jarrett, Derek, *England in the age of Hogarth* (London, 1974)

The ingenious Mr Hogarth (London, 1976)

Kunzle, David, *The early comic strip: narrative strips and picture stories in the European broadsheet tradition from c. 1450–1825* (Berkeley and London, 1973)

Oppé, A. P., *The drawings of William Hogarth* (London, 1948)

Paulson, Ronald, *Hogarth's graphic works*, two volumes (New Haven and London, revised edition, 1970)

Hogarth: his life, art, and times, two volumes (New Haven and London, 1971)

The art of Hogarth (London, 1975)

Popular and polite art in the age of Hogarth and Fielding (Notre Dame and London, 1979)

Phillips, Hugh, *Mid-Georgian London* (London, 1964)

Wark, Robert R. 'Hogarth's narrative method in practice and theory' in *England in the Restoration and early eighteenth century: essays on culture and society* edited by H. T. Swedenborg Jr (Berkeley, 1972)

Webster, Mary *Hogarth* (London, 1979)

Wensinger, Arthur S. and William B. Coley, *Hogarth on high life; the 'Marriage à la mode' series from Georg Christoph Lichtenberg's Commentaries* (Middletown, 1970). This work contains full-size reproductions of the prints of the series, a translation of Rouquet's *Lettre Troisième*, and the anonymous Hudibrastic poem, *Marriage-A-la Mode: an humorous tale in six cantos* (1746)